بسم الله الرحمن الرحيم

THE BLESSED CITIES OF ISLAM
MECCA-MEDINA

THE BLESSED CITIES OF ISLAM
MECCA-MEDINA

PHOTOGRAPHS

ÖMER FARUK AKSOY

Published by The Light, Inc.
26 Worlds Fair Dr. Unit C
Somerset, New Jersey, 08873, USA

www.thelightpublishing.com

Art Director Engin Çiftçi
Graphic Design Murat Arabacı, Şaban Kalyoncu
Miniature Nusret Çolpan (p. 20)

Translated from Turkish by Hakan Yeşilova
English text edited by Jane Louise Kandur

Library of Congress Cataloging-in-Publication Data

Aksoy, Faruk.
 [Mekke-Medine, İslâm'in iki kutsal şehri. English]
 The blessed cities of Islam, Mecca-Medina / photographs, Omer Faruk Aksoy. -- 1st English
ed.
 p. cm.
 ISBN 1-59784-061-0 (hardcover)
 1. Mecca (Saudi Arabia) 2. Medina (Saudi Arabia) I. Title. II. Title: Mecca-Medina.
DS248.M4A44 2007
953.8--dc22

 2006031135

Printed by
Ege Basım & Hızır Reklam / Istanbul

Contents

Foreword by Ekmeleddin İhsanoğlu ..9

Preface ..10

Introduction ..12

A Short History of Mecca and Medina ...14

Stepping into His World ..26

The Ka'ba ...28

On the Way to Arafat ..124

Towards His World in His Footsteps ...178

Ömer Faruk Aksoy was born in Istanbul in 1952. He studied German and took photography courses in Switzerland. He was involved in some Turkish movies first as an assistant and then as a cameraman. He started filming documentaries in Britain in 1980s. He then moved to Saudi Arabia where he filmed and directed advertisements, promotion films, and photography for companies as well as state institutions, primarily for King Abdul Aziz University, Umm al-Qura Uninersity, Ministry of Hajj, Ministry of Information and the Administration of the two Holy Mosques.

Aksoy was cameraman for documentaries like National Geographic's "Inside Mecca," and the BBC's "The Hajj: The Journey of a Lifetime."

Aksoy was awarded first prize in 1989 in an international photography contest, "Preserving Islamic Heritage," which was organized by the IRCICA. His photographs were displayed in 2003 in an exhibition called "Mapping the Treasures of Arabia" at London University and later in the "Haremeyn" exhibition at CRR in Istanbul. Some of his photographs are in permanent display at Mecca Museum.

Foreword

here is no doubt that the Ka'ba is the most blessed place on earth for a Muslim. God Almighty refers to the Ka'ba as His House in the Qur'an. Mecca, hosting the Ka'ba, and Medina, the birthplace of Islam and Muslim civilization, are the two sanctuaries that have always been revered throughout history. Poets wrote magnificent poems about these cities in order to reflect the heavenly epiphany that they hold. Every Muslim dreams of visiting these cities, at least once in a lifetime, places where discrimination of race or color is out of question . . . where everyone feels themselves to be equal with all others.

A cosmic harmony is observed here; the material fits perfectly into the immaterial. Visitors notice immediately that they are not in an ordinary place the moment they step out of the airplane. The longing that those who are no longer there feel for these sanctuaries is unique and every object, especially a photograph, that reminds one of these cities infuses one with an unbearable excitement.

The Light Publishing has undersigned a great project with this album. These photographs, taken over 25 long years of meticulous work and professional mastership by Ömer Faruk Aksoy, not only reflect the "place," but also the "meaning" of the holy lands, which are treasured to a greater degree from the texts accompanying them. One cannot help but fall into a deeply reflective mood as they browse through the pages of this album.

I extend my heartfelt thanks to everyone who participated in making this project come true.

His Excellency
Prof. Dr. Ekmeleddin İhsanoğlu
Secretary-General
The Organization of Islamic Conference

Preface

"Study, be virtuous, and be a servant to the Prophet . . ."

A few months after he had stated the above wish to his grandchildren, Hacı Şükrü Aksoy Efendi surrendered his soul during Friday prayer at the Köprülü Mehmet Paşa Mosque in Çemberlitaş, Istanbul, where he officially served as a muezzin and attendant. It seems his wish and prayers were answered.

Many years have passed . . . Ömer Faruk, one of his grandchildren, has chosen to reside in cities that were once part of the Ottoman State, after long and tiresome years in Europe. In the meantime, a decision has been passed in Saudi Arabia to expand the Masjid al-Nabawi, the Grand Mosque in Medina, in order to meet demands from the Islamic world.

The grandson of Hacı Şükrü Efendi and his crew are commissioned to capture the construction work of this expansion on camera. When Hafız Fikri Bey ve Hacı Fethiye Hanım came for pilgrimage to visit the holy lands, they find their son in the Grand Mosque in the service of the Prophet, peace and blessings be upon him. They unite, tongue-tied, as tears run down their cheeks.

Since that time, three kings have reigned, but Ömer Faruk continues to carry out the same duty.

Mecca and Medina are in the dreams of more than a billion Muslims all over the world. They are the hosts of the House of God and His beloved Prophet.

The Hijaz is where Adam and Eve met; the footprints of Abraham, the patriarch of all divine religions are there. The Hijaz has been the cradle of numerous civilizations and a main station on the route for trade caravans.

Photography is probably the most difficult in Mecca and Medina. Therefore, all praises and thanks be to the Almighty who is the Fashioner (Musawwir—who creates His creatures in any form He wills) for allowing me to take countless photographs in the last quarter of a century.

I am most grateful to my grandfather Hacı Şükrü Efendi and my parents Hafız Fikri Bey and Hacı Fethiye Hanım who have never deprived me of their prayers, despite making them suffer the pangs of separation for many long years; for this I ask their forgiveness.

I extend my warmest thanks to the present custodians of the Two Sanctuaries, the late King Khalid, King Fahd, and the new King Abdullah bin Abdul Aziz; I also thank Dr. Sami Anqawi of Harvard University, Islamic Architecture Department, for his official support and kindness throughout my filming and photography over the long years, Dr. Usama al-Bar, Dean of Pilgrimage Research Faculty, Iyad Madani, Minister of Information and Culture and his undersecretary Professor Abu Bakr Baqadir, Abdul Muhsin bin Humayd, Director of the Administration of the Two Holy Mosques, Dr. Halit Eren, who uttered the following wondrous words: "If God wills, He will change your path from London to Mecca", the British director Abdussabur Kington, who was my camera teacher; and Abdul Latif Salazar, an old friend and an American director who has been awarded for his most recent works. Without their contributions and invaluable support, I am aware that the picture archives used for this album would have taken much longer and been more costly to bring together.

I am indebted to my beloved wife, Dr. Siham Amba, and my children Rakan and Meral, who had to endure my frequent and lengthy journeys, which are a natural part of my profession, throughout our 22 years of marriage.

And finally, my heartfelt thanks go to Fethullah Gülen Hocaefendi; the inspirational texts which have been selected from his works are perfect companions to the pictures. I am also grateful to Engin Çiftçi, Murat Arabacı, and Şaban Kalyoncu for their meticulous art work and page design and to Dr. Reşit Haylamaz and Dr. Faruk Vural for their collaboration and dedicated endeavor to realize this album.

Ömer Faruk Aksoy

Introduction

e learn from the traditions of the Messenger of God that the surface of the Earth is a mosque, Mecca is its mihrab, Medina is the pulpit, the Prophet Muhammad, peace and blessings be upon him, leads all believers and preaches to all of humanity, and that he is the chief of all Prophets.

Certain times and places are special and unique, to be regarded as superior or precious in proportion to the value that the "Lord of all time and places" ascribes to them. In this respect, Mecca and Medina are superior to all other places. The honor of a place is acquired from those who reside there; these cities are filled with traces left by the Prophet and, moreover, their honor is endorsed in heavenly revelations. Their superiority is not confined to a certain slice of time in history, but to virtue, from the first man, Prophet Adam, until the end of time. Hundreds of Prophets and Messengers before Prophet Muhammad, peace and blessings be upon him, visited the Ka'ba; here, they knocked on the door of the Mercy and hundreds of them took their last breath while enjoying the ecstasy of reunion with the Divine Friend. From the very first day, the Ka'ba has always been the direction of worship for all humanity, with the exception of some unfortunate but temporary periods.

The divine scriptures, scrolls, and books entrusted to the Prophets as guidance for humanity have always indicated these sanctuaries and all the Messengers have focused their communities' attention on Mecca. For these appreciative souls, Mecca was a place to visit, a place to kiss the ground, while Medina was the secure place to which the Last Messenger was to emigrate. Countless seekers of truth deserted their families and homelands, traversing long distances in order to stand in prayer, waiting for him to come. This city was to be the meeting point of the beginning and the end.

Mecca suffered from ecliptic periods until Prophet Muhammad, the Trustworthy, honored the earth at Mount Paran, making it once again the qibla for all humanity, building a shelter of prayers to establish a security that would last forever.

His luminous climate, which embraced Mecca from the lonely bays of Hira, was not welcomed in the materialistic horizons of his contemporaries, who then dwelt in this city. He had to leave for Medina, the cradle of human civilization, which would become his refuge until he

returned with tens of thousands of companions. For the Last Messenger, Mecca became like an Emigrant and Medina a Helper among his companions, both becoming fortresses for the cause of God.

The blessed memories of the blessed Prophet resonate in the rocks and dust of these cities. These sanctuaries shook with the heavenly trust of revelation that speaks to their sincere visitors.

Every square meter of this land is imprinted with the oath of Hamza, Mus'ab, Abdullah ibn Jahsh . . . Badr, Uhud, and The Trench.

"God is one!" Bilal's cry echoes at Mount Paran; today it keeps rhythm with "God is Great!"

Every Muslim dreams of making pilgrimage to these sanctuaries, however, it is not always possible for all, due to financial or physical incapability. There seems to be no other way to sooth this longing than to listen to the memories of the fortunate ones.

This album is a compilation of the best pictures of these sanctuaries captured by a lover of truth with inspirational texts written by a man of heart who has dedicated his entire life to the Messenger's cause. Every frame revives pleasant memories of the pilgrims while stimulating the longing of those who have not yet been able to go. The inspirational texts, pouring from a heart that reflects the meaning of these sanctuaries, have been selected from the works of M. Fethullah Gülen; they accompany almost every picture, bringing a spiritual enrichment.

We hope this album will be a means for the gate of benevolence to be opened and may His most beautiful fragrance fill our hearts once again, peace and blessings be upon him.

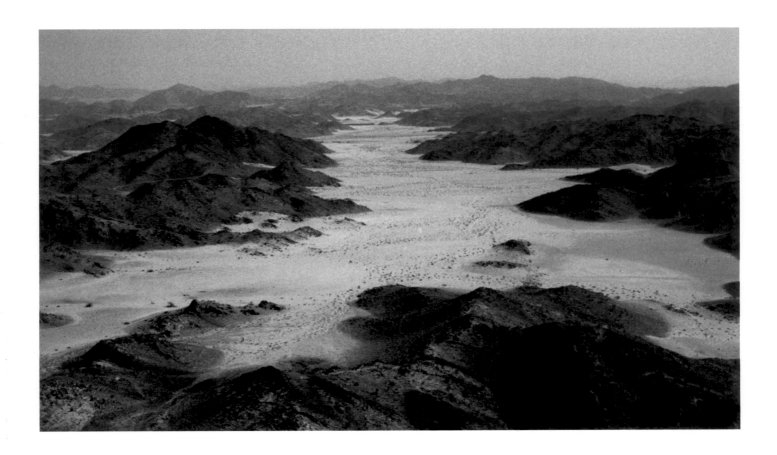

A Short History of Mecca and Medina

ecca is the first stop on mankind's journey, a journey which started with Adam, the first Prophet. Mecca also nursed Prophet Muhammad, the last link in the Prophetic chain; thus, it is the only place with this unique feature of merging the true beginning and end.

The first place of worship was constructed in this city and the doors of servanthood were opened to all humanity for eternity. In the words of the Qur'an, Mecca is the Mother of Cities (An'am 6:92) and the direction eyes turn for prayer.

Adam and Eve, our eternal parents, have been reunited in Arafat; this is still today the meeting point of the lover with the Beloved.

All throughout history, Mecca has undergone numerous thunderstorms and floods, and its brightest colors have faded at times; however, there has always been a helping hand extended to raise her back to her feet.

Prayers are answered in Mecca. "My Lord!" prayed Abraham one day, "Make this (untilled valley) a land of security, and provide its people with the produce of earth, such of them as believe in God and the Last Day." With the abundance of this prayer, Mecca has been filled with millions of visitors every year.

Abraham brought Hagar and Ishmael to the valley of Becca, which is at the foot of Mount Paran. Another time, and again with the guidance of Gabriel, Abraham rebuilt the Ka'ba with his son on its original foundations . . . their intention was pure; their steps were sincere and determined. As they wiped the sweat on their foreheads they prayed:

> Our Lord! Accept (this service) from us. Surely You are the All-Hearing, the All-Knowing.

> Our Lord! Make us Muslims, submissive to You, and our offspring a community Muslim, submissive to You. Show us our rites of worship and accept our repentance. Surely You are the one who accepts repentance and returns it with liberal forgiveness and additional reward, the All-Compassionate.

> Our Lord! Raise up among that community a Messenger of their own, reciting to them Your Revelations, and instructing them in the Book and the Wisdom, and purifying them. Surely You are the All-Glorious with irresistible might, the All-Wise. (Baqara 2:127-129)

The Lord Almighty answered their prayers centuries later by sending the Last Messenger. As a result of a variety of destruction, due to floods and damage from the elements over the long centuries, the Ka'ba has been restored several times in the past, and has been handed down as a special keepsake to the future, to its true master.

And Muhammad, peace be upon him, was twenty-five when the main agenda in Mecca once again became the restoration of the the Ka'ba. It was before he was charged with the messengership and he had not started his career of inviting humanity to the truth. The craftsmen were commissioned and the necessary building materials had been supplied. However, an unexpected quarrel arose suddenly when the walls were reached the level where the heavenly stone, Hajar al-Aswad, was to be placed. All tribes claimed that this honor was something that they deserved; ego and tribal pride replaced commonsense and the threat of a feud that might continue over the centuries was felt in the air. God Almighty treated the Meccans with mercy that day and one of them came up with an idea: the first person to come to the Ka'ba would act as arbitrator to reach a solution. They all waited for some time, and it was not long until Muhammad appeared in the distance; Muhammad, the catalyst of the universe, was a respected member of the community. When he was informed of the crisis, he asked for a wide cloak to be spread on the ground. Then, he laid the Hajar al-Aswad in the middle. His solution was that a representative from each tribe would held of the edges of the cloak and raise it to the height where the stone was to be placed. Everybody agreed that this was a good idea, as they could all carry the stone. And finally, Muhammad himself placed the stone in its original position. There is no such thing as blind chance in the universe; all the circumstances were adjusted in such a way that God allowed for the stone to be installed by its real master, whose message was to embrace everyone, peace and blessings be upon him.

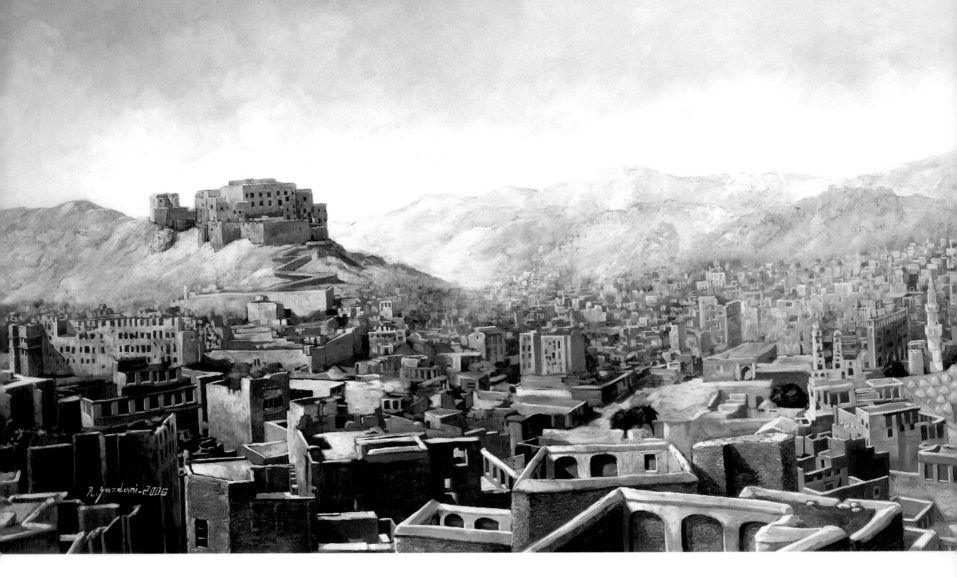

The revelation started showering upon Mecca, but this rain of Mercy did not last for long. The Prophet had to leave the Ka'ba, his soul mate, to depart for Medina. This separation lasted for eight years, and when he returned and declared mercy on all those who feared revenge and the death penalty, people rushed in groups to this fountain which previously they had shunned. Hijaz was now a land of peace.

Contrary to what was expected, the Prophet chose to stay in Medina, as a token of loyalty to the warmth of the Helpers. From then on, Mecca emerged as a city of learning and worship, while Medina remained as the center of administration.

Caliph Umar and later Uthman bought up and removed the houses in the environs of the Ka'ba to allow more space for worship. The Umayyad and Abbasids did the same in order to expand the sanctuary allowing for more worshippers to be present at the same time. Mecca and Medina were annexed to the Ottomans when Egypt was conquered by Sultan Selim I (Yavuz). The Ottoman sultans, who devoted utmost care to the holy lands, established many foundations to standardize services to Mecca and Medina. Numerous madrasas and other institutions, as well as the porticos which embellish the Ka'ba like a necklace, were built by the Ottomans.

Yathrib was the former name of Medina before the Prophet's emigration (hijrah). This city was mentioned in previous scriptures and many seekers of truth were drawn to this place even before the Prophet was born. A group of people from the Prophet Aaron's offspring came to Medina looking for the coming of the last Prophet; another group of believers who escaped the

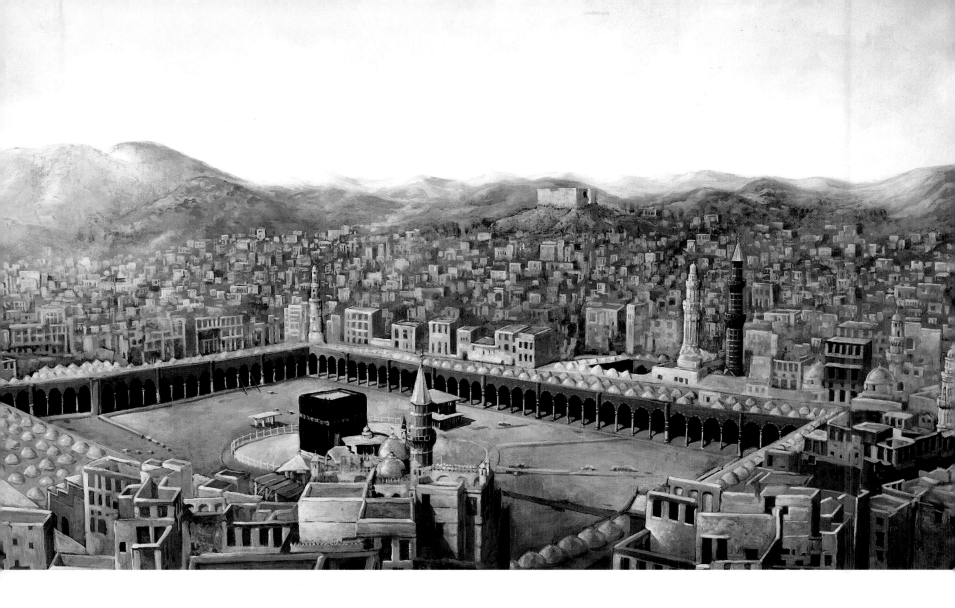

tyranny of Nebuchadrezzar, leaving behind their wealthy lands and families, chose this city to dwell in centuries before the Last Messenger came. Perhaps, these groups also have a share in the reason for Medina having a gentler climate than Mecca; their self-sacrificing attitudes and their preference for a place in which to seek God over everything else may have been a reason for such a reward.

A gilded lock for the Ka'ba, made during the reign of Sultan Ibrahim ◀*(1640-1648).*

17

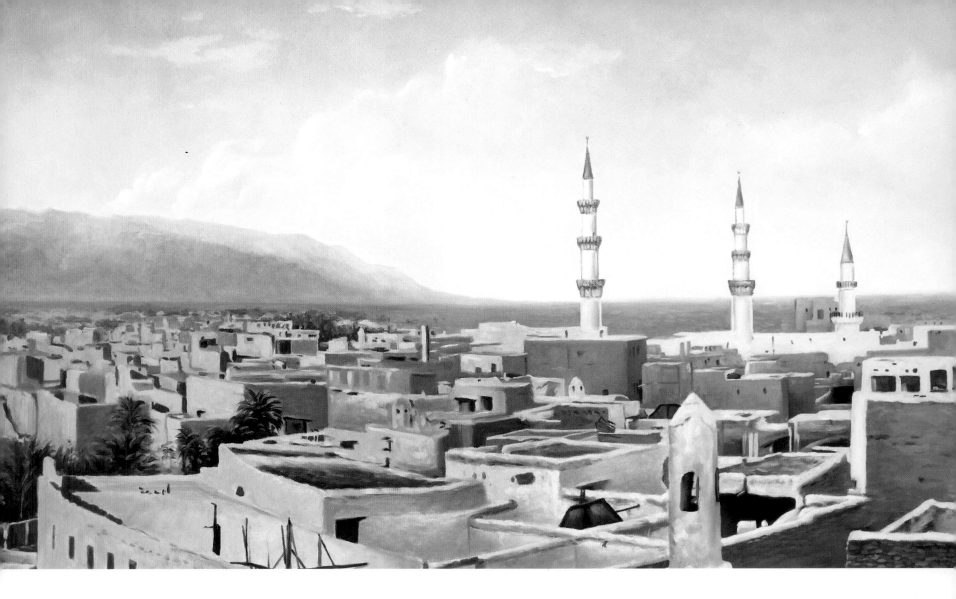

Medina continued its central administrative position after the Prophet passed away, until the capital was moved to Qufa by Caliph Ali, at a time when circumstances were rather negative.

The Prophet's Mosque has also been repeatedly renovated due to the need for more space as the number of visitors constantly increased. Major renovations started with Caliph Umar and later with Umar bin Abdul Aziz, who bought the houses around the Mosque and expanded the area of worship.

The first Ottoman construction activities in Medina started during the reign of Süleyman the Magnificent, in 1540. The renovation expenses were met by an allowance from the treasury in Egypt; the first examples of Ottoman architecture can be found in this period.

Medina is more renowned as a "city of lovers of God." It has always remained as a center of learning, culture, and worship; visitors to Medina have never returned to their homes without having tasted the most exquisite serenity that can be found in this sanctuary.

Mecca and Medina witnessed 23-years of revelation and the Age of Happiness. Today they still speak to the pilgrims in the same sonorous voice and inspire them to share the divine message of the Messenger with all who come there.

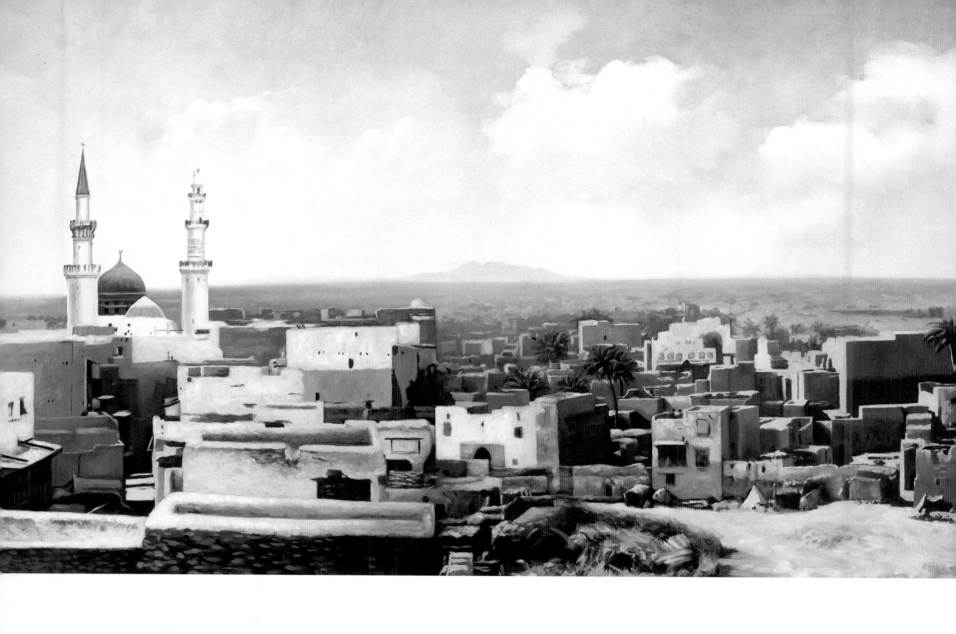

Mecca. A panoramic view. Illustration dated 1778 (1197 AH).

1. Bab al-Salam
2. Hajar al-Aswad
3. Hatm (Hijr Ishmael)
4. Door of the Ka'ba
5. Northern corner
6. Golden Gutter
7. Hajar al-Aswad corner
8. Station of Abraham
9. Safa Gate
10. Safa Hill
11. Marwa Hill
12. Batn al-Wadi
14. Mount Sabih
15. Masjid al-Ibrahim
16. Mount Arafat
17. Batn al-Wadi
18. Mount Mercy
19. Muzdalifah
20. Quzah Hill
21. Mina
22. Jamrat al-Aqabah
23. Site for slaughtering sacrificial animals
24. Site for shaving and cutting hair
25. Masjid al-Khawf
26. Muhassab
27. Farewell gate
29. Public fountain
33. Tomb of Abbas

34. Station of Hanafi
35. Station of Shafii
36. Station of Maliki
37. Station of Hanbali
38. Pulpit
39. Abu Qubays Hill
41. Abdullah Hill
42. Sabir Hill
43. Sharif Hill
44. Thawr Hill
46. La'la Hill
48. Indian Hill
49. The spot where the miracle of splitting the moon took place
50. Mount Hira
51. Mount Nur
52. The spot where Prophet Abraham prayed
53. Mualla Cemetery
54. Tomb of Khadija
55. Blessed House
56. Molla sector
57. Murat III Masjid
58. Süleymaniye Madrasa
59. Qayitbay Madrasa
62. Baths
63. Marketplace

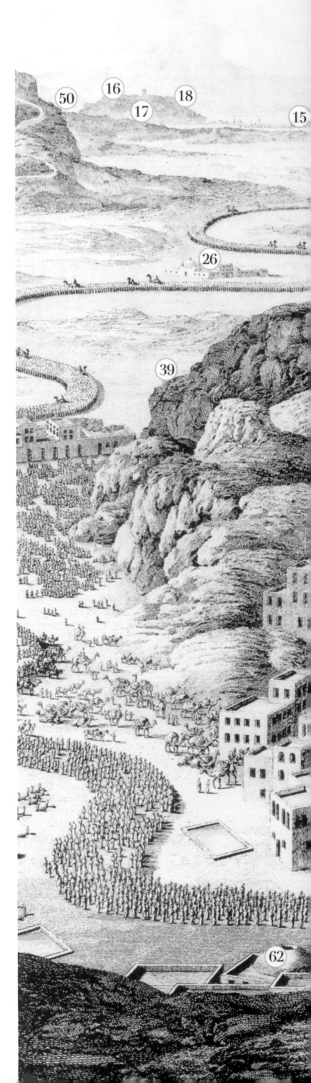

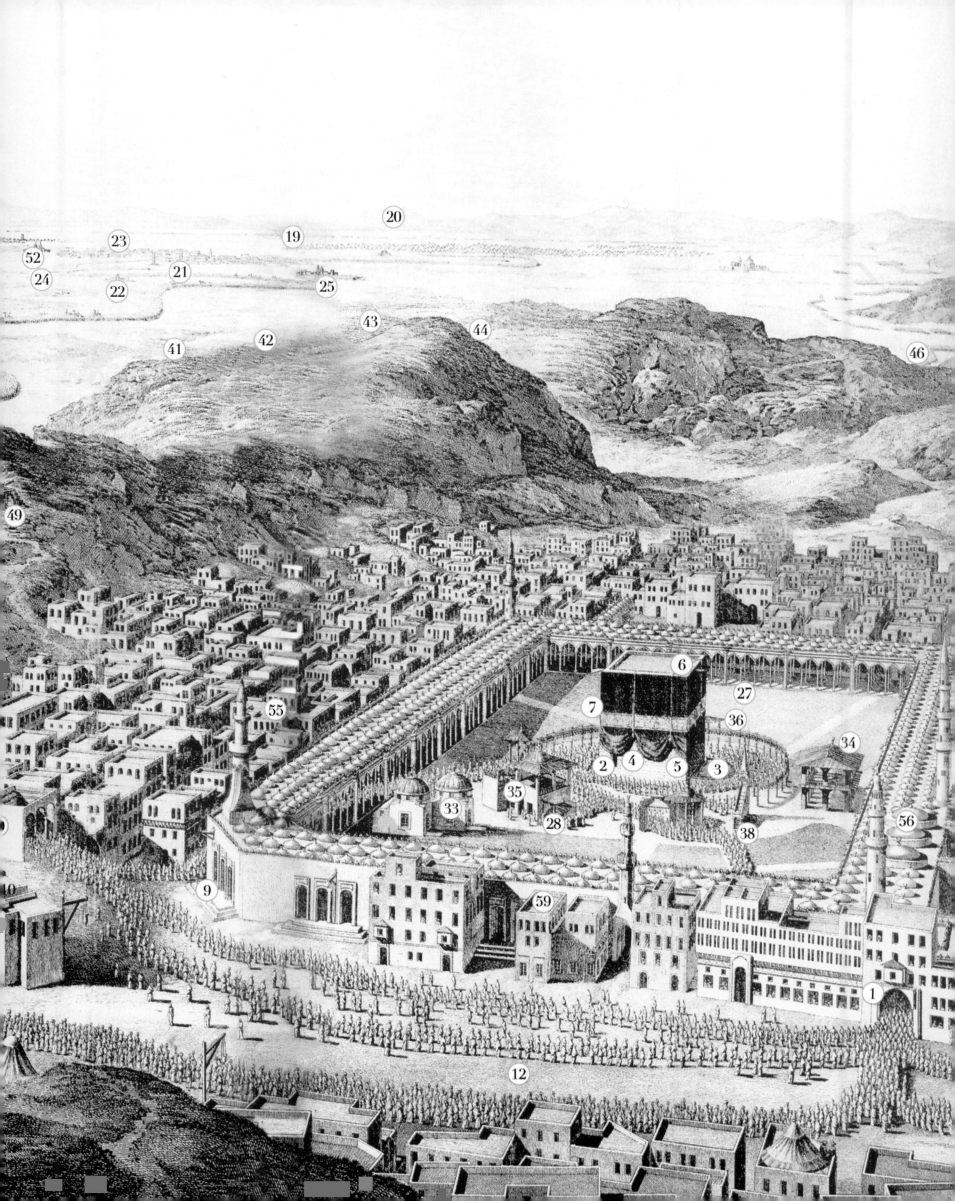

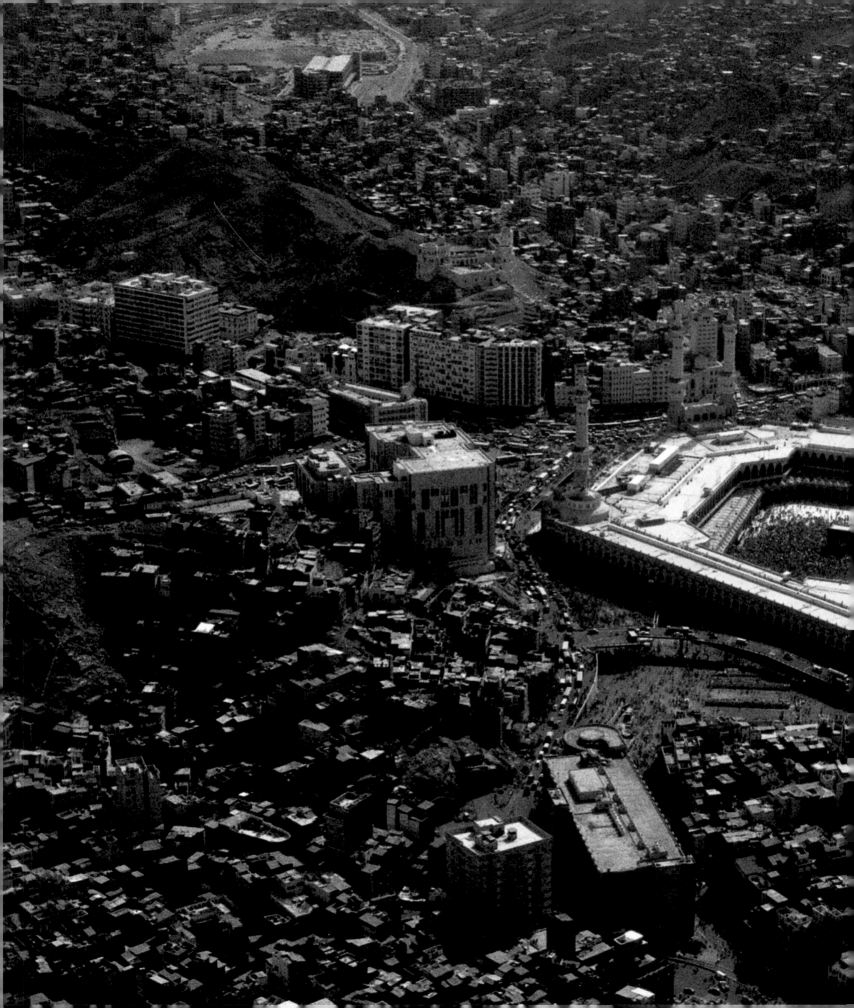

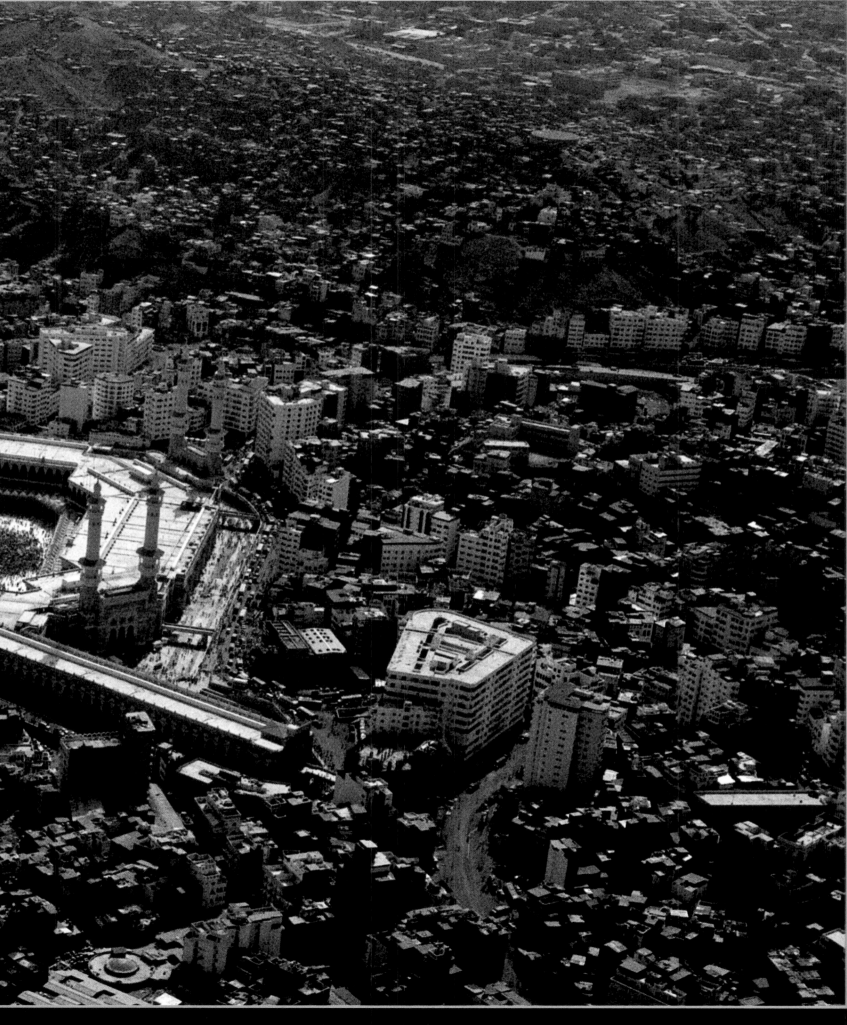

Mecca and the Blessed Sanctuary, 1980s.

Stepping into His World ...

Remember when We assigned to Abraham the site of the House (Ka'ba) as a place of worship, (directing him): "Do not associate any partners with Me in any way, and keep My House pure (from any material and spiritual filth) for those who will go round it in devotion, and those who will stand in prayer before it, and those who will bow down and prostrate themselves in worship."

Publicly proclaim the (duty of) Pilgrimage for all humankind, that they come to you on foot and on lean camels, coming from every far-away point, so that they may witness all (the spiritual, social, and economic) benefits in store for them, and offer during the known, appointed days the sacrificial cattle that He has provided for them by pronouncing God's Name over them. Eat of their meat and feed the distressed, the poor.

Thereafter let them tidy themselves up (by having their hair cut, removing their *ihram* (Hajj attire), taking a bath, and clipping their nails, etc.), and fulfill the vows (if they have made any, and complete other acts of the Pilgrimage), and go round the Most Ancient, Honorable House in devotion.

(Hajj 22:26–29)

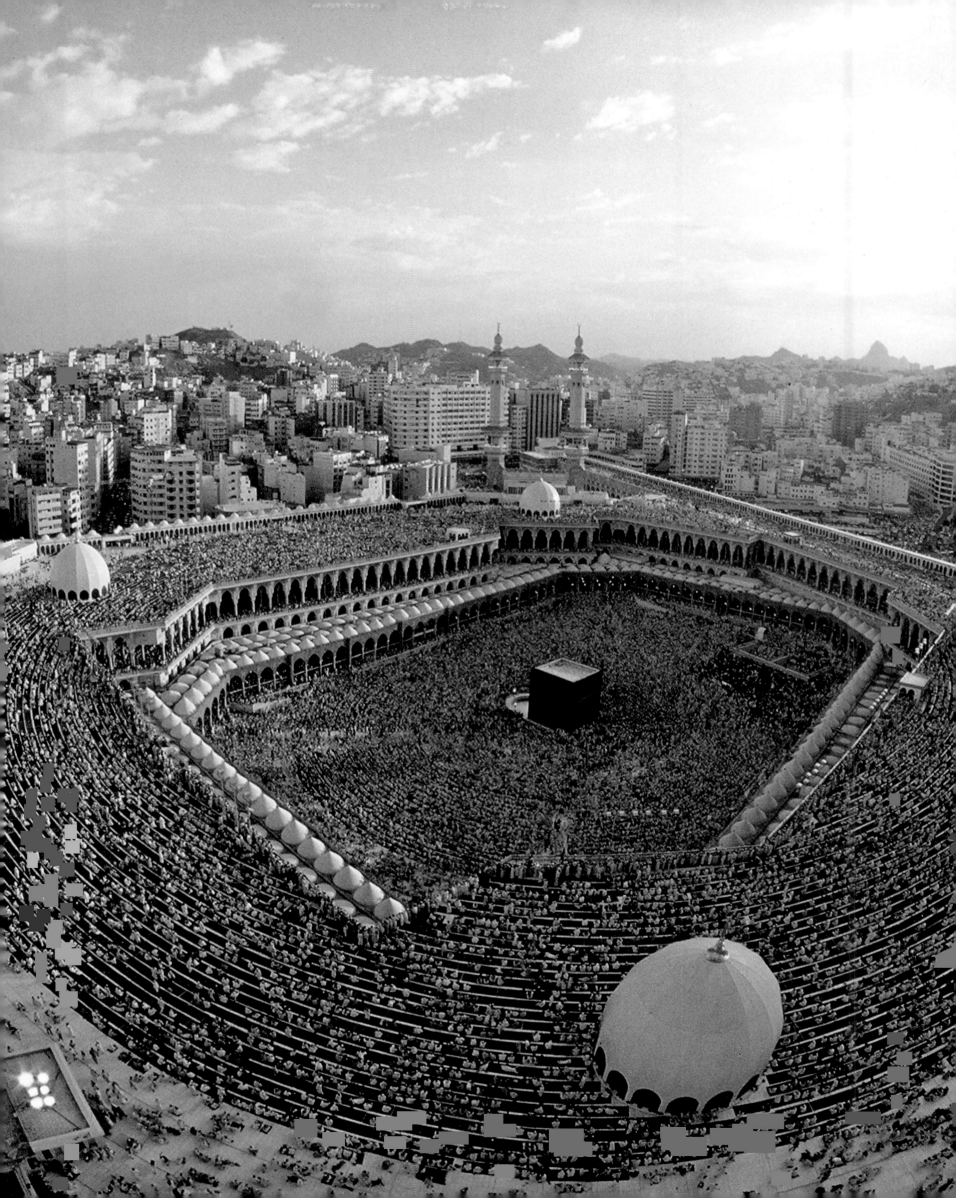

The Ka'ba

he Ka'ba is the direction (*mihrab*) where the hearts of all Muslims beat as one. It is the temple that is glorified with being "the first house for humanity." Its foundations were planned in a realm beyond the heavens and at a time when plaster, stone, or brick were not within the domain of knowledge; and these foundations were laid by a pure Prophet. The area where it stands was pre-determined to be allocated for this purpose years and years before the earth was honored with Prophet Adam. We know this to be so, for the angels told Adam, "We circumambulated the Ka'ba many times before you were created." After the Flood, the Ka'ba was rebuilt over its foundations, which had been completely leveled: *And when Abraham, and Ishmael with him, raised the foundations of the House (they were praying): "Our Lord! Accept (this service) from us. Surely You are the All-Hearing, the All-Knowing"* (Baqara 2:127).

The Ka'ba is the tangible projection of a luminous column rising from the center of the earth, all the way up to the Furthest Lote-Tree (Sidrat al-Muntaha), around which mankind, the jinn, and the angels incessantly turn. It is a building without peer, its value is on par of heavens; billions of pure souls, visible and invisible, long for its sanctuary and seek union therein. This is why both in the heavens and on the earth it is called Baytullah—the House of God.

Believers stream every year by plane, ferry, car, or any other means of transportation available to its soft, most green and warm aura, its very gates ushering them to the beyond. At the exact moment of departure, as they put on their pure, white garments, they immediately unburden themselves of their mundane concerns and discomforts; they resemble angels, instilling in others an indescribable craving.

Every traveler on this sacred journey feels in some way that they are traversing across the beaches of a different and wondrous world. Their stance is as dignified as an oak tree, as imposing as the silence of the woods, and as awe-inspiring as the vast ocean; they cover great distances in total submission and sincerity.

The paths to the Ka'ba are very long and the distance is merciless. This sacred expedition certainly contains some trials and tribulations, much like the spiritual journey of the Sufi, the suffering of purification; there are mountains to be scaled that surround Paradise, and there are chasms in the environs of Hell. Nevertheless, the presence of these difficulties is indispensable as they increase the spiritual tension and help lead to the completion of inner preparations. In accordance with the capacity of each person, everyone undergoes an exercise, a self-charging process, and when they reach the Ka'ba their enthusiasm has escalated to the peak.

In the past, expeditions to the Ka'ba used to be on horses or camels. Pilgrims would visit hundreds of sacred stations and tombs, stroll across the lands where the greatest Prophets lived, and imagine that they were meeting with them. On this sacred journey, pilgrims of the past could join the assemblies of saints and be illuminated by their radiant circles; the journey felt

as if they were hovering along a peaceful, meaningful avenue. As if showered by beauty, a poem, or romanticism, they would be prepared to receive blessings from the world of meanings, and with this soulful power they could knock on the door of the Almighty.

A natural outcome of this journey would be a sharpened perception in their hearts and souls, and when they reached their destination they would find the Ka'ba welcoming its visitors with a burning fervency, looking down upon them from its abode above the skies. They would cast themselves into its embracing arms with an overwhelming desire for reunion. Beholding its dignified face and its shadow that was reflected on the surrounding marble surface, with its meaning stretching out into the heavens, and its glowing ambiance, every soul could intuitively discern the reality behind this profound face. In a most joyous prayer they would realize the delight in the purpose of this journey and reach unattainable pleasure.

The Ka'ba is in such harmony with the spot where it stands that a prudent observer instantly notices the close connection between this land and its epiphany. It stands as if it has not been built of ordinary substance, but as if it has sprouted from the earth, or, more likely, as if it was constructed by the angels in the heavens and later brought down to earth.

It appears as the leader of a circle of remembrance among the great and small, among the scorching mountains and hills, among the stone piles that lie nearby. Every single object around it moans together with it, opening their hands for prayer, and listening to the Ka'ba in silence.

The Ka'ba is a sanctuary for the privacy of a friend, and its surroundings are a greeting hall for others. Safa-Marwa is an observatory from which to enjoy the scenery of truth; the Station of Abraham is a blissful stairs that rise to the heavens; the well of Zamzam is a cupbearer in this assembly of love. Greeted by these sacred sites all at once, the travelers of love attain an otherworldly presence and start observing the divine dominion; the human imagination sets sail for such a vast horizon that the travelers feel as if they were to take one more step they would enter the wondrous realm of the beyond.

The Ka'ba is a building of this world and the necessary substance of its construction has been taken from its environs. Nevertheless, it gives the impression of a lotus which has taken root in the heavens and carries the secrets of all existence in its soul. Its indirect relation with both the earth and the heavens can easily be detected. It is the noblest and the most historical diamond; it carries traces from every past age, and is an ancient building that always remains new while increasing in value.

Just as Adam, peace be upon him, was an important source of the spirit, character, and behavior for all human generations, the Ka'ba is a mysterious house that carries the spirit, the meaning, and the content of all buildings and the phenomenon of construction on earth.

(Overleaf) Eid al-Fitr at the House of God, Baytullah. Ramadan 2005.

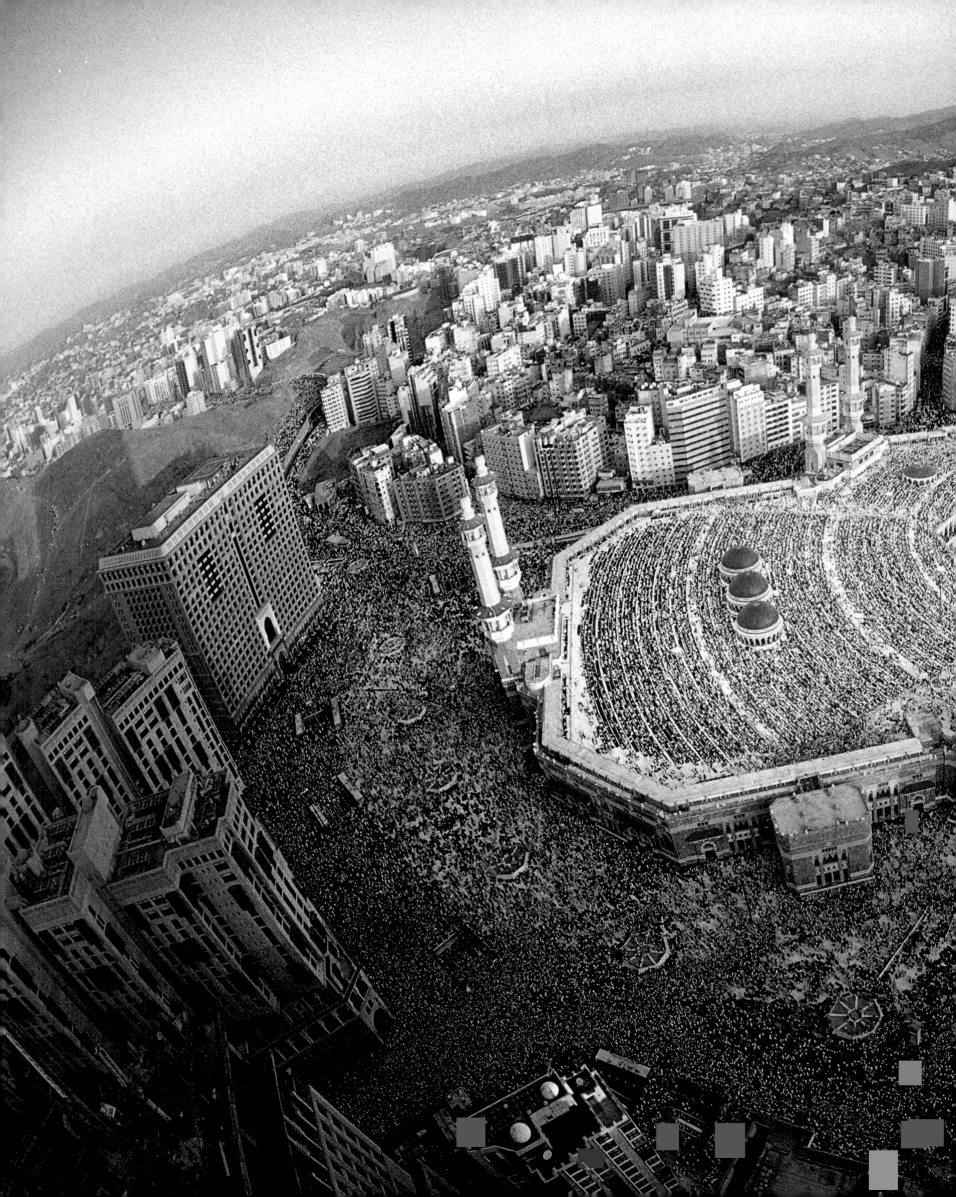

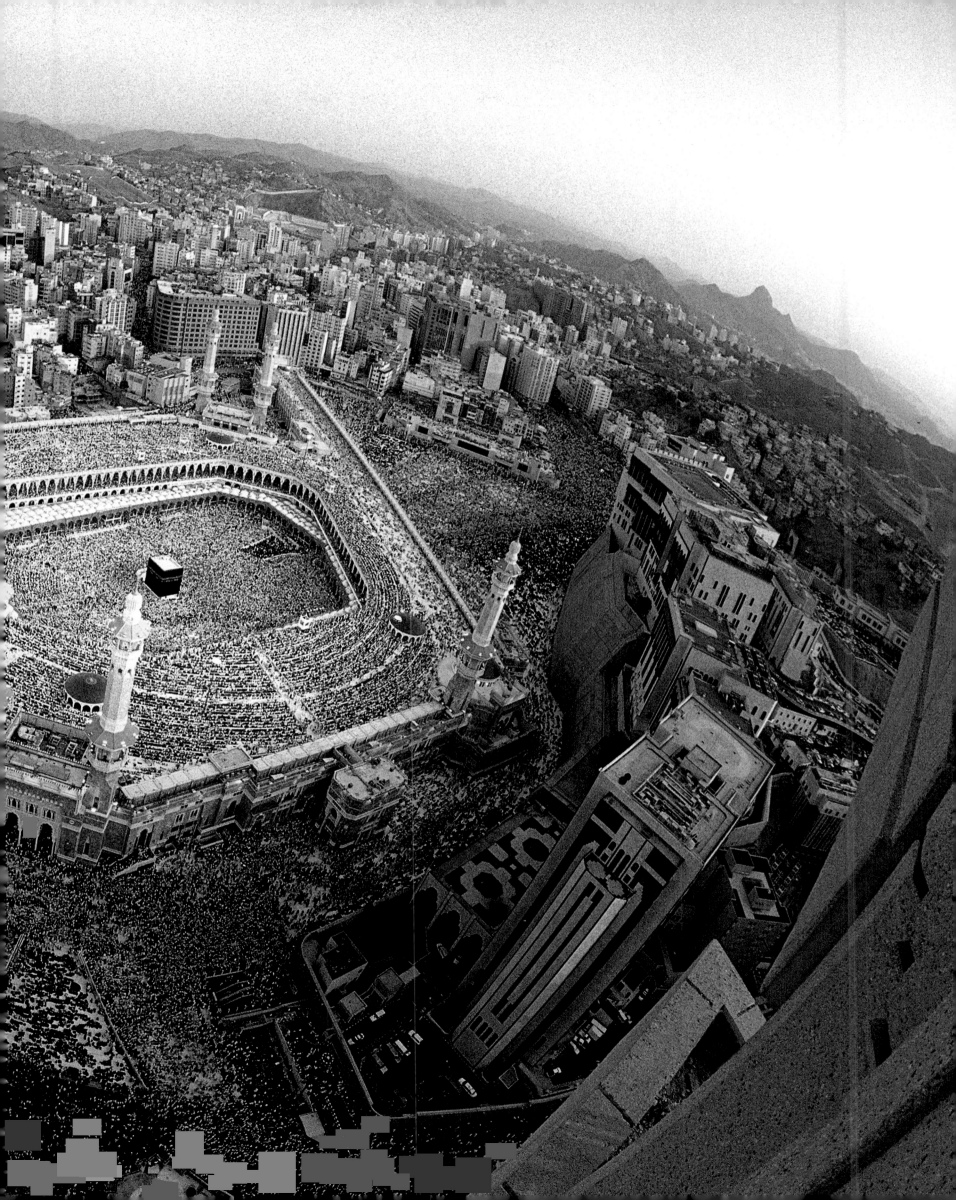

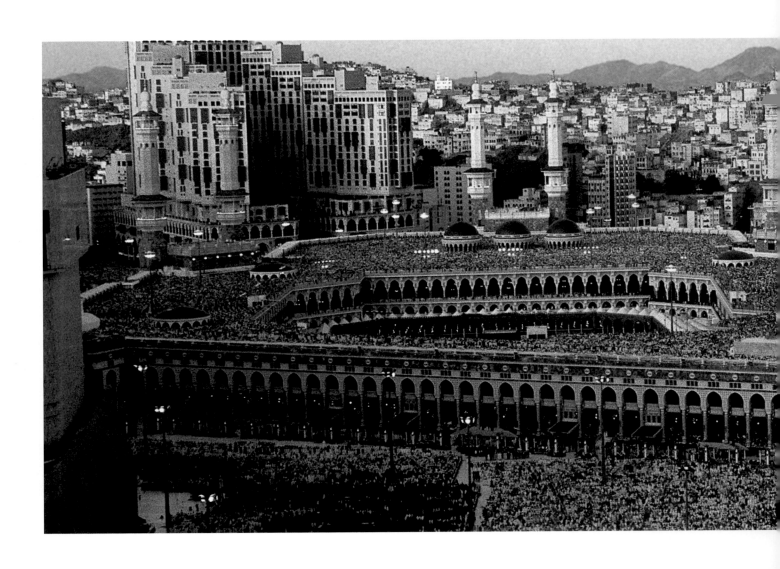

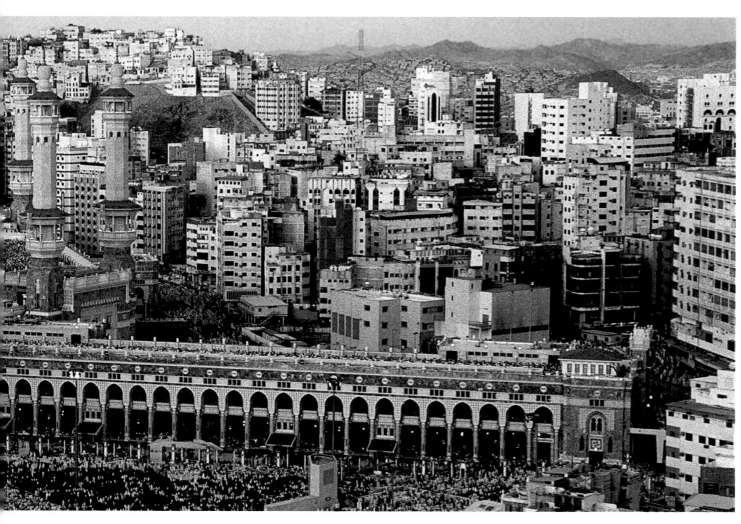

1990s . . . an Eid morning. The first rays of sun reflecting on the hills of Mecca.

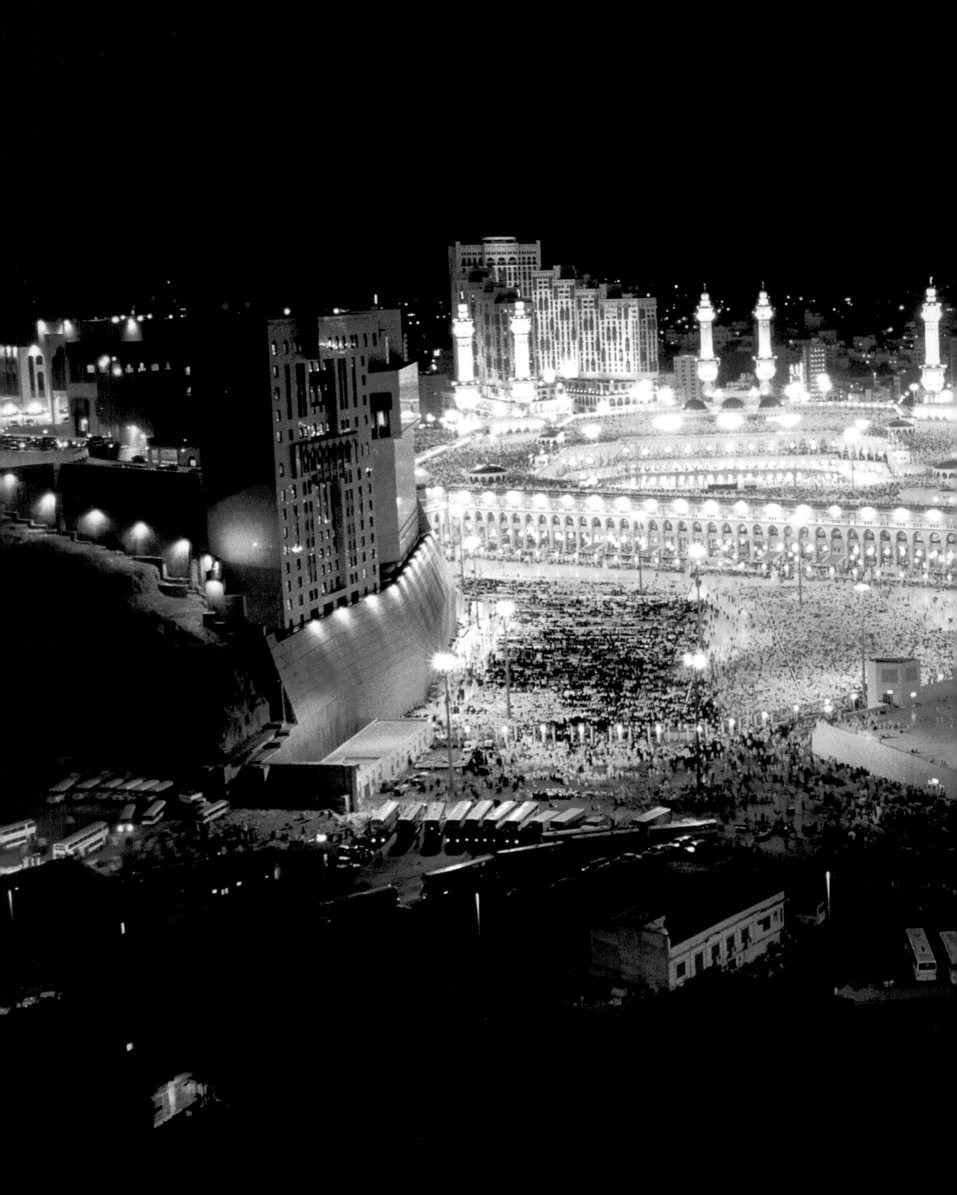

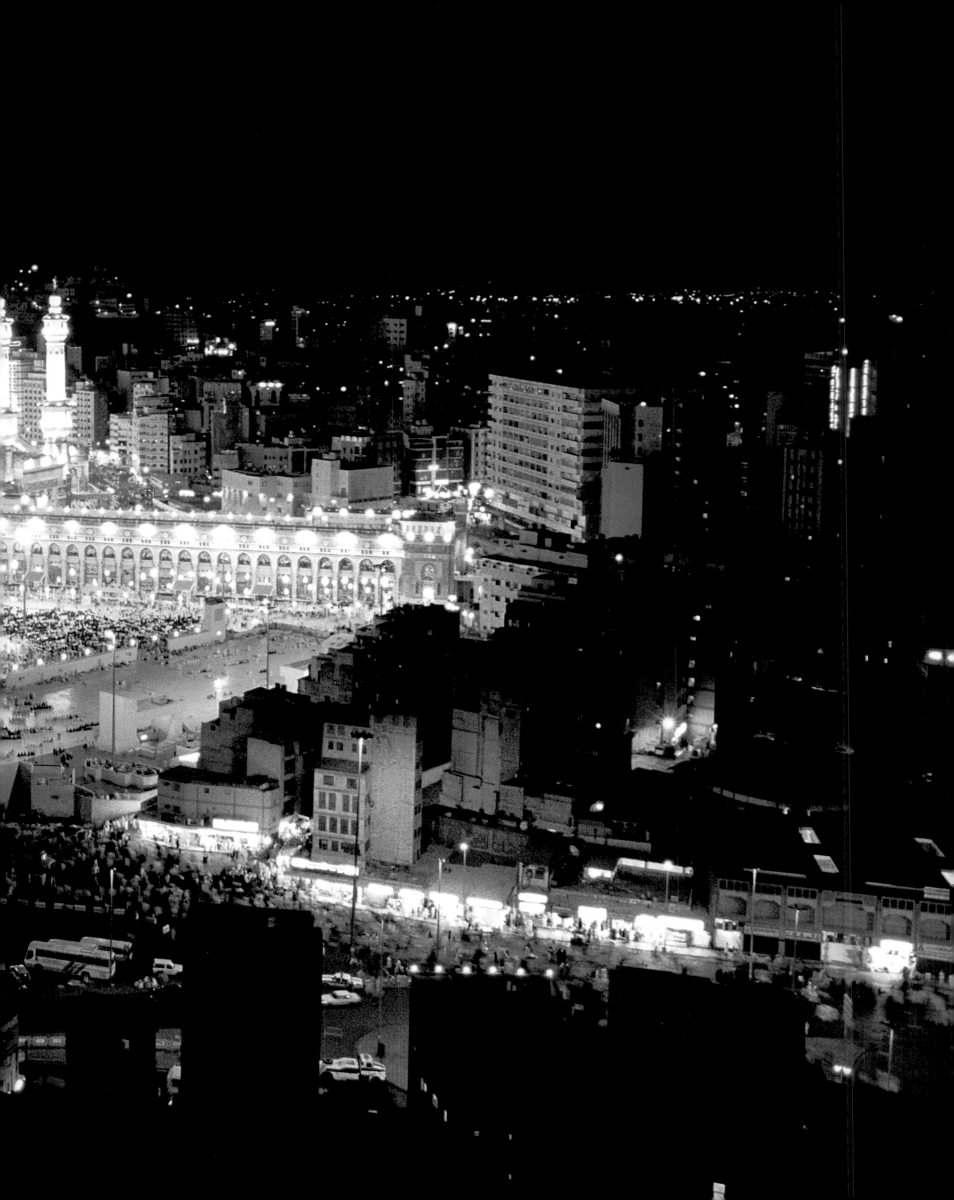

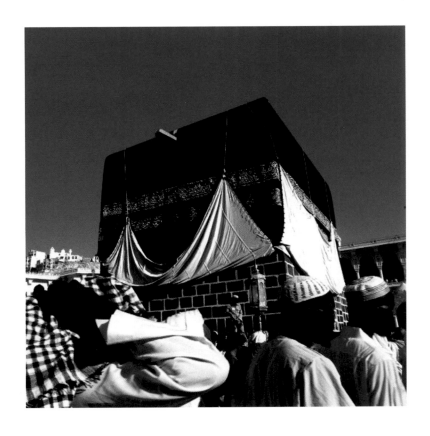

he Hajj is a grand and a comprehensive symbol of Islam in which Muslims from all over the world are united. No other place on earth and no other congregation can match its magnitude in this aspect. The Ka'ba dates back to the time before Adam was created. It was rebuilt by the Prophet Abraham. It is directly linked with the nation of Abraham, peace be upon him. The Ka'ba corresponds the Truth of Ahmad in the heart of the heavens as well as acting as a womb for the light of Muhammad, peace and blessings be upon him. The Ka'ba is the direction of prayer for all celestial faiths and it is a matchless center of Divine Unity (**tawhid**). No other building can be compared with the Ka'ba, nor can it be called the House of God.

Outside the Masjid al-Haram during a Hajj season. Pilgrims are getting ready for the Friday prayer, forming lines. Mecca overflows with guests during the Hajj. The Blessed Sanctuary cannot hold all the visitors at the same time so the congregation stretches out into the streets. ▶

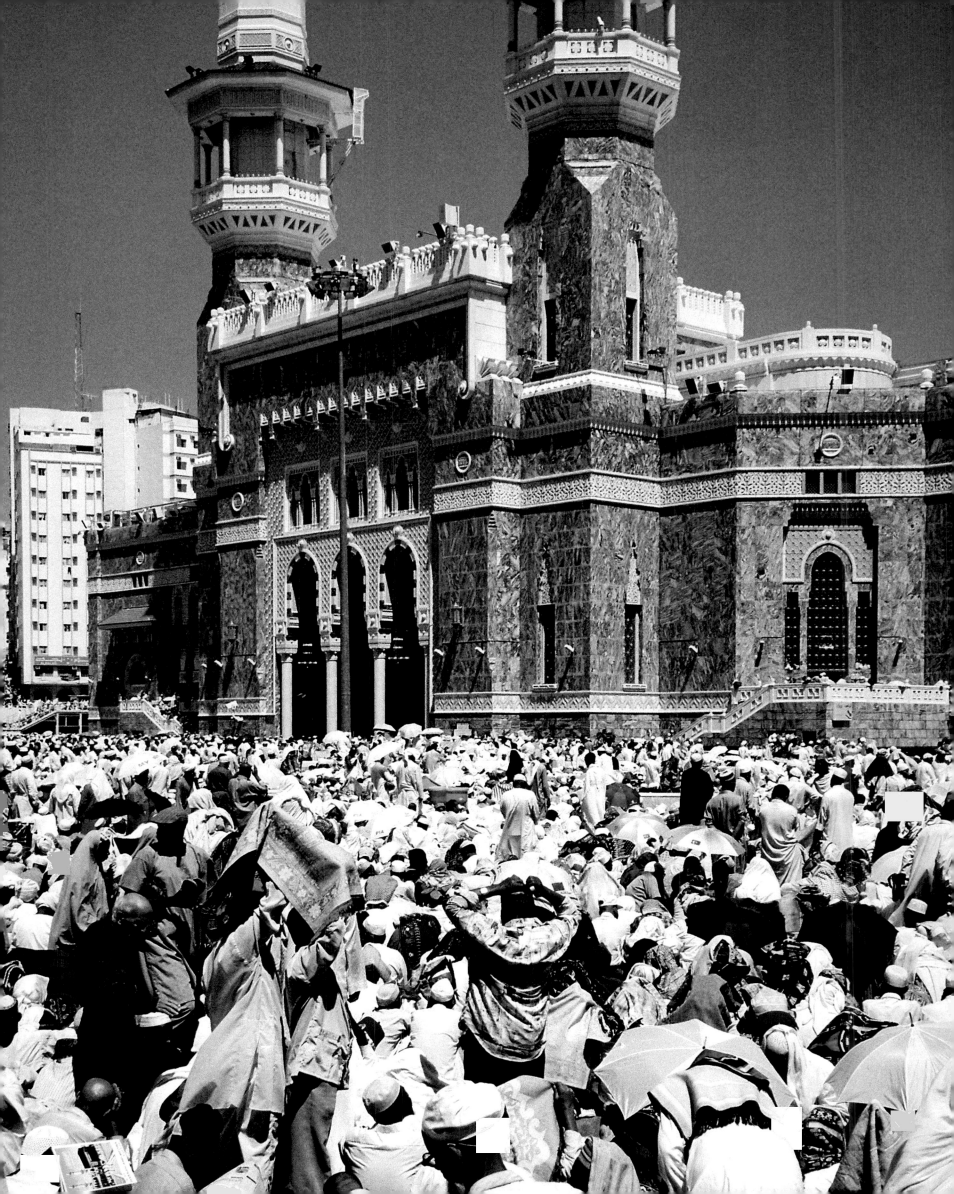

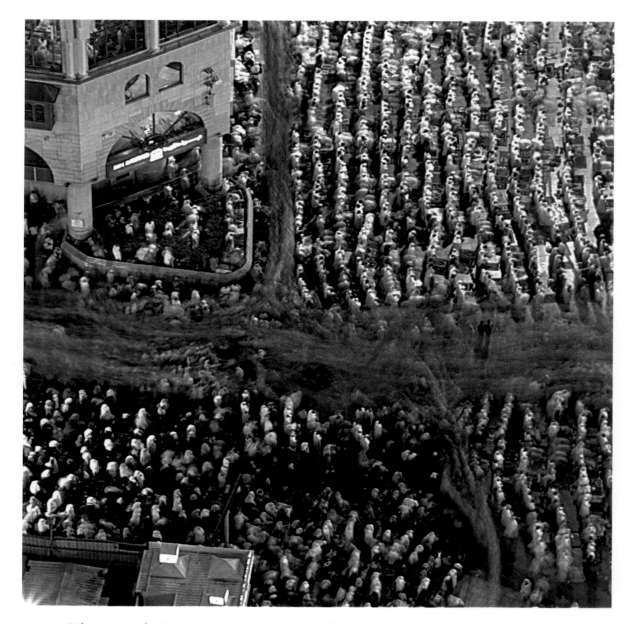

Pilgrimage to the House is a duty owed to God by all who can afford a way to it. (Al Imran 3:97)

Evening prayer (maghrib) at Baytullah. ▶

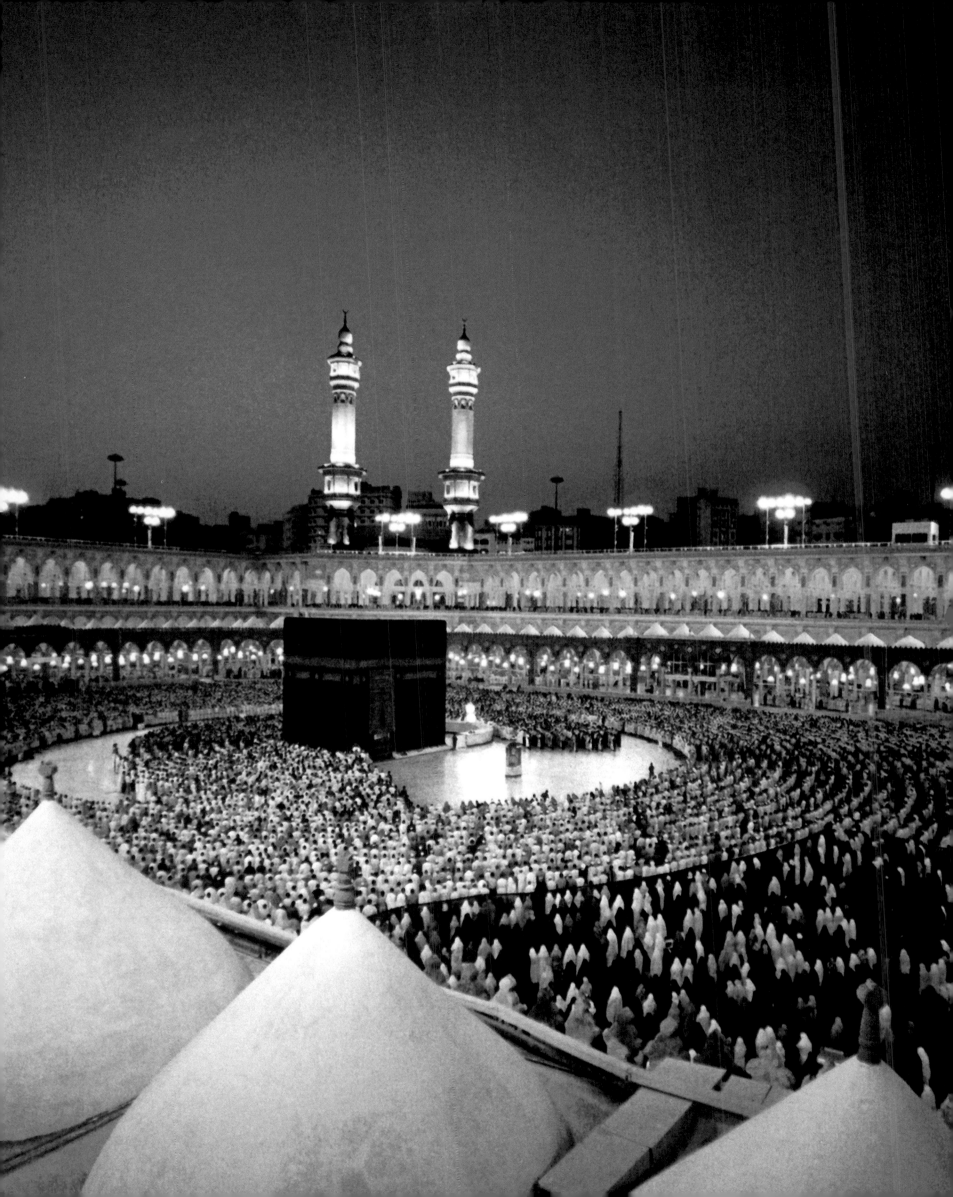

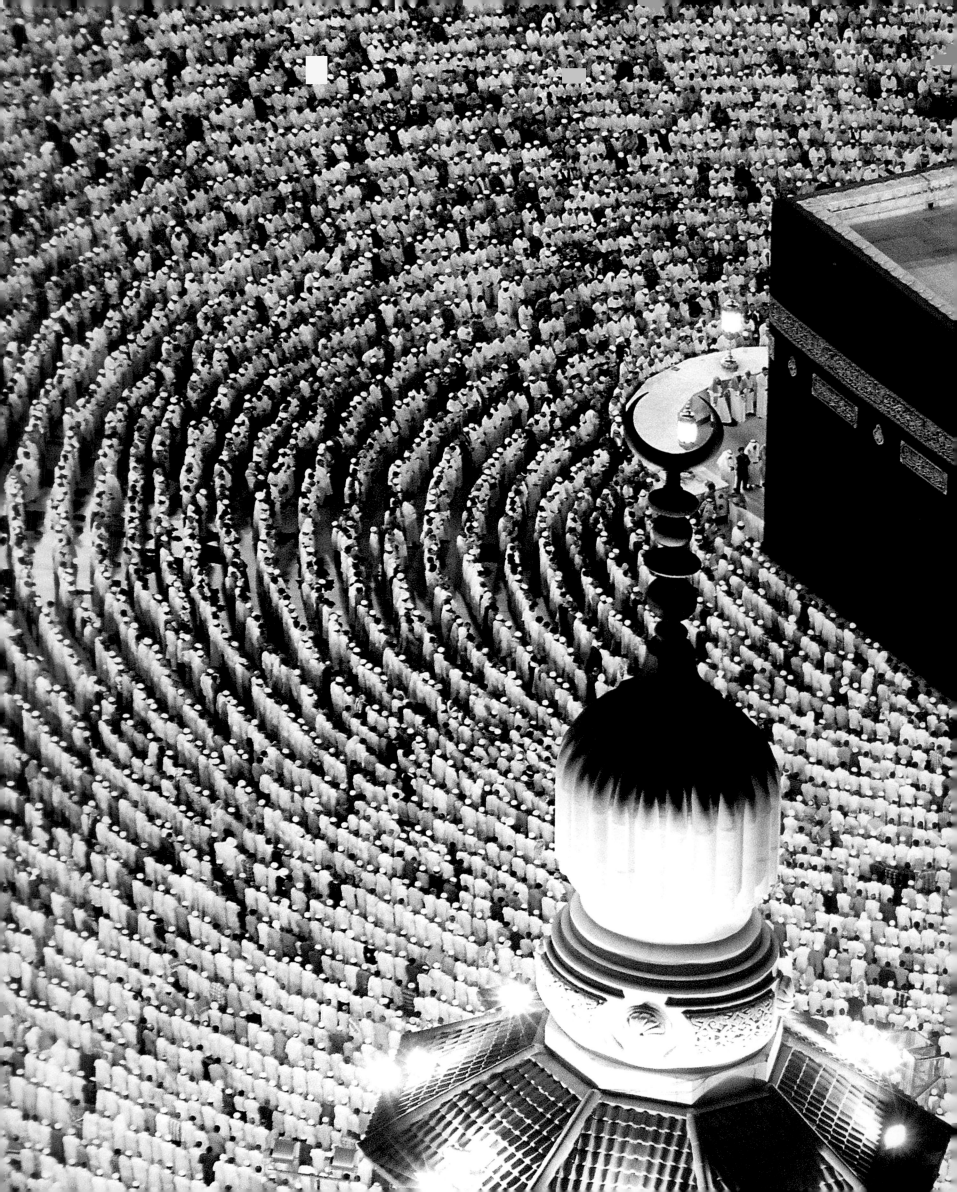

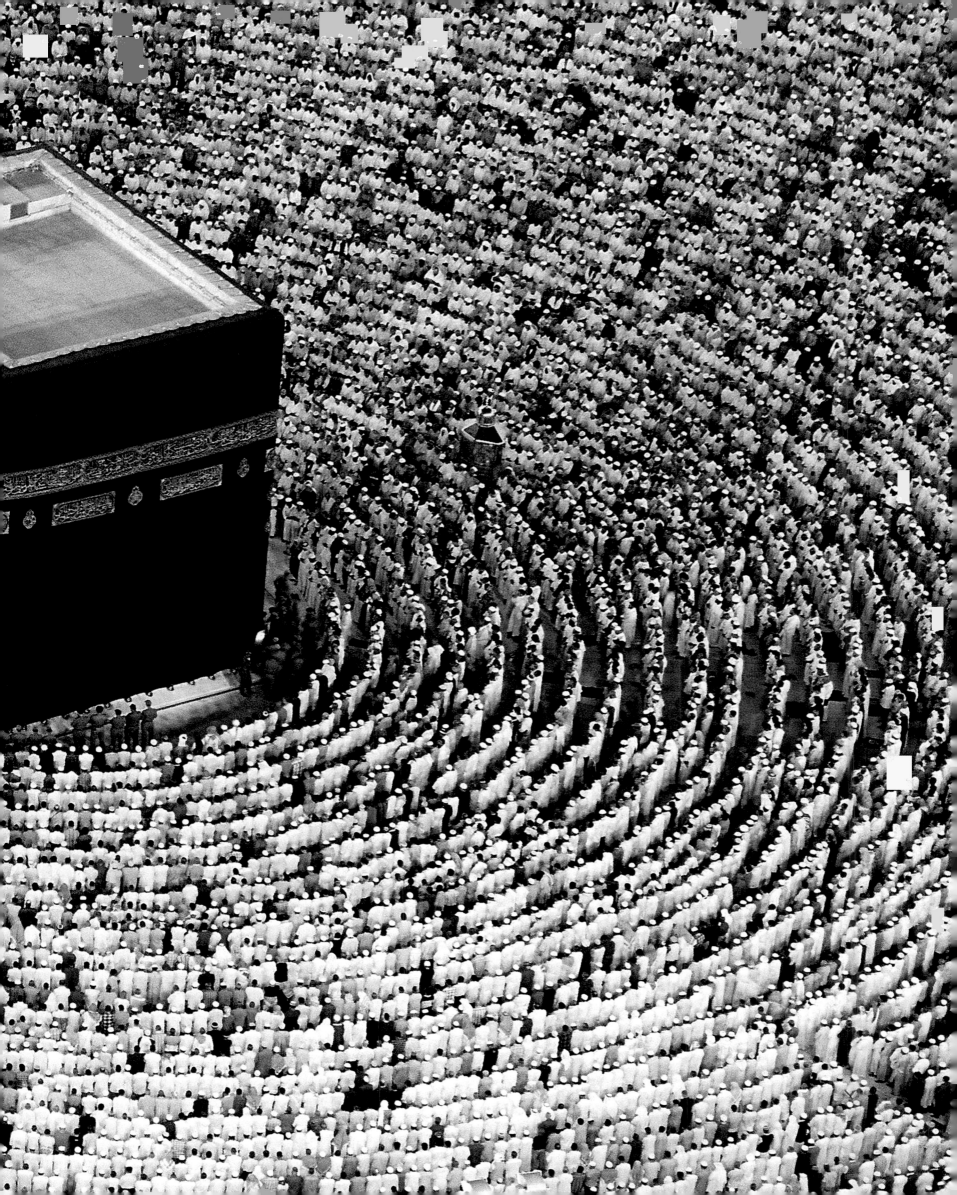

"There is no deity but God and Muhammad is His Messenger" is inscribed on the cover of the Ka'ba.

he Ka'ba is like a mother who is seated in the dearest corner, the vantage point of our home. She shares the joys of her children or grandchildren, and feels their sorrow in her soul. As she observes all around, she sometimes moans with pain, and at other times she sends smiles of relief.

Those with the ability to discern can see the Ka'ba constantly observing both us and then the sky, welcoming us into its sanctuary with the dignity and solemnity of thousands and thousands of years, as if saying:

> *"Come, O lover, you have intimacy with Us,*
> *Come, this is the station of intimacy.*
> *I have seen you as a faithful one!"*
>
> Nasimi

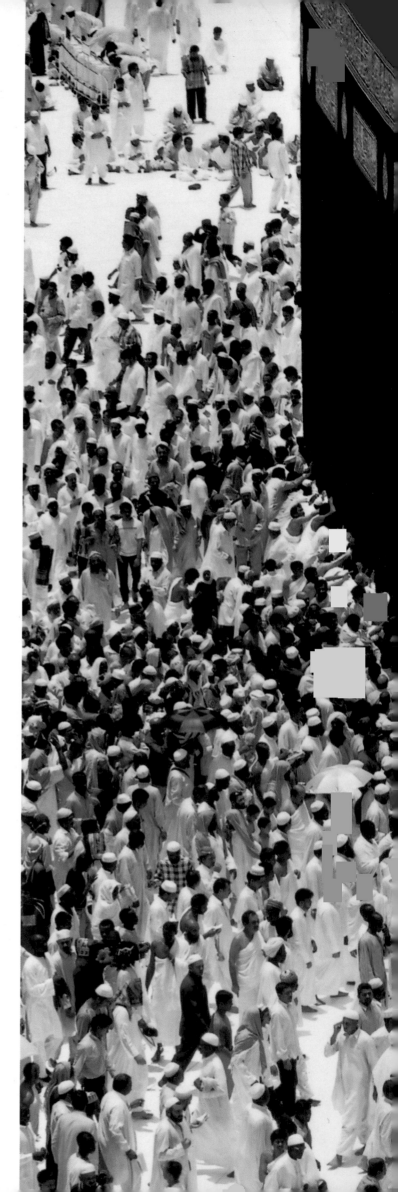

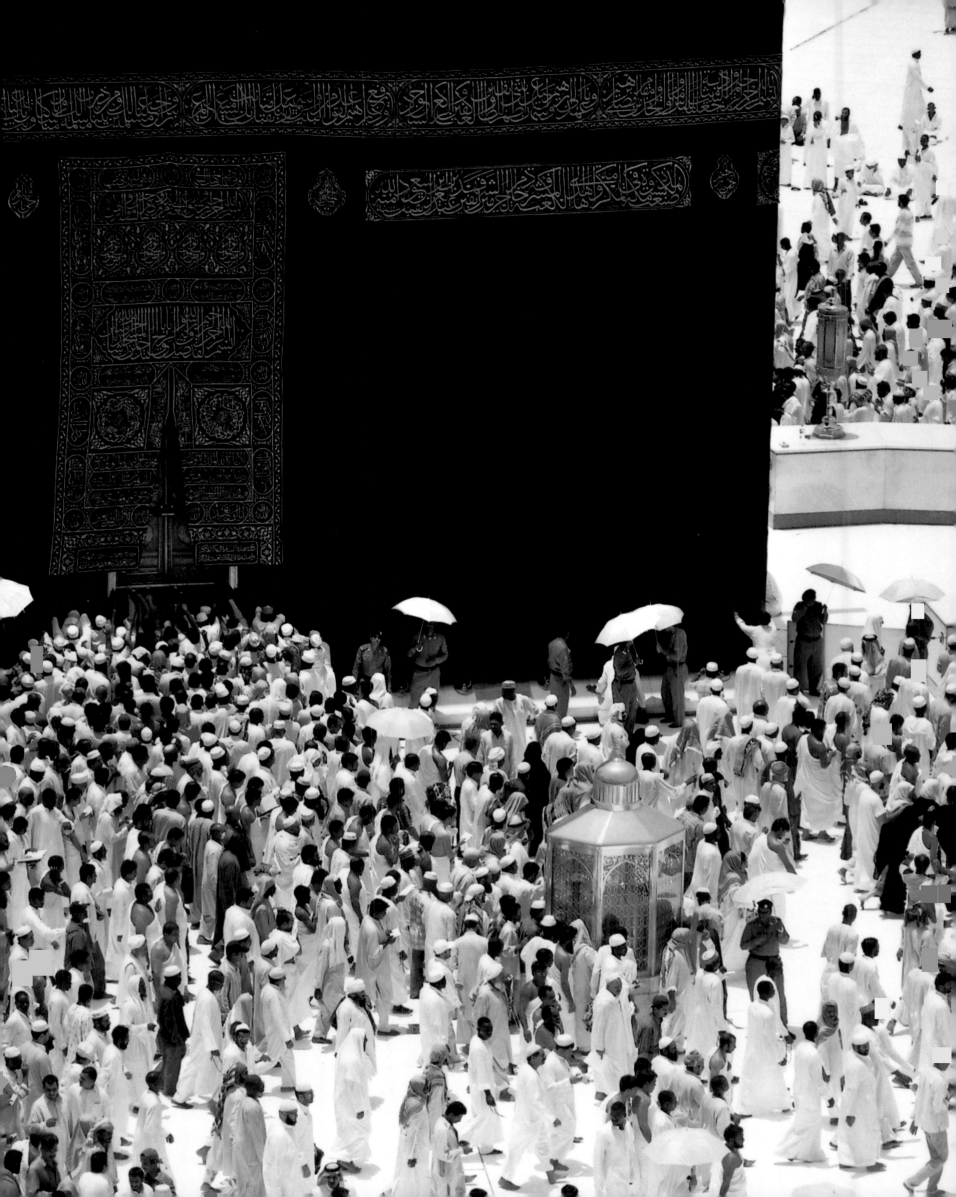

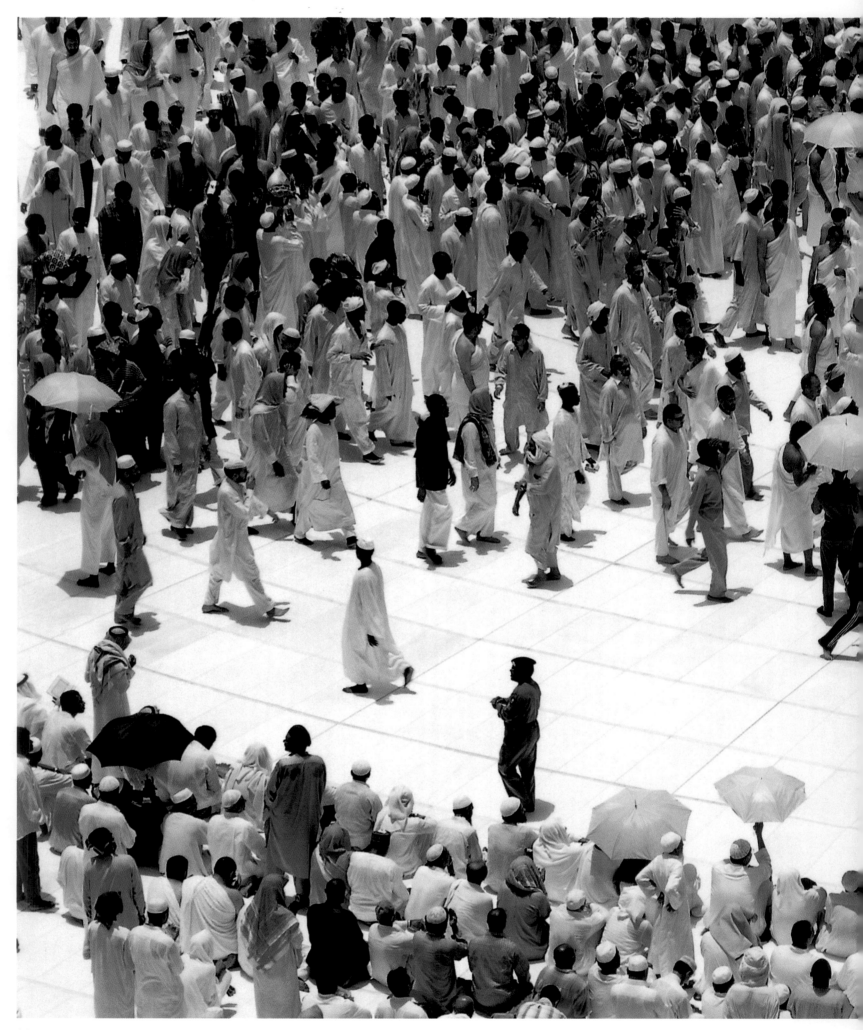

Haram Aghas. Only a few remaining to our day, the haram aghas serves as a screen between men and women for a more comfortable circumambulation and to prevent any congestion that may arise from crowds rushing to the Ka'ba.

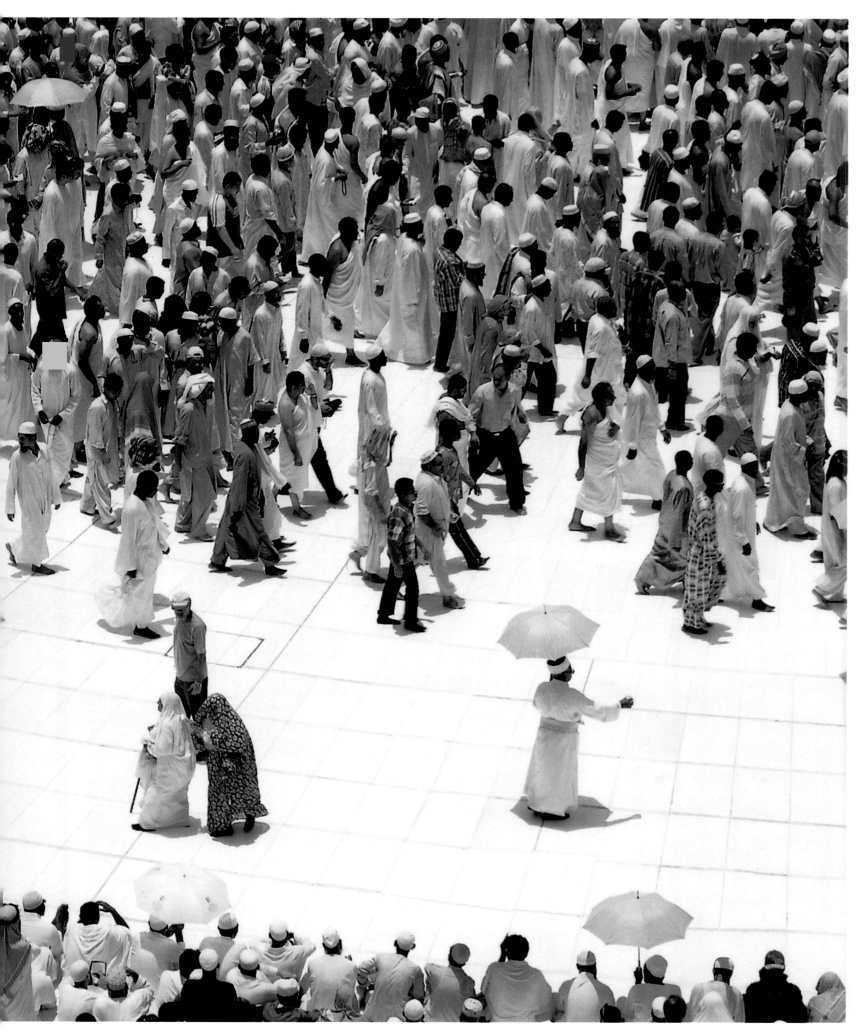

The person standing alone in the picture, holding a green umbrella,
dressed in a white gown with a yellow belt and turban, is a haram agha.

ukn al-Yamani. *Rukn* means column or pillar. Rukn al-Yamani and Rukn al-Hajar (Hajar al-Aswad) are two corners of the Ka'ba which are still in their original places. The other two corners are at the other end of the building, where now Hijr Ishmael, the semi-circular area, is located; it is believed that this was originally part of the structure built by Prophet Abraham and Ishmael. Prophet Muhammad, peace and blessings be upon him, sometimes prayed in between these two corners.

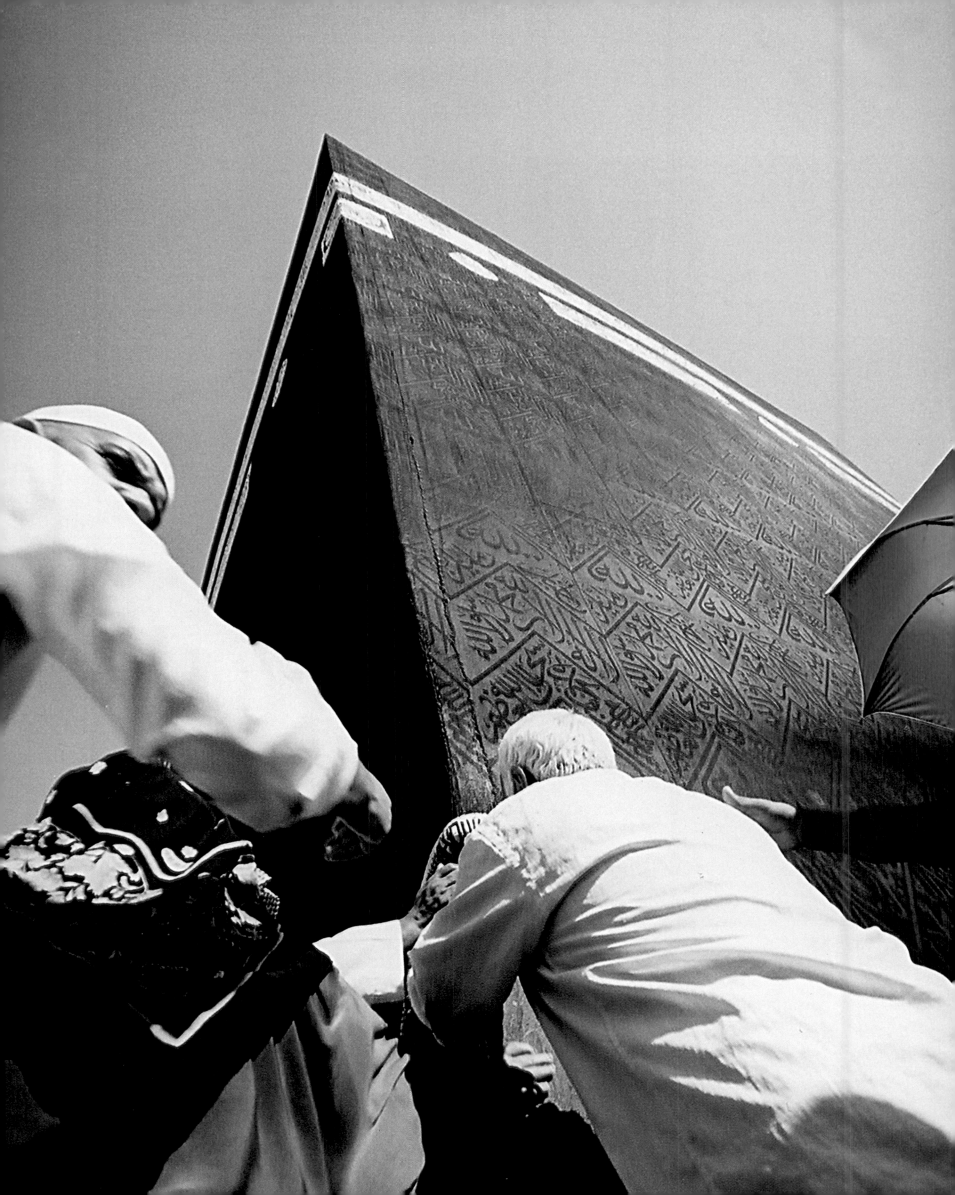

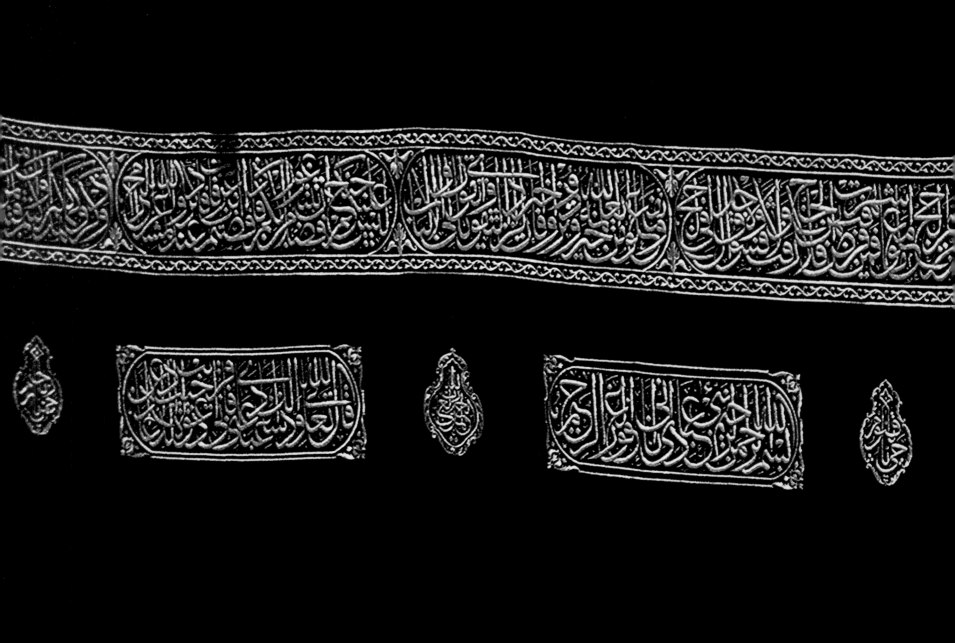

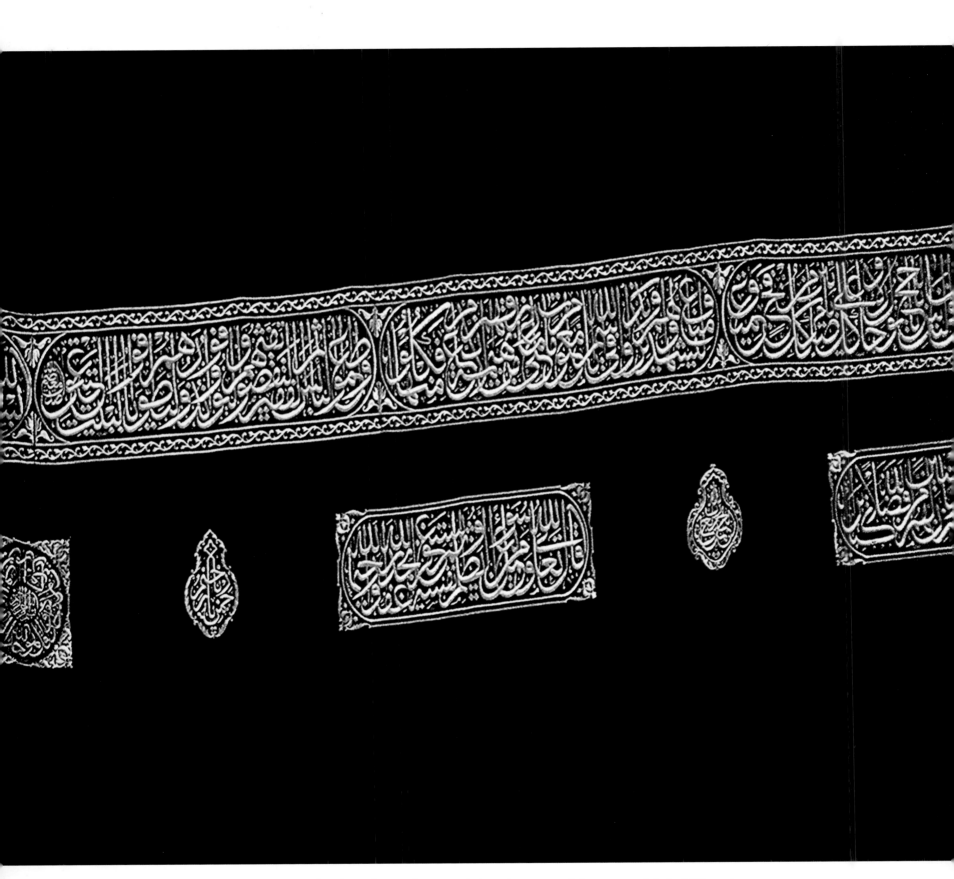

There are several reports about when the Ka'ba was first covered. According to one of these reports, As'ad al-Himyari, the Ruler of Yemen in the sixth century, marched with his army to Medina. After meeting two young men in this city he became a believer. In order to pay tribute to the Ka'ba he covered it, thus starting a tradition that still continues today.

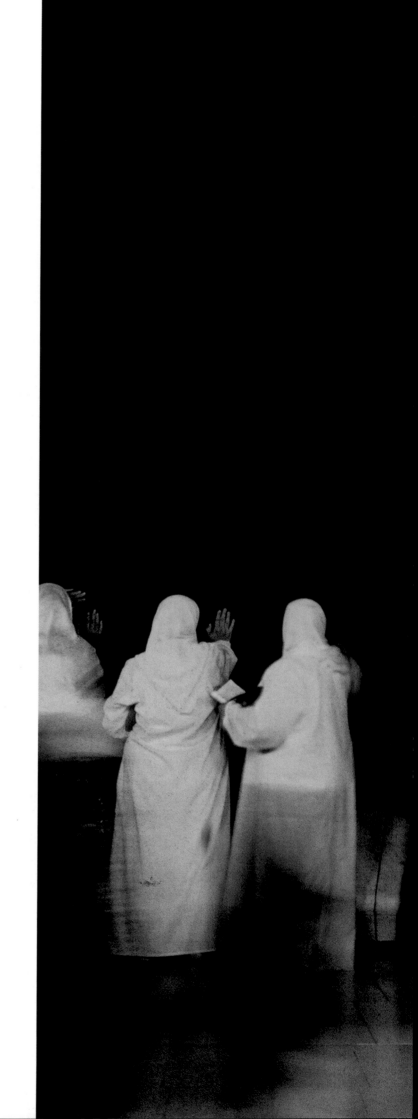

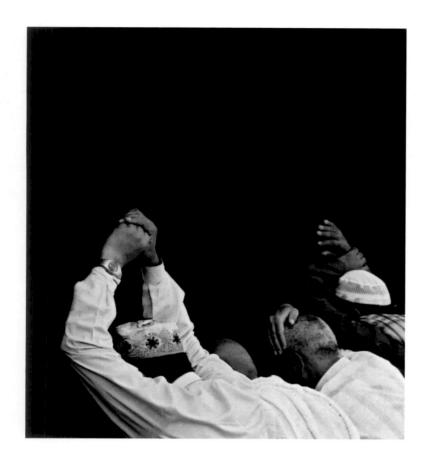

 ith half of their bodies uncovered and part of their white garments (*ihram*) wrapped around their shoulders, the pilgrims are enthused as they stride, with a little haste, but always vigorously and filled with hope. The contentment, comfort, and romanticism inspire those around the blessed house with a mysterious dream that is beyond description. The otherworldly scenery of the crowd makes pilgrims able to hear the secluded silence of this divine sanctuary, even before they start the circuit. Many profound souls pass by countless doors of sanctity as they turn around the Ka'ba; they touch to knock on unknown gates and raise countless shutters that veil the beyond. Making circuits with ever fresher feelings at each turn, they come around this ancient, but not decrepit building, the pilgrims are stunned to witness the blessings that pour through their imaginations, the lights that flash in their hearts, and the secret that makes their souls soar.

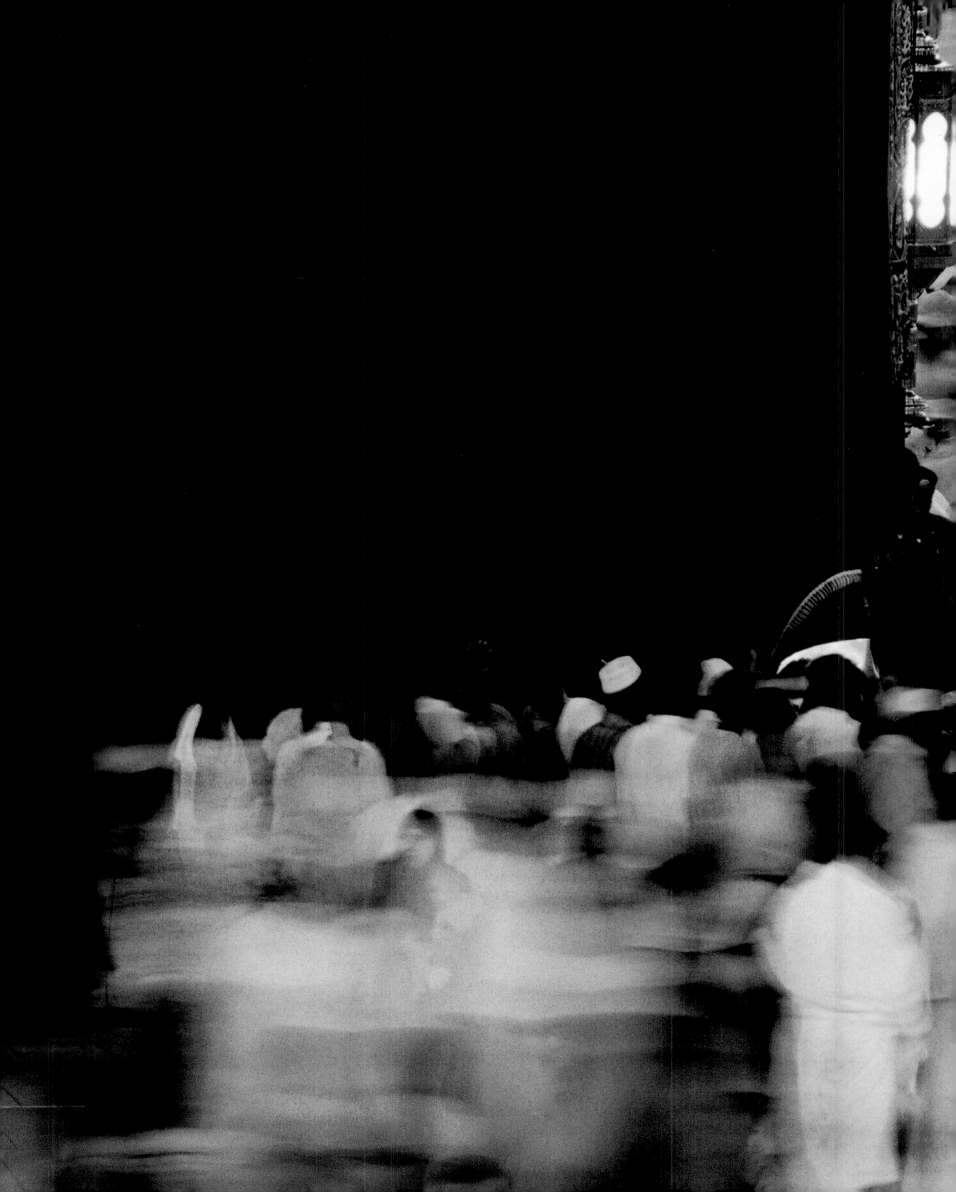

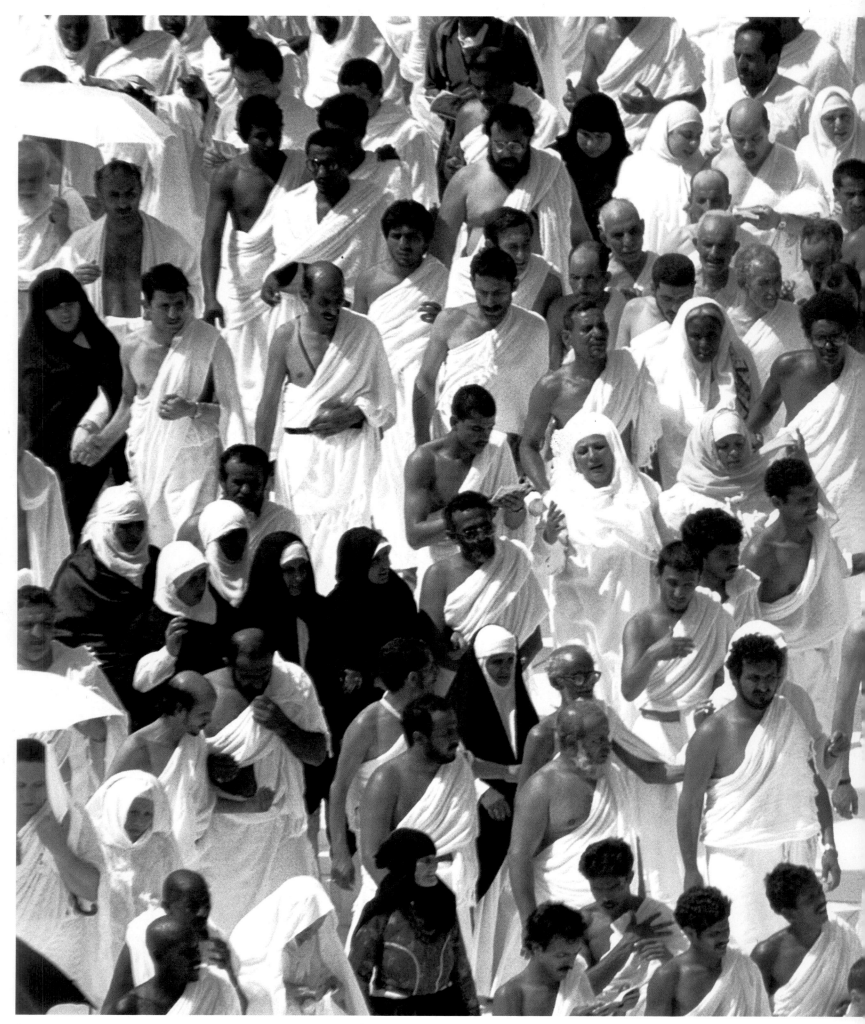

It is the tide of love and zeal, one following the other . . .
it is the joy of reunion. Each and every cry or moan makes hearts shudder, just like gates creaking open for a friend.

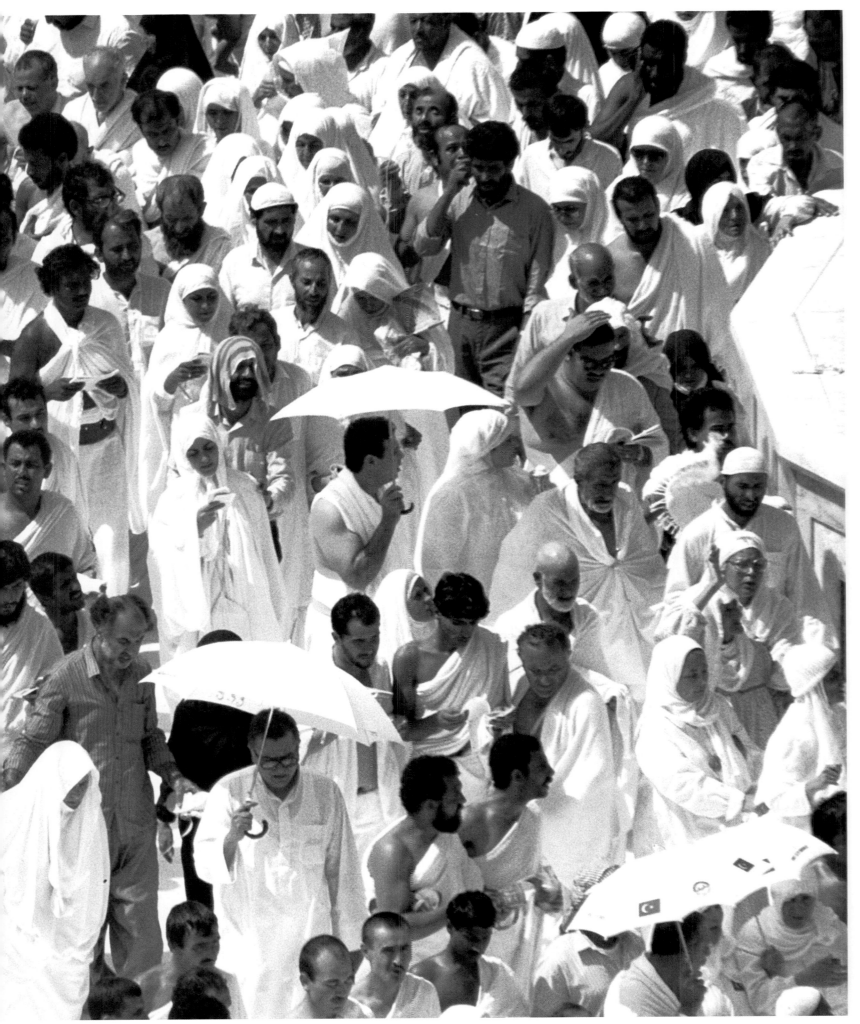

'Overleaf) The necklace of the Ka'ba . . . a keepsake from Sinan the Architect.

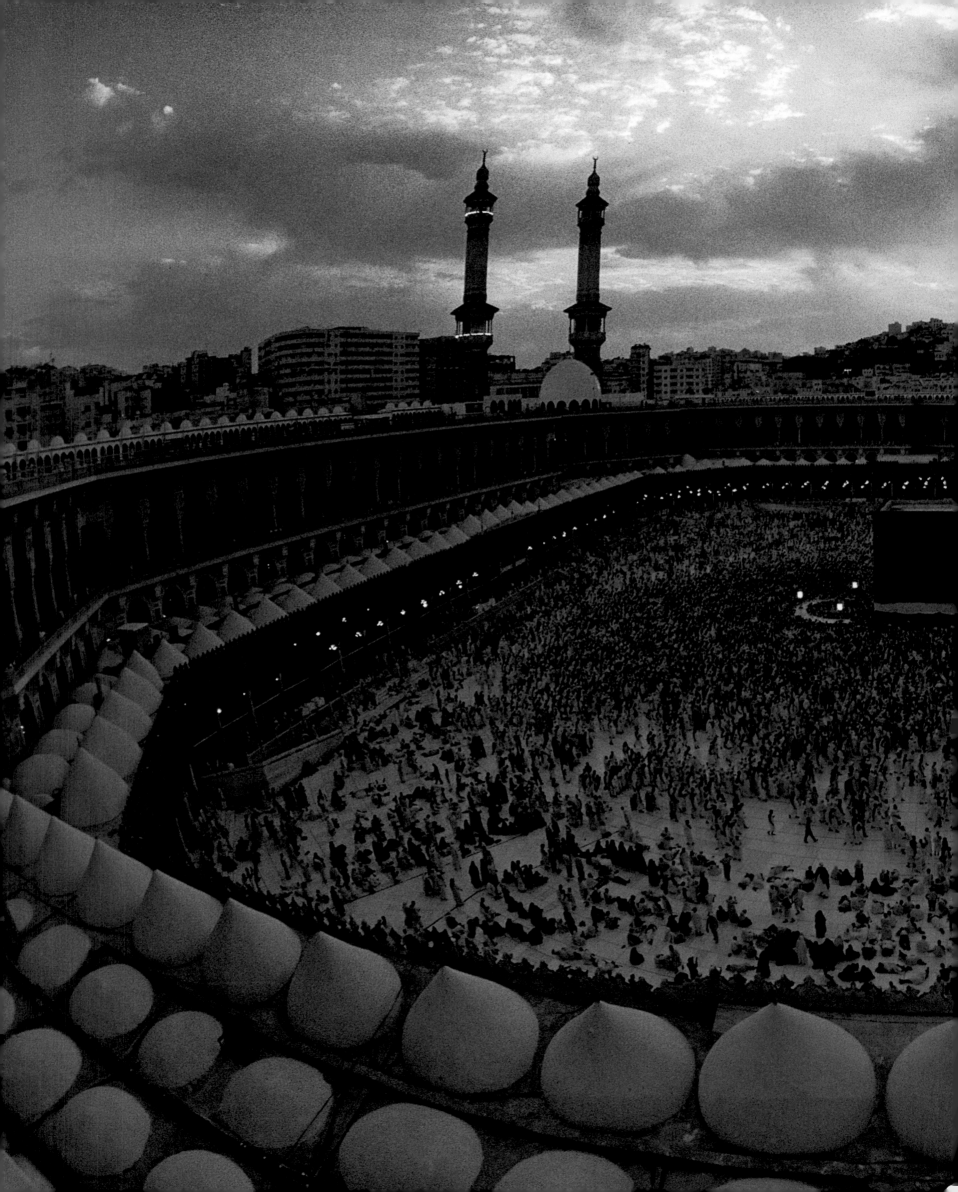

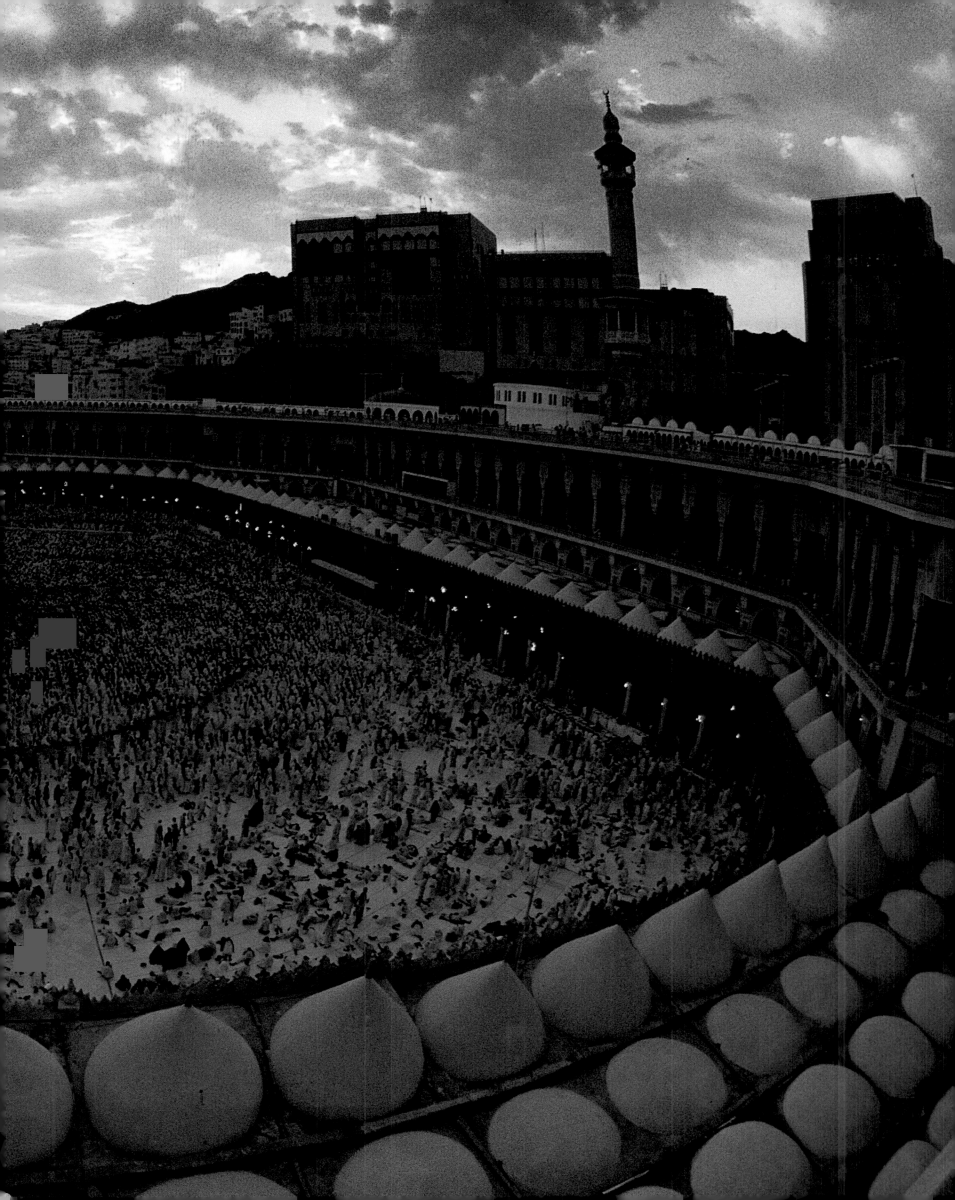

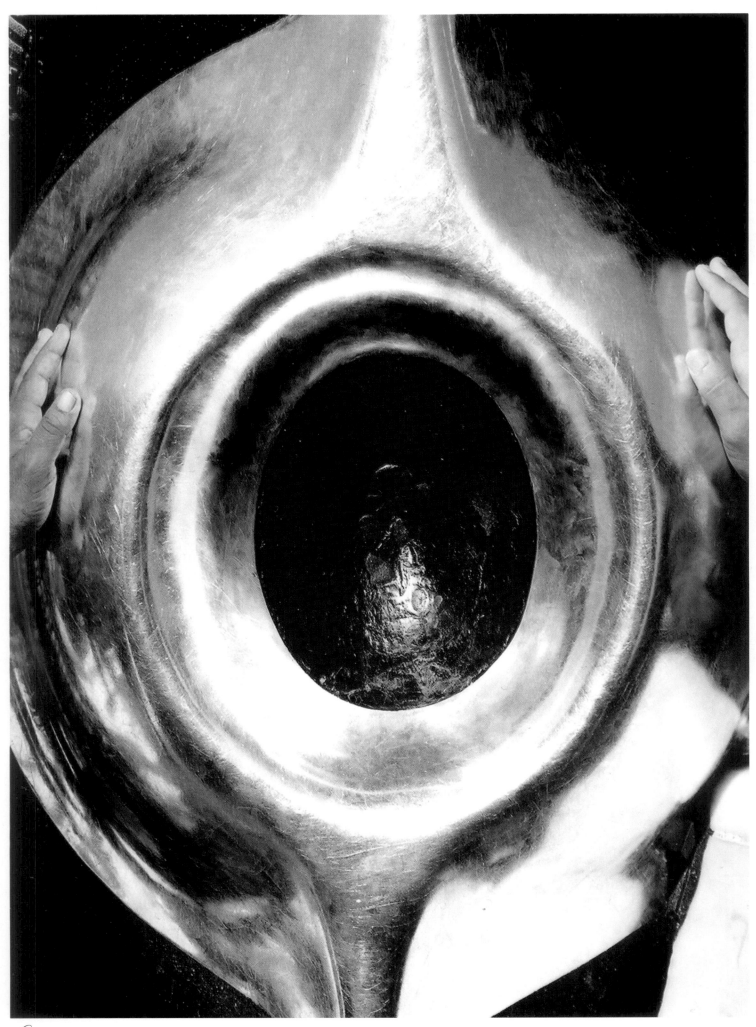

Hajar al-Aswad. The Messenger of God kissed this Black Stone from heaven and showed it respect.
How fortunate is the one who can hold it!

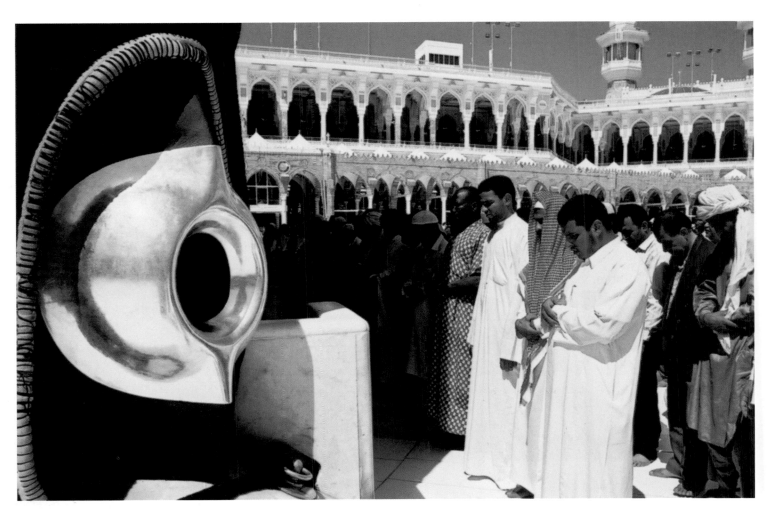

What bliss it is to stand so close and wait for reunion with the Almighty!

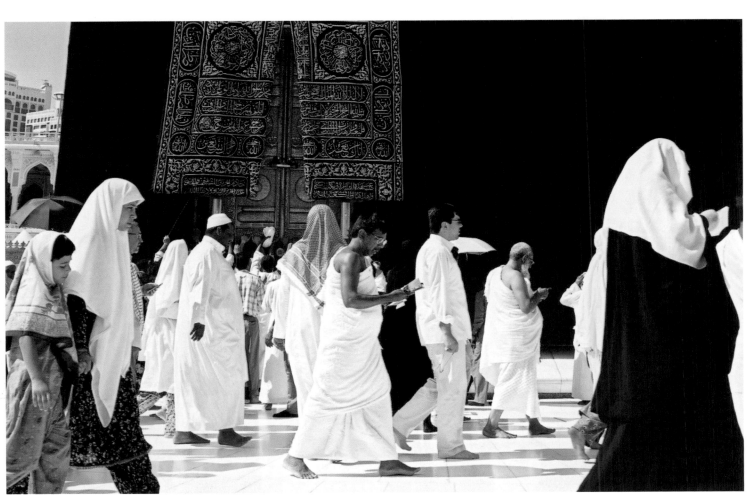

Pilgrims perform the circuit of the Ka'ba barefooted.
While reciting prayers, pilgrims walk towards the horizons of proximity to the Divine, not looking back.

 e feel at every step like a door will be opened and we will be invited inside; our pulse rate increases as we flow into a pleasure the nature of which we cannot know. At every point in which we stand amid such feelings, we sense with all that we are from top to toe, the overflowing majesty, the profundity, and the charm of the Ka'ba, and we cannot help but tremble with emotion.

Commissioned by Sultan Ahmed I, the Golden Gutter was made by Dervish Zilli Mehmed, the father of Evliya Çelebi and the chief palace jeweler. ▷

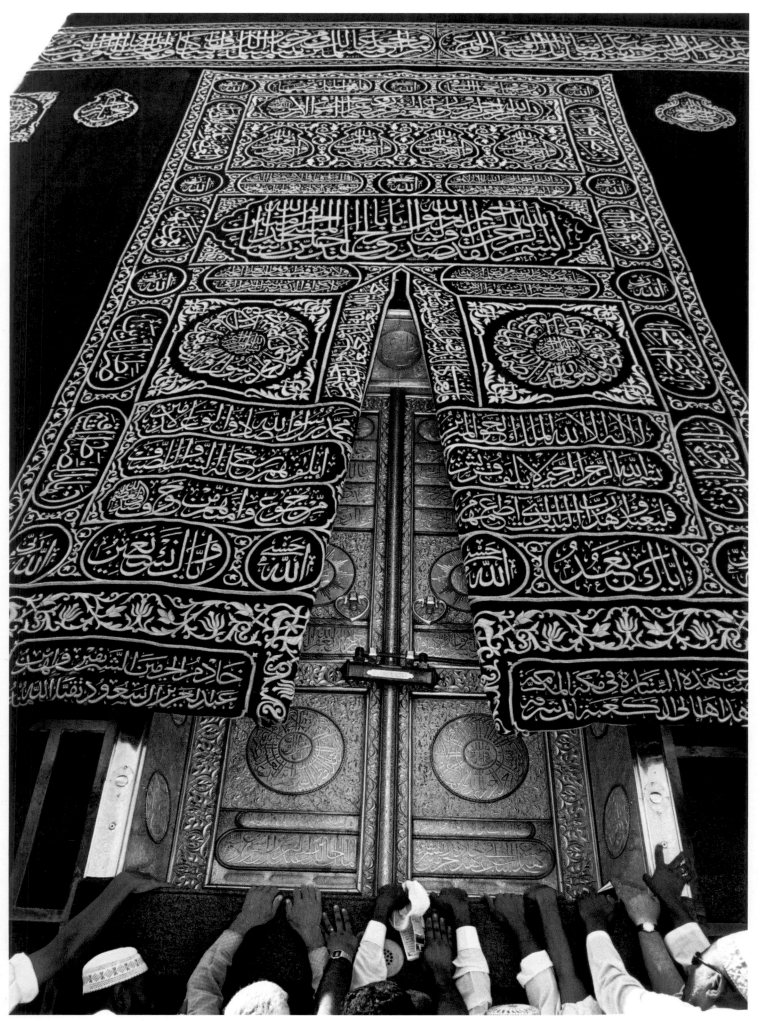

Pilgrims are thrilled at the door of the House of God, expecting mercy. "Pray to Me, (and) I will answer you"
commands the Owner of the House . . . If he did not wish to give then He would not have given us the desire!

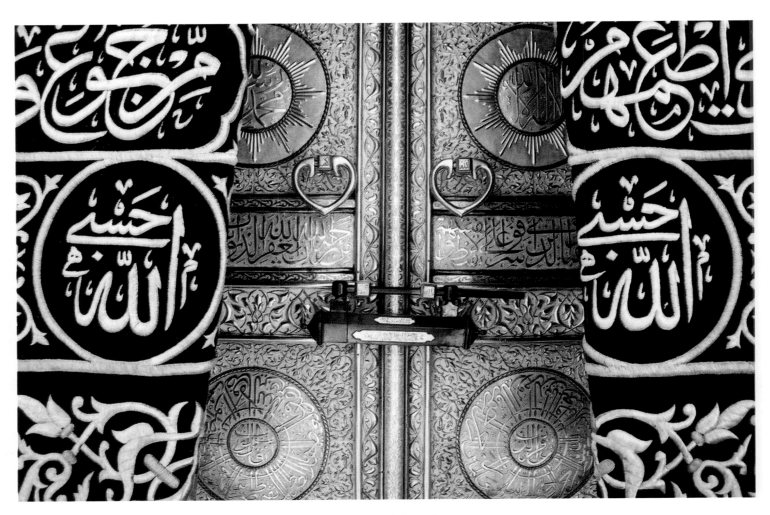

The Door of the Kaʻba

The Lock of the Kaʻba

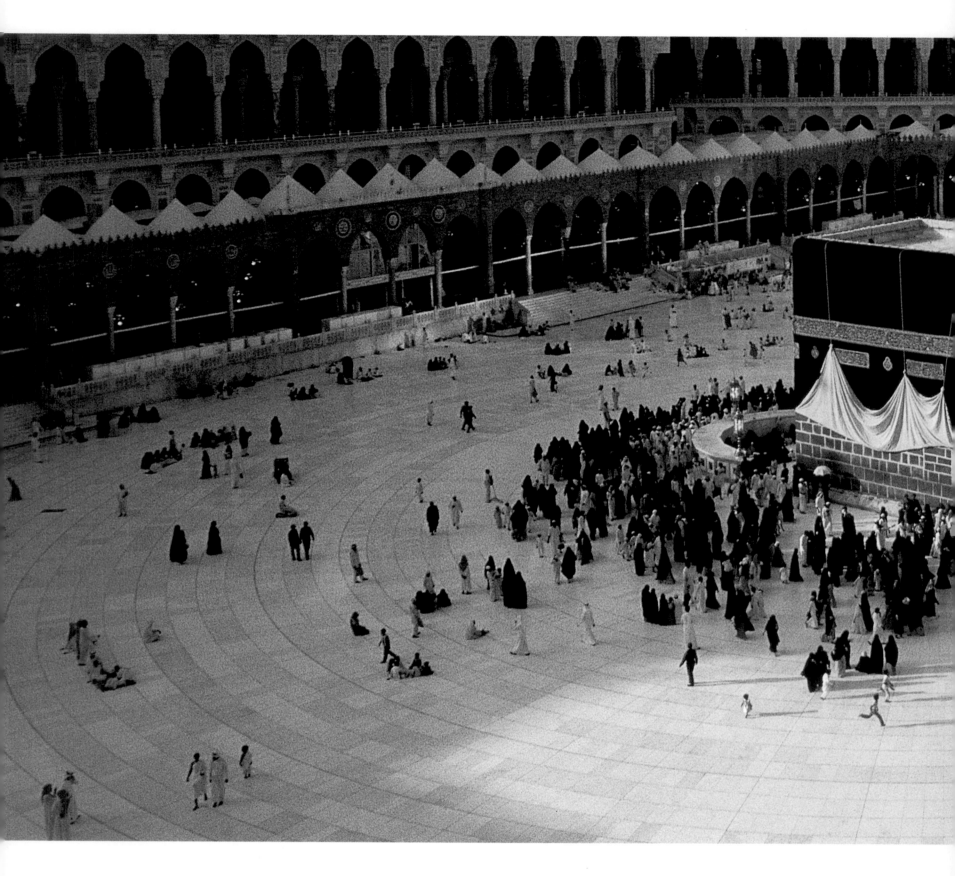

The ninth of Dhul Hijja is the time for gathering on Arafat. This is one of the rare days at the Ka'ba when it is the quietest;
it is as if in preparation for the Festival of Sacrifice (Eid al-Adha), the following day.

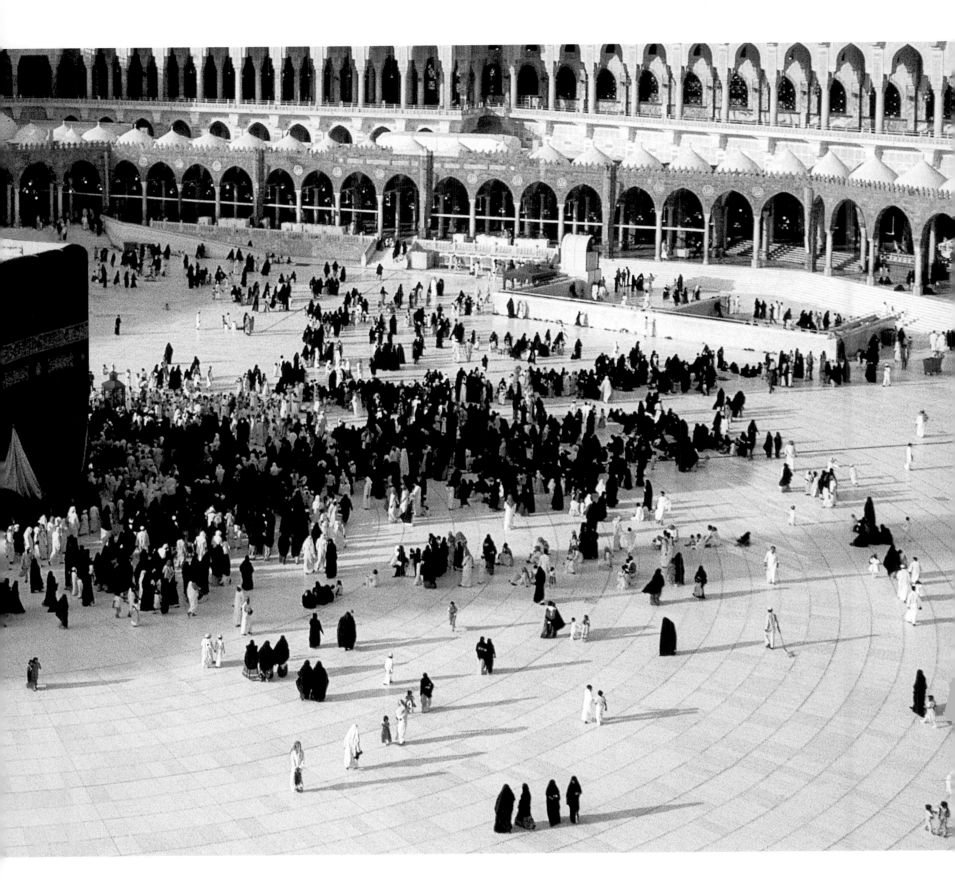

A rare opportunity for the residents of Mecca—especially for women—who are able to circumambulate in peace.

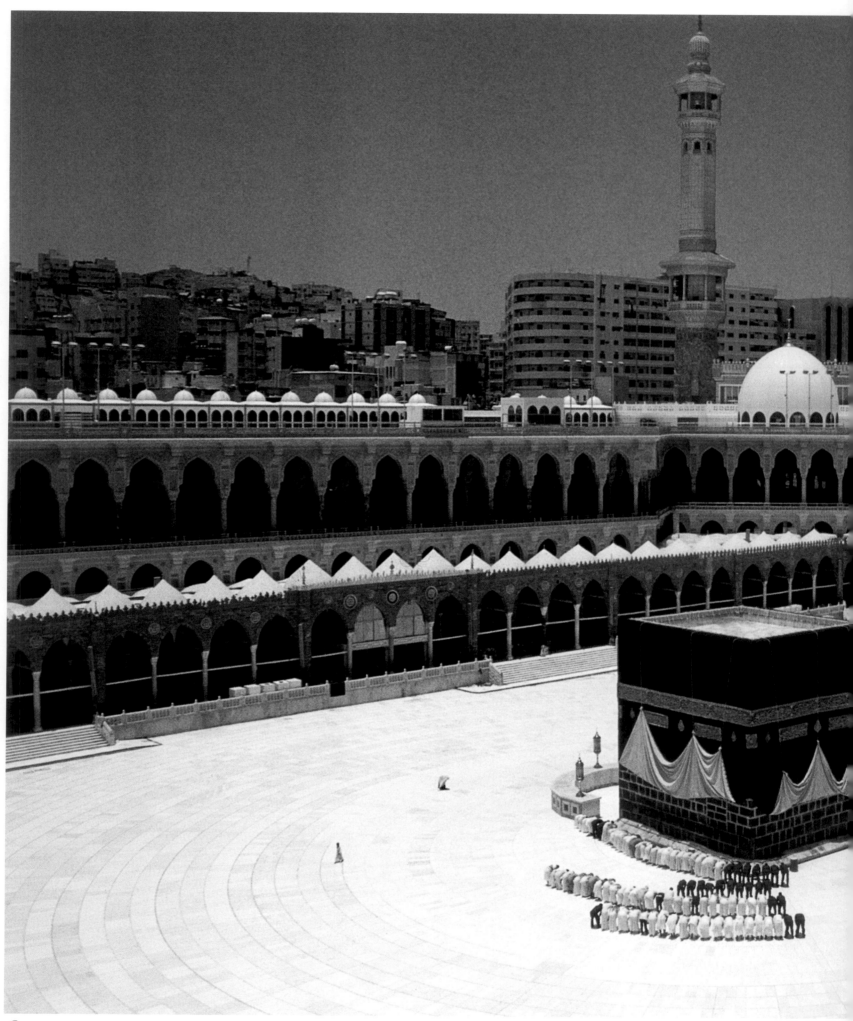

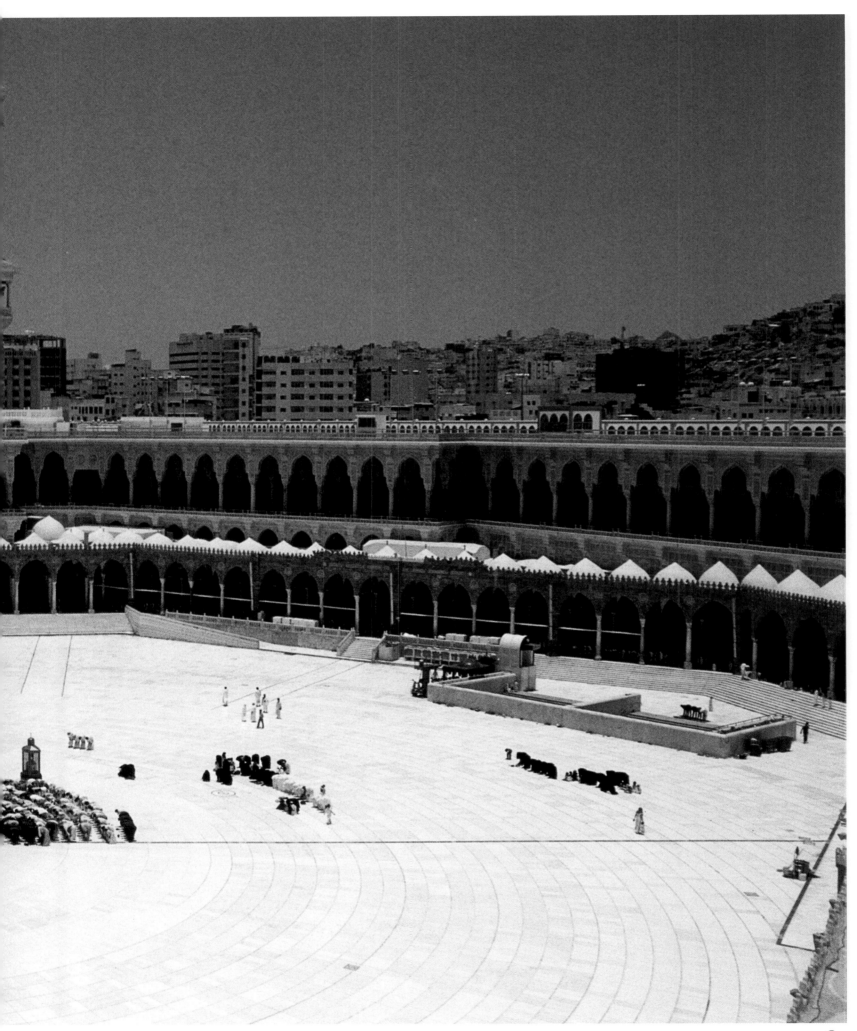

The noon prayer at the Ka'ba while pilgrims camp on Arafat. Participants in the prayer are for the most part
Meccans who enjoy the quiet of the Grand Mosque.

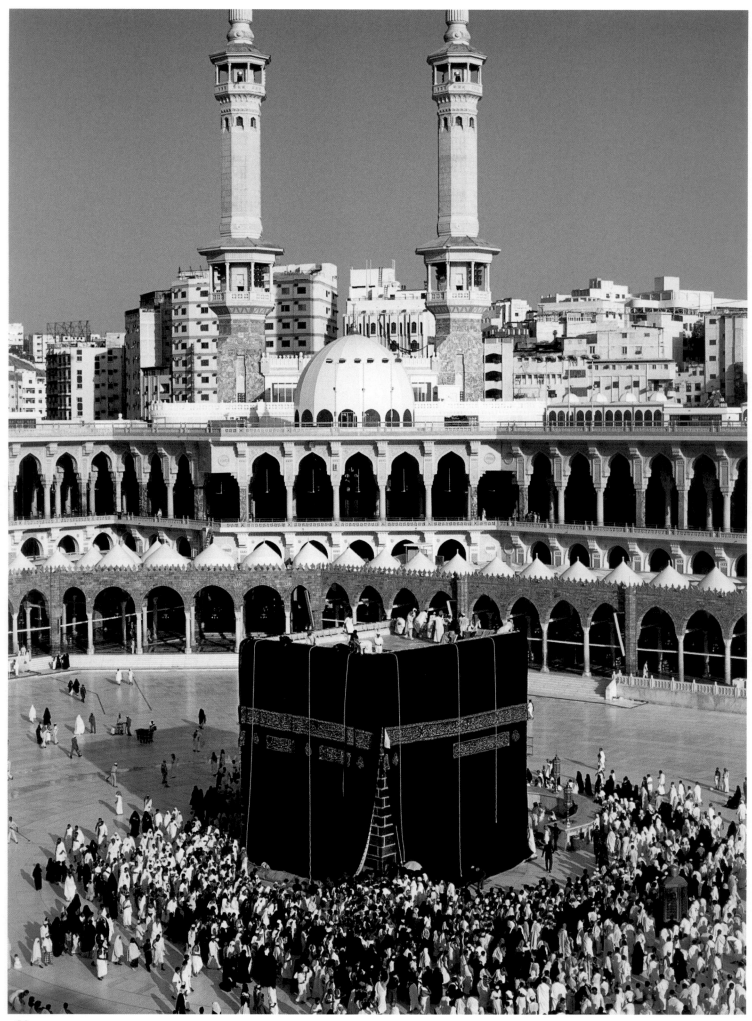

66 *The Ka'ba cover is replaced with a new one every year on the ninth of Dhul Hijja.*

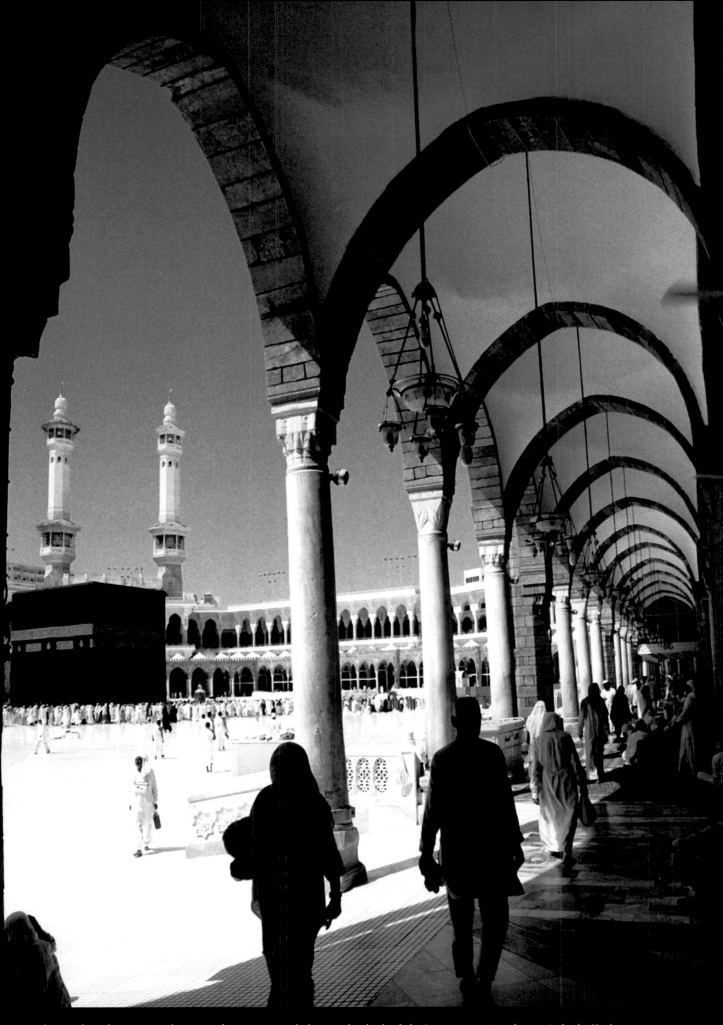

Under scorching heat, some pilgrims prefer to circumambulate in the shade of the Ottoman porticos that encircle the Ka'ba.

A festival morning at the Ka'ba

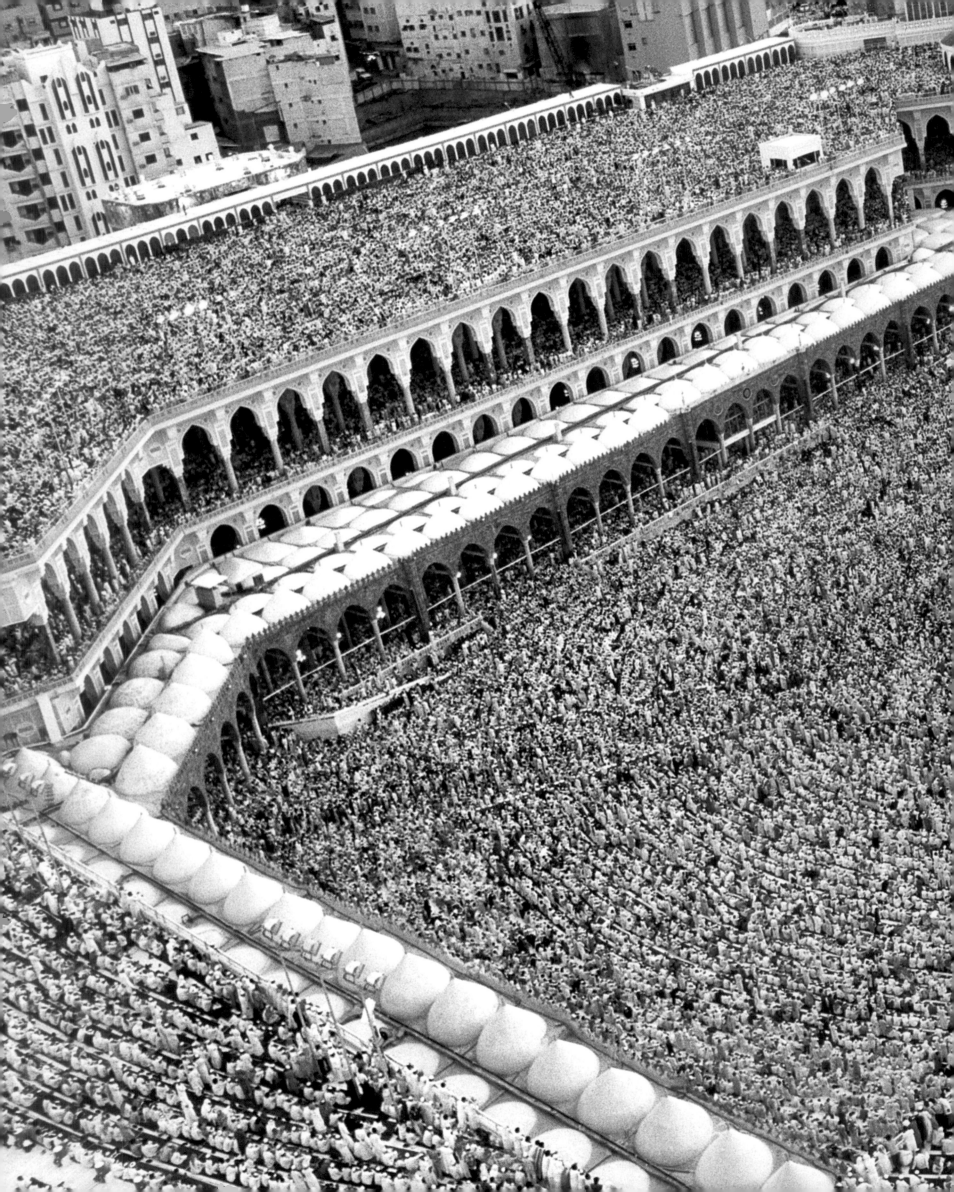

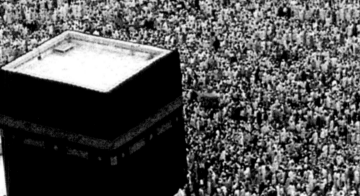

he Ka'ba, or Baytullah (the House of God), and Bayt al-Ma'mur (the Celebrated House) which is the celestial counterpart of the Ka'ba, are praised for not a second passes in which they are not being visited in utmost reverence by angels, mankind, and the jinn.

The visitor who circumambulates the Ka'ba, this center of the Earth, the heart of the Secure City upon which the Divine Look falls, inclines to God Almighty and it is hoped that they are duly complimented in return. Visitors to this sanctuary are regarded as guests of God. The fortunate guests then set themselves free into the currents of a reviving waterfall, and they are filled with hopes of being safe from eternal deprivation, from denial and deviation. Those who have seen the House of God because of their faithful efforts hopefully will not die with unbelief.

The Furthest Lote Tree (Sidrat al-Muntaha), Bayt al-Ma'mur, and the Ka'ba are interconnected with one another, and all of them have a point of connection with the believer's heart; thus the heart is, in this sense, a station of the Arsh (The Throne), Sidra, Bayt al-Mamur, and Baytullah, provided that the heart is a "heart."

When the hearts stand on the stage in this sanctuary, Mercy descends, and hands which are opened do not return empty.

It is an unusual day in Mecca, and those who have rushed to the Ka'ba are being showered by the rain . . . mercy is pouring out through the Golden Gutter.

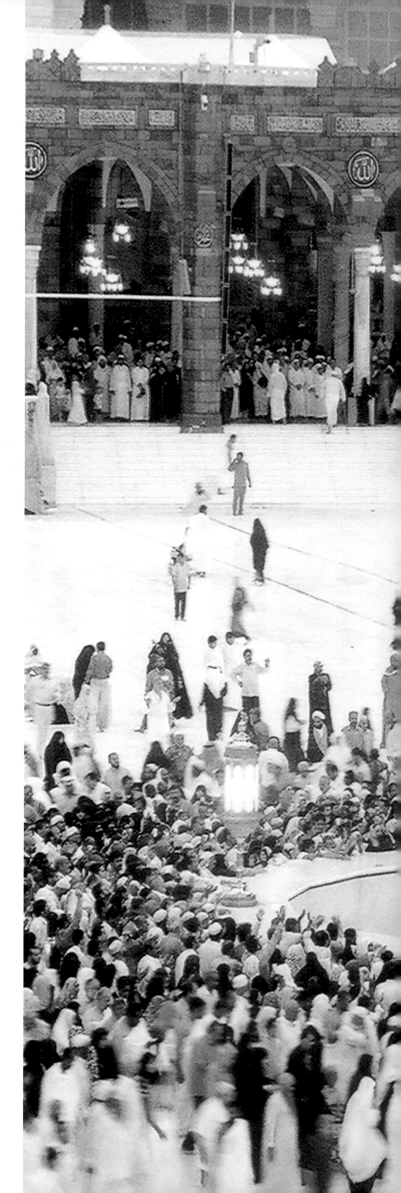

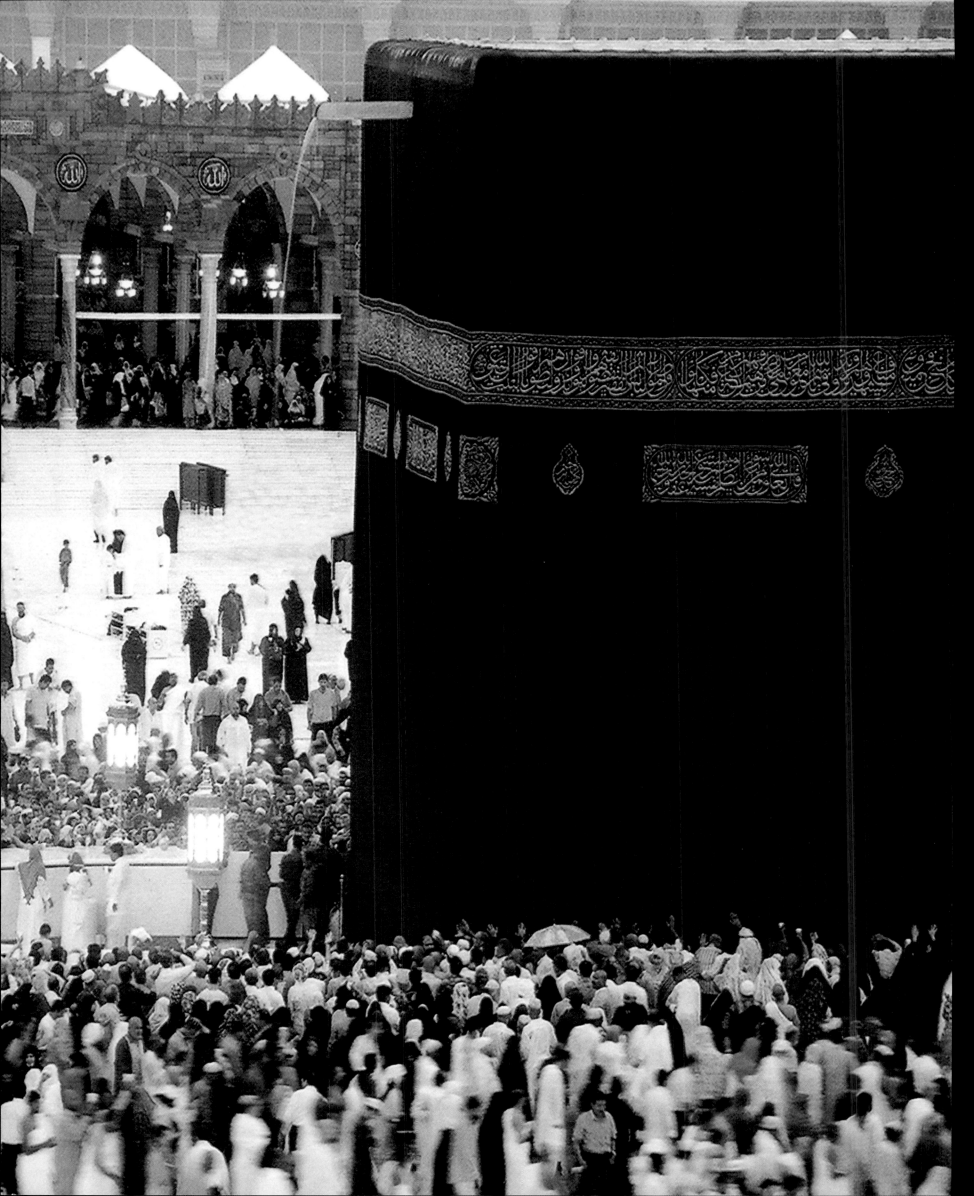

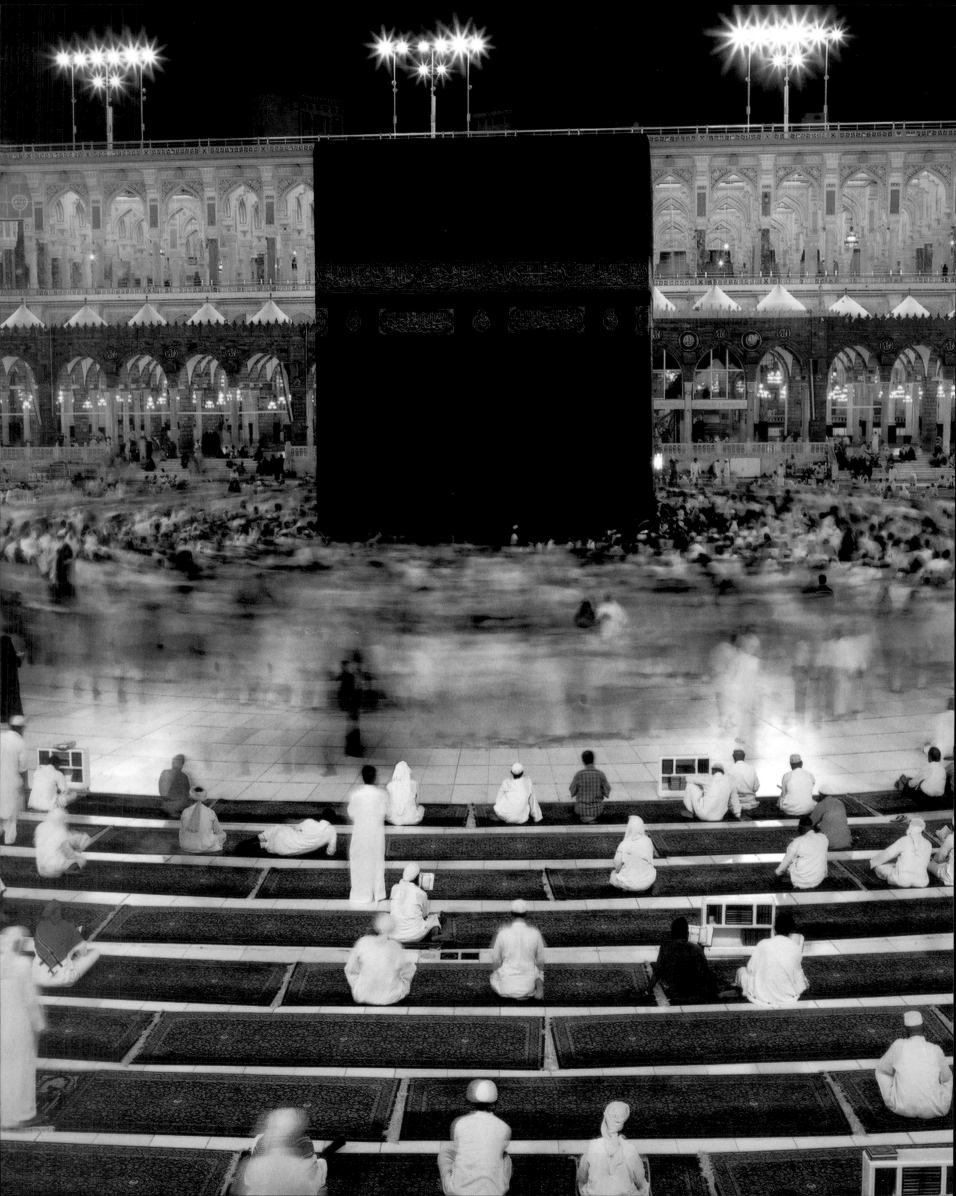

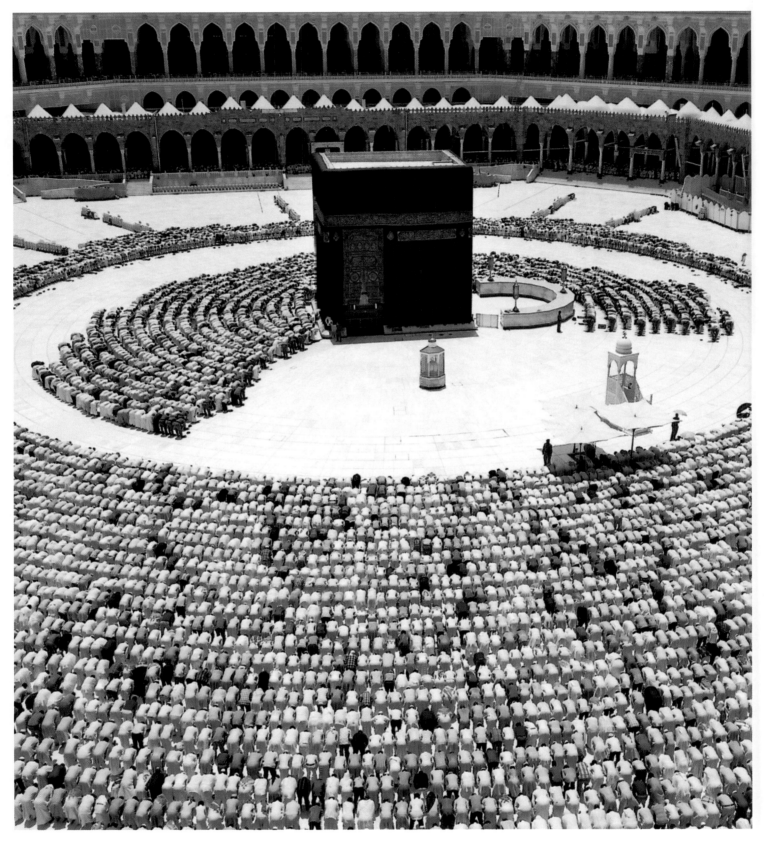

August 12. Friday prayer at the Ka'ba.
Dressed in their distinctive clothes, people of all colors bow at once . . . like the most exquisite flowers.

"To be present" or "to die" at the Ka'ba . . . both are considered blessed events. It is a pity to return empty-handed, as is being unable to go there despite insatiable longing. The appointed hour is hidden and who knows when we will be surprised with a knock on the door. How fortunate it is to be surprised at the Ka'ba . . . to be welcomed into eternity during the pilgrimage season . . . to lie down at the skirts of the Sacred House, and to be prayed for by pilgrims . . . to take steps towards the Lord with the testimony of thousands . . . taking our last breath with a last beat of the heart where it has been softened . . . and to stay in the soil where the Blessed Prophet walked.

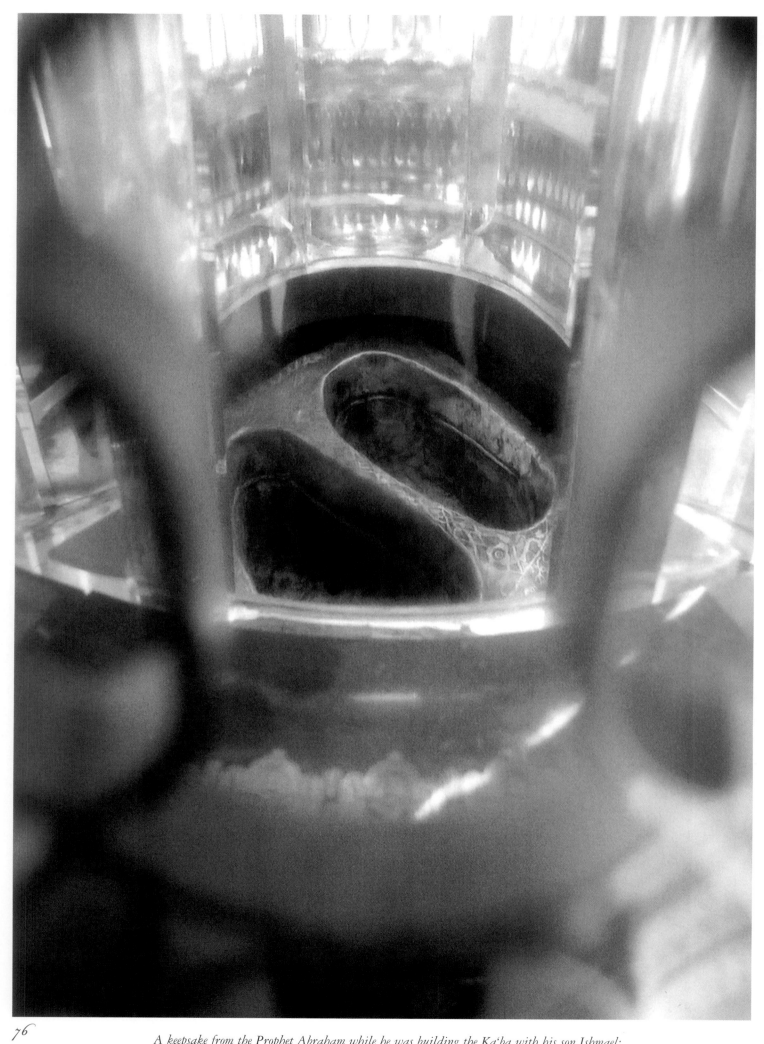

76

A keepsake from the Prophet Abraham while he was building the Ka'ba with his son Ishmael:
his footprints on the Station of Abraham.

In it there are clear signs and the Station of Abraham. (Al Imran 3:97)

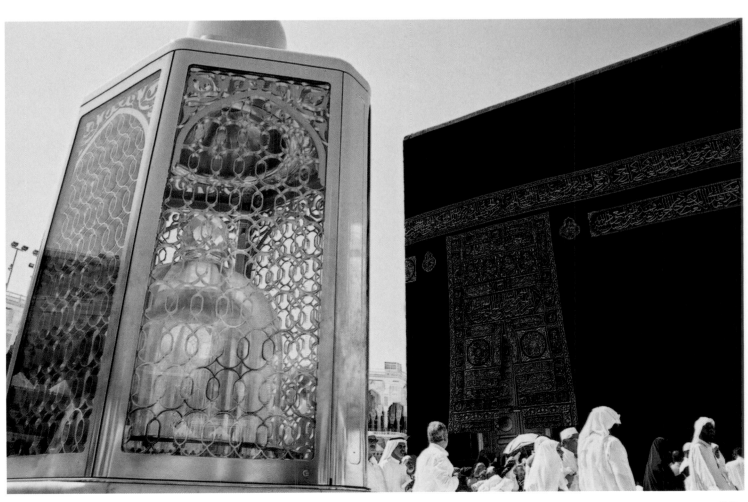

It is virtuous to pray behind the Station of Abraham after circumambulating the Ka'ba.

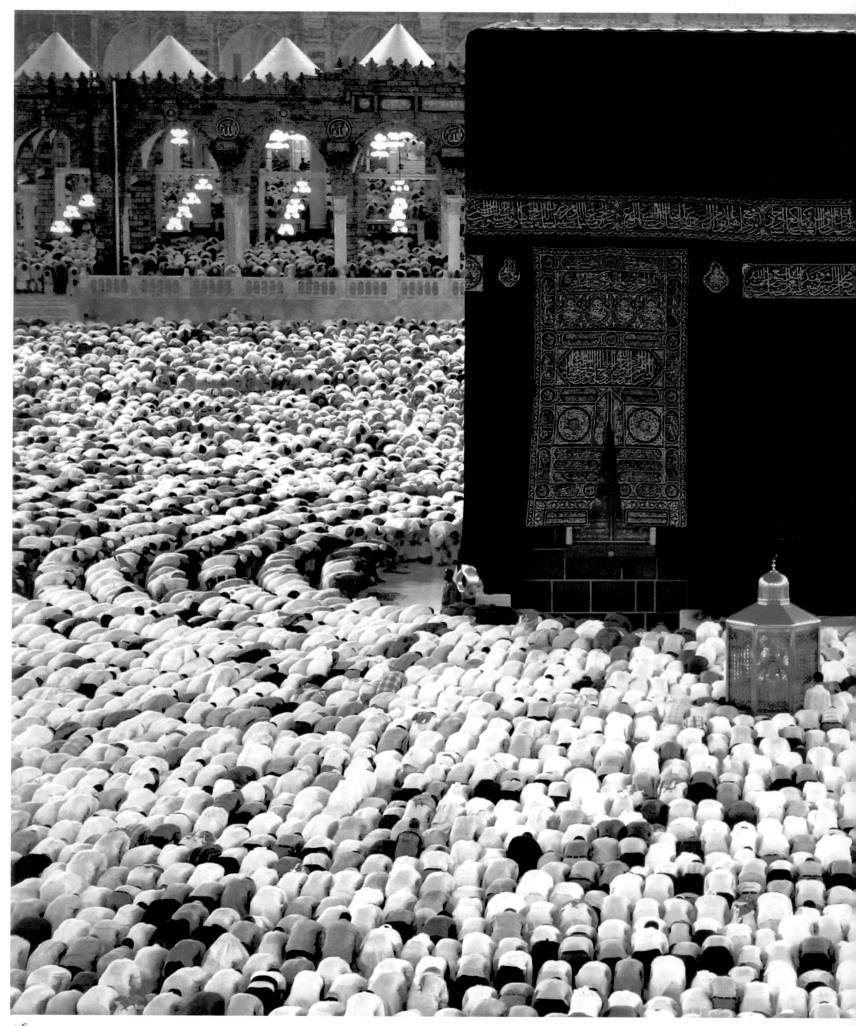

During congregational prayers, worshippers do not stand in the semi-circular area,
Hijr Ishmael, for it is considered to be part of the Ka'ba, an eternal resting place for many prophets.

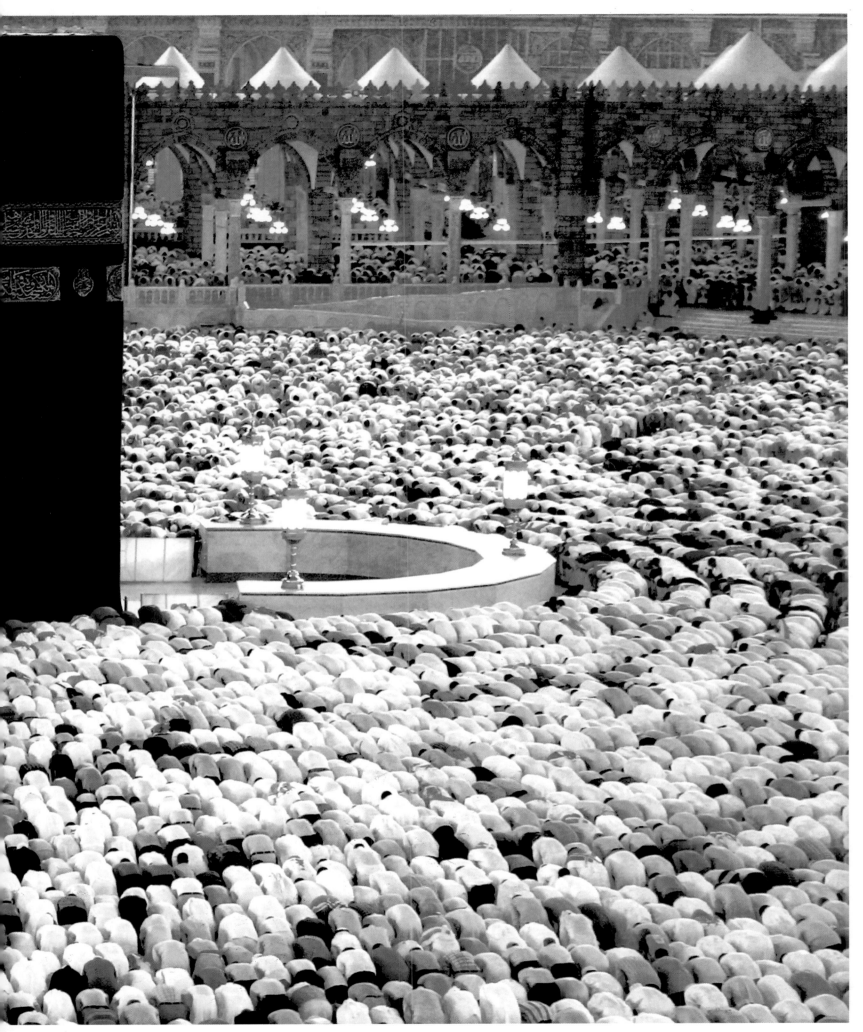

(Overleaf) Festival sermon at the Ka'ba...

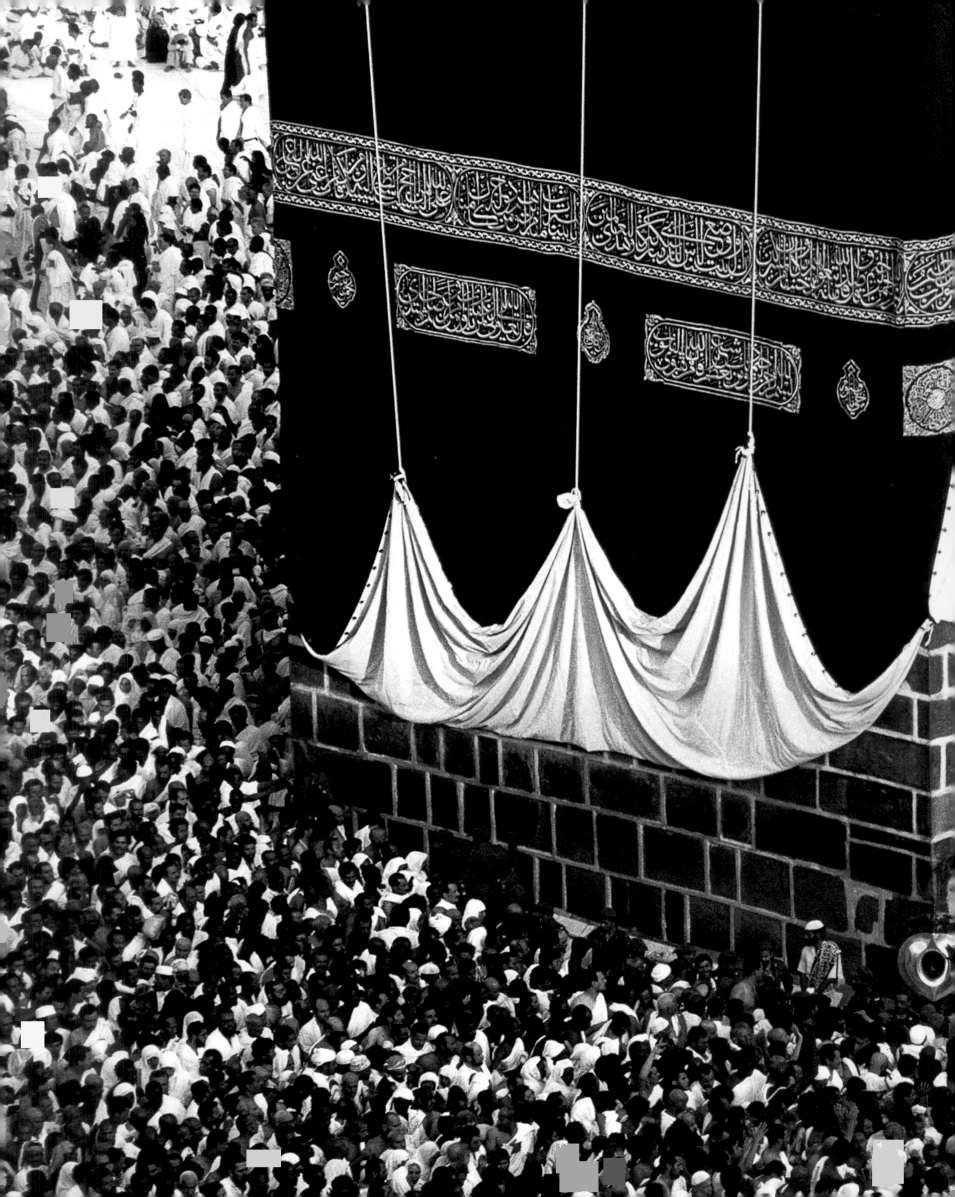

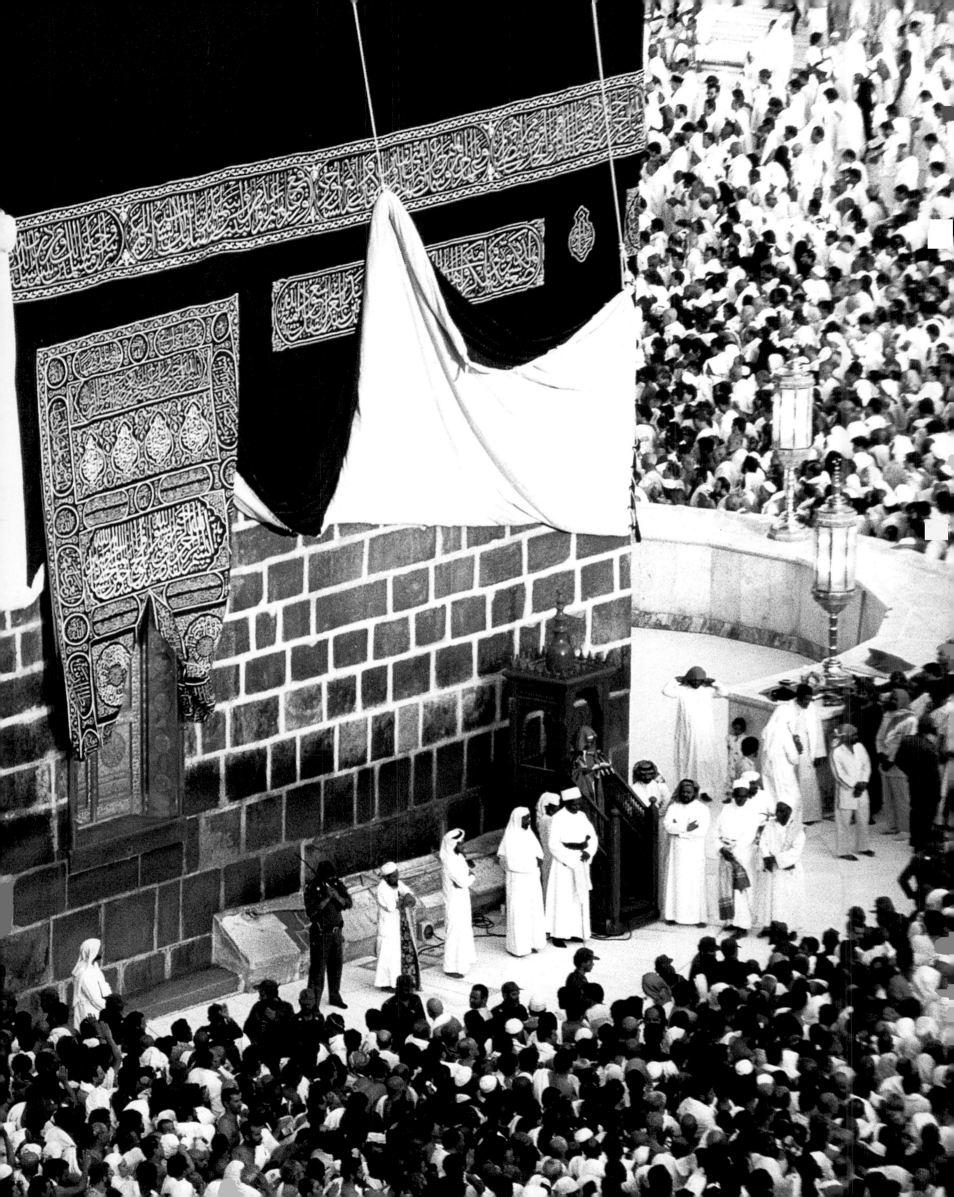

 ceans are nothing more than a drop next to the Qur'anic inspirations that pour into a believer's heart; the sun remains a candle next to a mind that has been illuminated with the light of the Qur'an. The breath that the Qur'an blows into our hearts is our lifeblood, and thanks to the light it casts upon the cosmos, every existence is a proof for the Almighty. The voice of the Qur'an revives even the remotest corners of this world, as if the horn has been blown by Israfil; hearts are born again when they hear its message.

" . . . (The Qur'an) is the light of insight from your Lord, and a guidance and a mercy for people apt to believe and deepen in belief." (Araf 7:203)

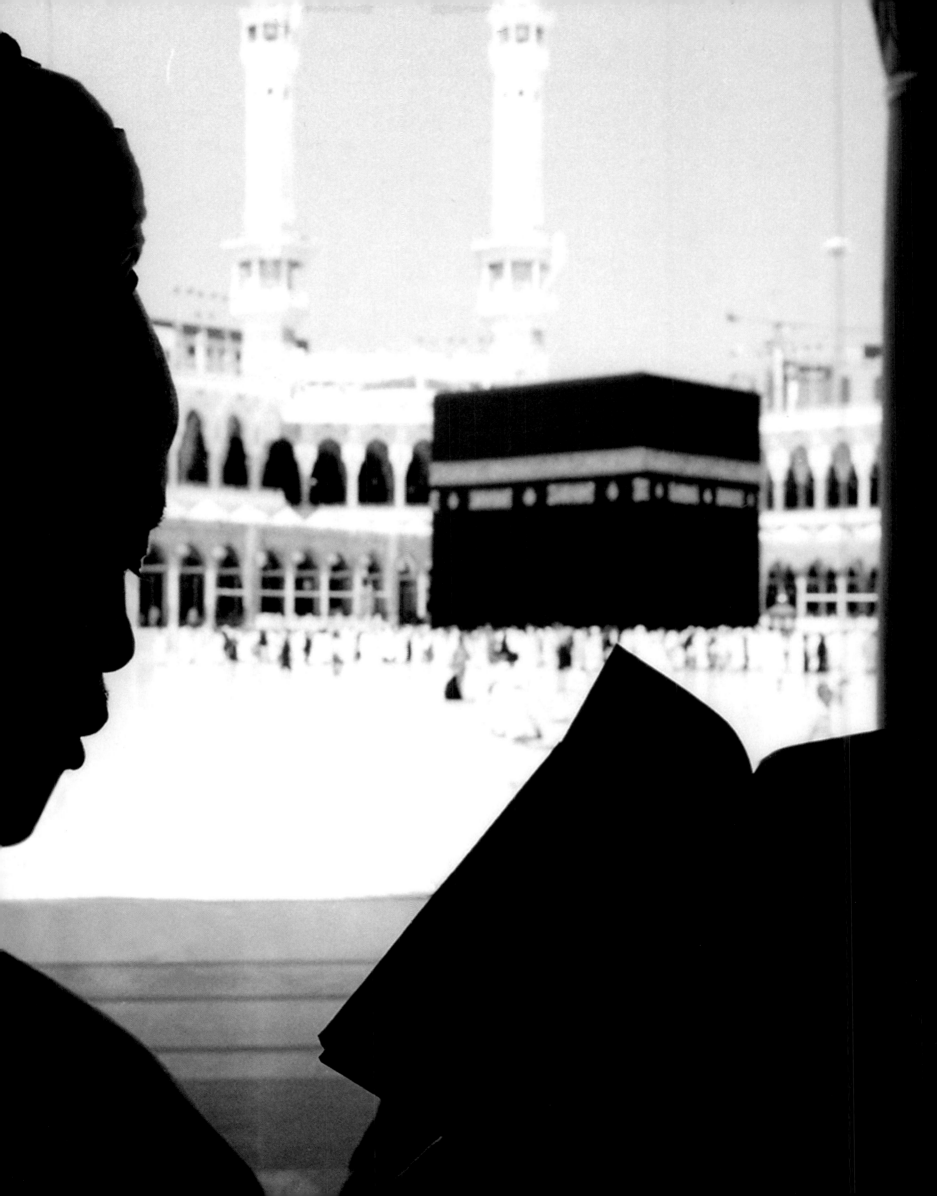

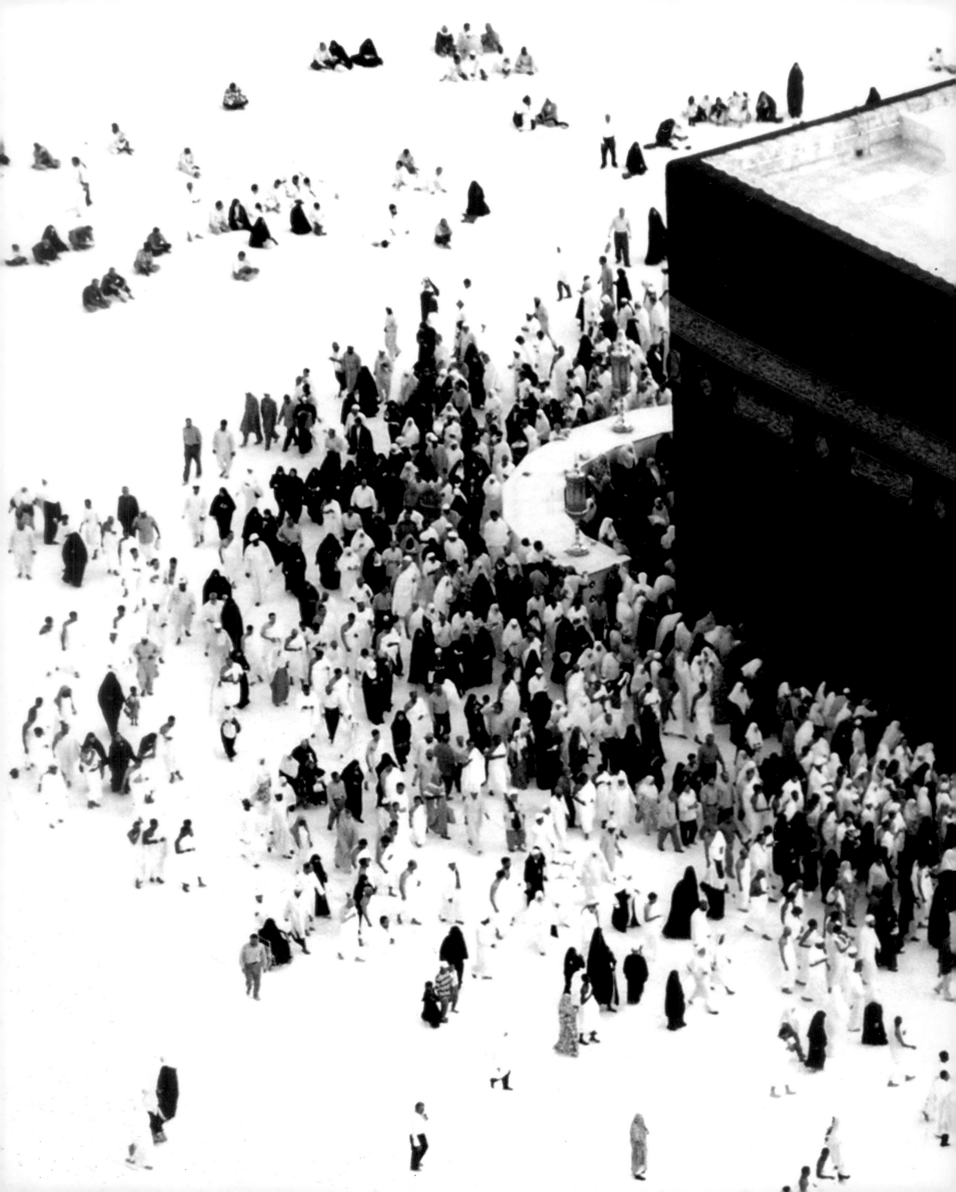

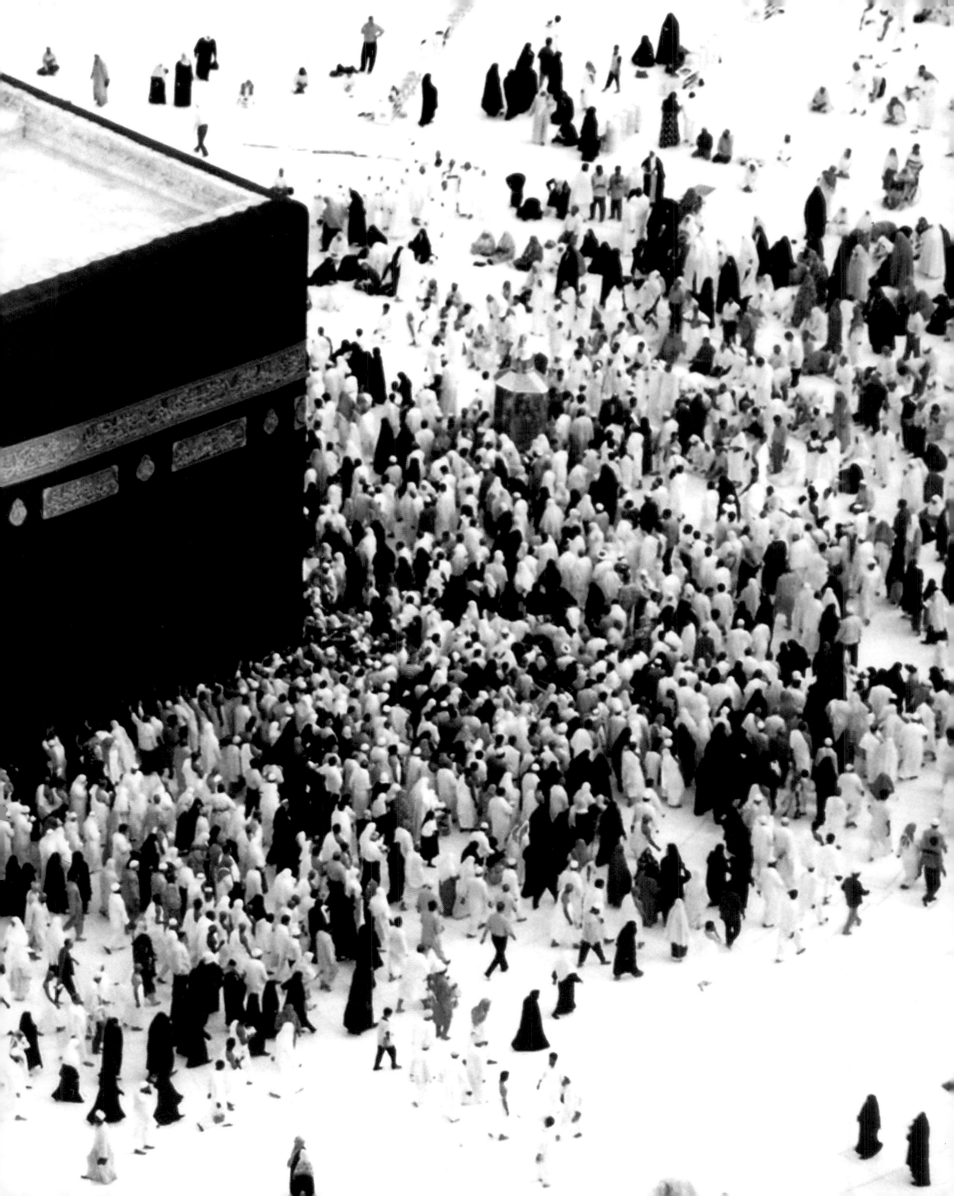

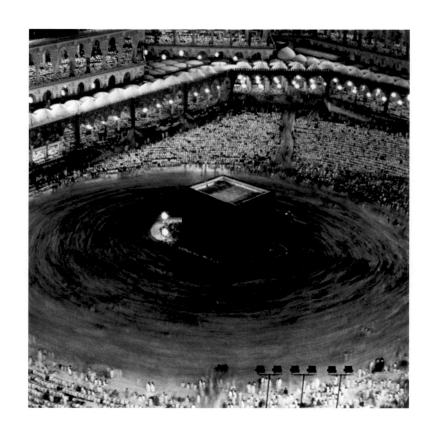

ncircled by imposing mountains and hills, the Ka'ba appears like a lotus that puts out its petals; but more than that, it is a bell jar hiding secrets of the cosmos; it is the projection of the Furthest Lote-Tree; it is a crystal made up of the essence of the realms beyond. A pilgrim who is aware of their observance may feel many secret blessings as they turn around this mysterious bell jar; they can behold the heavenly worlds through this prism.

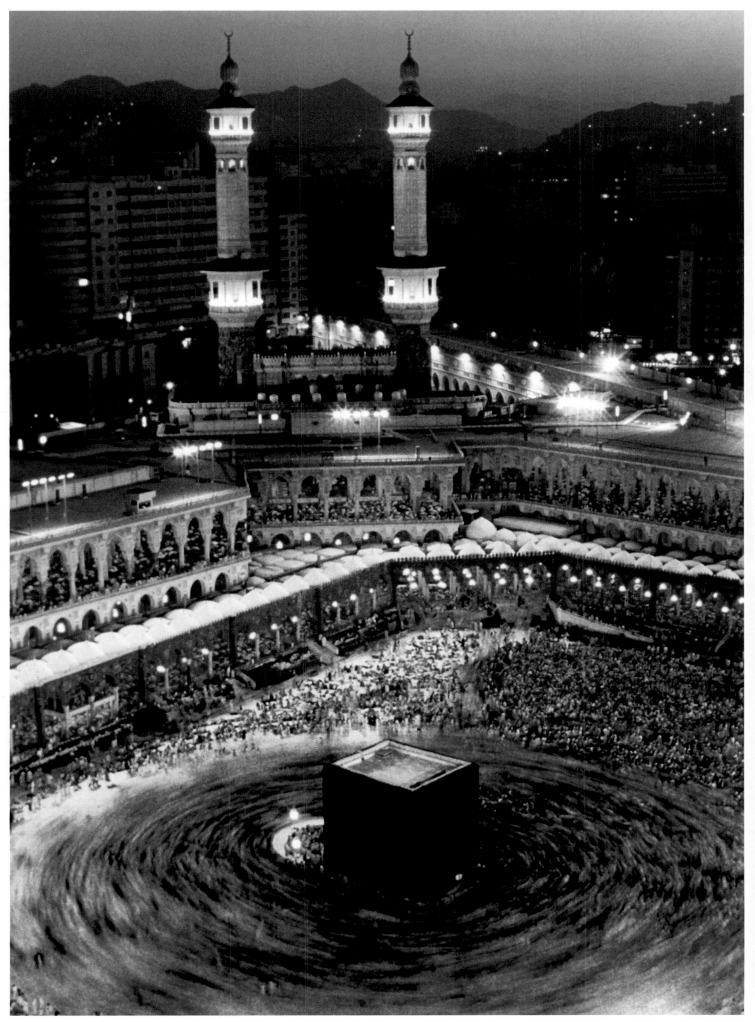

The Ka'ba on the Night of Power, Ramadan 27.

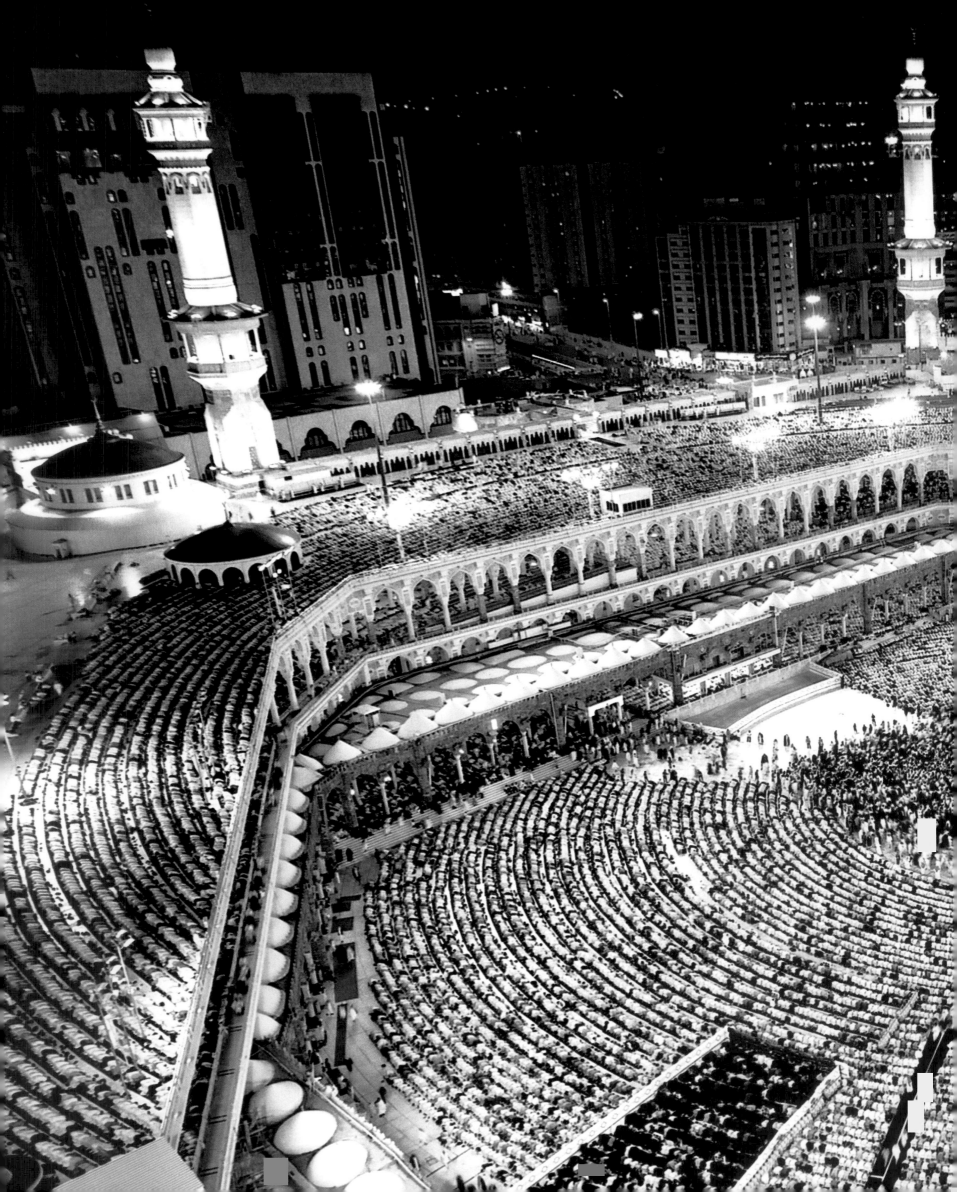

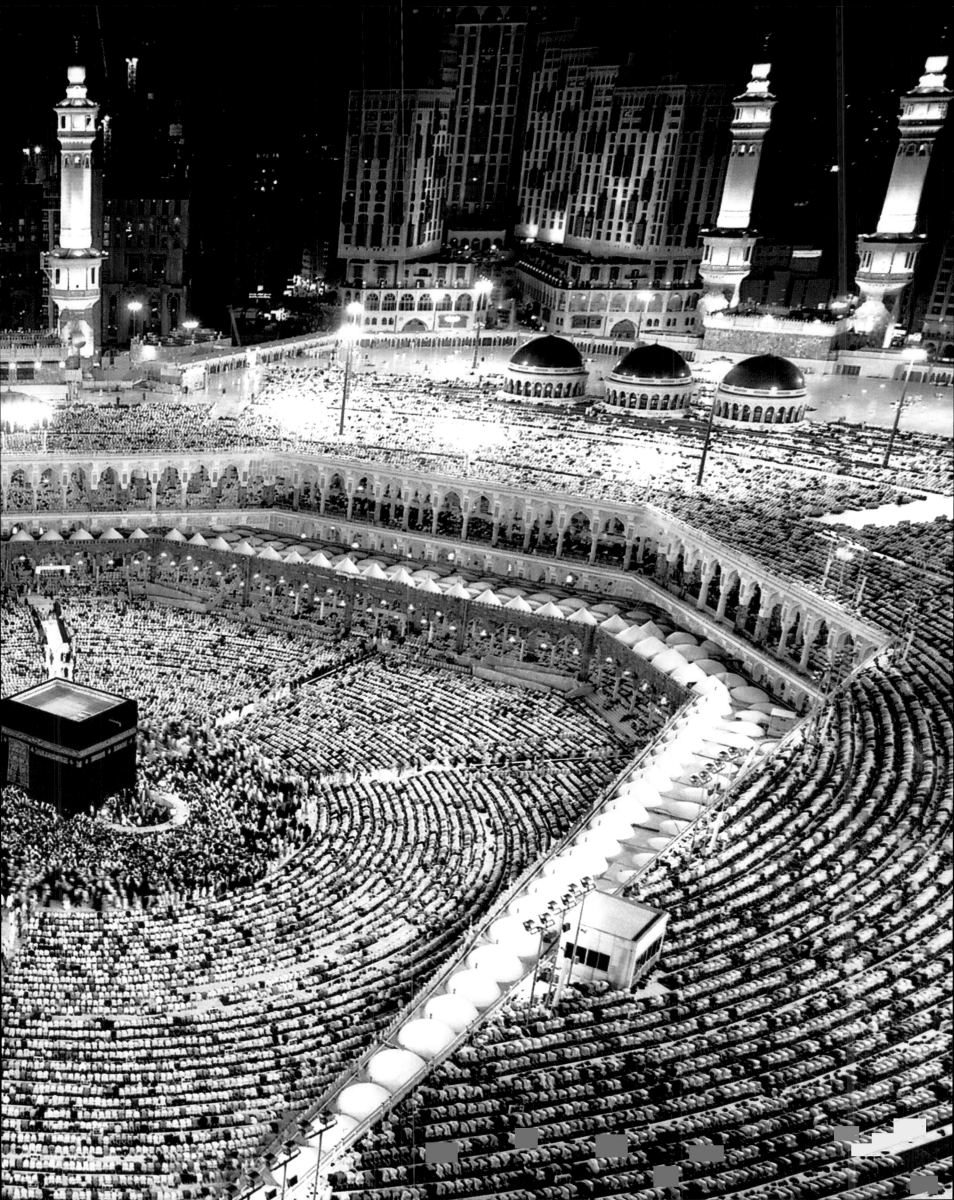

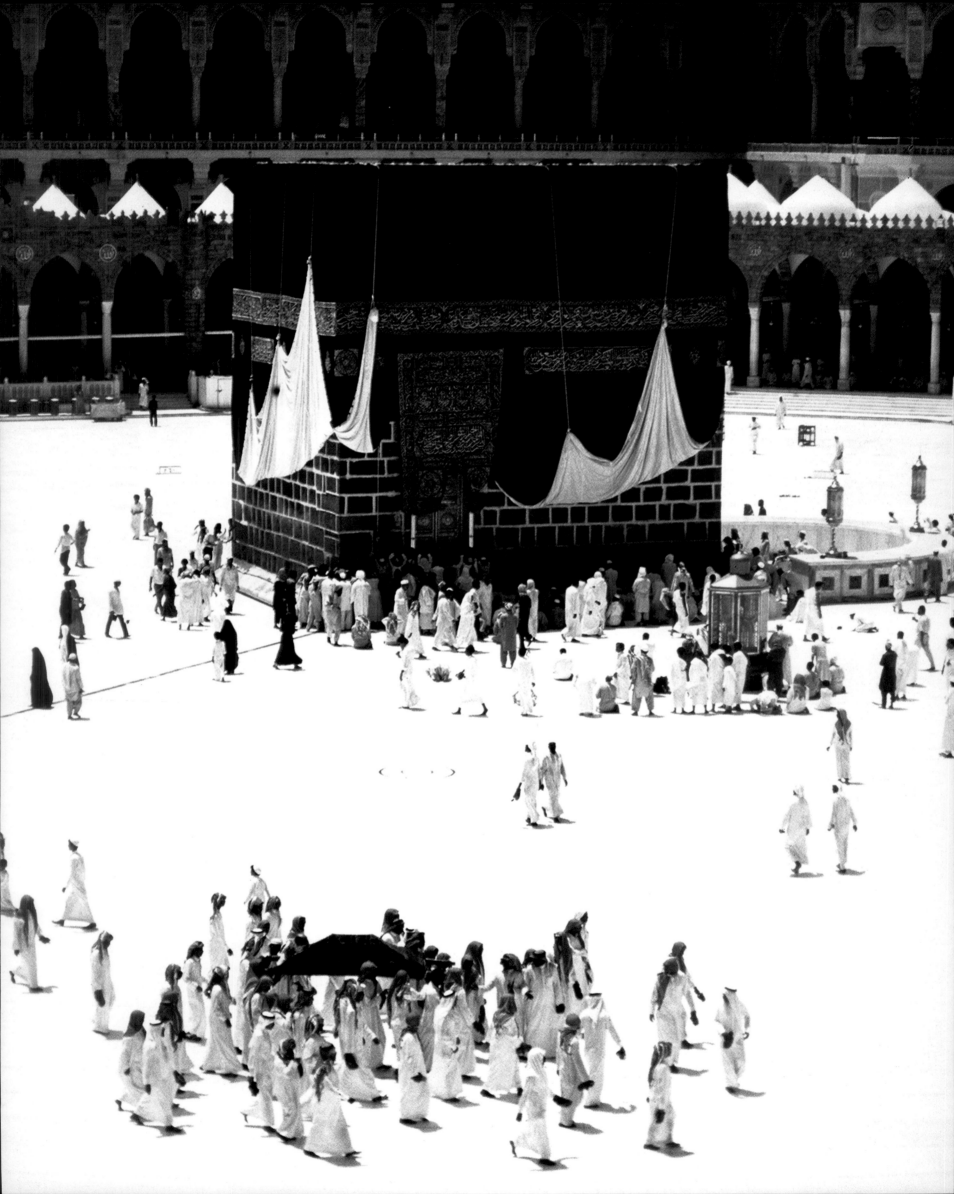

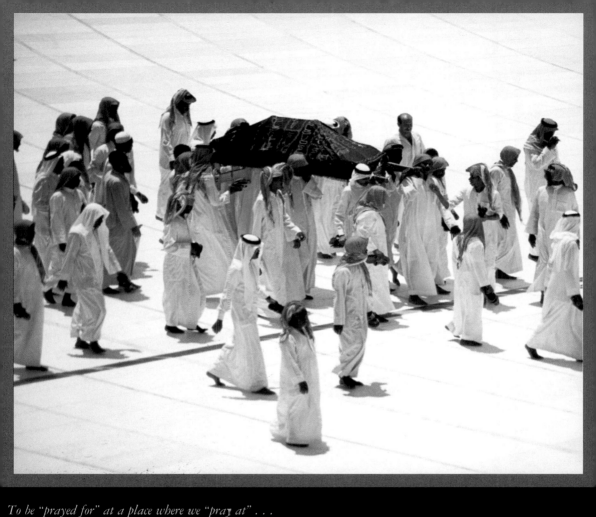

To be "prayed for" at a place where we "pray at" . . .

Death is not asked for but, "Ask for a good life and a good death" says the Messenger of God. Death at the Ka'ba is hoped to be a good one. A life that is lived as joyfully as the circumambulation and which reaches the end where the circumambulation ends . . . and from that point on we say hello to a new life.

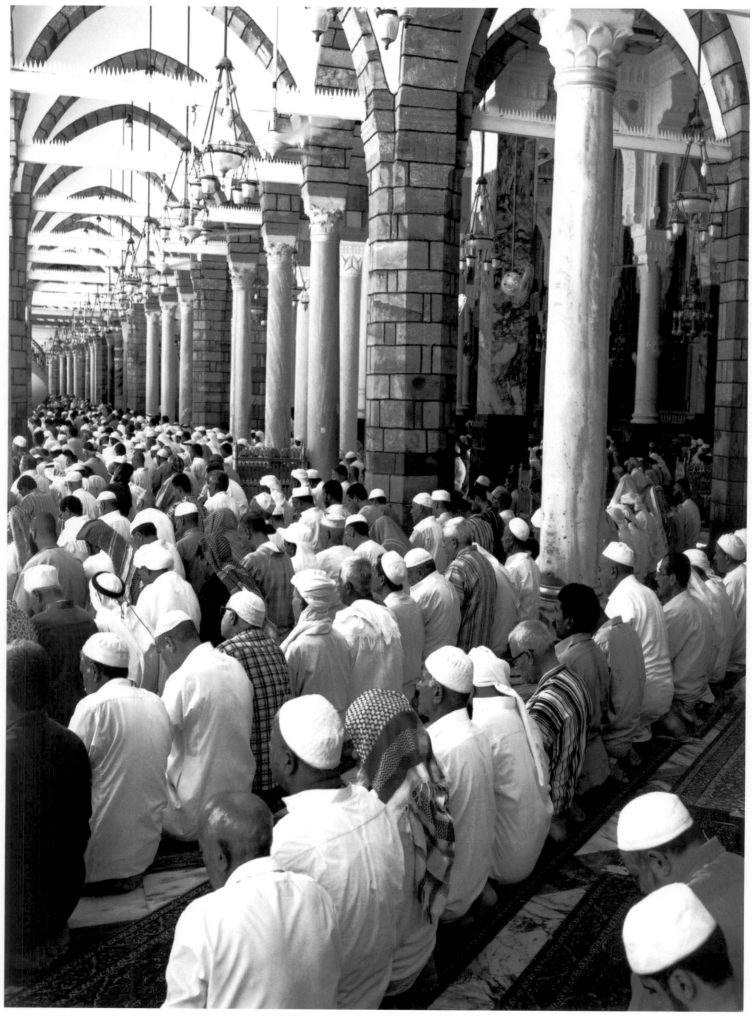

Through the porticos, the Ka'ba smiles at those facing it. ▶

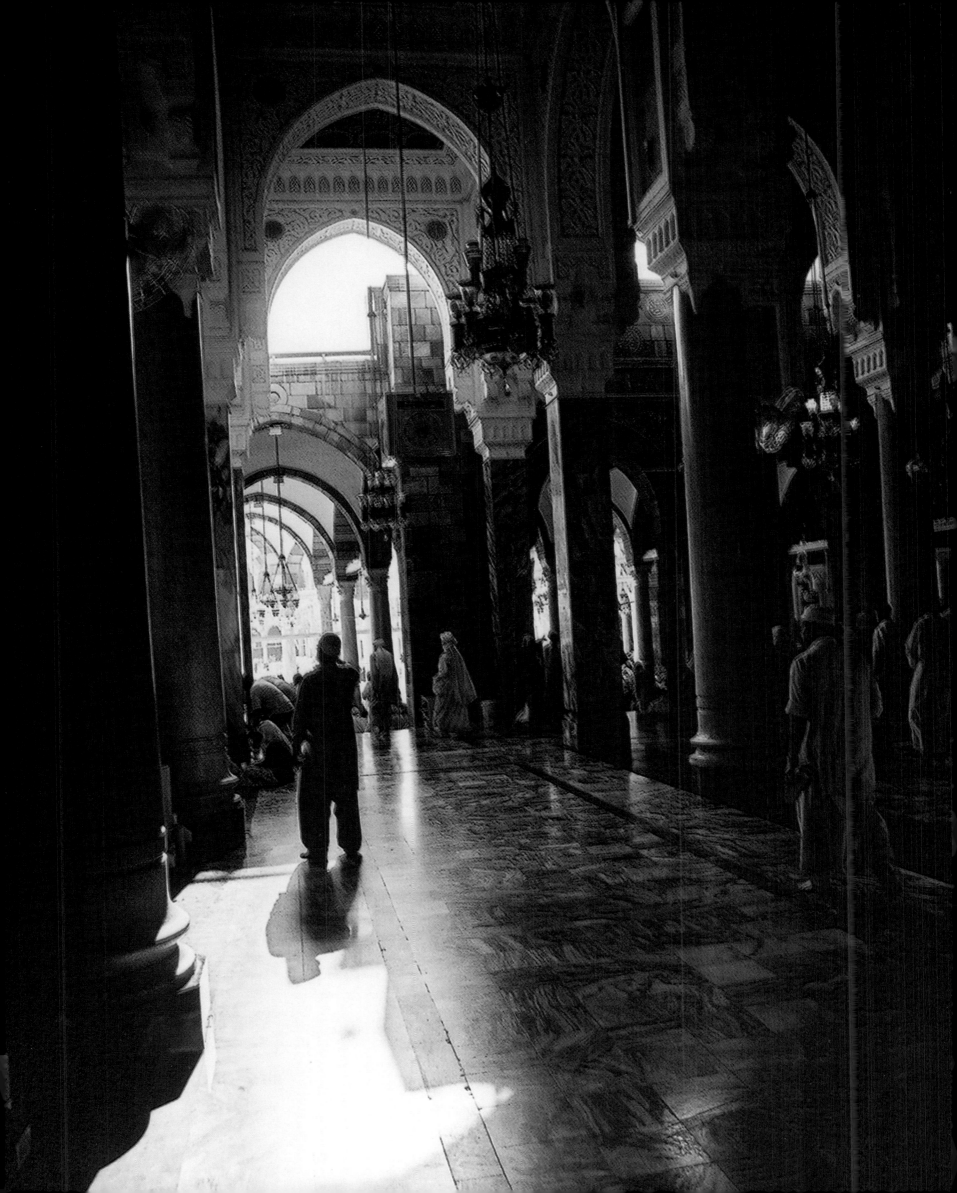

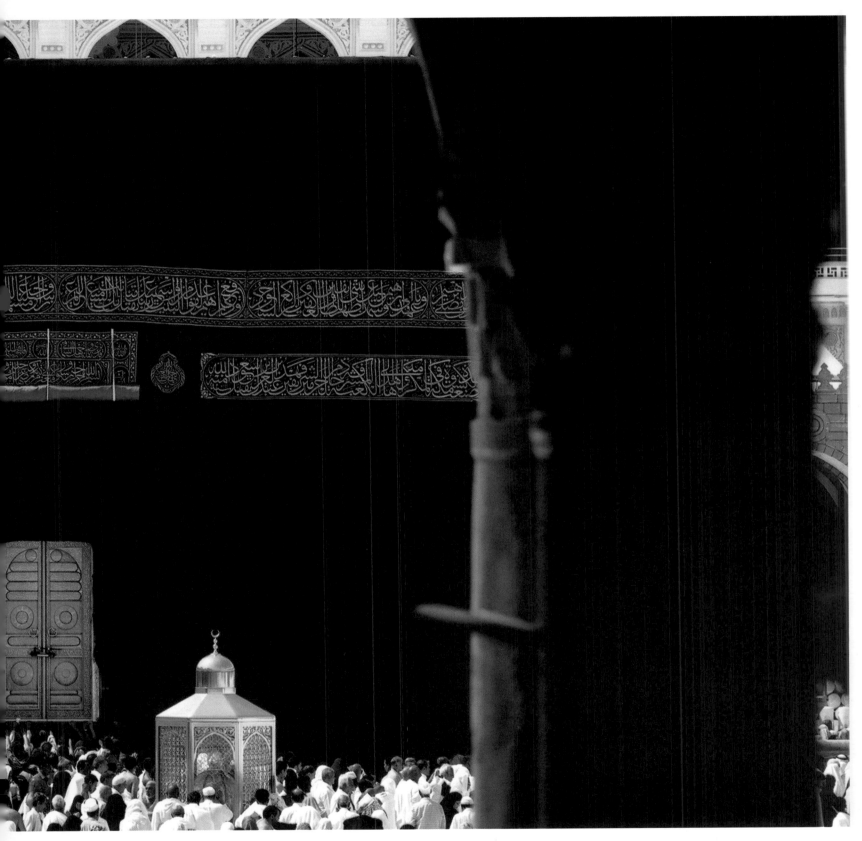

The time when the door of the Ka'ba can be seen as a whole, once a year.

The Ka'ba has been washed with perfumes of musk, the door has been sealed, and the cover is yet to be lowered.

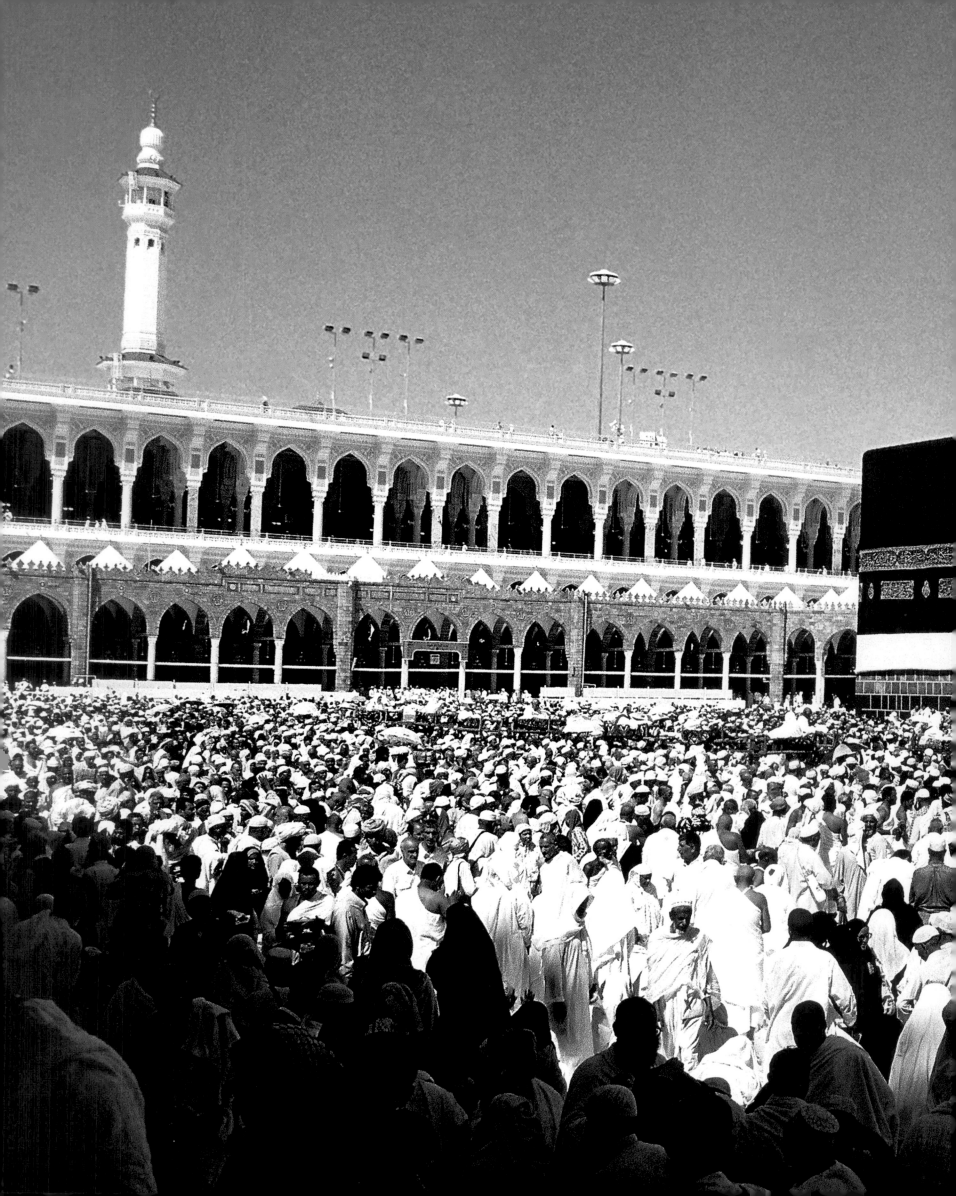

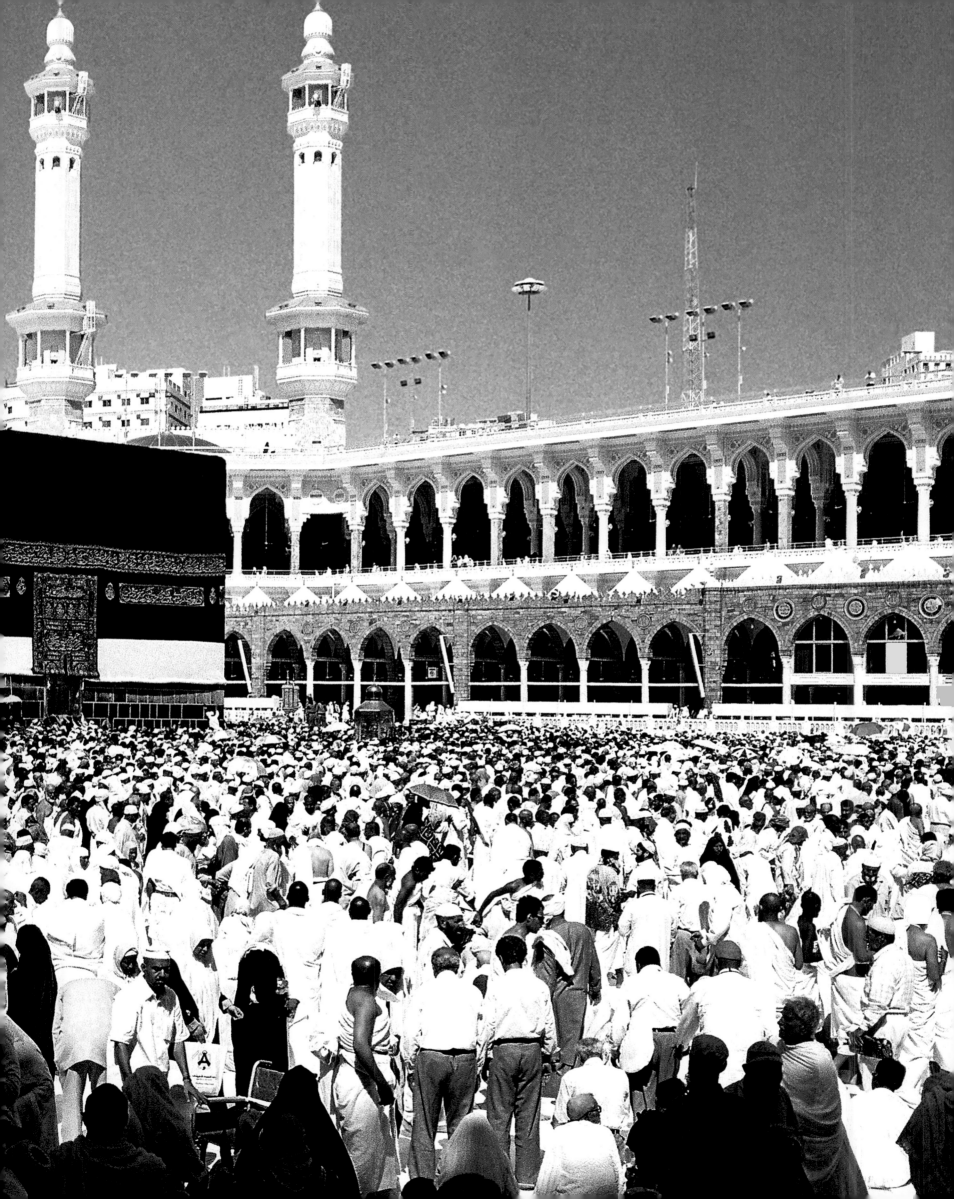

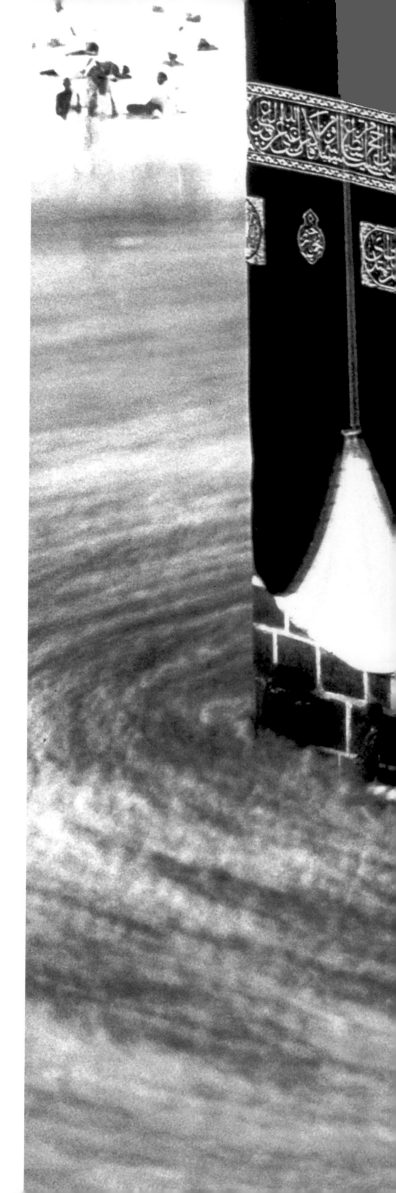

 he mother of buildings compassionately embraces the pilgrim who walks around her. Everyone performs the circuits in comfort and with the confidence of a child who is tightly holding its mother's hand. Among hundreds of thousands of believers, a pilgrim soars around the Ka'ba enthused, as if heading towards Almighty God.

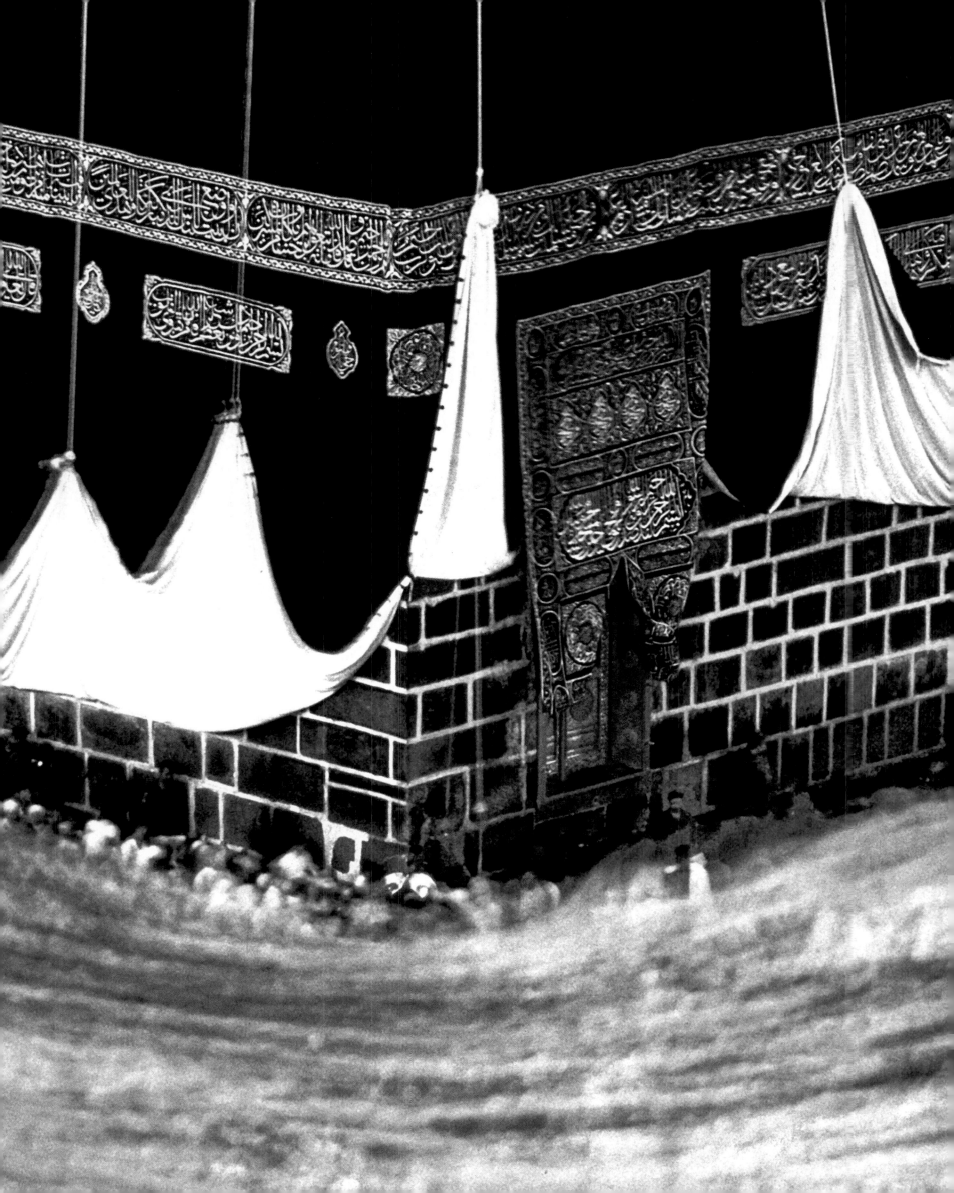

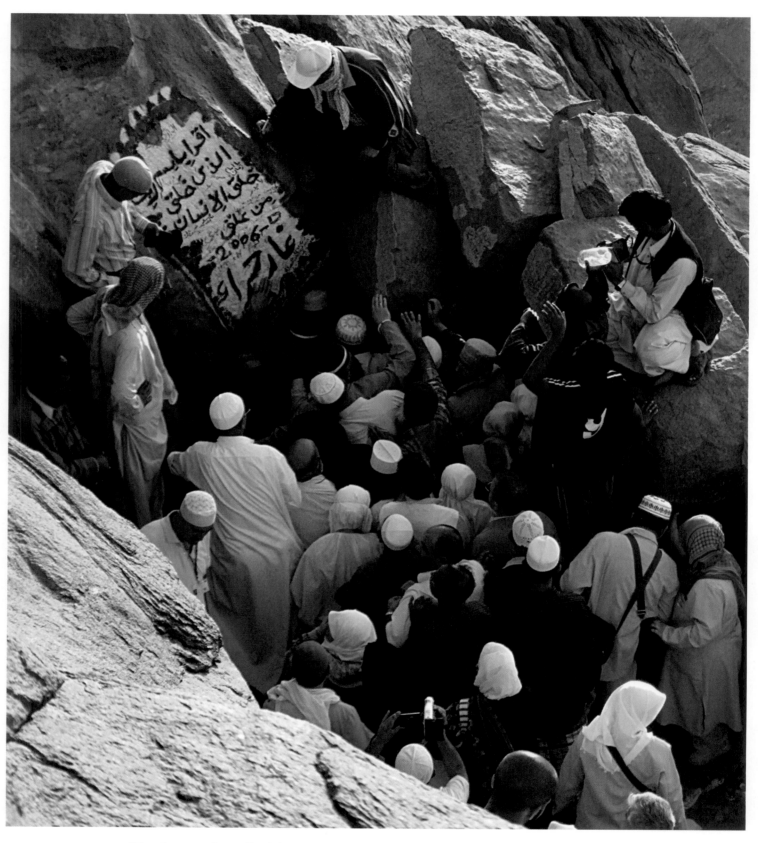

Hira Cave was the cradle of the revelation. The Messenger of God, peace and blessings be upon him,
would frequently retreat here before his mission started. The cave was the first witness to the Eternal Light.
Pilgrims sweated on the slopes of Mount Nur (Light) and seek reunion in Hira as they lend an ear to its quiet but momentous message.

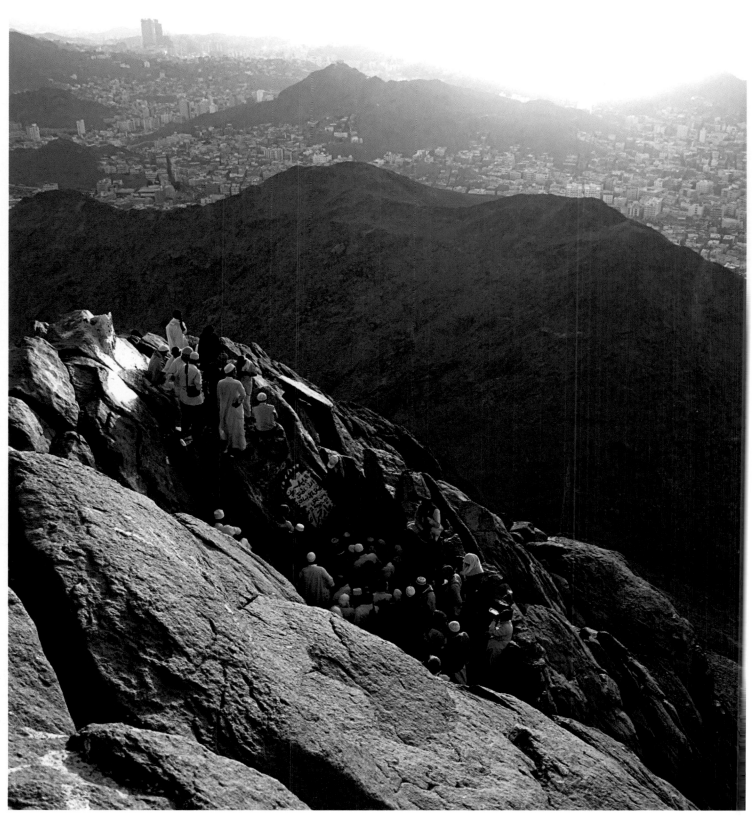

Mount Nur facing the Ka'ba. No doubt the Blessed Prophet observed the Ka'ba, his soul-mate, and longed for the days when it would be respected for its original purpose.

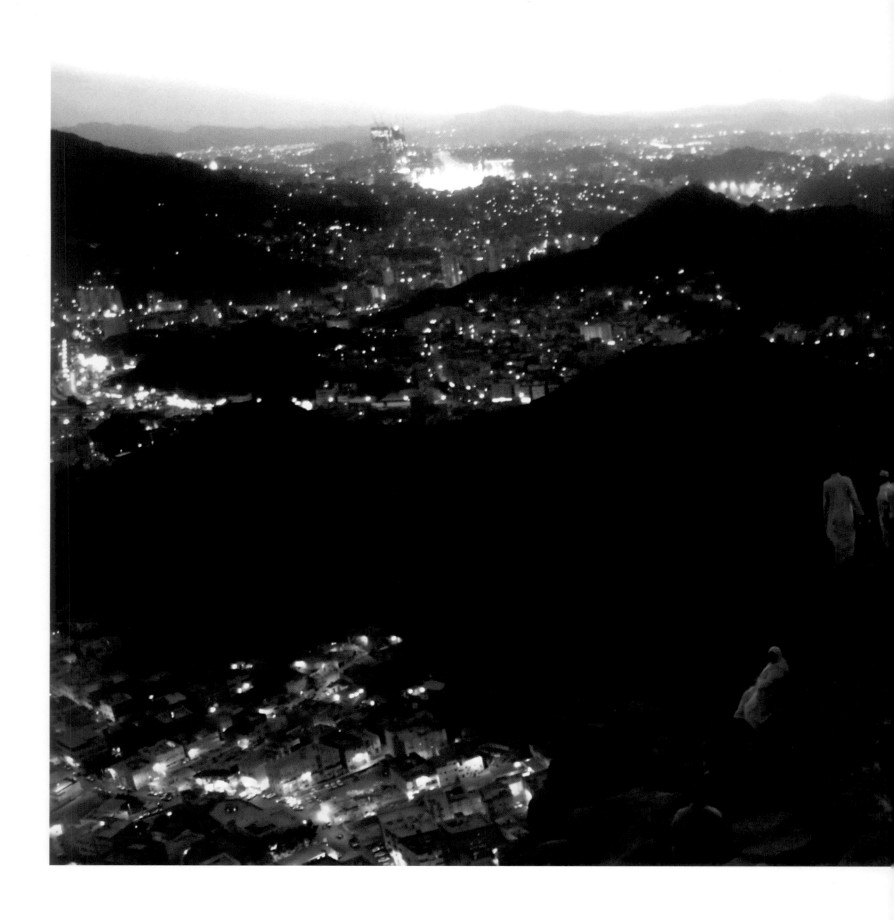

Mecca. View from the Hira Cave. Belief is like an ember illuminating the city.

(Overleaf) Light upon light, from the Mountain of Light.

 ircumambulation around the Ka'ba is, in Sufi terminology, "journeying in God" (*sayr fillah*); this refers to a journey that is centered around a sacred goal while moving on deeper within. In a similar sense, the cycles of rapid walking between the Safa and Marwa hills (*sa'y*) symbolize "journeying to God" (*sayr ilallah*) and "journeying from God" (*sayr minallah*). Under the storm of such feelings, as they walk back and forth between these two hills, the pilgrims experience in the rhythm of the sa'y the running in search of aid, the entreaty for relief, and the crying out for a helping hand. The search continues, as if in pursuit of something very crucial; the reality is mixed with dreams . . . and people all around are seen as breathing anxiously at times, or being relieved at other times, enraptured with the dichotomy of delight and concern surrounded by the profundity of silence together with screams of sobbing . . . they are being dragged towards the Judgment in one direction, or rushing towards the river of Paradise in the other. Every moment along this course is so elusive that, if not flattered or shown attention, it can evaporate without a trace, as if it never existed.

Safa hill ▶

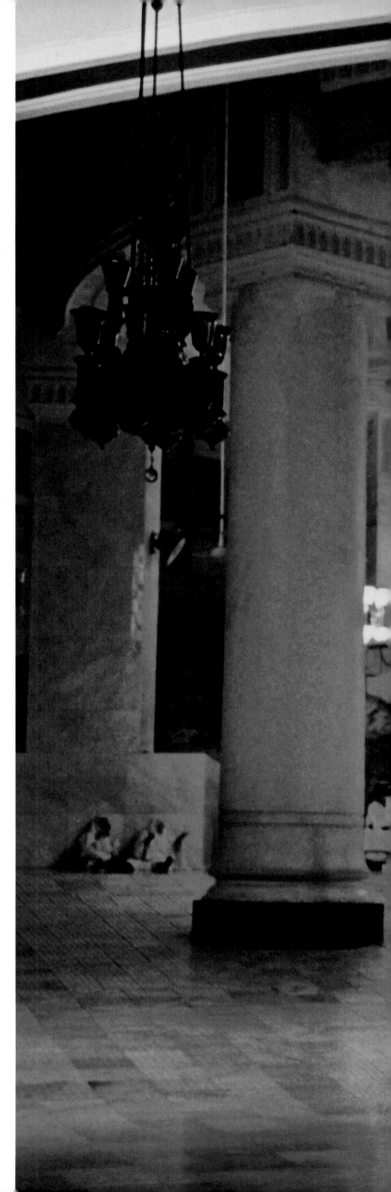

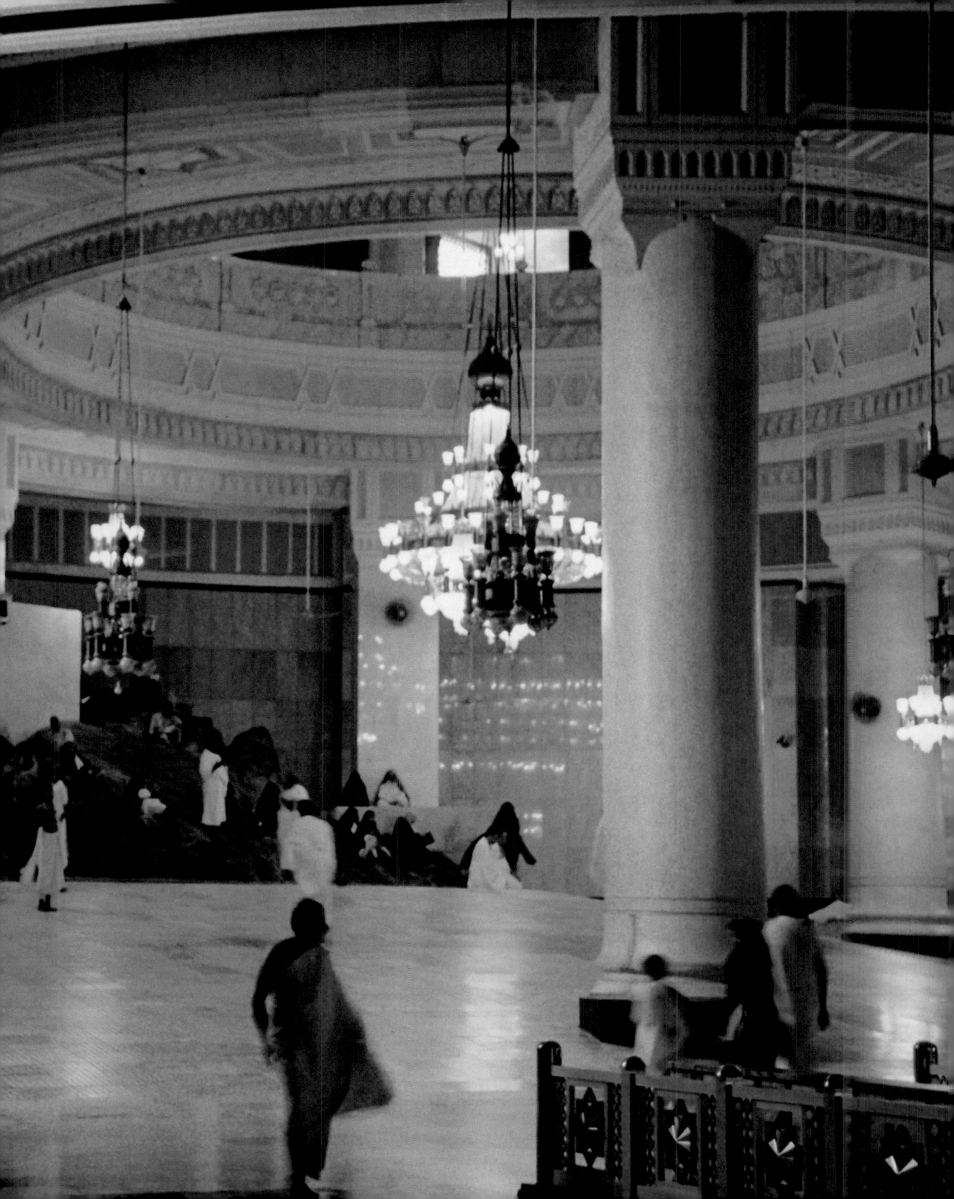

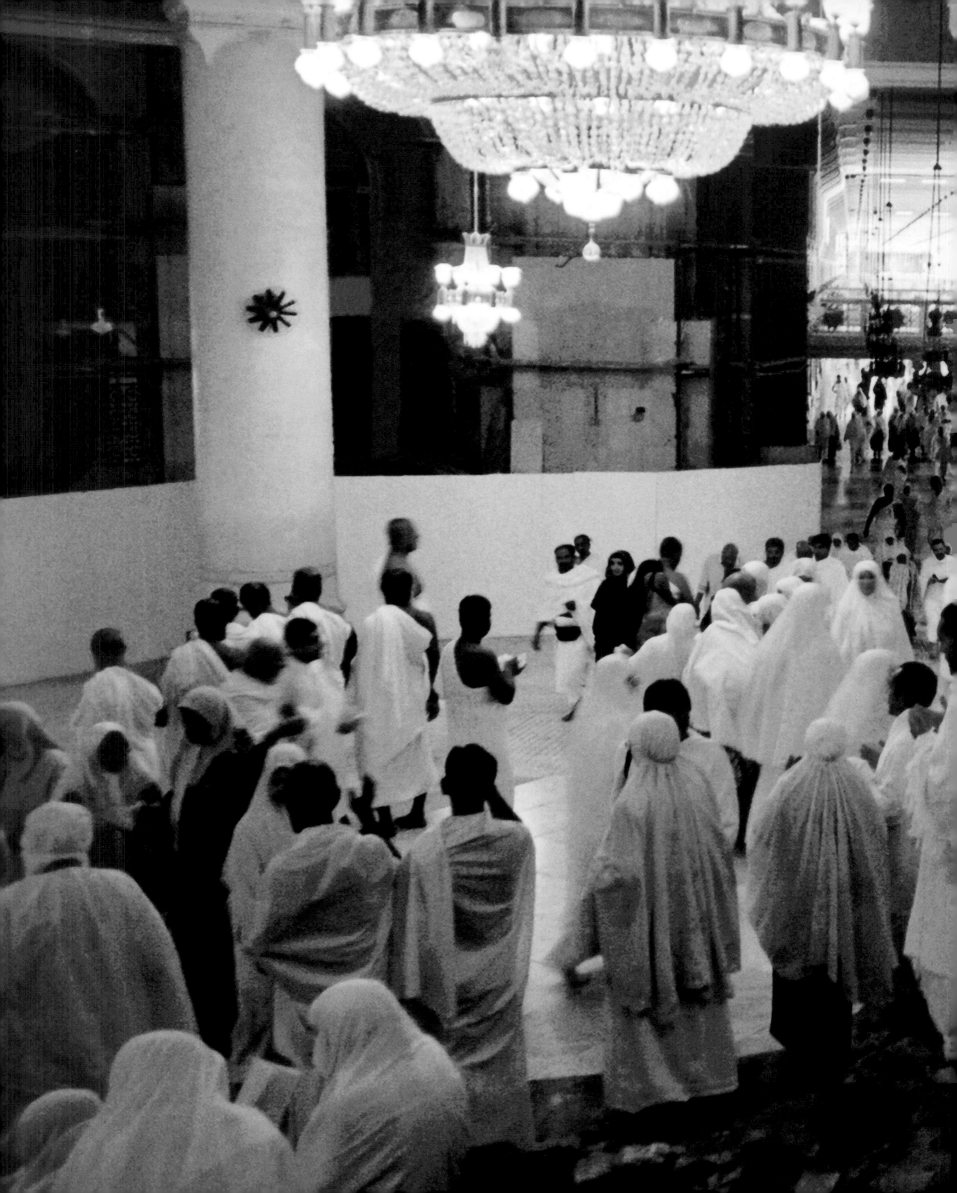

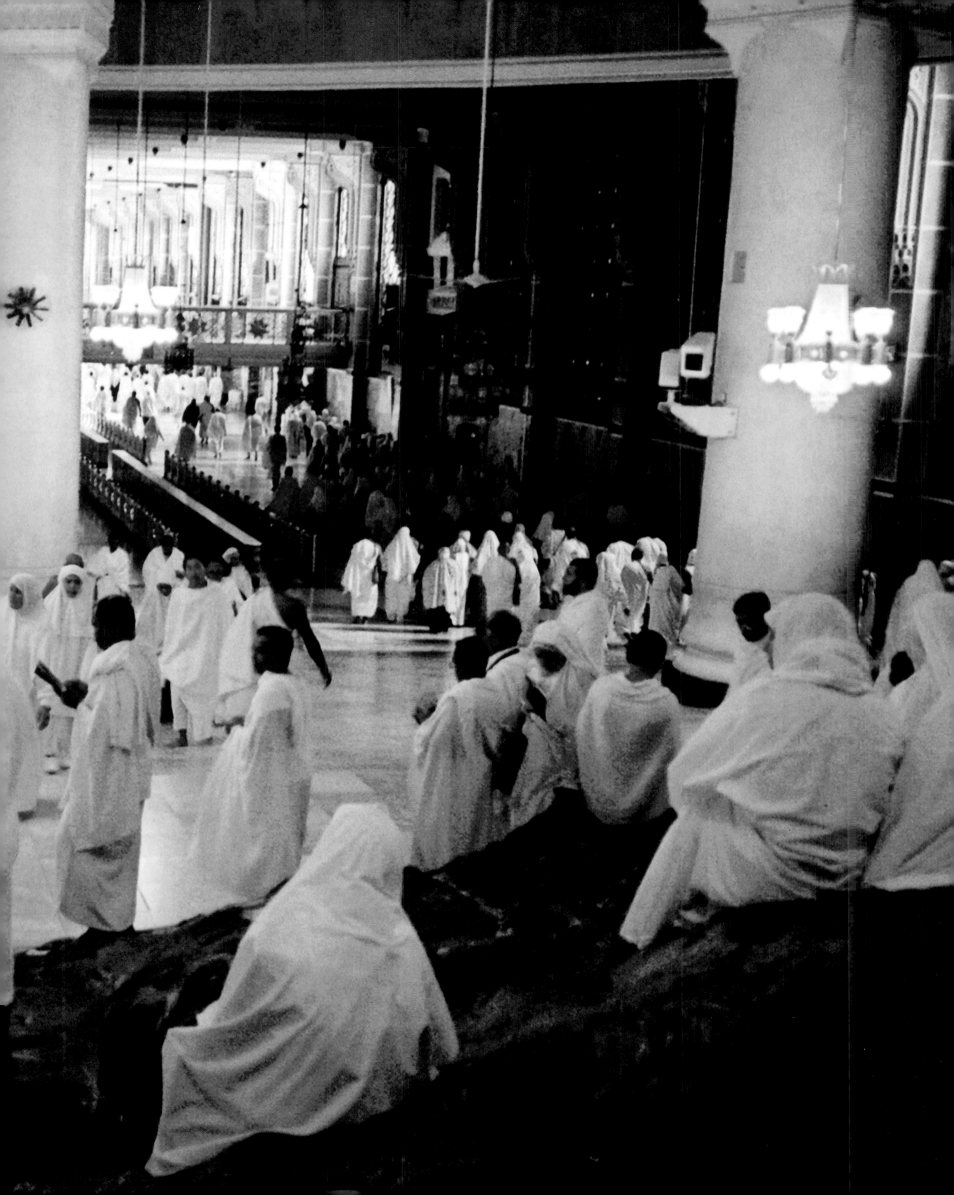

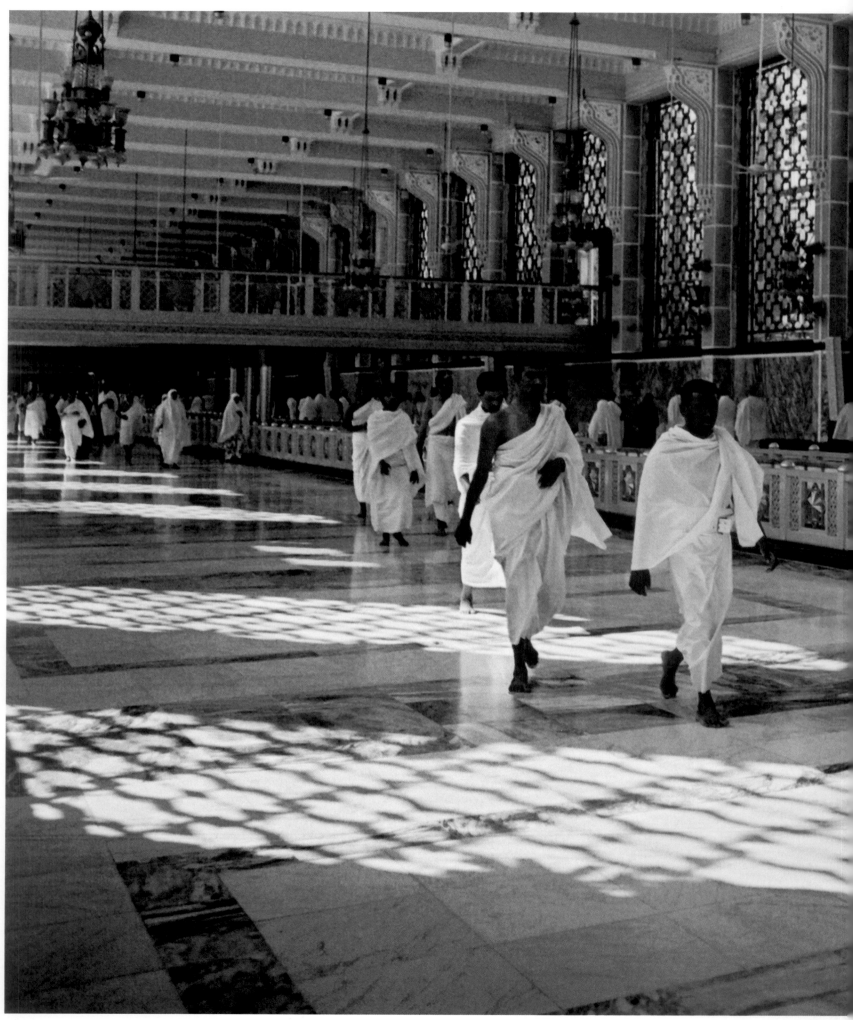

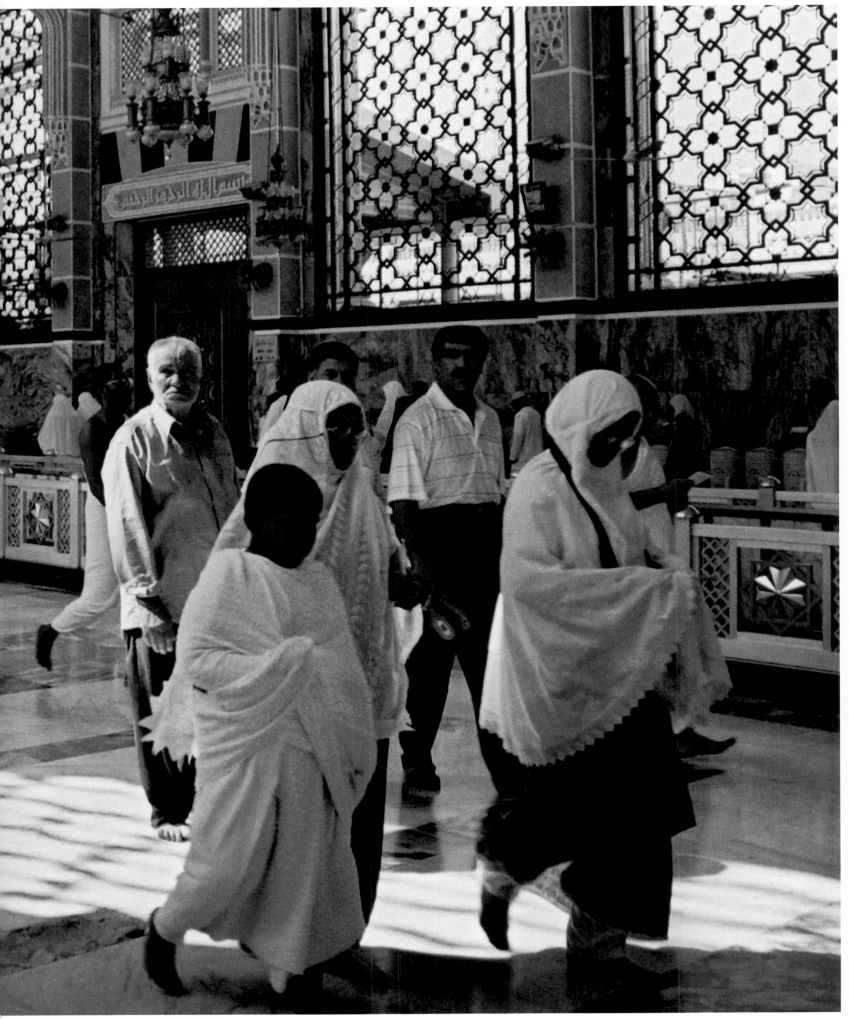

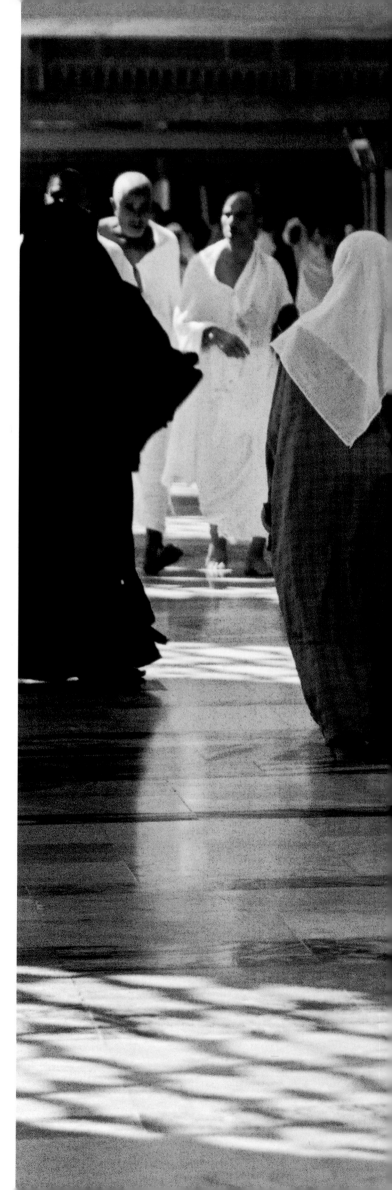

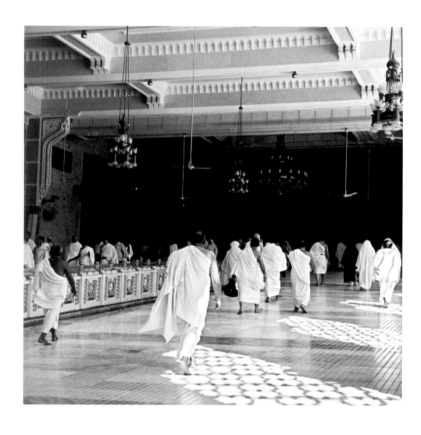

 erforming the *sa'y* between Safa and Marwa, pilgrims experience the same torment that Hagar suffered while searching for water for her son, Ishmael. A believer must empathize with her anxiety and ecstasy, as well as experience the powerful faith she had in God.

> (The hills of) Safa and Marwa are among the emb-
> lems God has appointed. Hence whoever does the
> hajj to the House or the umra (the minor pilgrima-
> ge), there is no blame on him to run between them.
> And whoever does a good work voluntarily surely
> God is All-Responsive to thankfulness, All-Knowing.
> (Baqara 2:158)

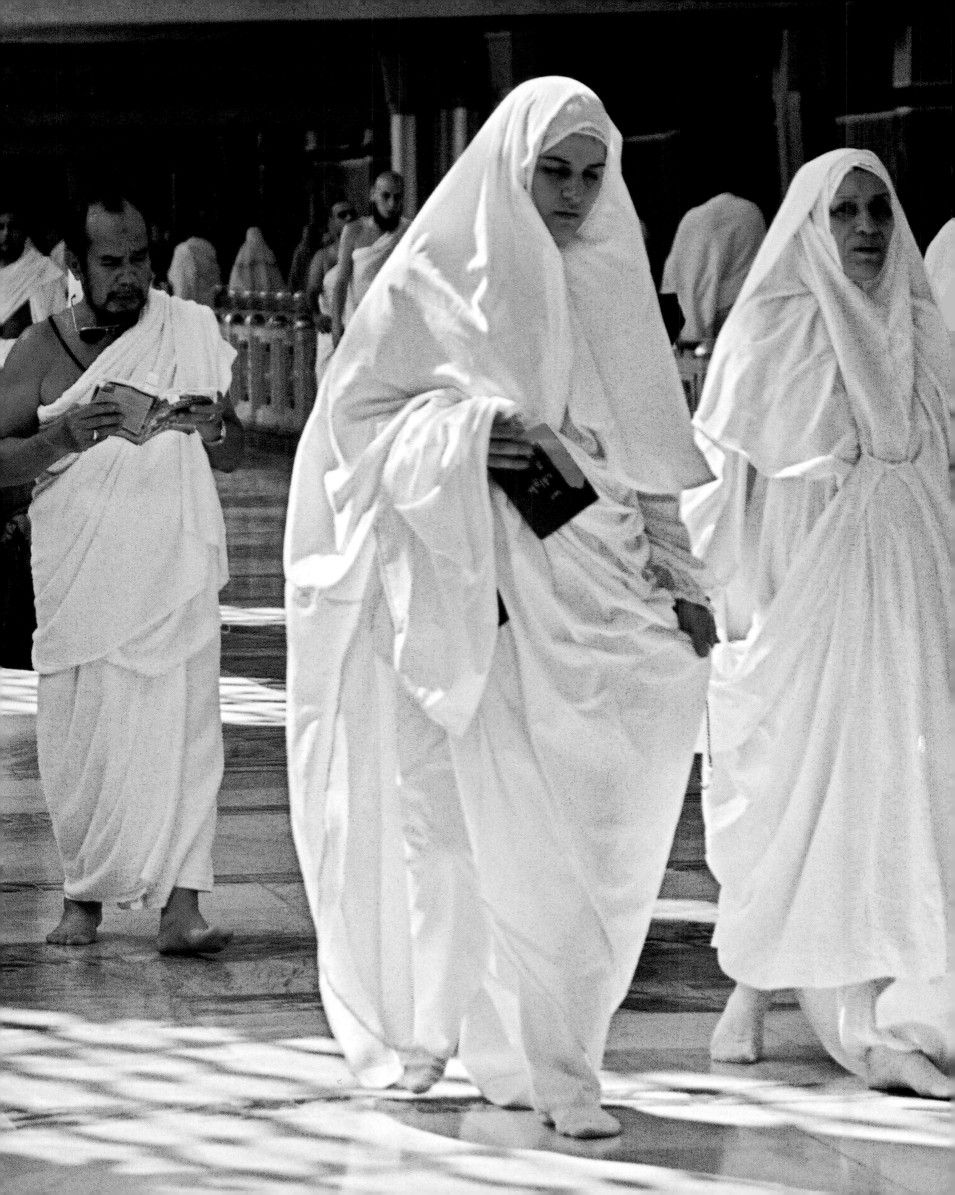

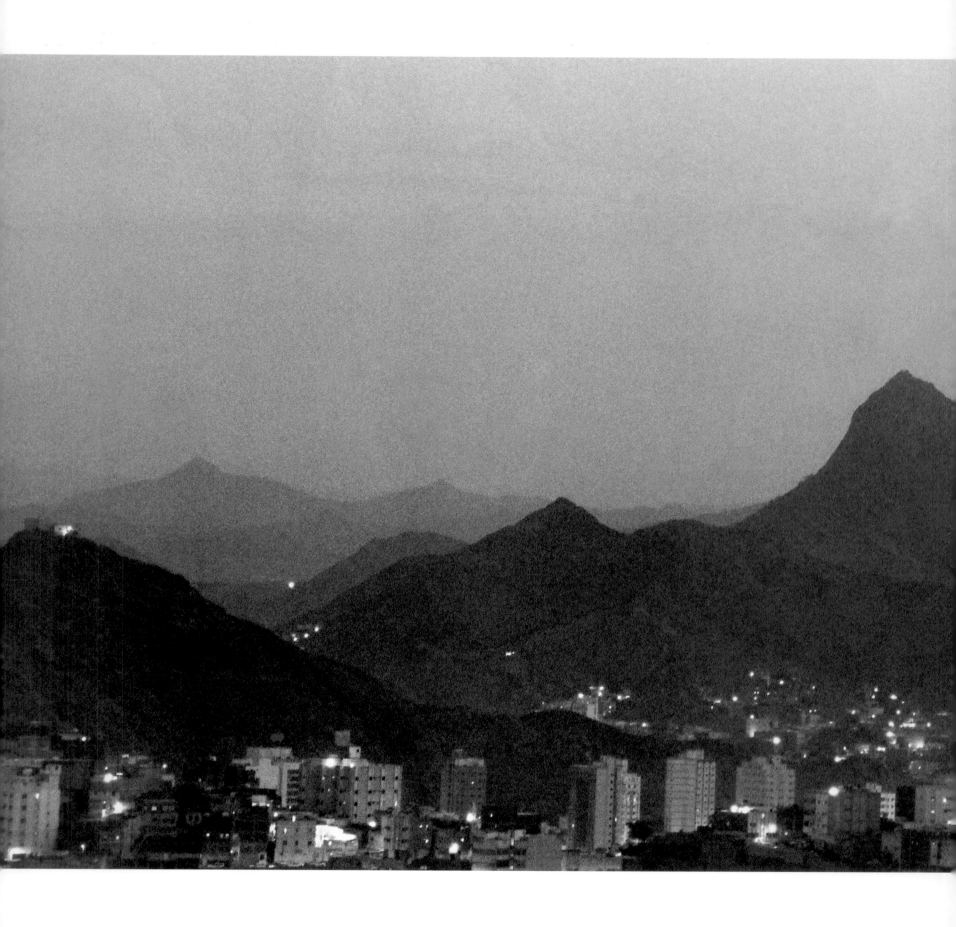

Mount Nur and the Paran mountain range. With the peak sloping slightly toward Mecca, Mount Nur bows to the Ka'ba in humility. In the Age of Ignorance, the Messenger of God, peace and blessings be upon him, would retreat to the Hira cave on this mountain and spend days in prayer there.

(Overleaf) Dawn of Eid al-Fitr (Festival of Ramadan) breaking over Mecca and the Mount Nur in the distance.

115

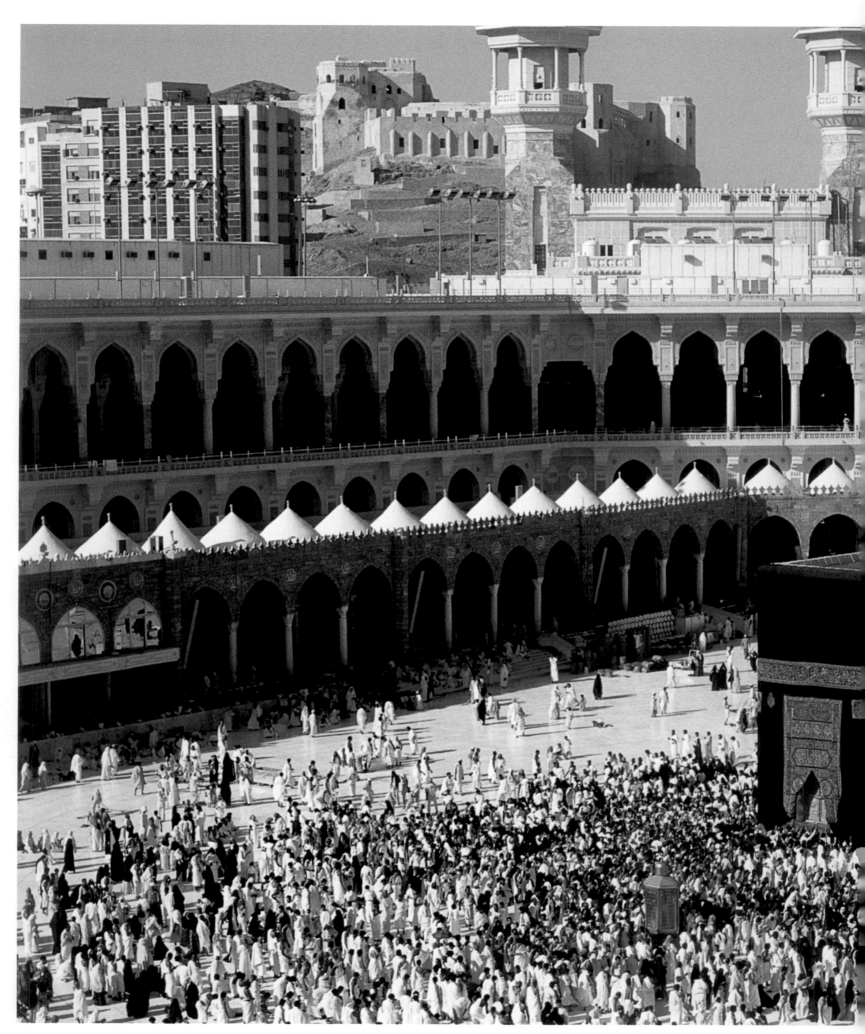

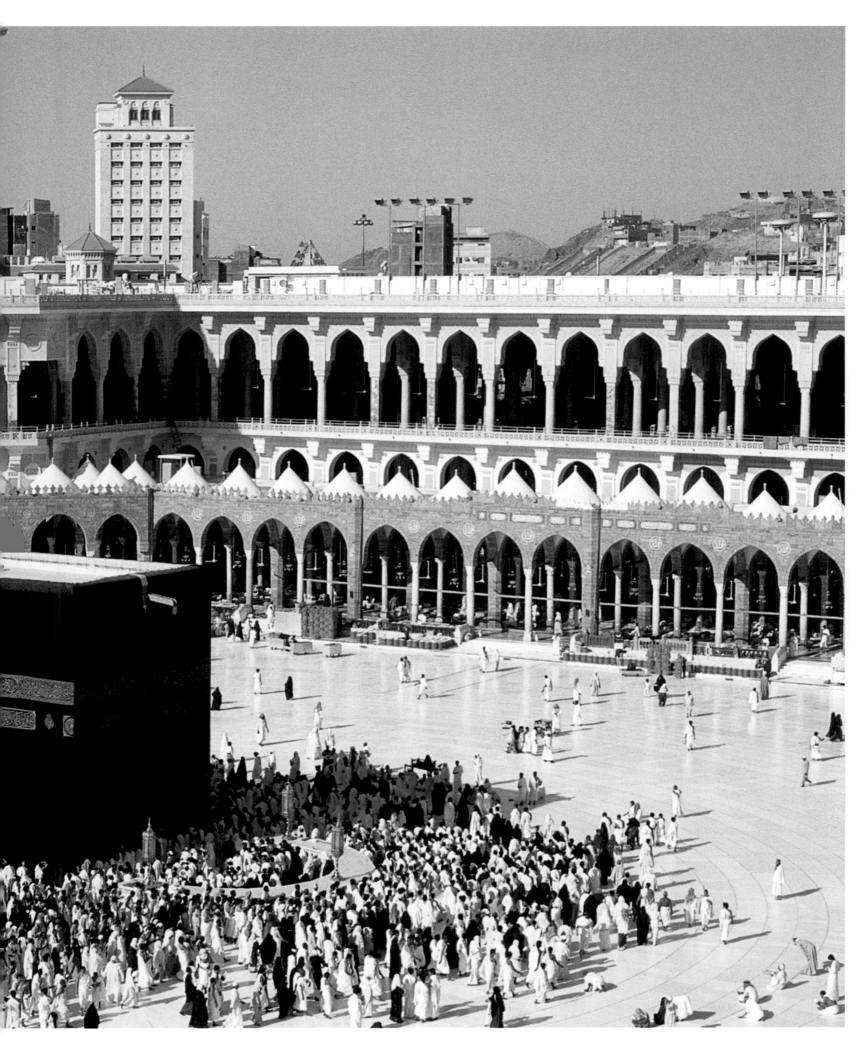

The Ka'ba is in such harmony with the spot where it stands that a prudent observer instantly notices the close connection between this land and its epiphany. It stands as if it has not been built of ordinary substance, but as if it has sprouted from the earth, or, more likely, as if it was constructed by the angels in the heavens and later brought down to earth.

Ajyad (Ecyad) Fortress. Ajyad means "purebred horses" and this name was adopted after Asad al-Himyari, a ruler of Yemen in the sixth-century, camped here with his army when he came to cover the Ka'ba. Ajyad fortress was built by the Ottomans in eighteenth century. It was demolished in 2002.

A spider web, like this one, at the mouth of the cave was one of the miracles that helped save the Prophet and his loyal companion from the evil of the pagans.

he plan and mission were vast and celestial . . . the distance between departure and arrival is merciless . . . all along the way numerous devils and ghouls await. Evil feelings burn in passion, there is the fire of mischief at every curve . . . Despite all such unfavorable circumstances he had in his tongue and heart "God is sufficient for us; how excellent a Guardian He is!" the powerful source of hope, confidence, and consolation. He relied on God, abided by His assistance, and set off for this long journey. He walked without looking back and without abandoning those he left behind . . .

Mount Thawr. Situated about five km (three miles) southeast of Mecca, Thawr accommodates the cave in which the Messenger of God, peace and blessings be upon him, and Abu Bakr took refuge during the Emigration. As a precaution, the Blessed Prophet waited in this cave, which is located high above on Mount Thawr, on the opposite side from Medina.

Thawr hill ▶

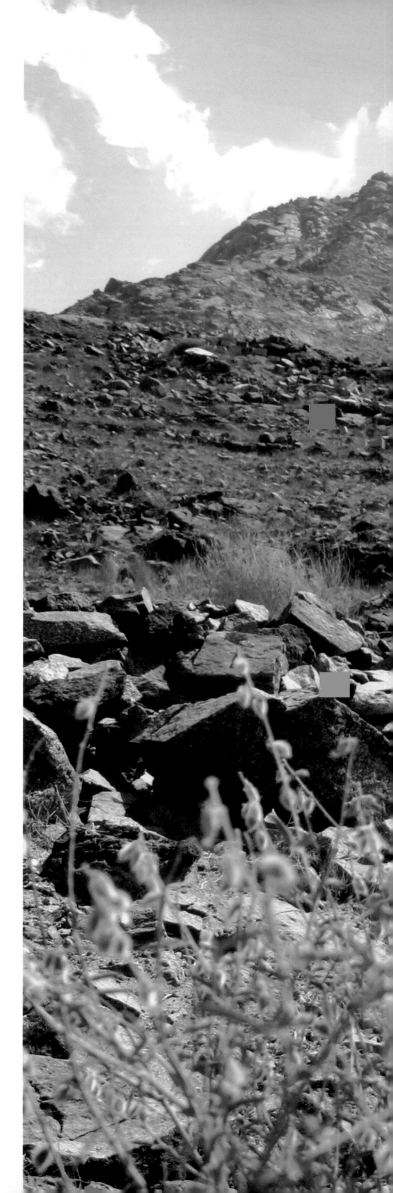

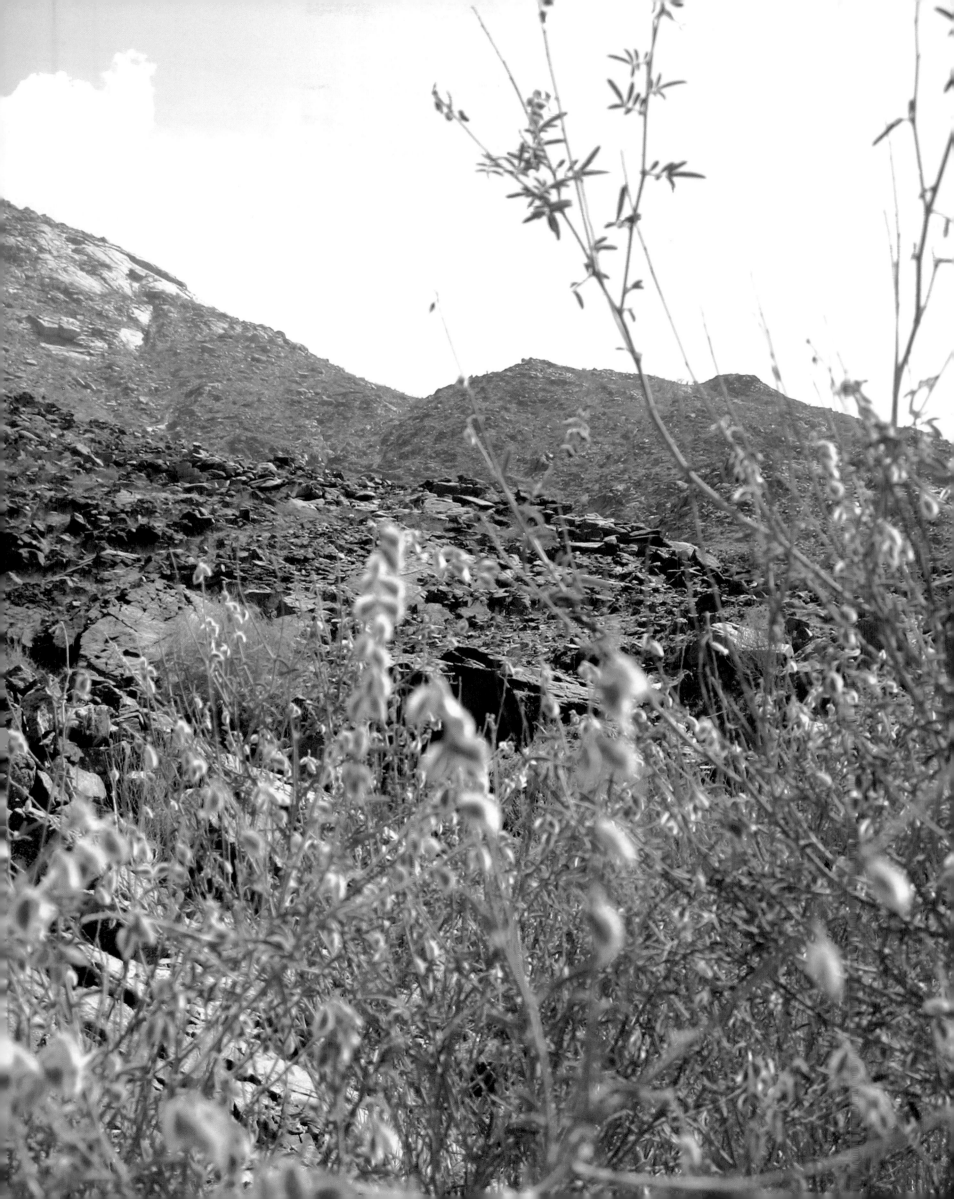

On the Way to Arafat

A s we prepare ourselves in Mina for our souls to soar, Arafat is being decorated, like a bridal suite. It opens its gates for the visitors-to-come, who will ascend to the beyond from here. It waits for the guests of the Almighty, who rush with a longing for reunion. Arafat is an exceptional place with its luminosity and the profound time that is experienced therein; fortunate souls blessed with being in this sanctuary once will never suffer absolute ruin nor will they die a profane death. A few hours spent on Arafat make the observant Muslims blossom like roses all through their lives never to wither. Each and every moment spent in its compassionate and love-soaked ambiance radiates on the eyes of our heart like the first rays of the morning sun. The silent or outspoken cries of those sharpened with love resound, singing like nightingales here and there on Arafat, revealing their faith and wisdom that is honeycombed in the most sacred corner of their hearts, echoing in our ears and stimulating our hearts to long for the beyond.

For the soul to become refined and attain a level of saintliness every one should "become" Arafat; they should be present there and inhale its sunrise and sunset at least once in a lifetime. Arafat is the stage for the sincerest of all prayers, invocations, and the expulsion of whatever is secreted in the breast. In the afternoon of the Arafat, voices shake with a tone instilled by the approaching departure time, with humbled but deeper feelings, and with the purity of the heavenly screams of the angels.

The pilgrims feel younger; they feel eternal as if they have been stretched with the tenderness, compassion, and hope that is heard on Arafat. The darkened horizon at sunset calls for a farewell as our hopes materialize and pour into our souls; our minds are brightened with the blessings of Arafat and we are freed of our molds as we melt with the setting sun. We are now lighter than the birds, we have now been transformed into a spiritual state and we are stunned to see what has become of us.

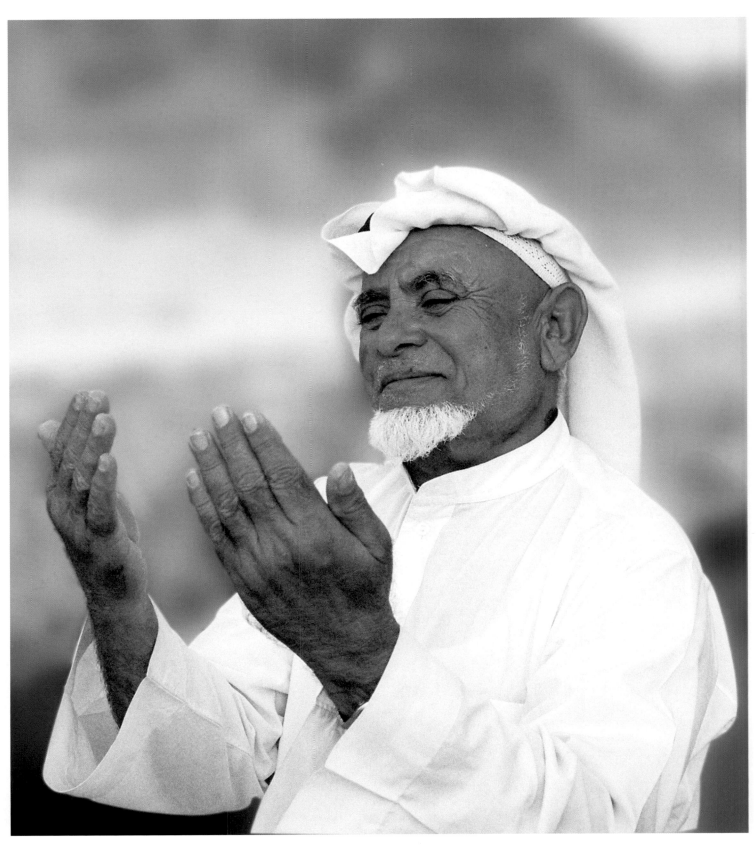

O the Lord of the heavens and the earth . . . O God who created out of nothing and who will return everything to its original form . . .

I am embarrassed to open my hands to You; but there is none other to whom I can turn.

There is no other to whose door I can go, to whom I can implore, or cry. Forgive me O Merciful One.

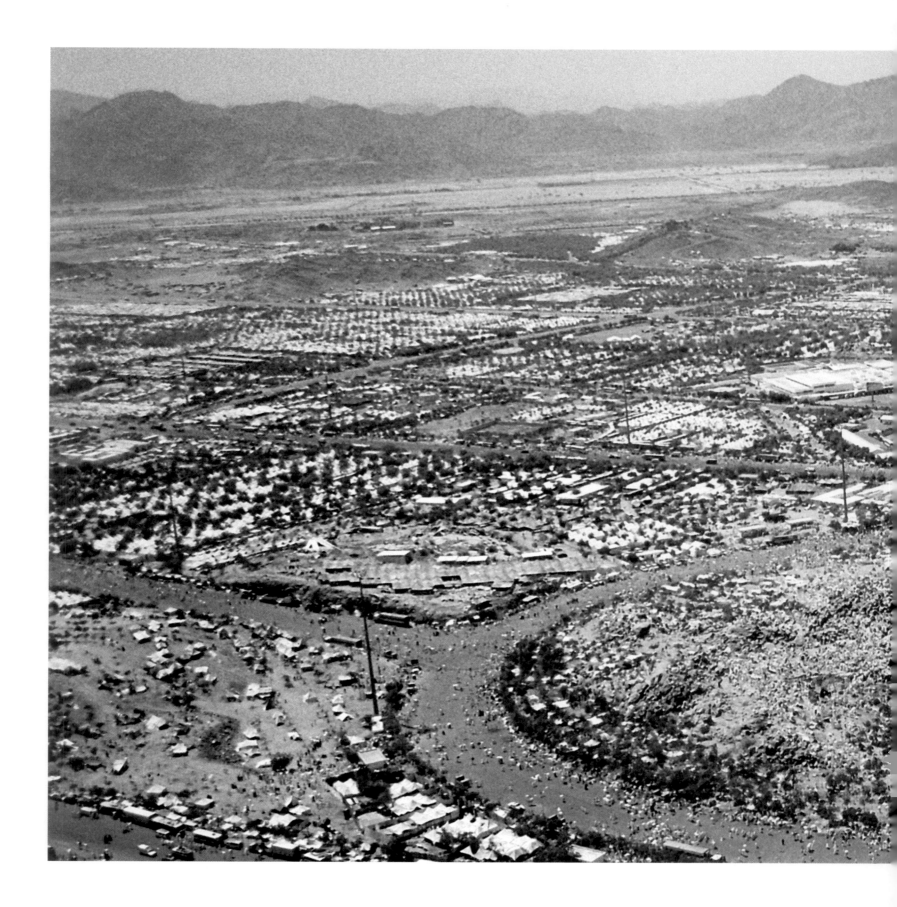

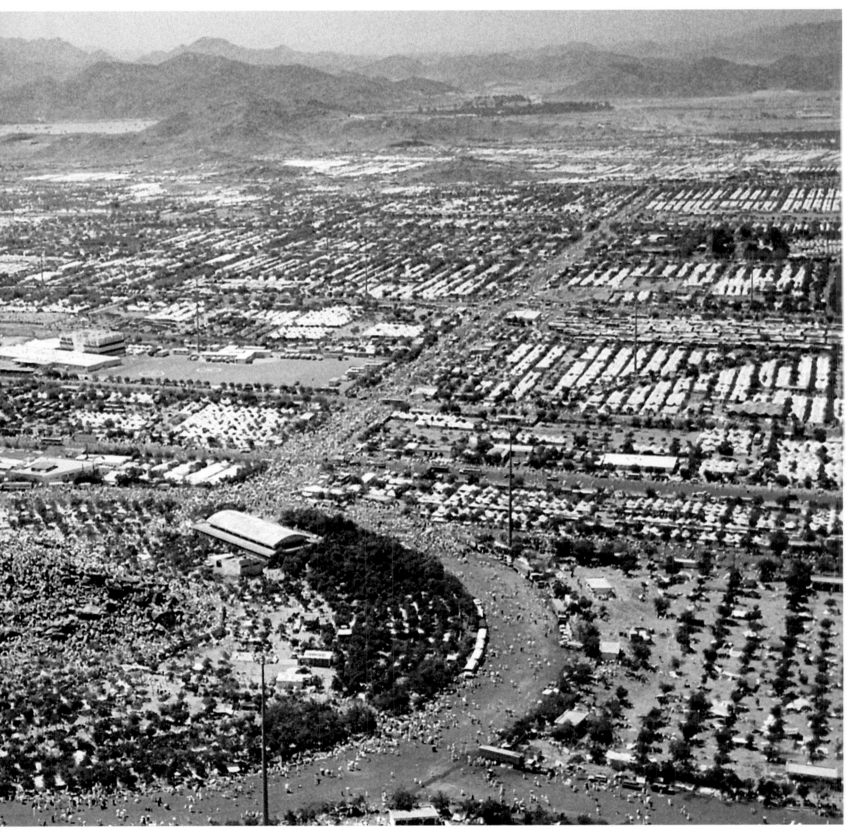

The place where one can draw nearest to the Lord of all Worlds.
The heart of the Hajj beats here. The sincerest supplications are invoked here . . . and sins are forgiven here.

 lover of the Truth, who had set off from northern India on foot, and passed through Pakistan, Iran, Iraq, Jordan, and Jerusalem, finally reaching Arabia. He refused the King's offer of a return plane ticket and took the same road back home.

Publicly proclaim the (duty of) Pilgrimage for all humankind, that they come to you on foot and on lean camels, coming from every far-away point. (Hajj 22:27)

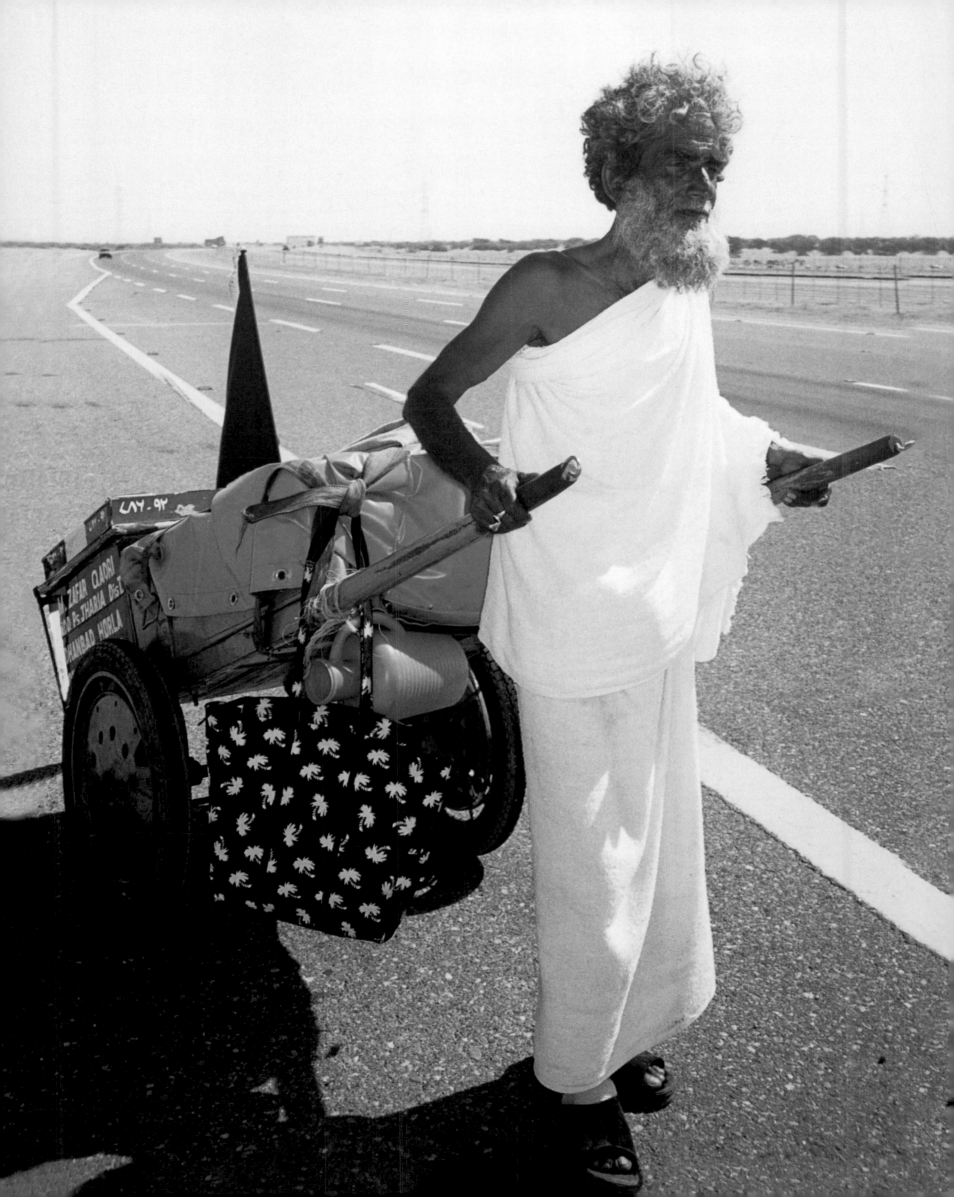

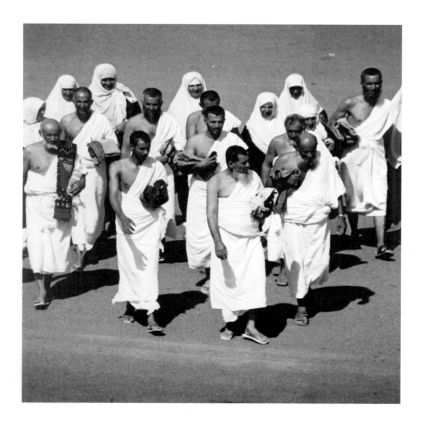

eople who have been stripped of all that is worldly stroll along this plain, concerned with the trial and the Judgment, and hopeful for the Mercy. Aspiring to forgiveness and salvation, they spend the day in such a way that they can be blessed with a balance worthy of many long years.

When you press on in multitude from Arafat, mention God at Mash'ar al-Haram. (Baqara 2:198)

(Overleaf) The noon (zuhr) and afternoon prayers (asr) are combined on Arafat and every moment is spent in prayer and remembrance.

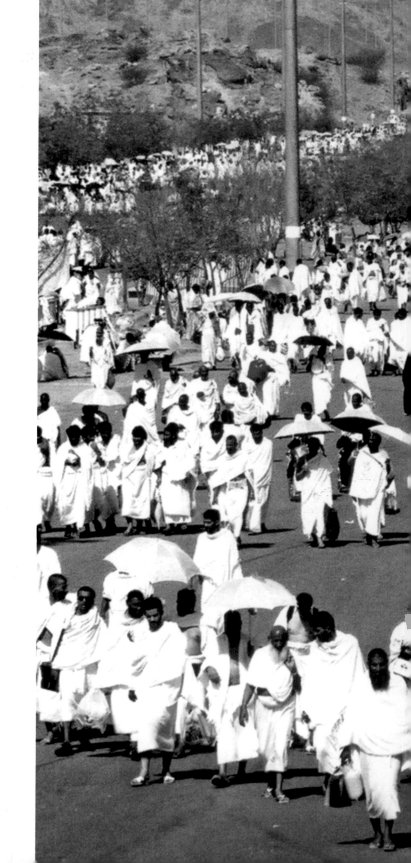

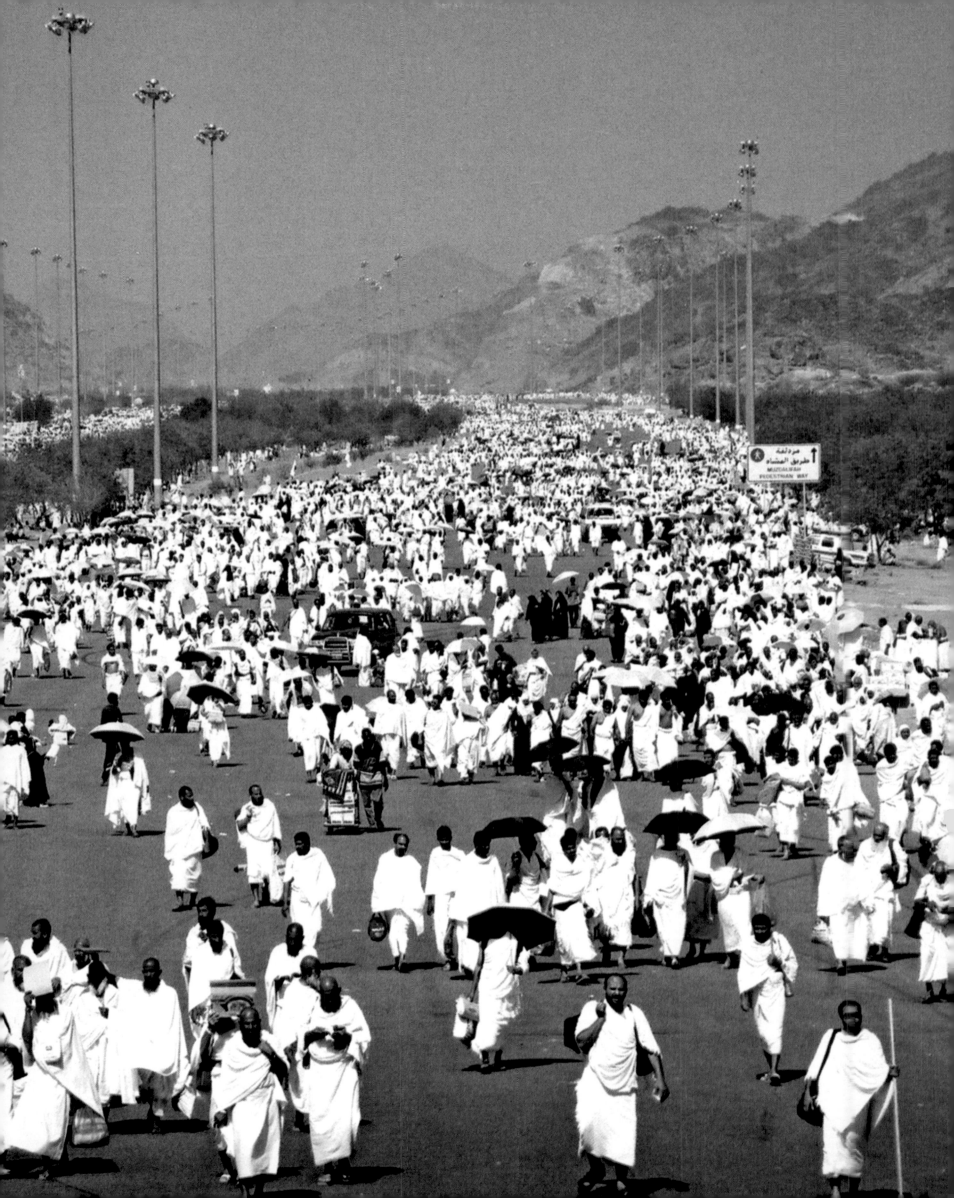

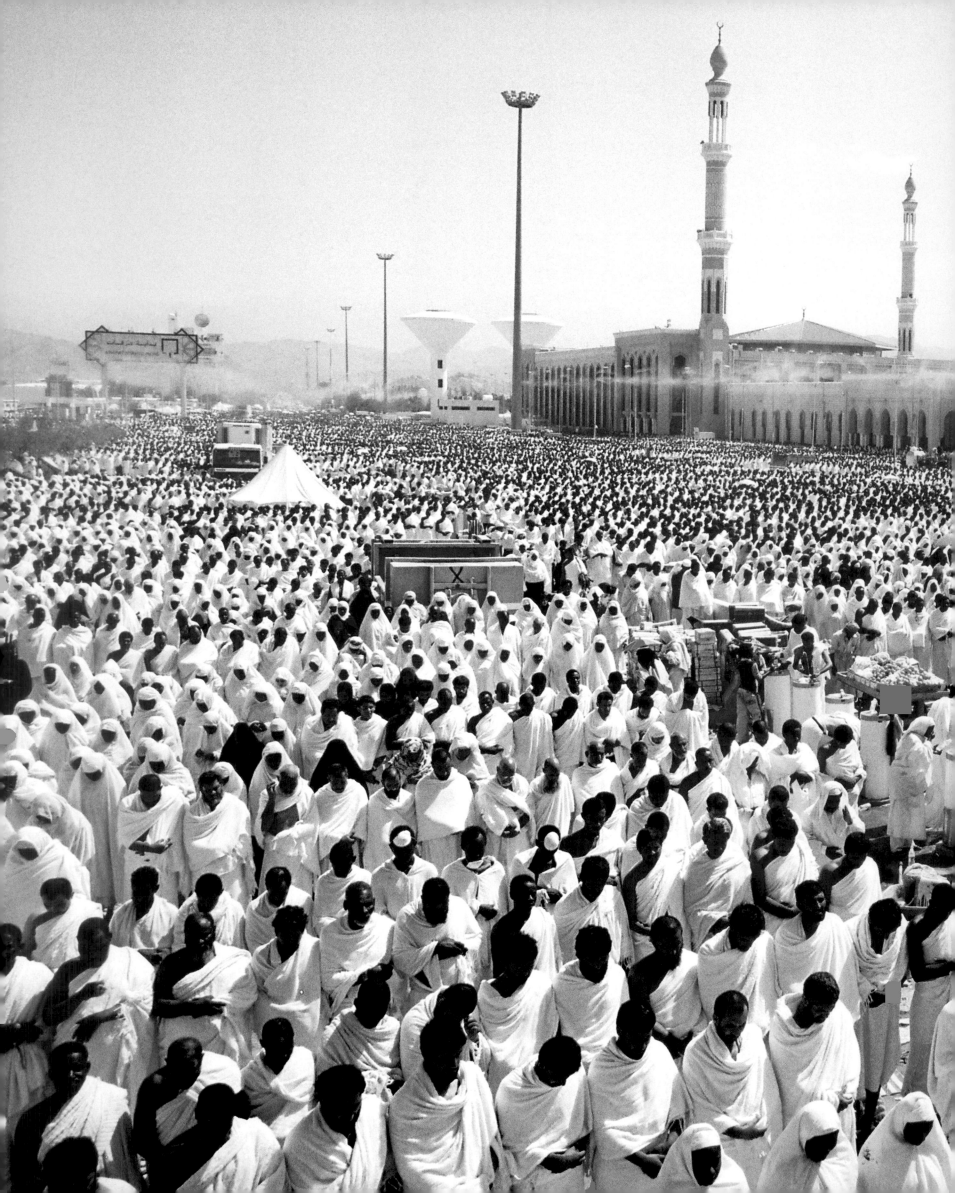

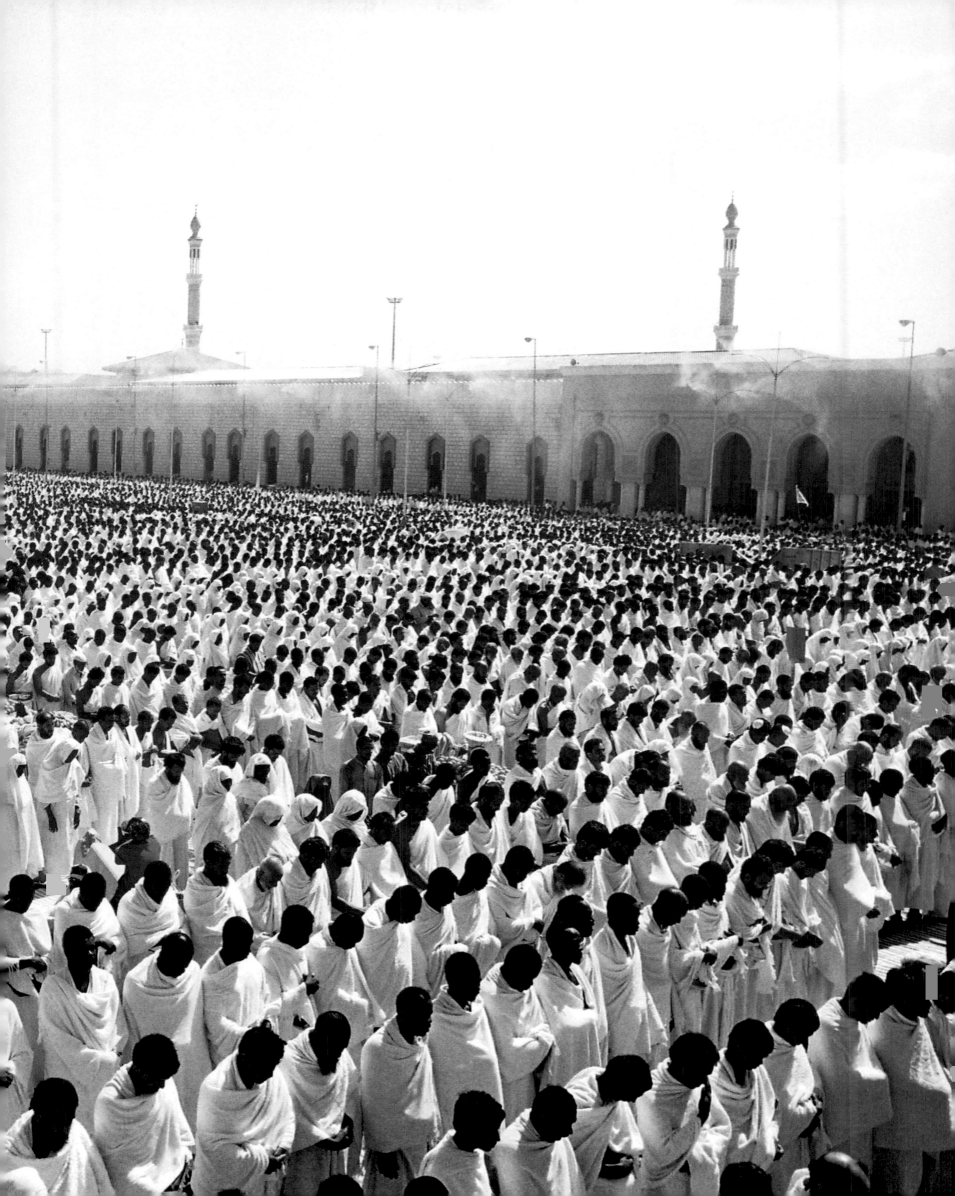

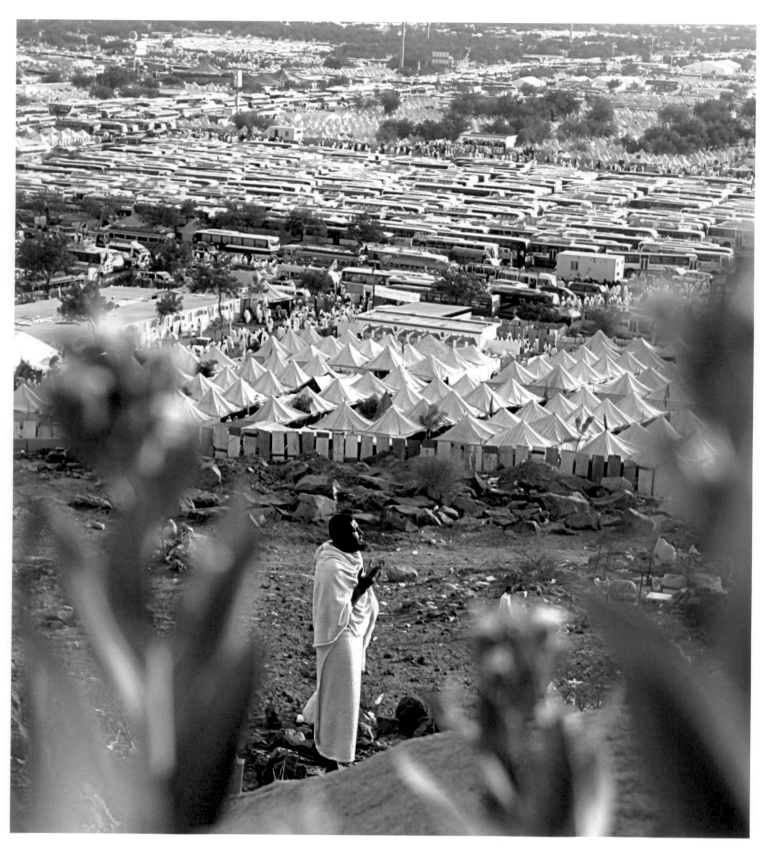

A few hours spent on Arafat make the observant Muslims blossom like roses all through their lives never to wither.

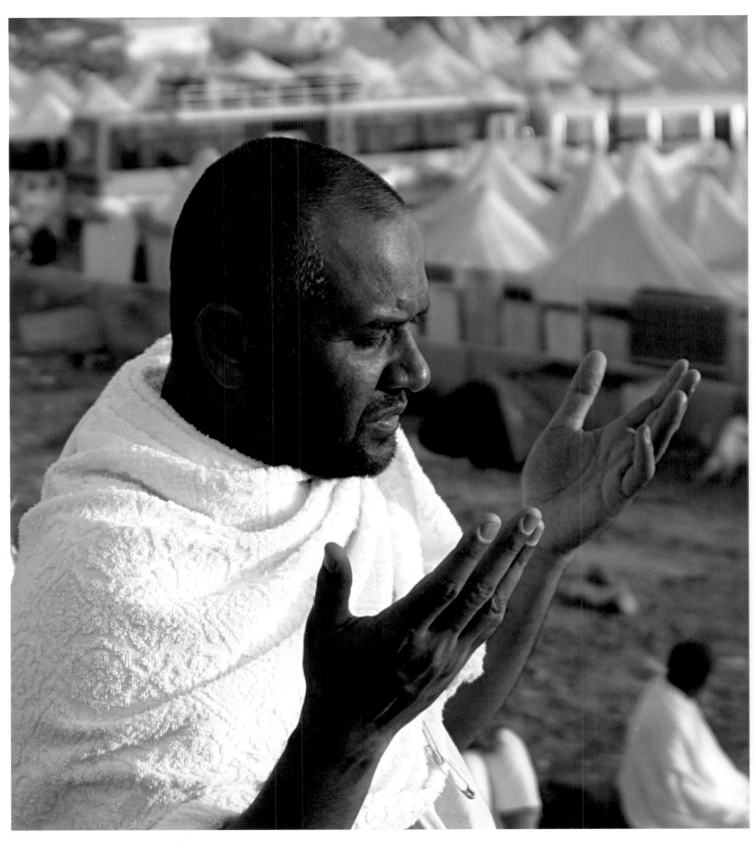

Each and every moment spent in its compassionate and love-filled ambiance radiates
on the eyes of our heart like the first rays of the morning sun.

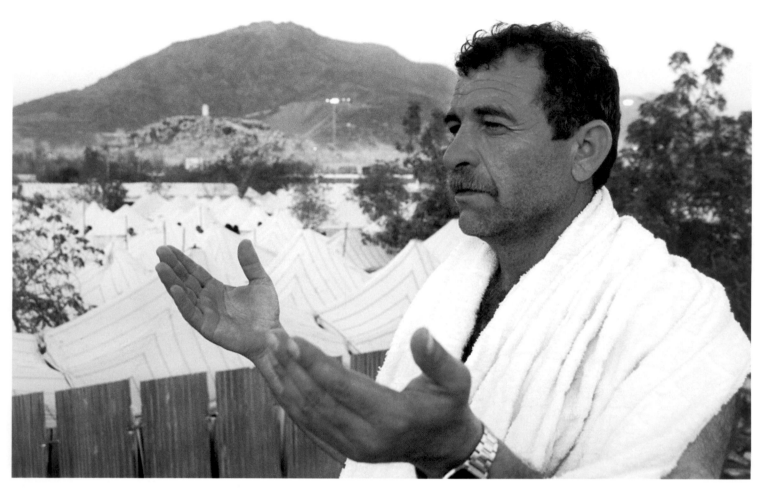

Hands opened to peace, all veiling causes are left behind . . .

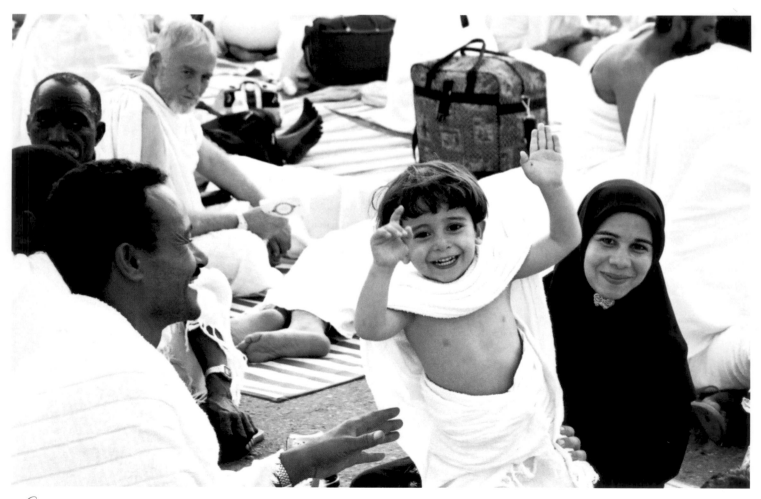

He smiles and makes other smile . . . he is dancing from joy . . . the center of attraction, a joyful young pilgrim.

One from the West (Britain) and the other from the East (Japan) send smiles from Arafat . . .

Pilgrims are in constant prayer, reciting, and reflection during the Hajj.

137

(Overleaf) Arafat in the '80s.

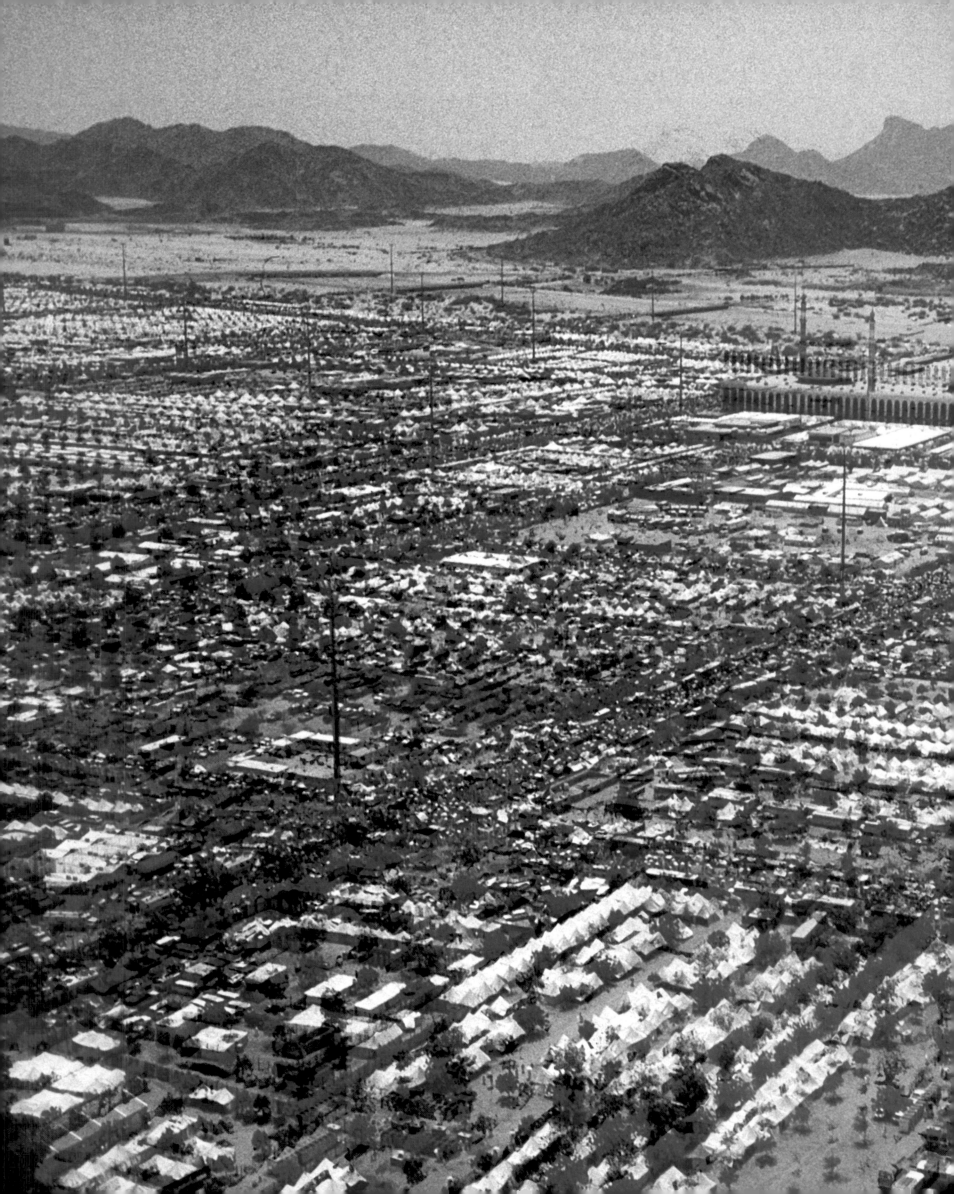

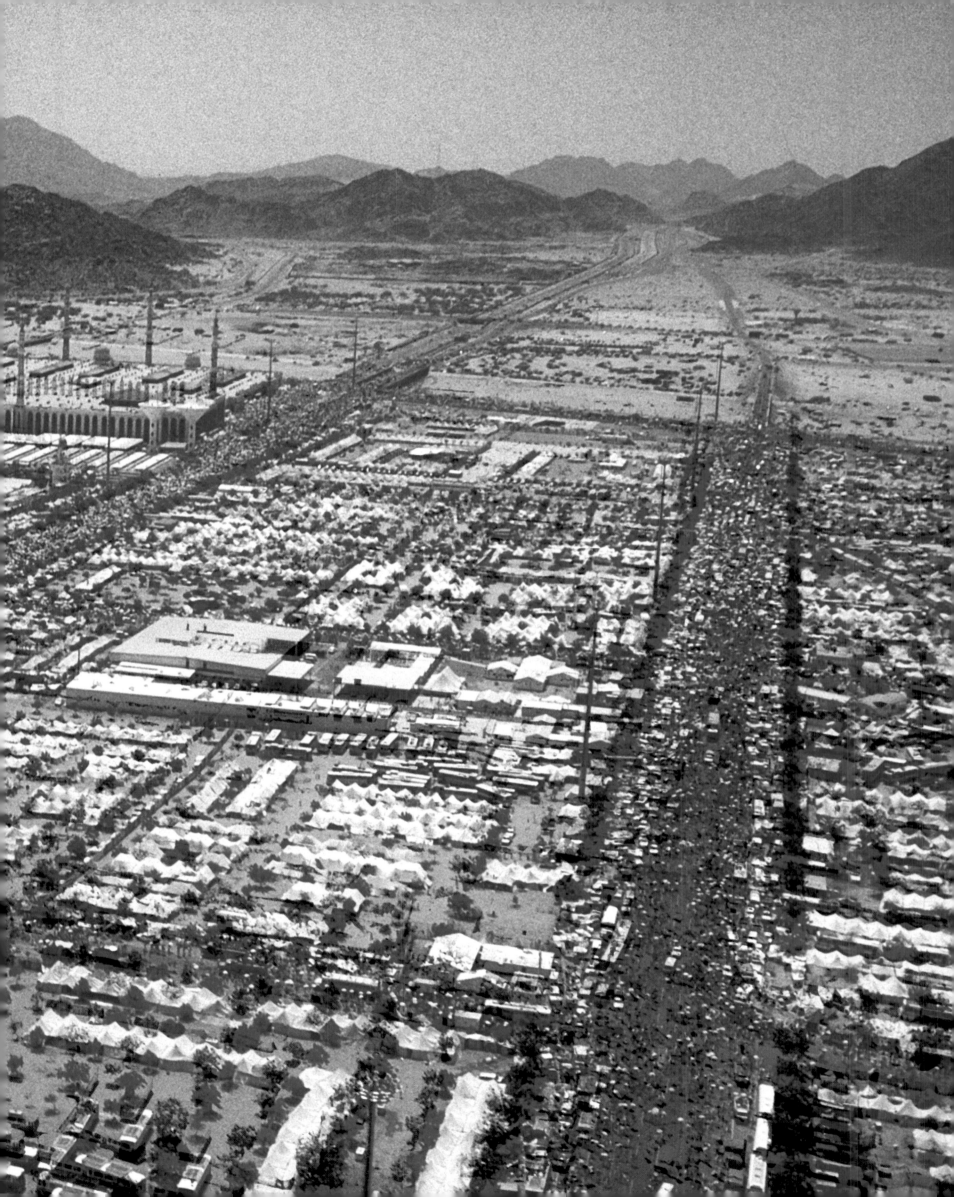

Arafat, the great venue of Adam and Eve, where prayers meet the Lord of the heavens and the earth.

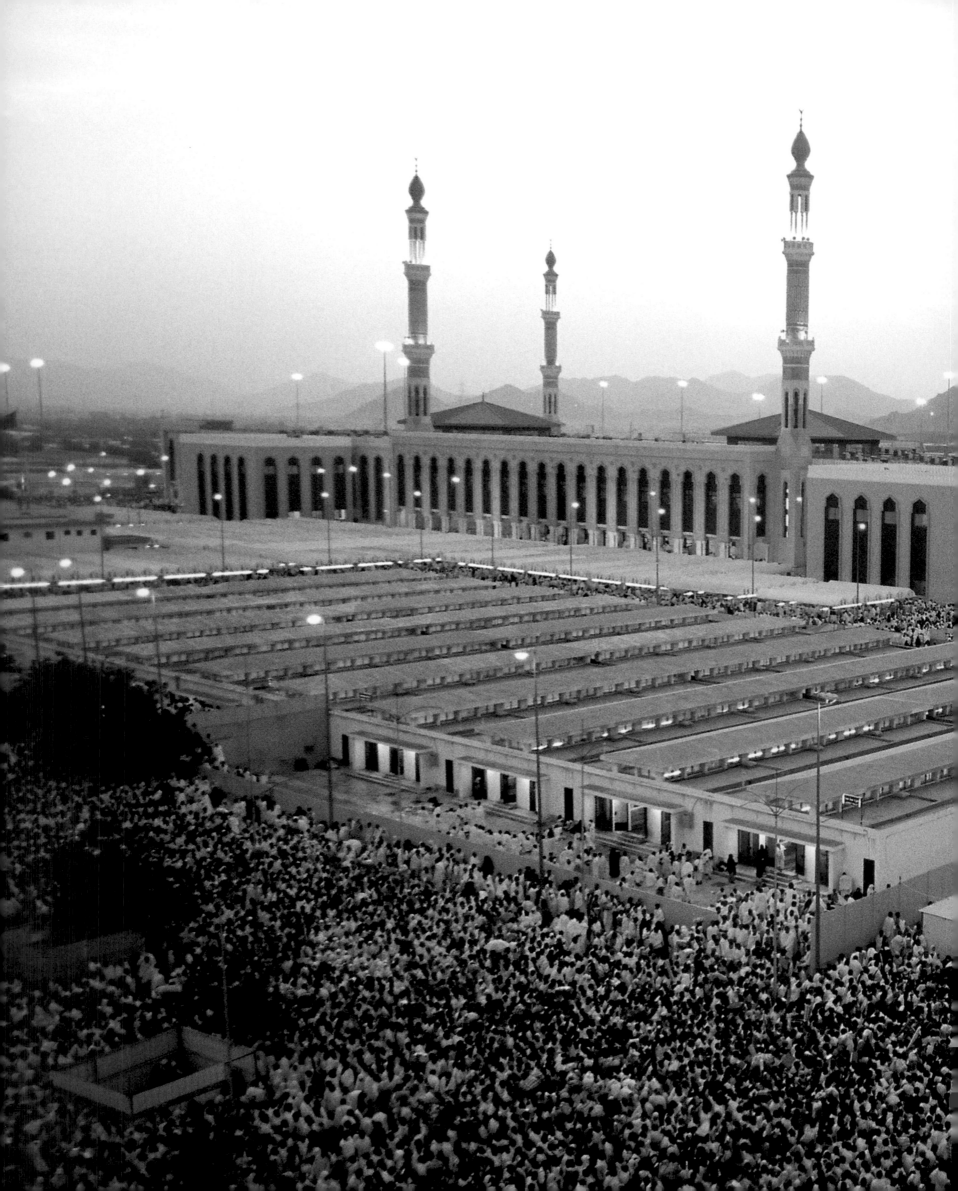

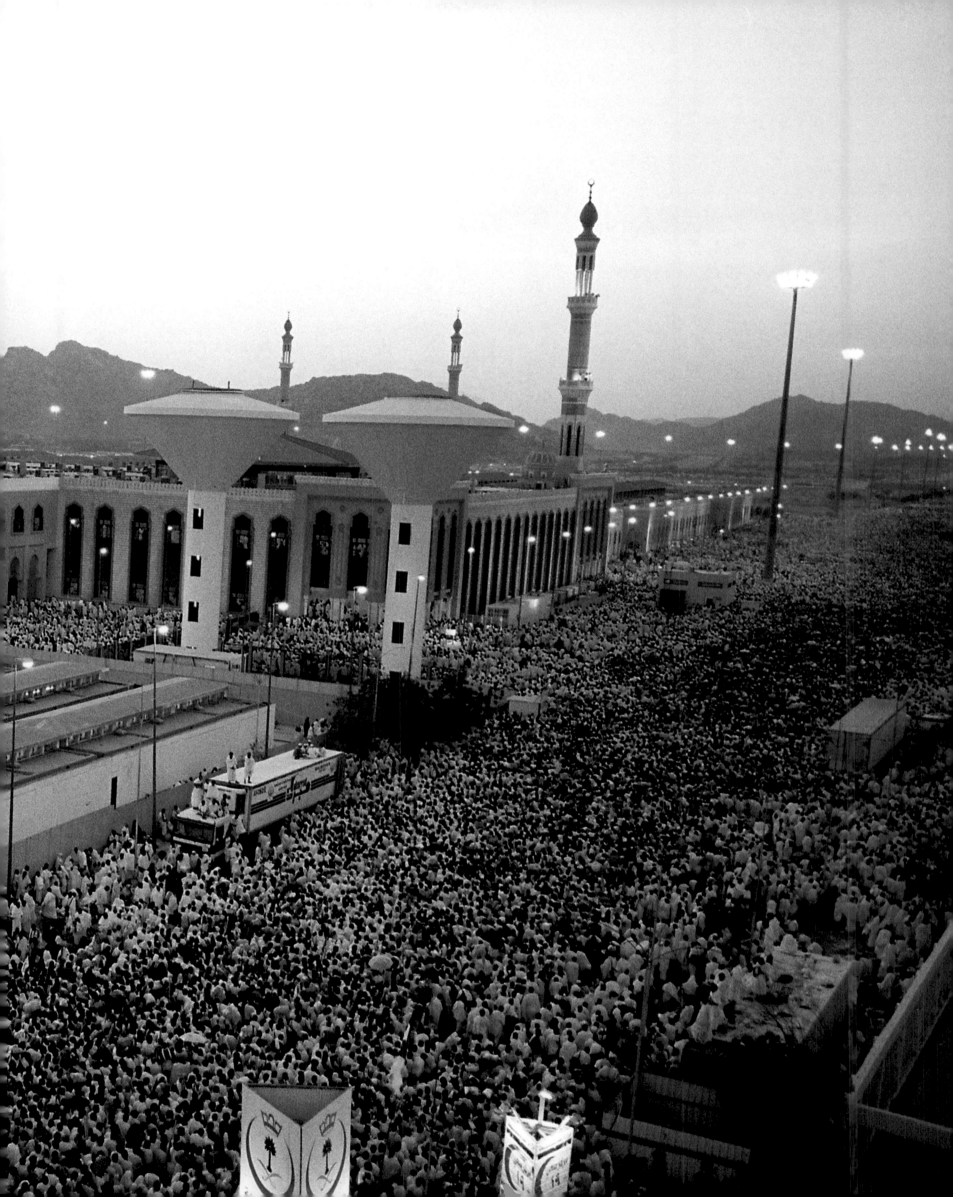

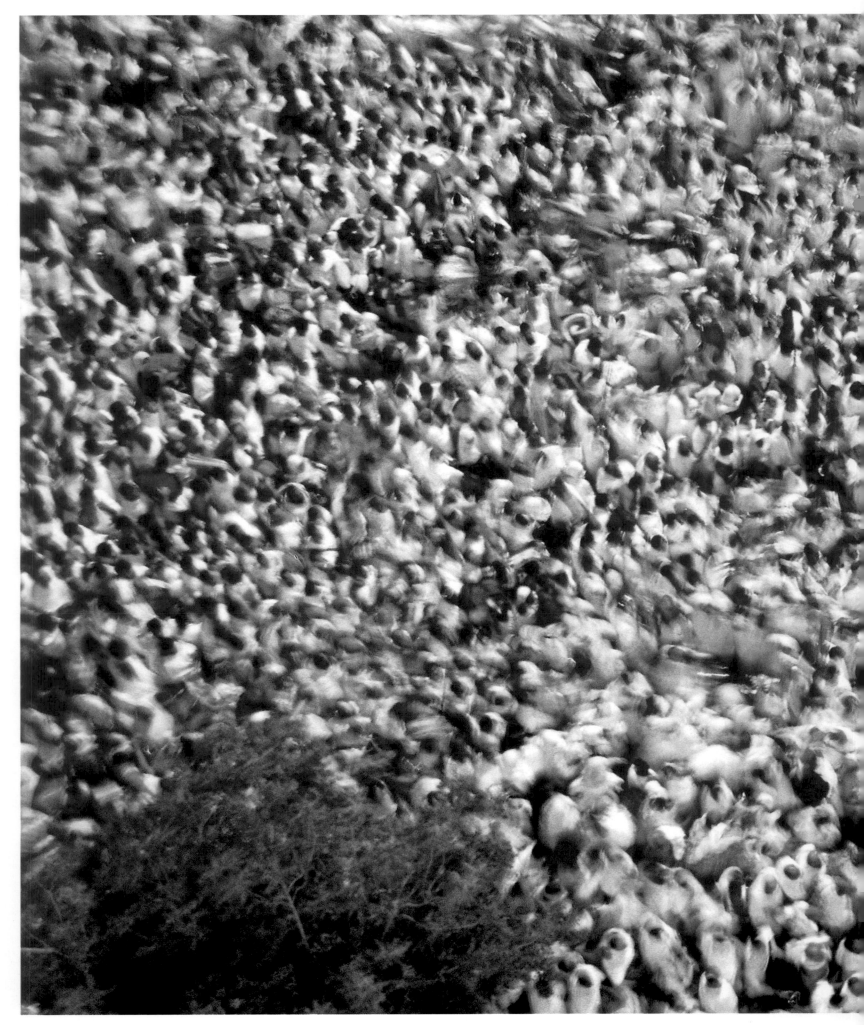

144

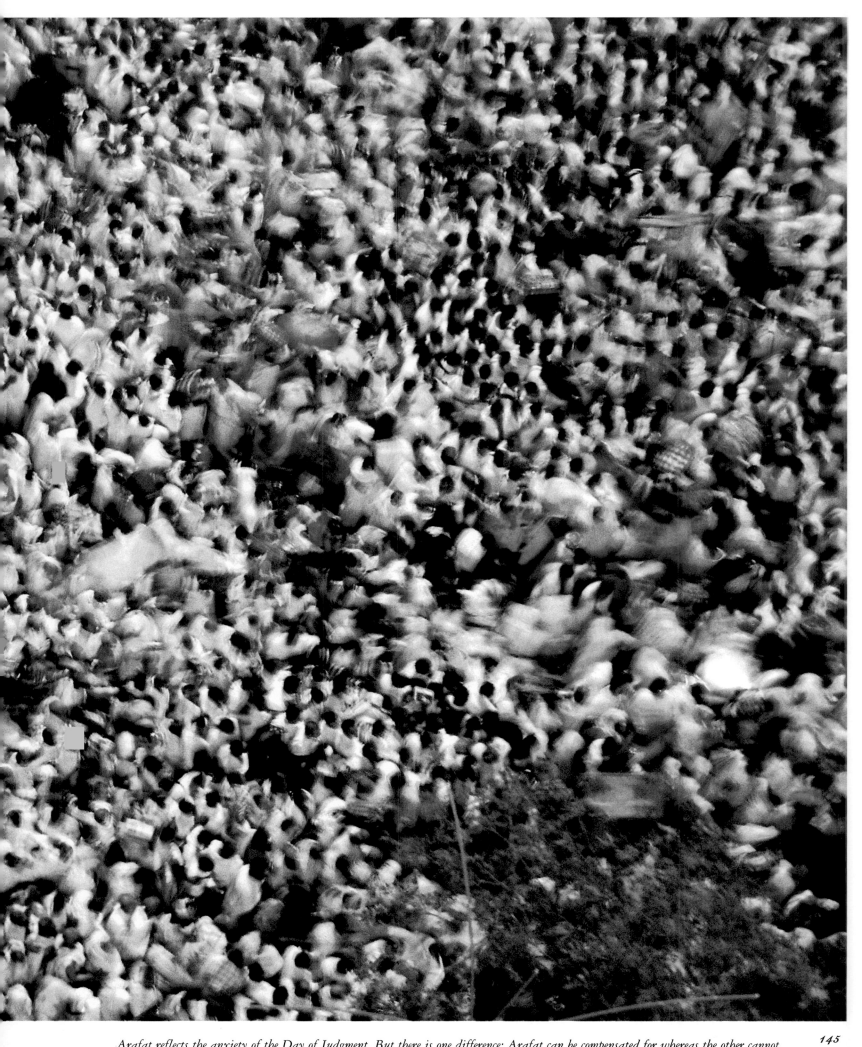

Arafat reflects the anxiety of the Day of Judgment. But there is one difference: Arafat can be compensated for whereas the other cannot.

(Overleaf) As the day draws to an end, the torrents of pilgrims on Arafat turn their direction to Muzdalifa.

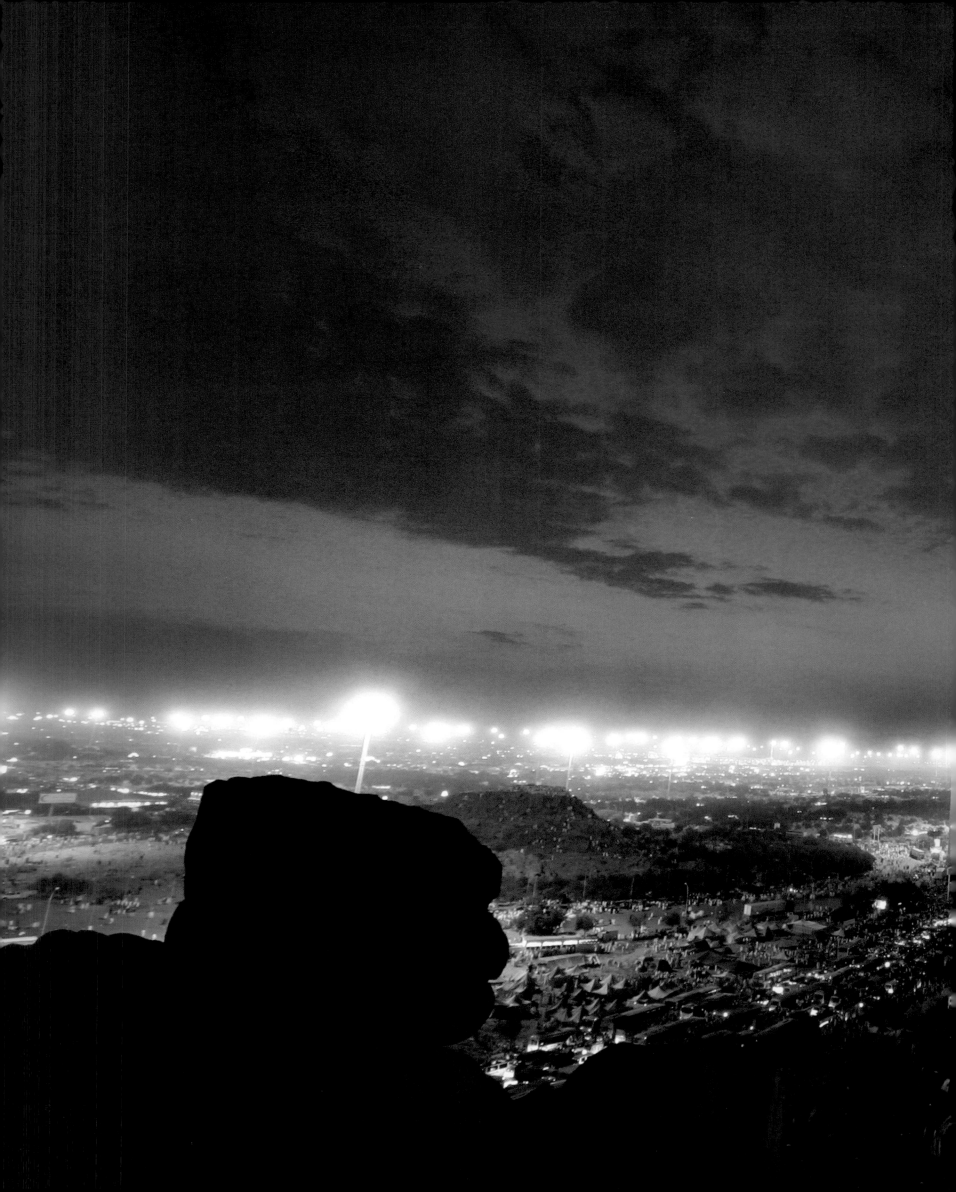

Moving from Arafat to Muzdalifa. Muzdalifa is located between Arafat and Mina, and it is the second stop to camp.

Pilgrims pray and remain for waqfa at Muzdalifa, which God calls Mash'ar al-Haram (Baqara 2:198).
The night is spent there as one of rites of the Hajj, with remembrance and prayers.

A short distance has become a long journey . . . a journey that lasted all night for those who stayed behind.

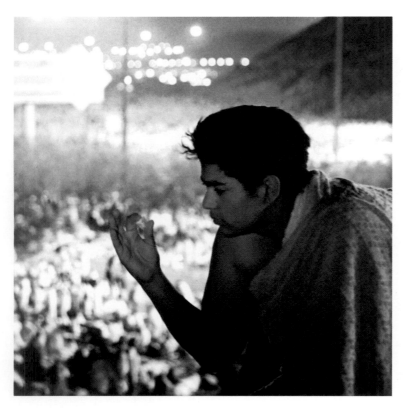

A pilgrim-to-be is carefully selecting his pebbles to throw at Mina.

uzdalifa is only experienced at night. The electric lights that illuminate the plain reflect the luminous faces and rapidly beating chests, adding to its charm. In the depths of the night, some pilgrims take a rest to refresh themselves for the hardships of the coming day, while some others stand vigil in prayer. Nevertheless, their voices are now inside, but at a higher pitch, equal to that of an angel.

(Overleaf) With the first rays of the sun glittering over the earth, the move from Muzdalifa to Mina begins. Each pilgrim carries with him forty-nine pebbles to throw at Satan.

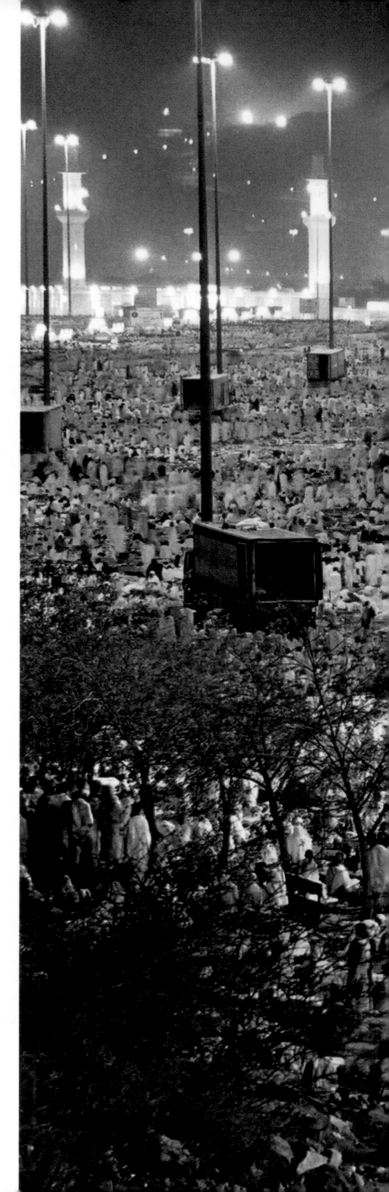

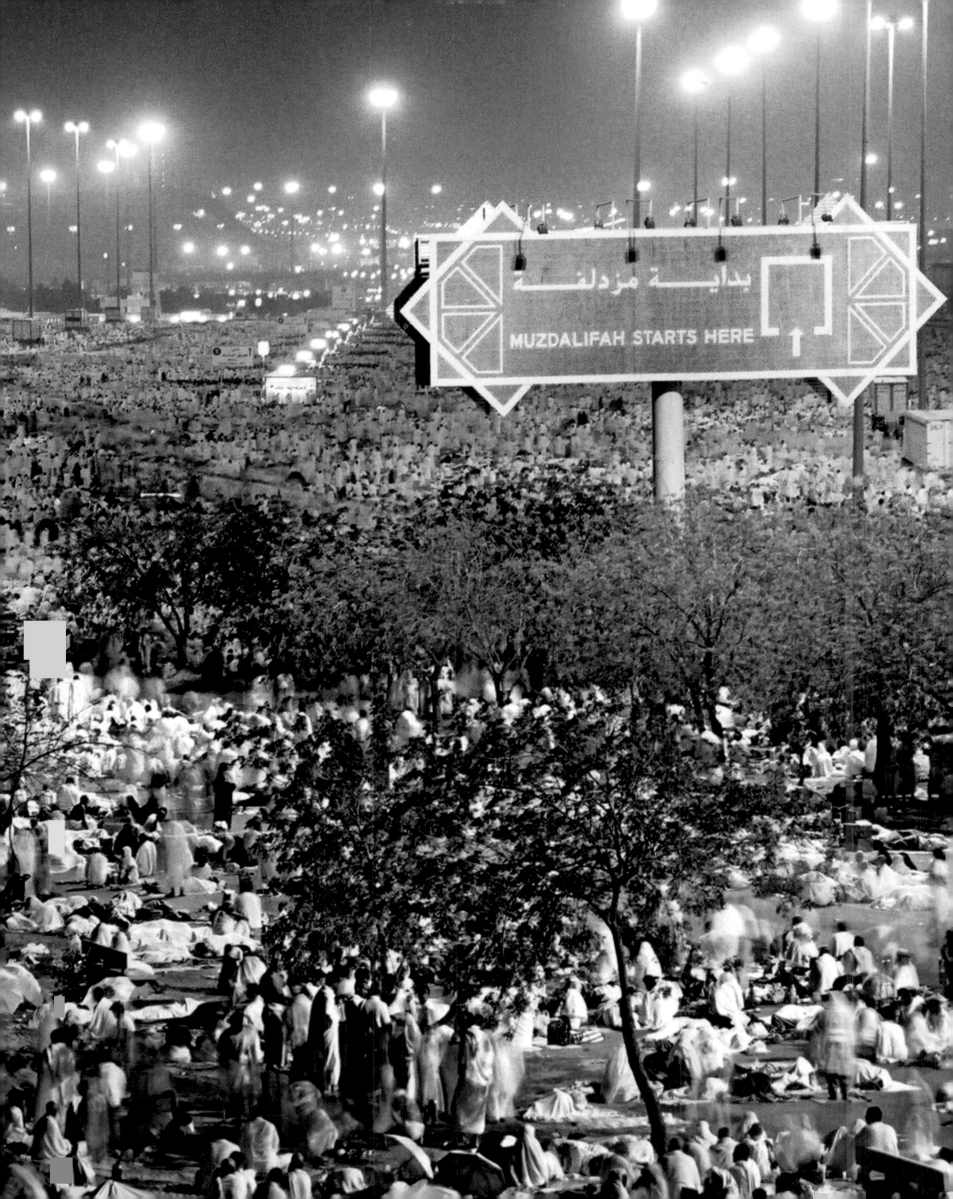

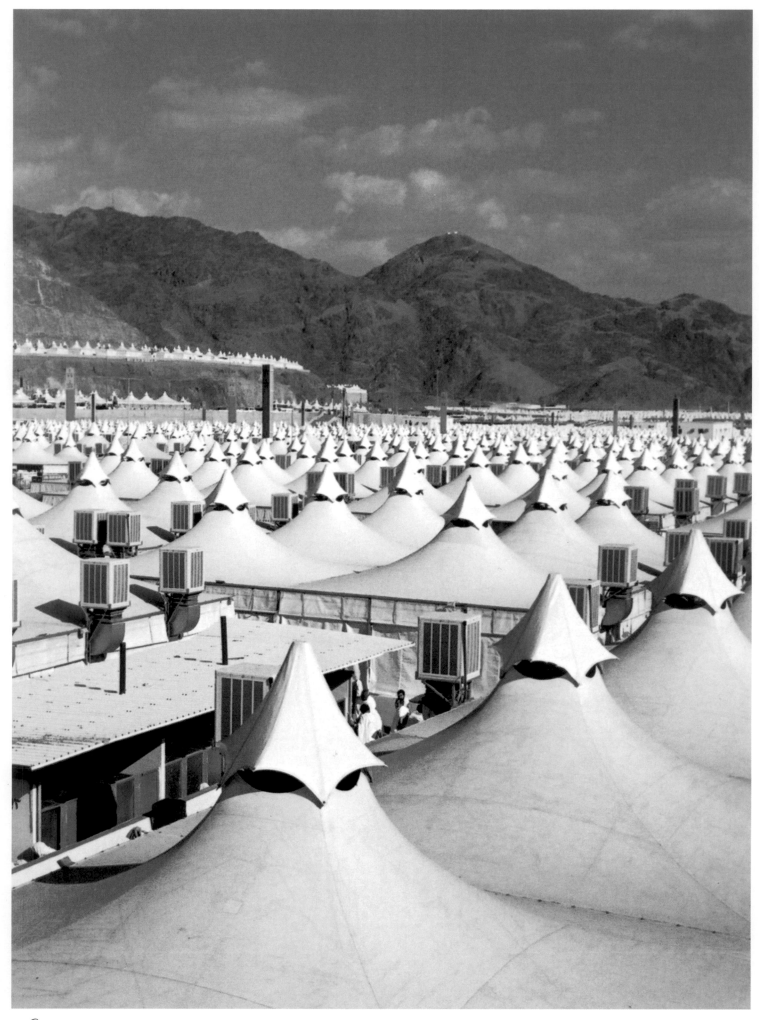

Mina of the Sacrifice extends to the hills of Muzdalifa . . .

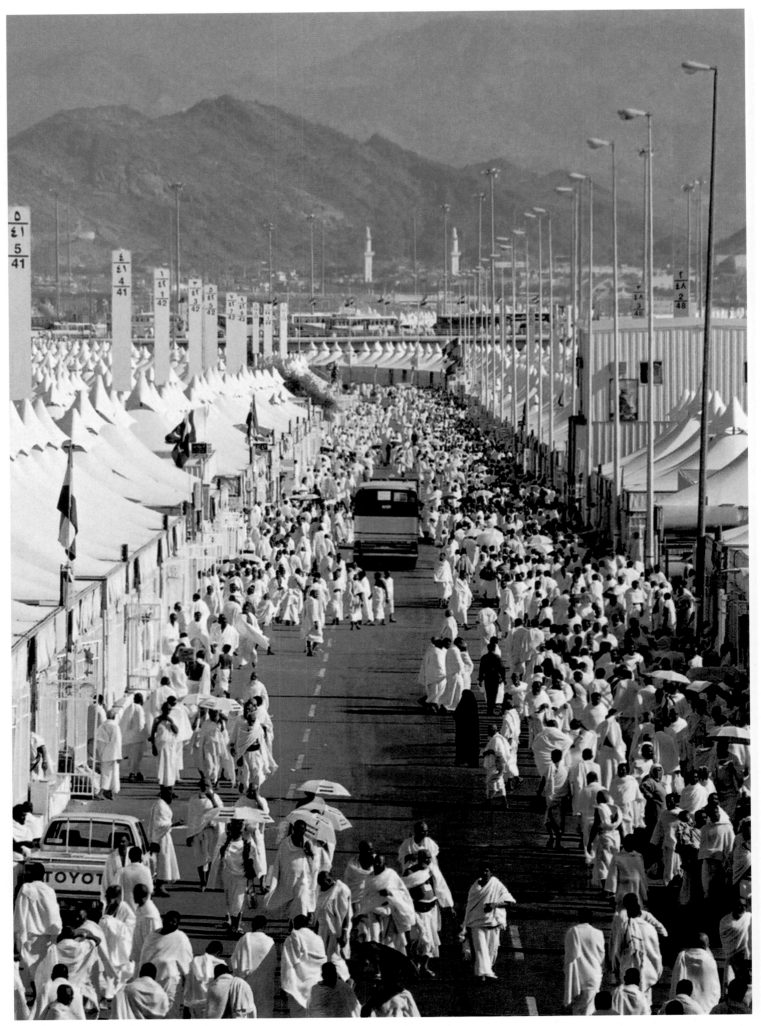

. . . and greets Arafat

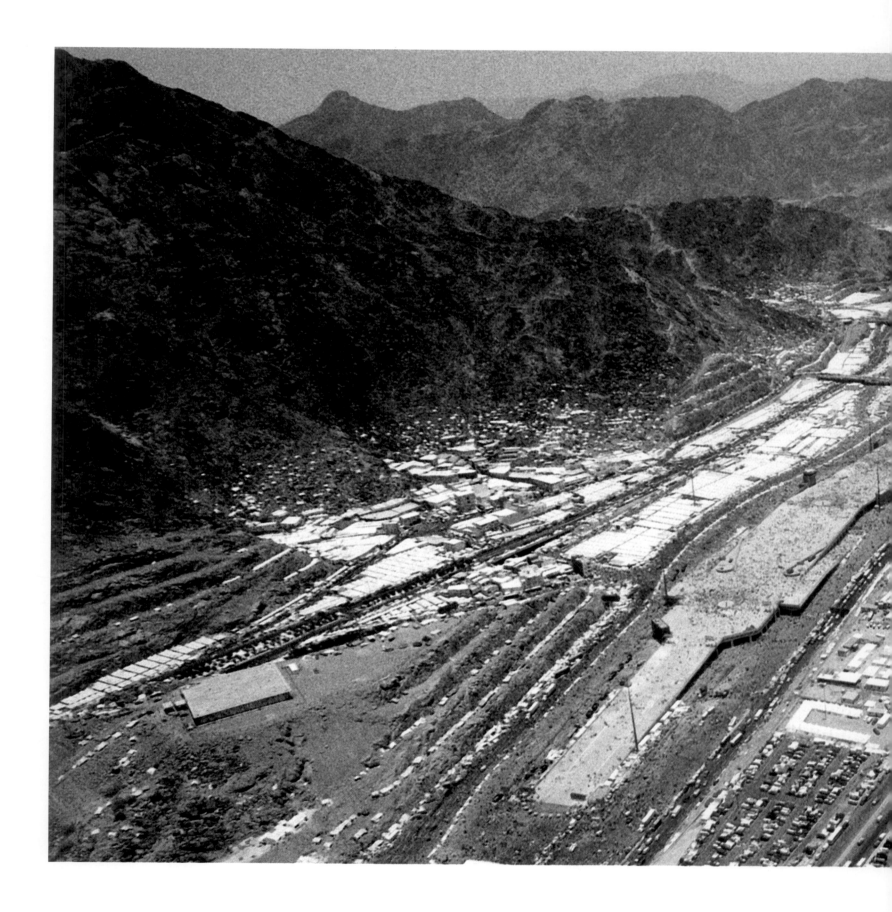

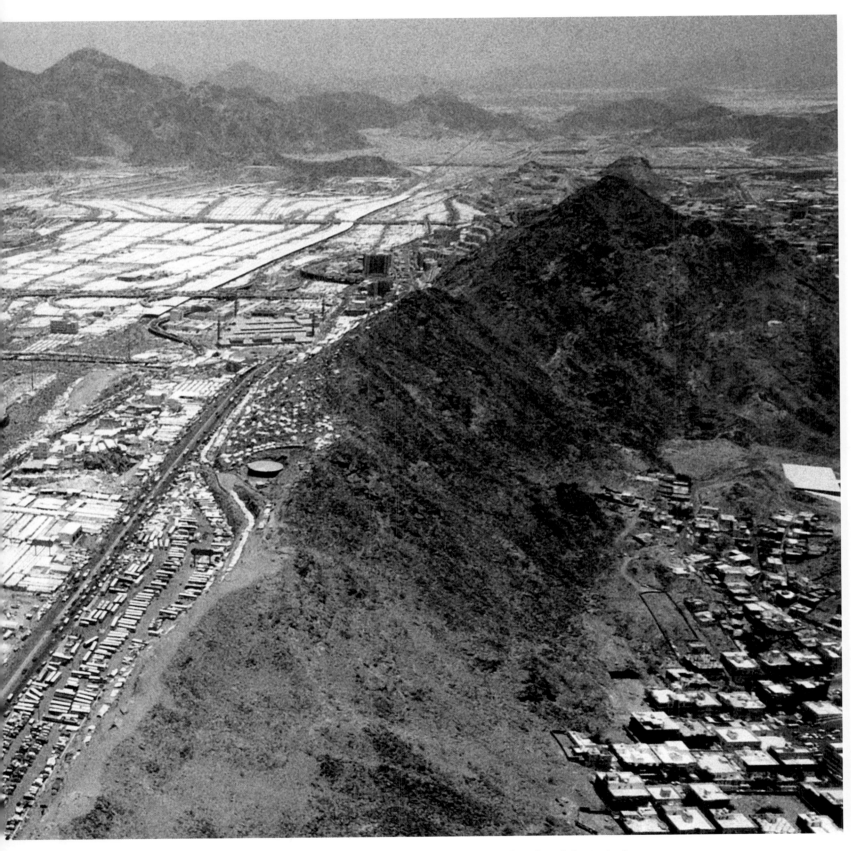

Mina is love; the day of Mina is the tenth of Dhul Hijjah, the first day of the Festival.

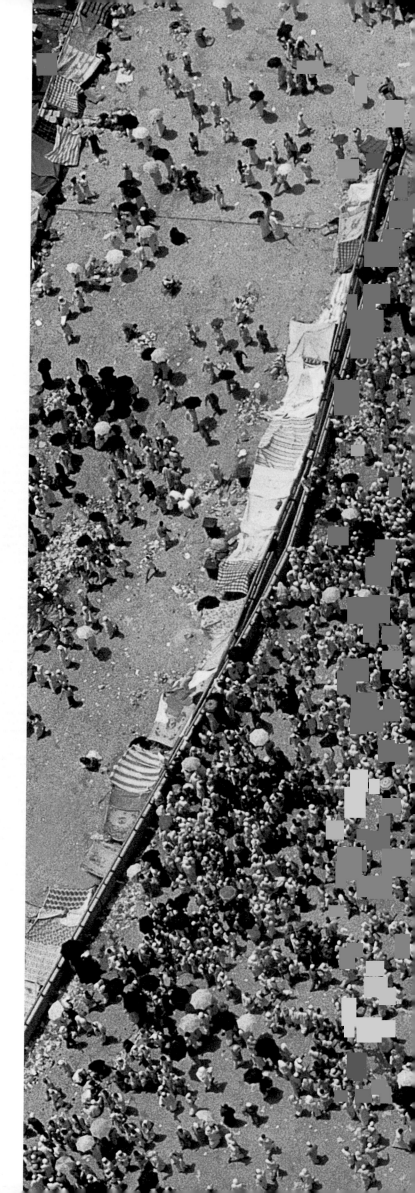

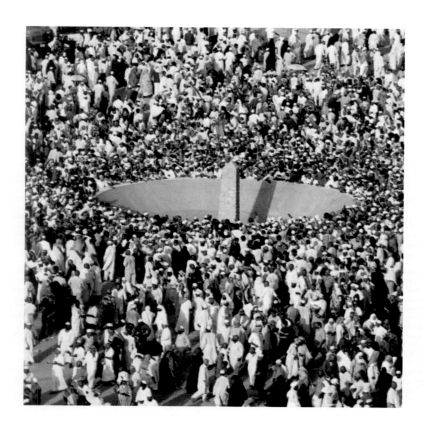

 ow Mina lies in front of us. It is time for purified souls to hand over the reins of straightforward logic into the hands of the soul. It is time to reveal true submission. From Adam to Abraham and then to the Honorable Star of Mankind, Mina has been the stage for thousands to withhold their reason and connect their perception to their hearts. While stoning Satan, our carnal selves are also given their due, and "worshipping just because it has been commanded" (*taabbudi*) is represented on a global scale.

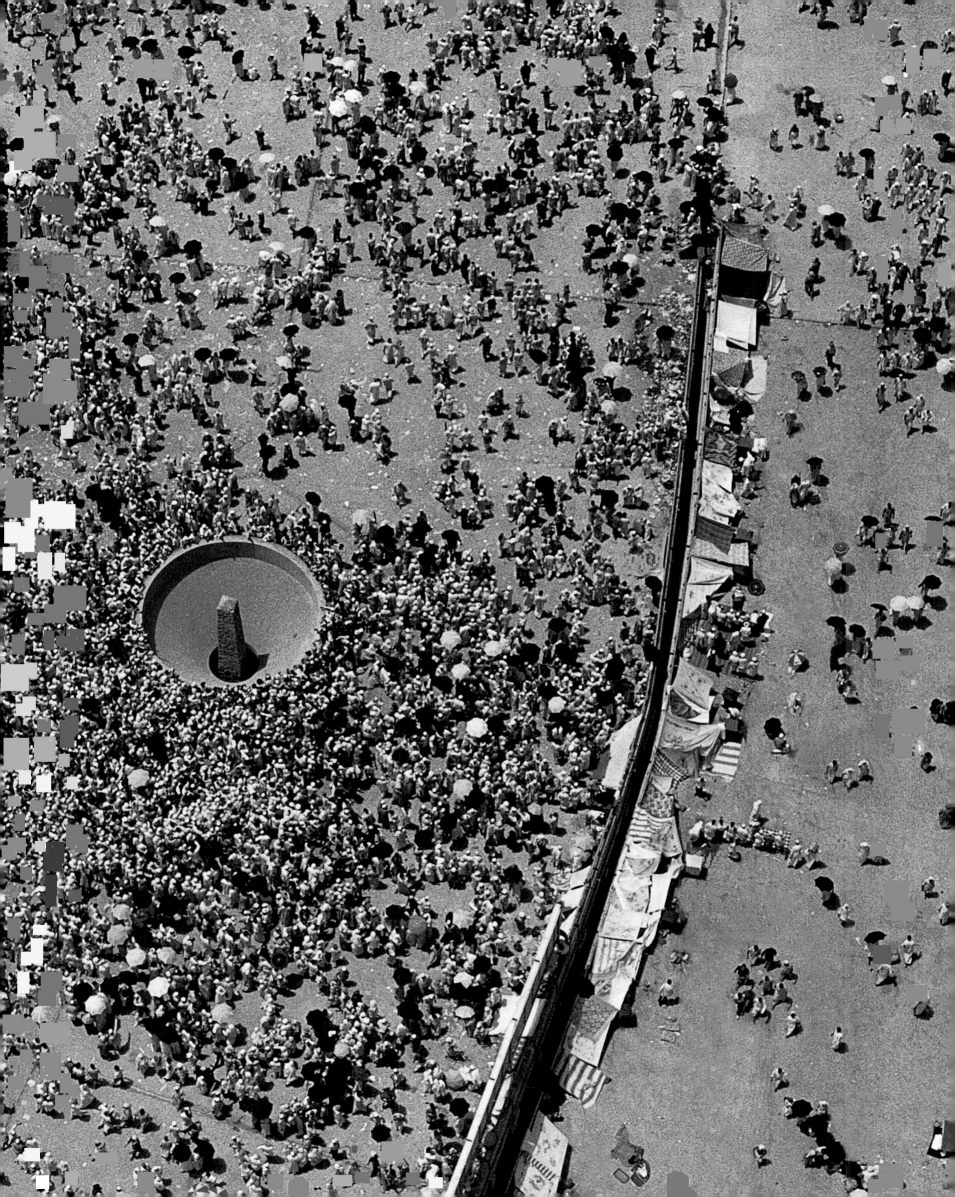

"Stoning Satan" appears contrary to logic. Muslims pray as they throw pebbles, "O Lord, I have submitted to You;
I am throwing these pebbles merely because You have ordered me to do so." The target is not only Satan, but also their carnal selves.

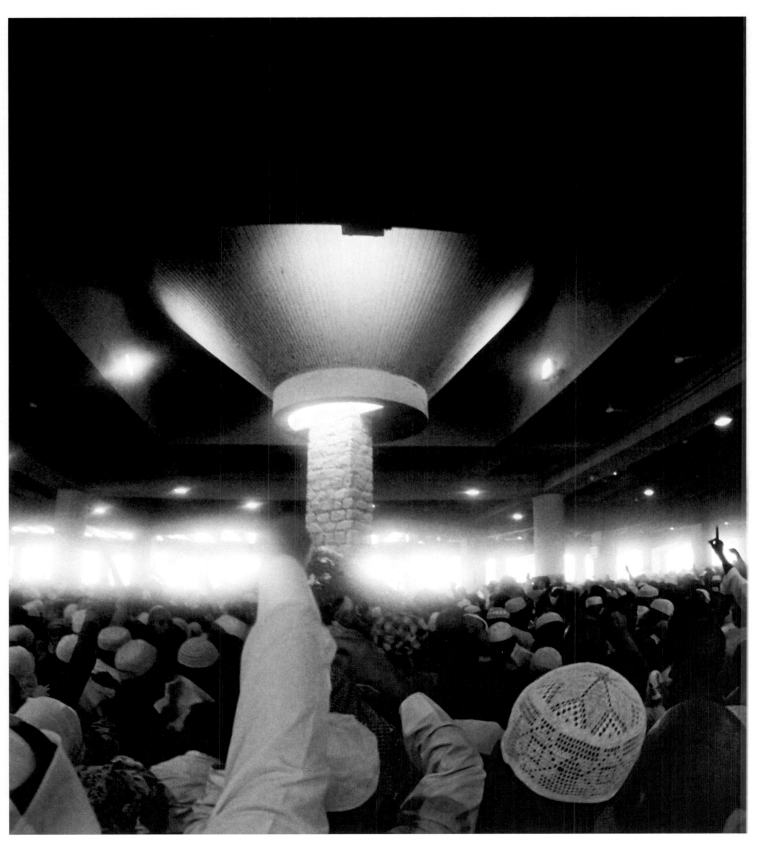

Surely Satan is an enemy to you, so treat him as an enemy. (Fatir 35:6)

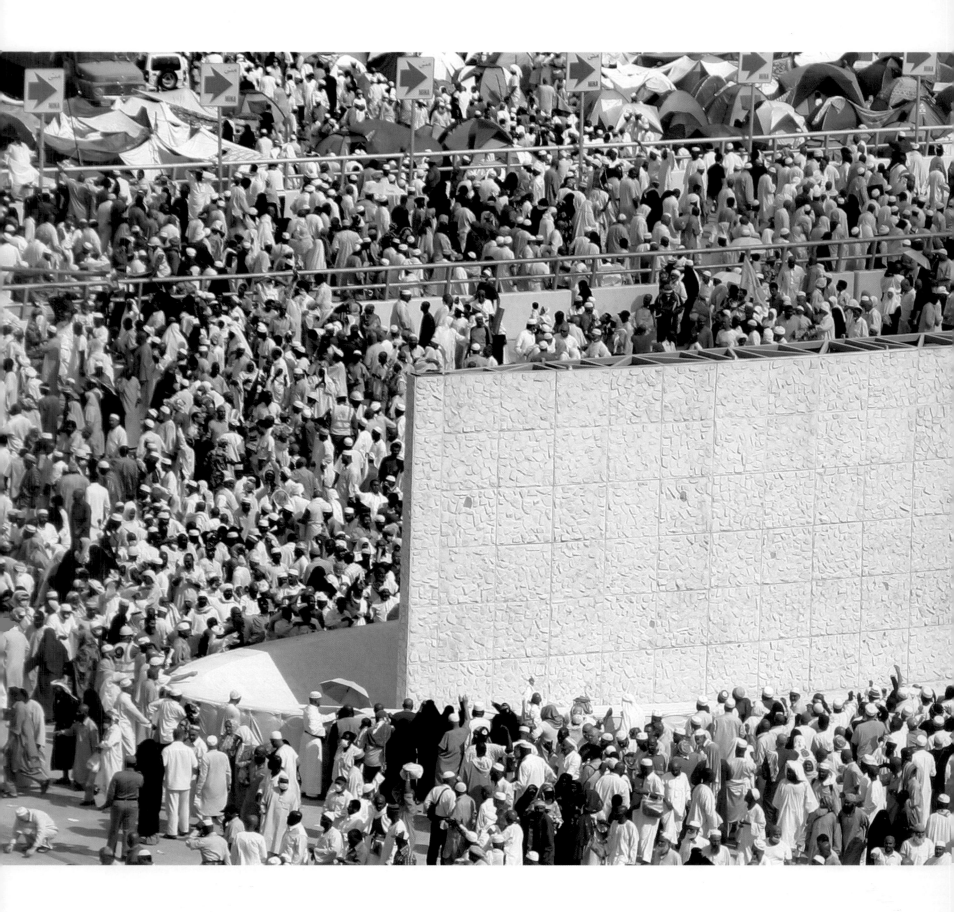

Sacrifice joins compassion in Mina. Enshrouded with love, a pilgrim comprehends the subtle significance of "obeying the order."

(Overleaf) The dizzying magic of Mina . . .

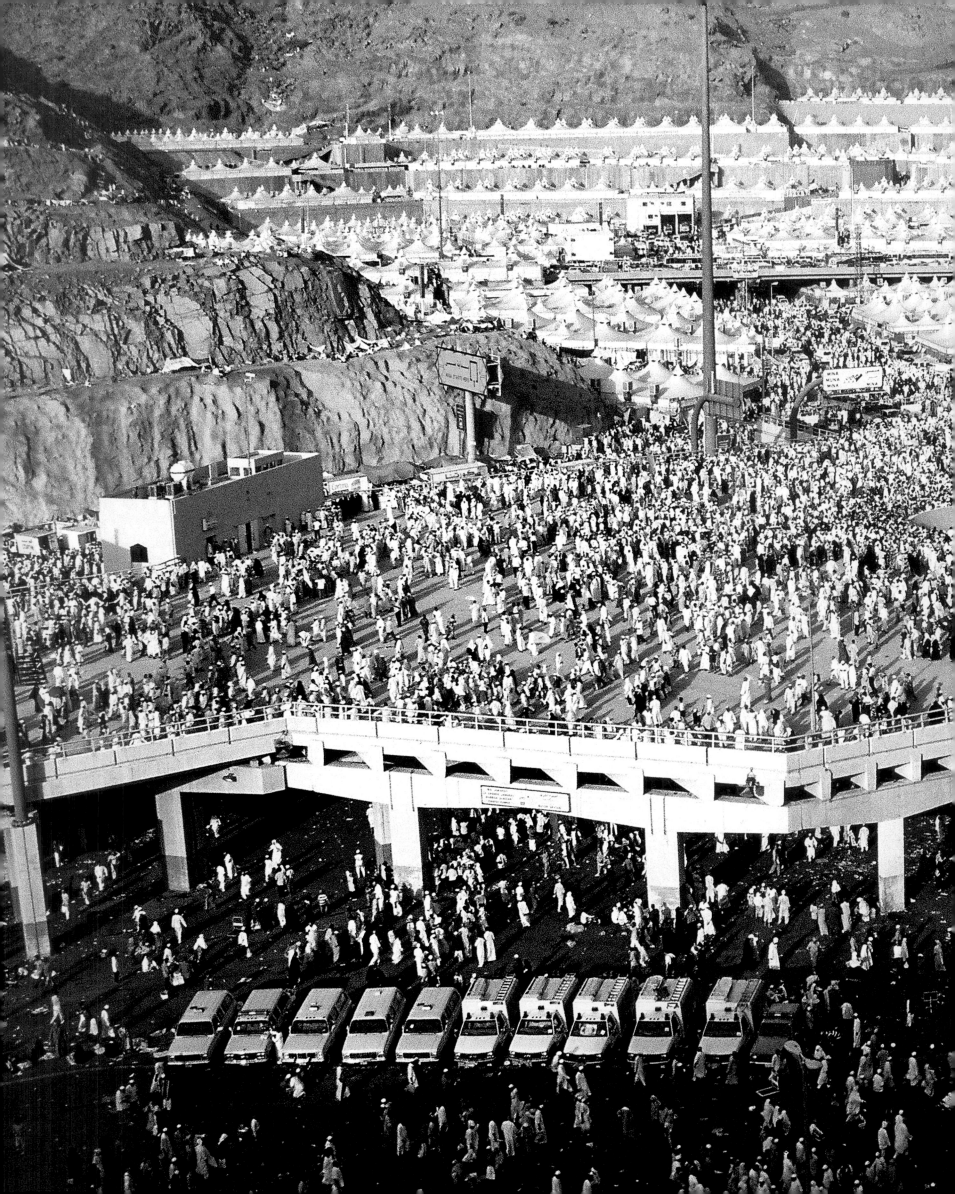

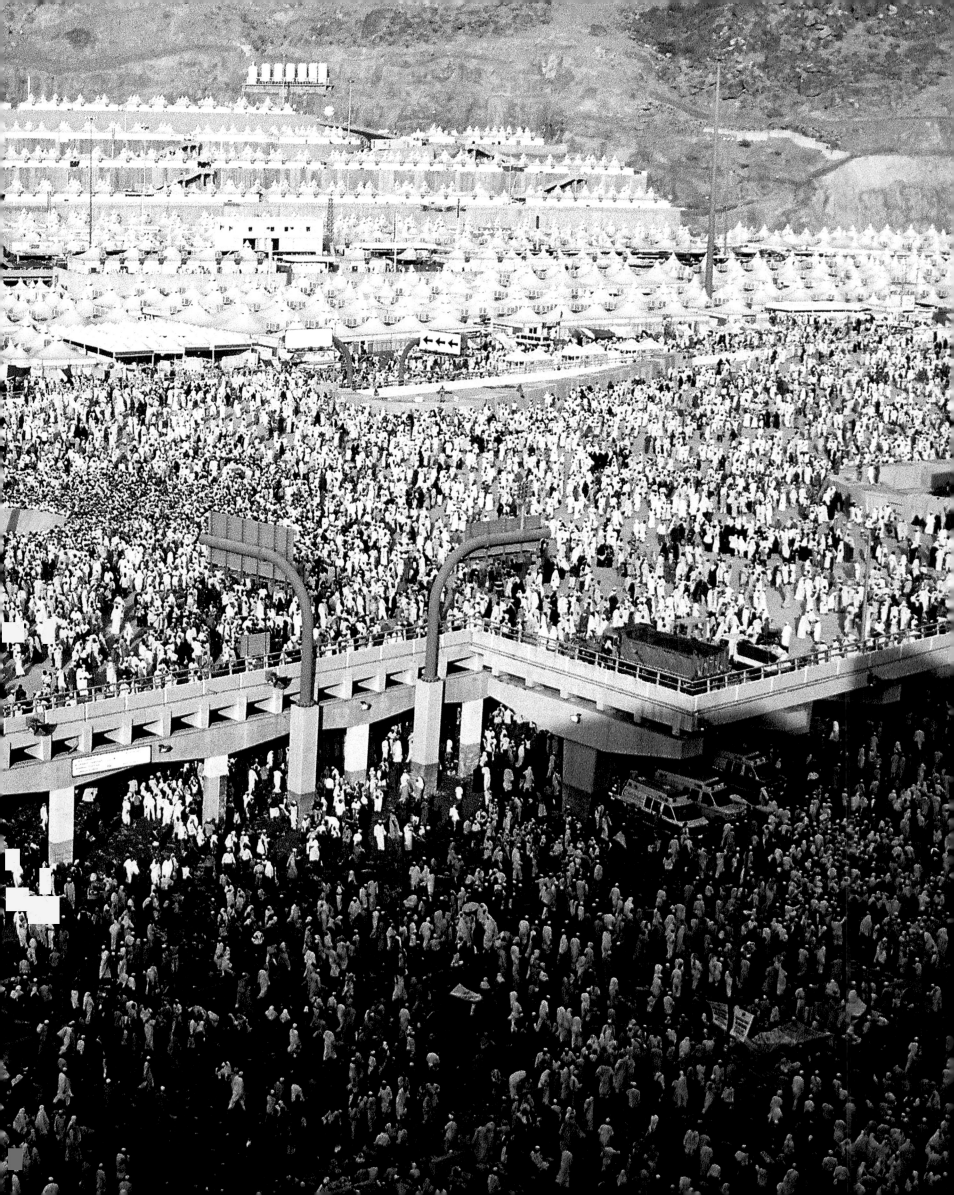

Having finished with the stoning ritual, pilgrims start on the road heading to the Ka'ba.

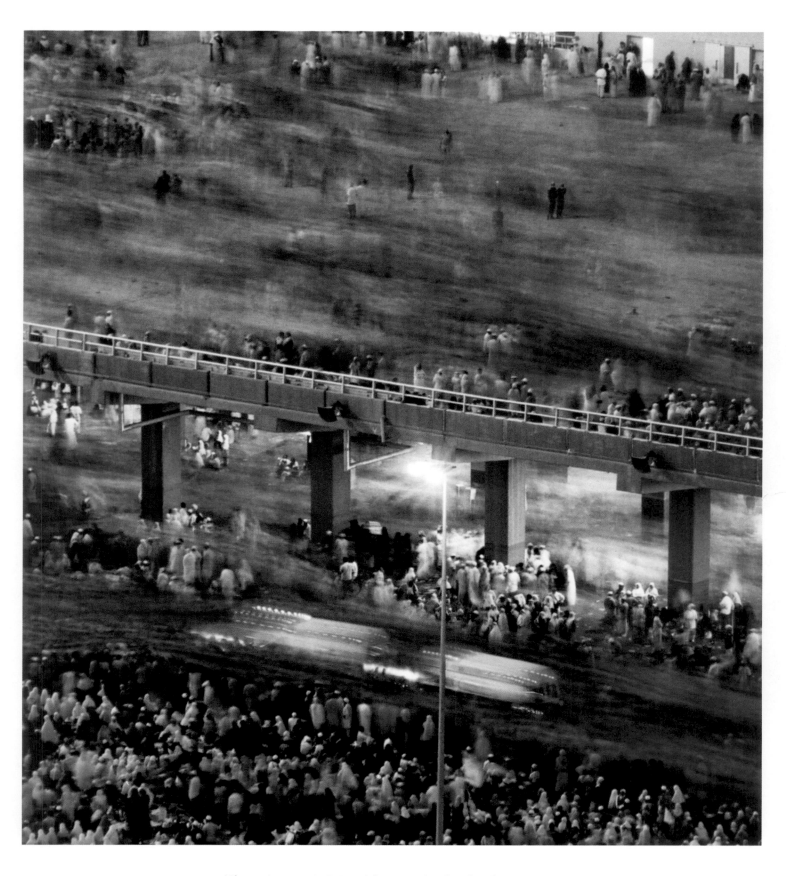

The stoning area in Mina. Often remembered with sad memories,
this area is now being reconstructed for safer performance of the ritual. ▶

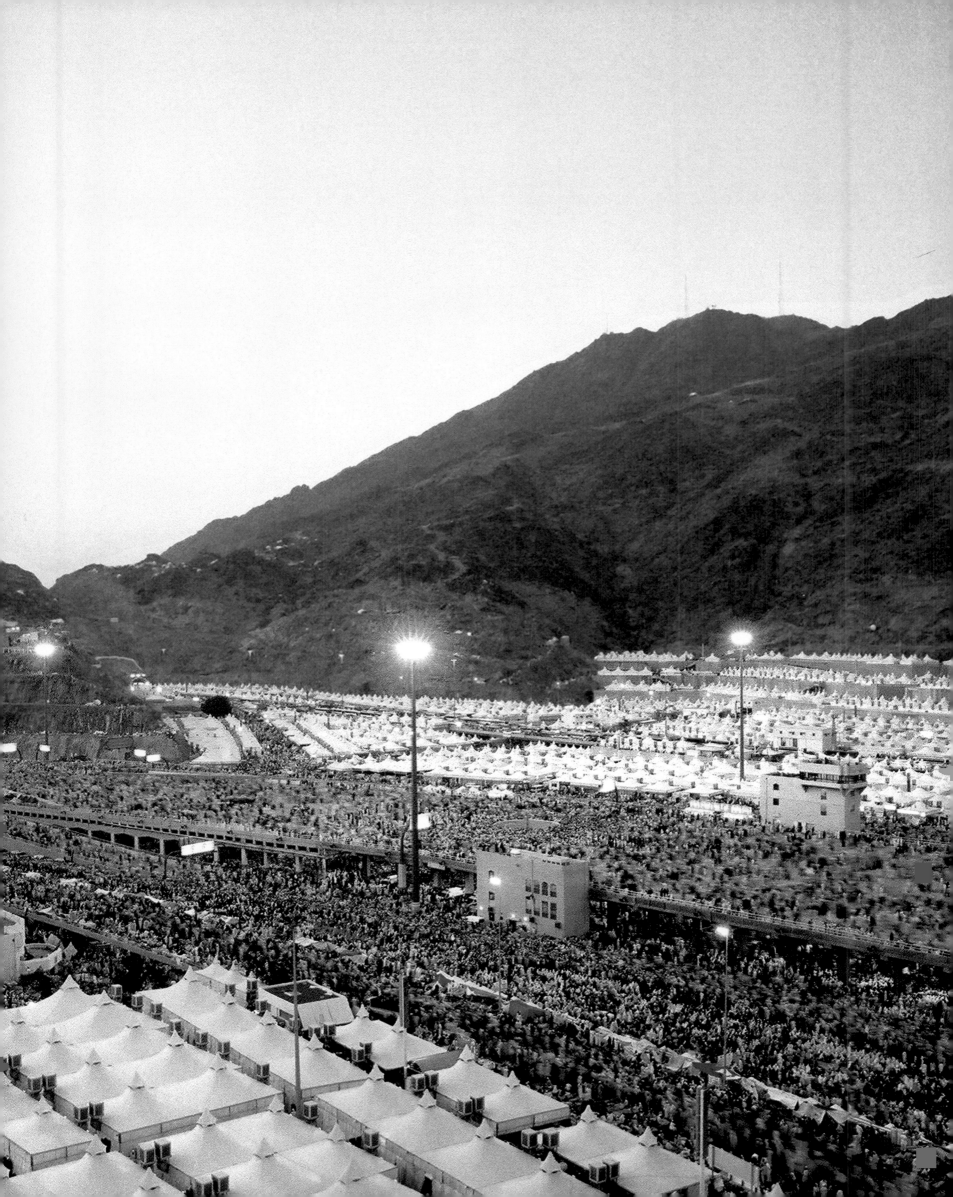

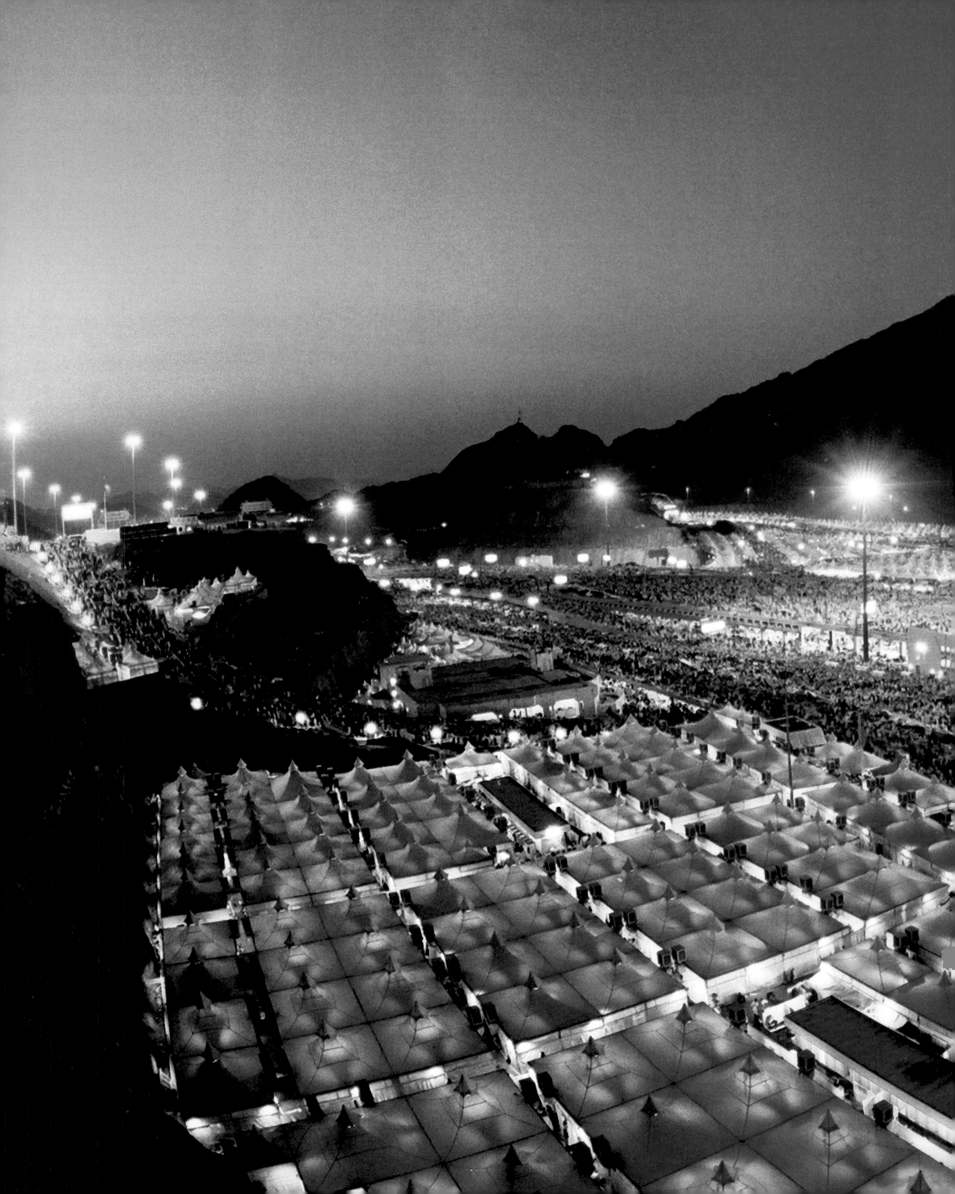

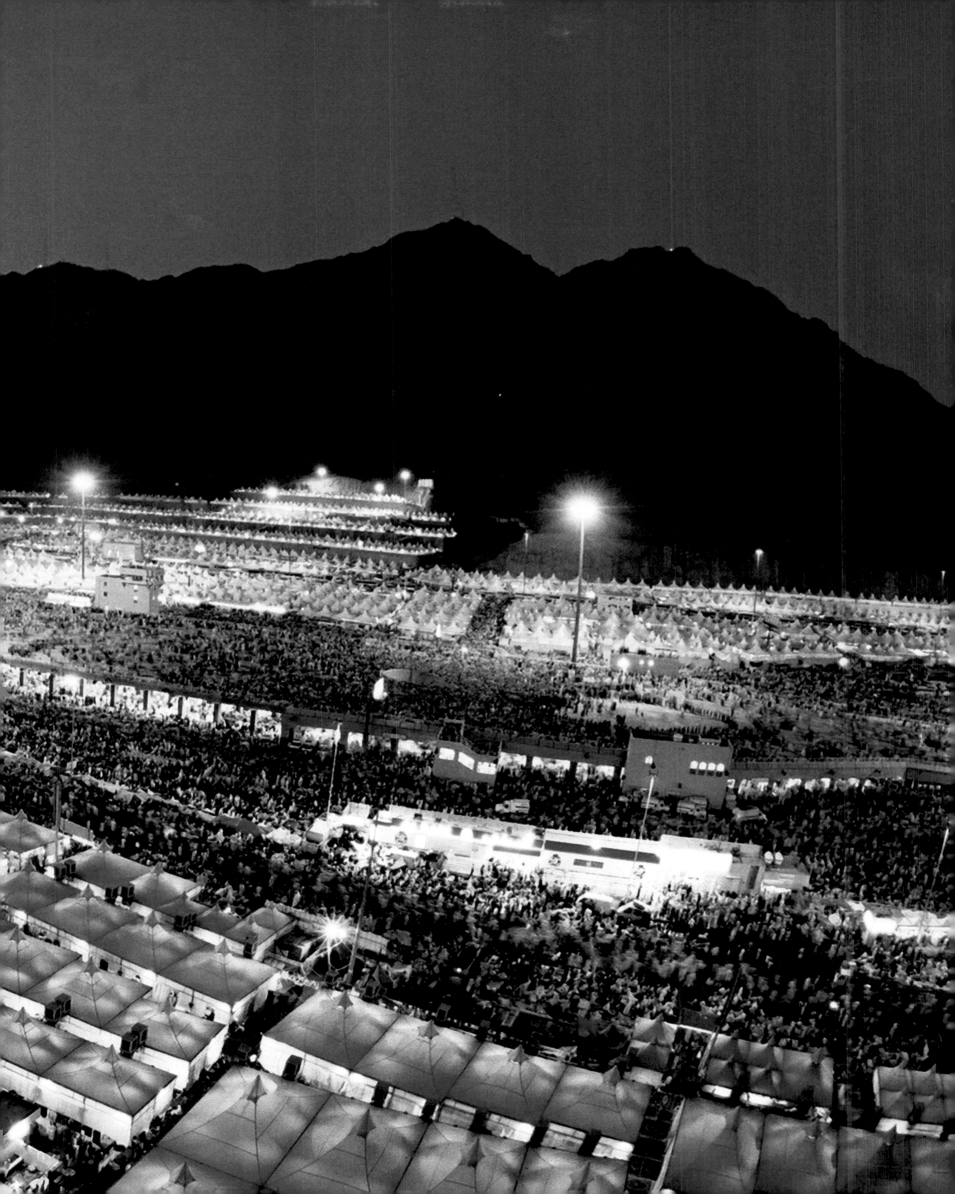

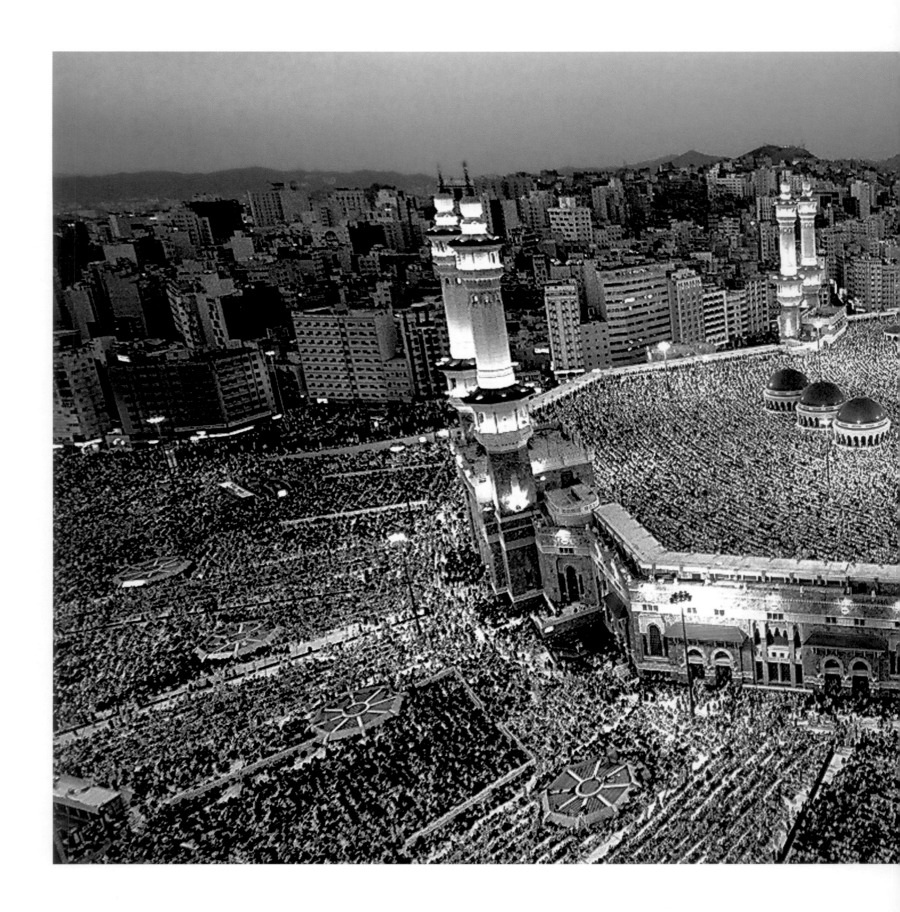

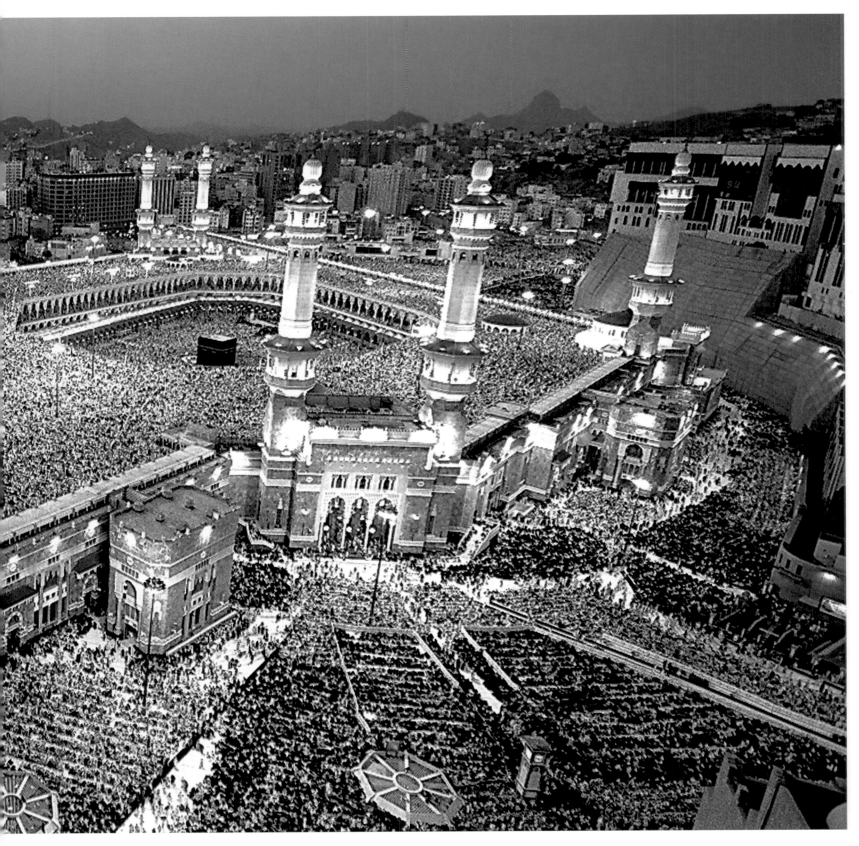

The Ka'ba, once again. Moths rushing to the light . . . a preview of the Resurrection.

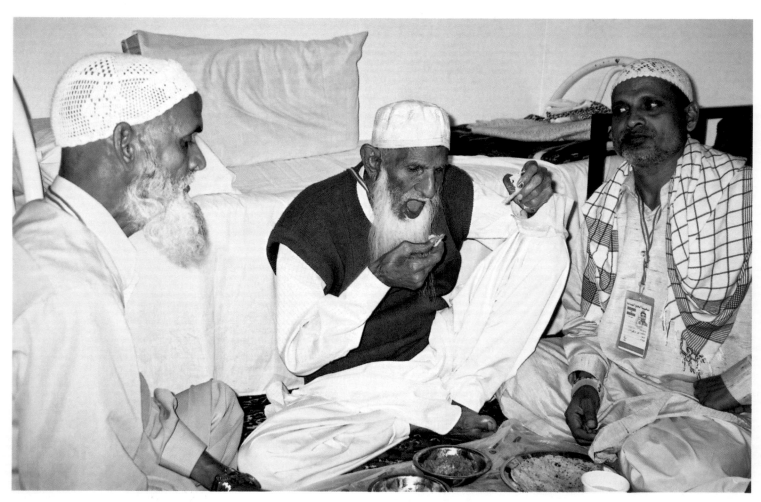

132 year-old Indian lover of the Almighty, who has come on Hajj with his grandchildren.

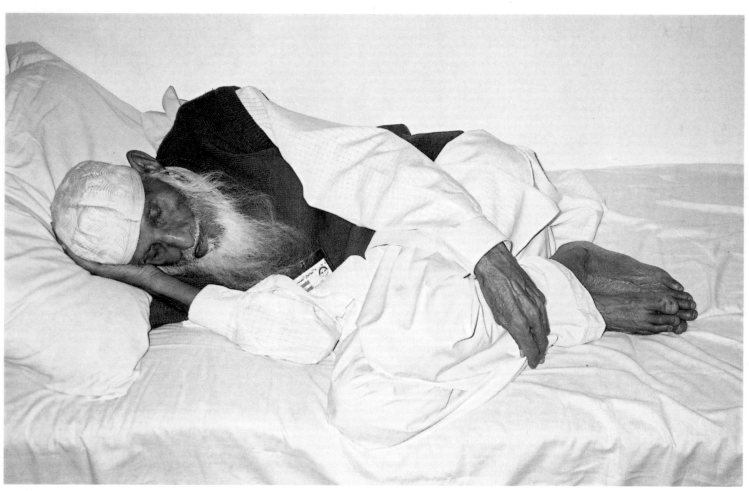

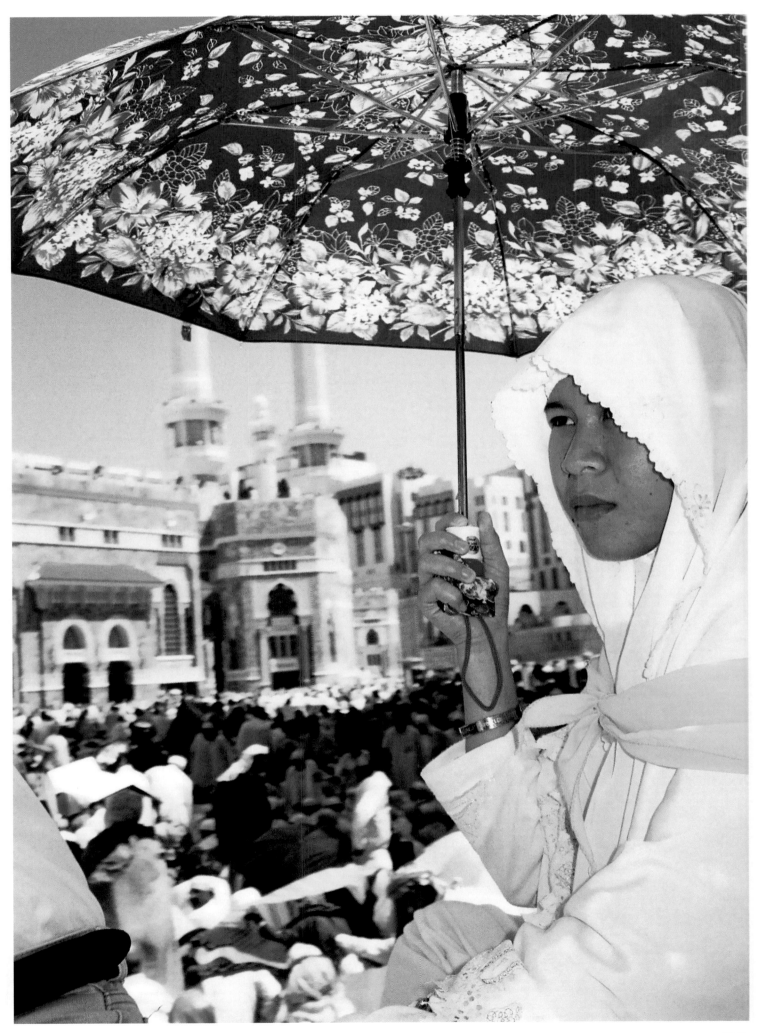

Towards His World in His Footsteps

he essence of the cosmos and the most subtle meaning of creation is Prophet Muhammad, peace and blessings be upon him. He is in a sense the root and the fruit of the tree of creation. The lyric of existence has been composed for his sake, and his body is like the final word of this poem. His honoring the earth was a sign for a re-birth of humanity; his prophethood was the means by which the veil over natural phenomena was removed; his emigration was the path of salvation for humanity; and his message is the bridge for bliss in both this world and the world to come. Thanks to your teaching, believing hearts have perceived the world as an exhibition, they have read the universe as a book, and have found the true route in your glowing milieu that lead to the Almighty Lord. Souls who have awakened to the truth related by him aspire for eternity; those who have grasped his reality have also obtained the essence of knowledge. Entering any place that reminds them of his lofty presence, believers feel love flow through their veins. Taking one step into his aura, they find themselves in the middle of the road that leads to God. A visit to his town is as if one is setting off from a launch pad to the Age of Light, and believers feel as if they are sitting knee-to-knee with him, instilling in their saturated hearts a fresh enthusiasm. No matter how many times one has visited him, or even if one notices the fading on the bloom of this blessed sanctuary caused by the destitution of his followers, whenever one proceeds to this green dome they will be filled with love; showered with music, they will change pace, and will find themselves in a tide of joy and sorrow.

Before the Green Dome, a pilgrim falls into deep contemplation over the circumstances that the Islamic world finds itself in. A kind of haze enshrouds this blessed sanctuary, and the mosque is suffused with sorrow. Right at that time the Green Dome appears, speaks to our soul, and positions itself next to the pilgrim, imploring the heavens, presenting the tale of our longing.

Sometimes at the Prophet's Mosque, everywhere is filled with light. It becomes the corona around the moon, and the dome seems to be offering the residents of heaven thanks for bliss. Projecting to the skies the dome appears, with its profound silence and silent grief, as an interpreter for all your troubles and a singer who expresses all your joys.

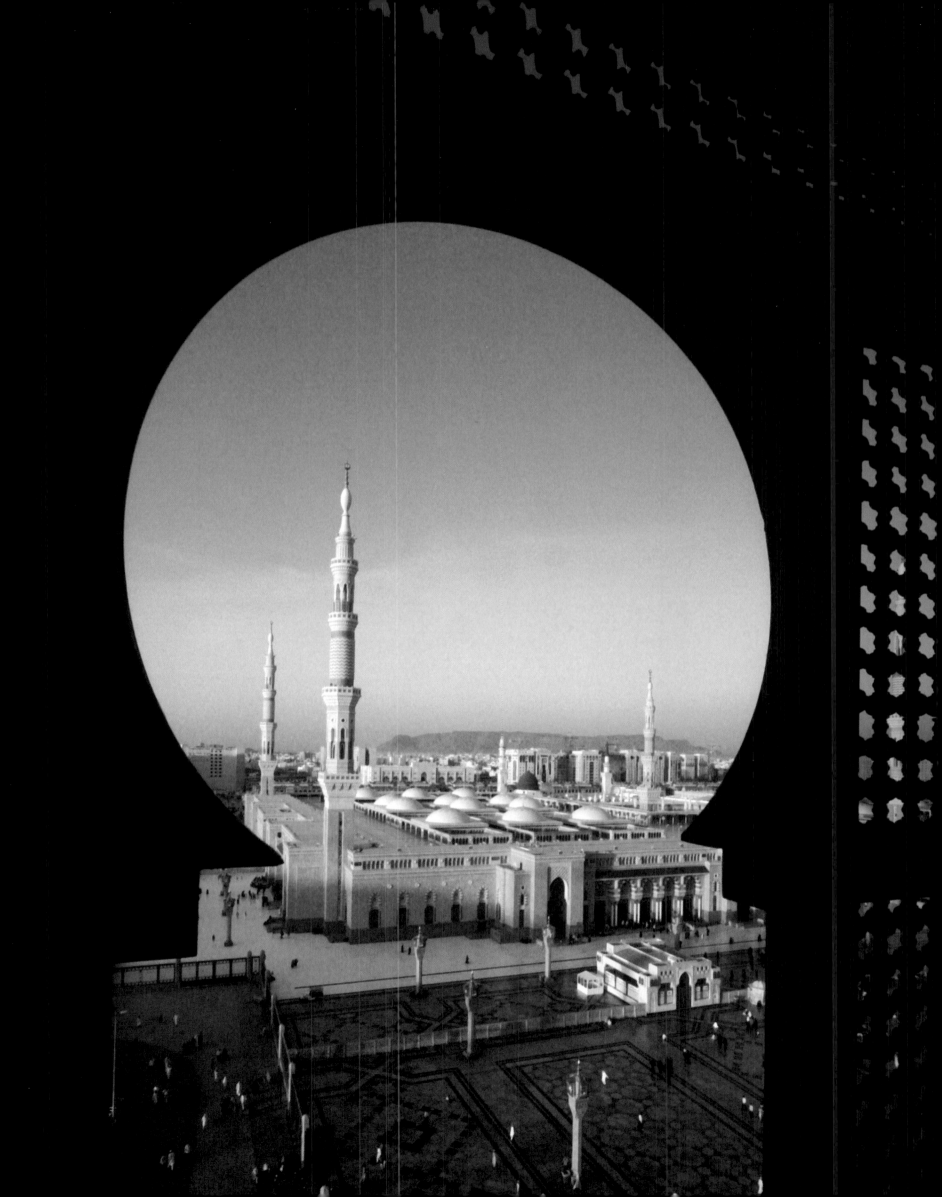

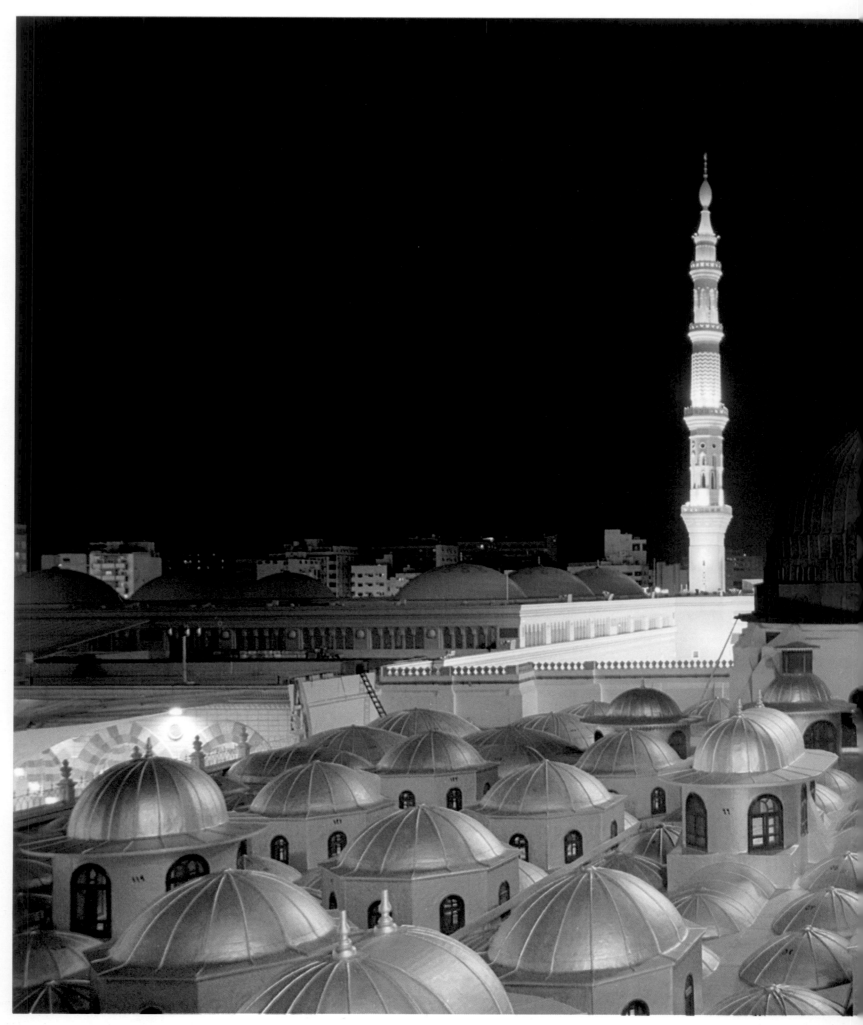

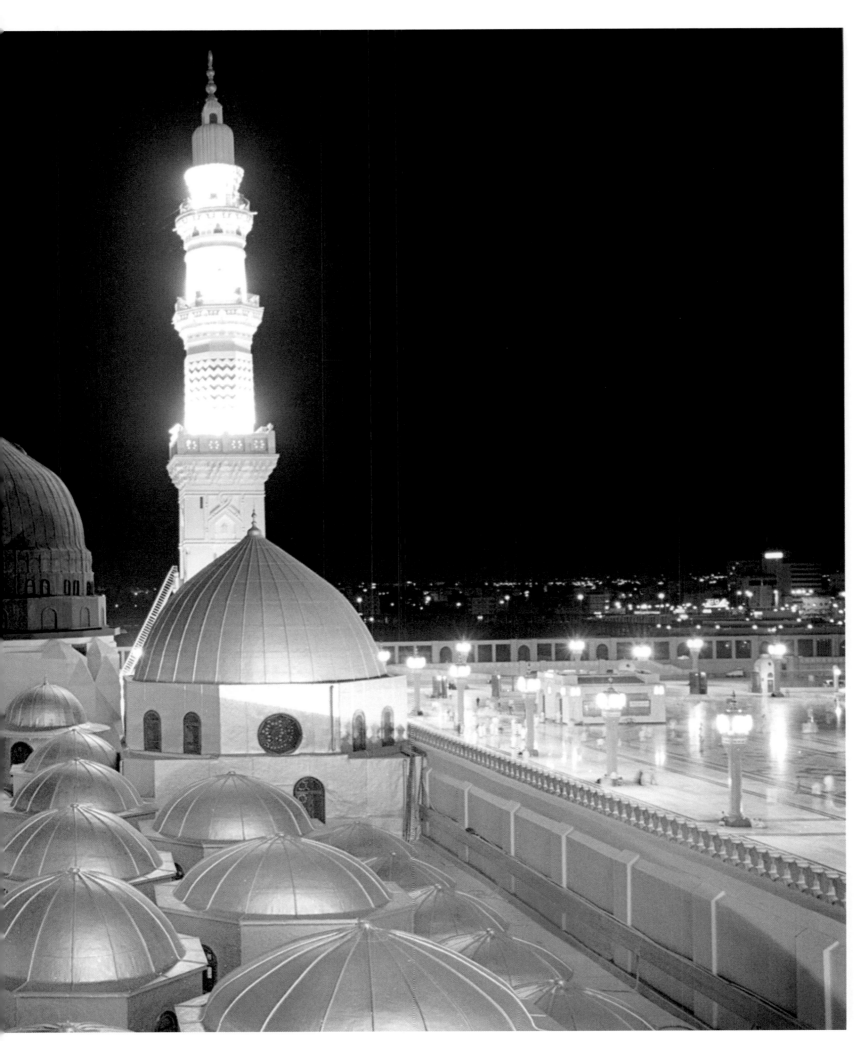

Mecca is the mihrab, for it hosts the Ka'ba, and its pulpit (minbar) is Medina,
for it cares for Rawda al-Tahira, which is cleaner than the gardens of Paradise.

he green dome and the encircling holy mosque are perfectly suited to this terrain, with hills both small and large, vast deserts and oases, all lying under the infinite skies. The outcome of this material-spiritual combination stands like a place where the heavens and the earth have merged. The moment they enter the aura of this place pure souls that have some affinity with the Master of this site feel as if they have joined the residents of the heavens. Their joy reaches a climax at the Garden of the Prophet (Rawda) when they meet a magic that enchants the eyes and the hearts. They pass through wondrous gates and listen to the primordial sermon that has been shaped by the Word of the Lord directly from His preacher's mouth. They prostrate with the delight of being a member of his community.

Such ecstasy and joy is certainly a communion of a strong faith, conviction, fondness, and a profound perception. For those with this level of perception, the Prophet's Village, the Mosque, and the Encounter—the lover's stop—have so much to speak of! With its unique stand, expressive silence, honorable appearance, and spiritual profundity, the Rawda sings of the joy of existence, plays the best melodies from the heavenly choir, pouring embers into sincere hearts, with everyone being filled with the love of reunion.

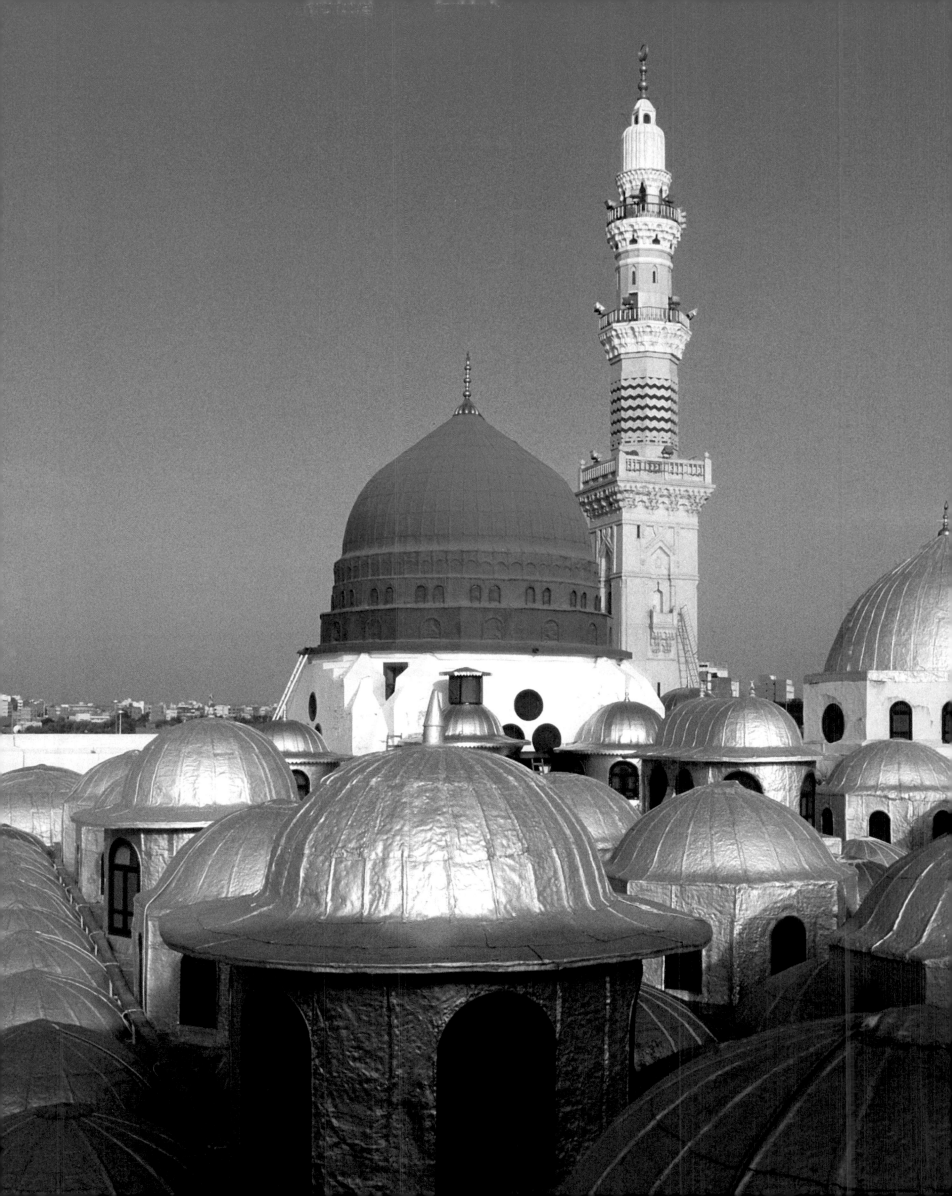

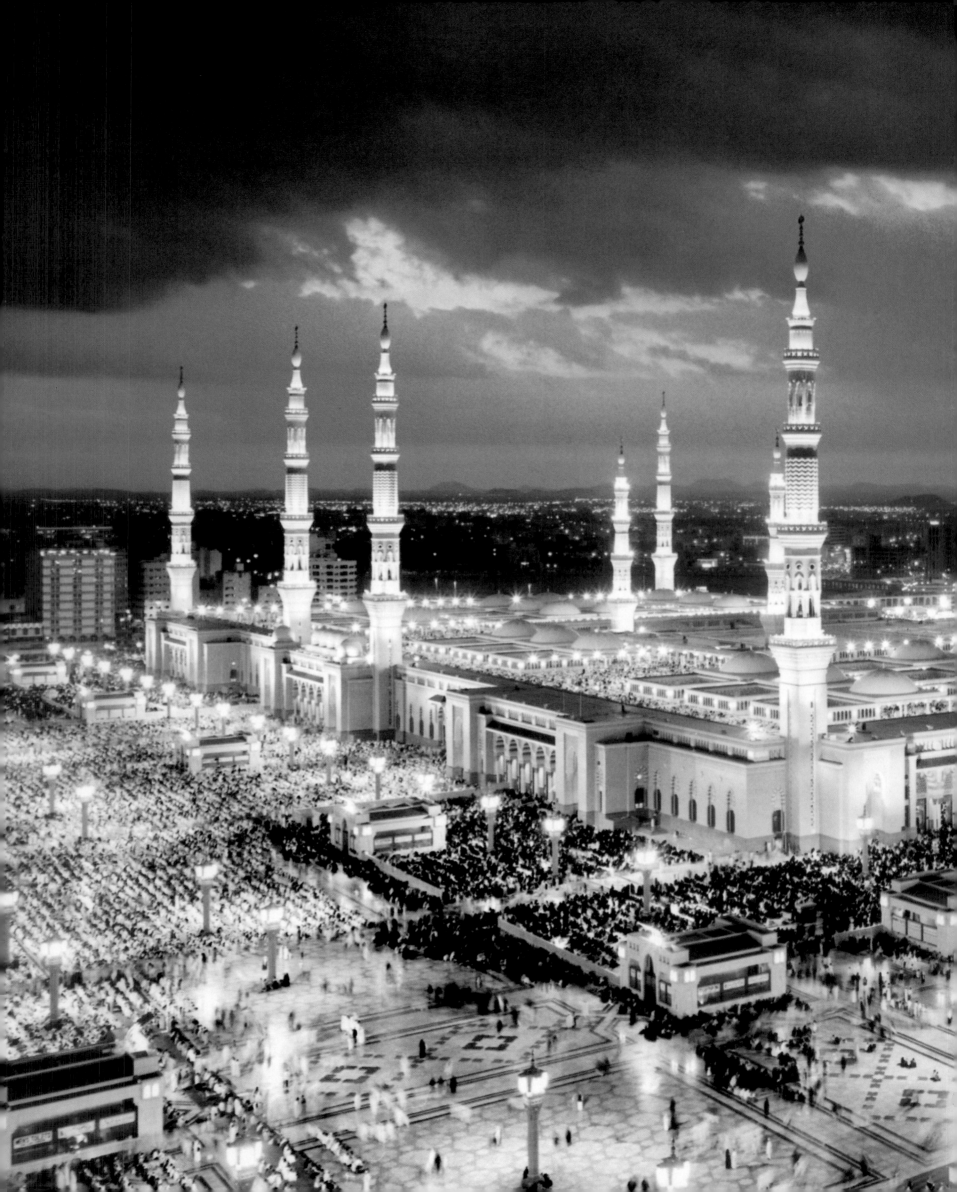

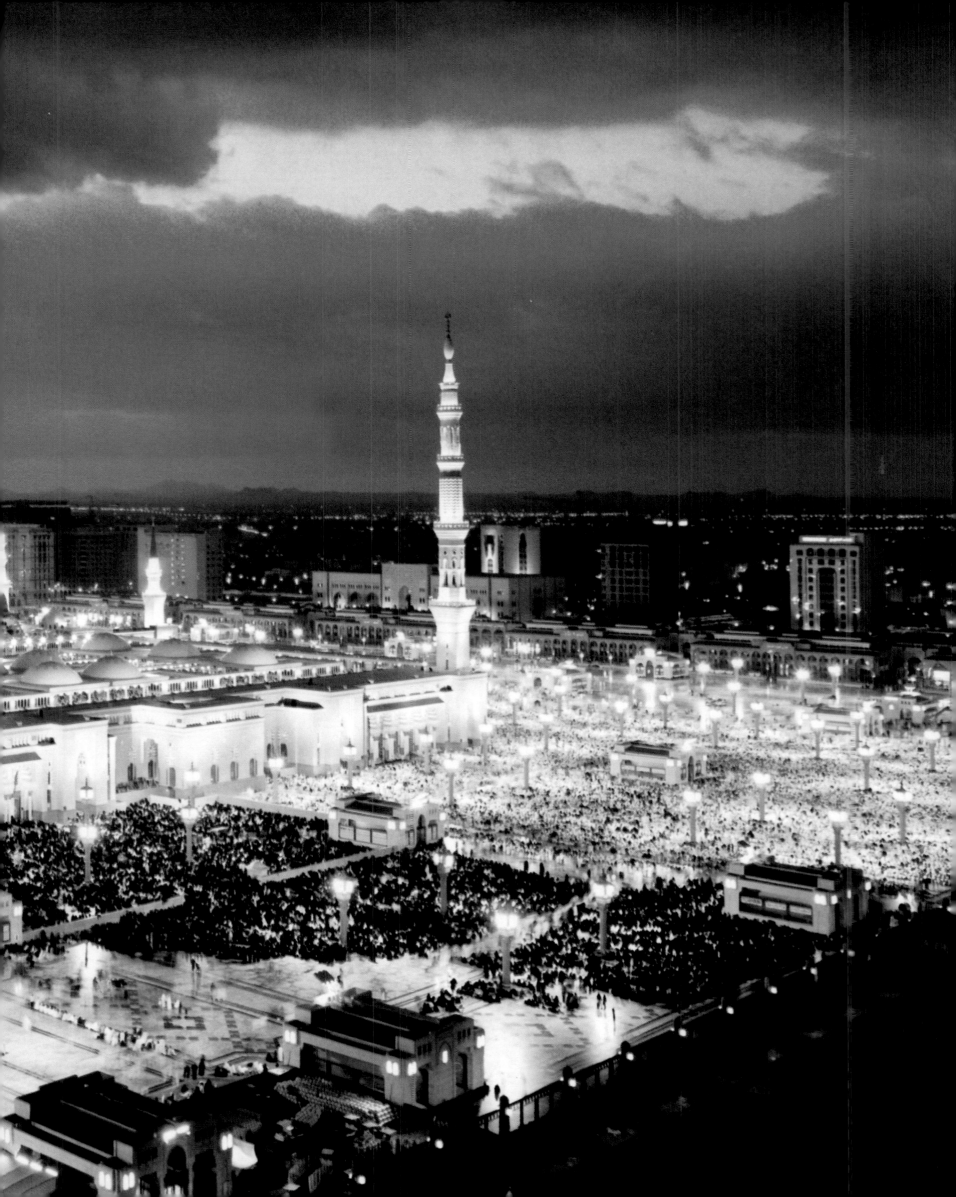

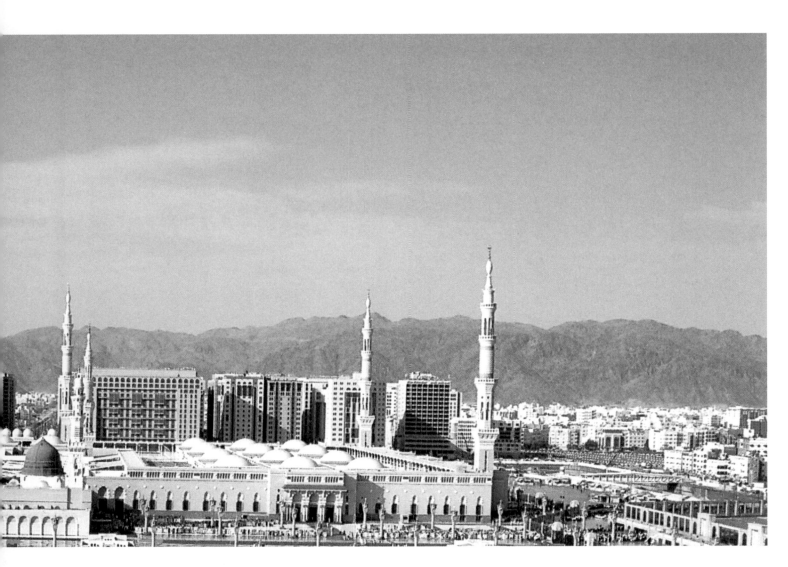

Rawda is the single building which whispers to us the spirit of being in the world. When we mention it, we fear that we might blunder in the most frivolous of faults; it is as if we were describing a "monument of honor" whom we know by his/her chastity.

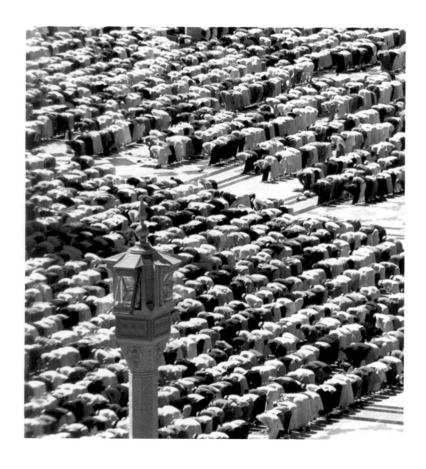

his blessed place has been subject to repeated changes in its form out of reverence and artistic considerations, and its external ornaments have been repeatedly modified; yet the spirit and meaning related to the realm of hearts have not been and cannot be touched.

Rawda has many gates, like the multiplicity of the doorways that open from His soul to humanity, or the doors that open toward the soul of its owner. The most reputed of these gates is the "Bab al-Salam" (Gate of Peace), referred to by the poet Nabi, "The crescent in the heavens is the bosom of the Gate of Peace that cracks open." Those who enter through this gate feel as if they would soon meet the Master of Hearts. And they find themselves swaying between varied breezes.

Umbrellas are being closed at the Prophet's Mosque before the evening prayer. ▶

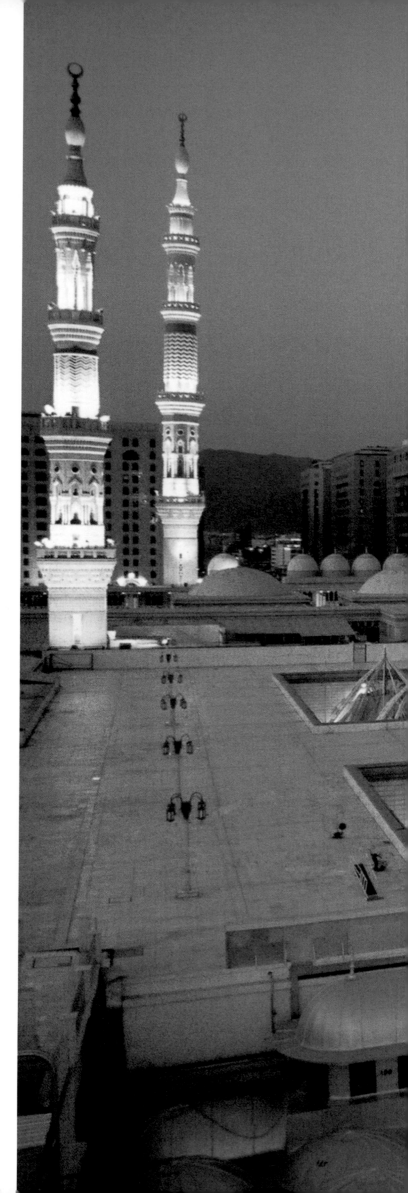

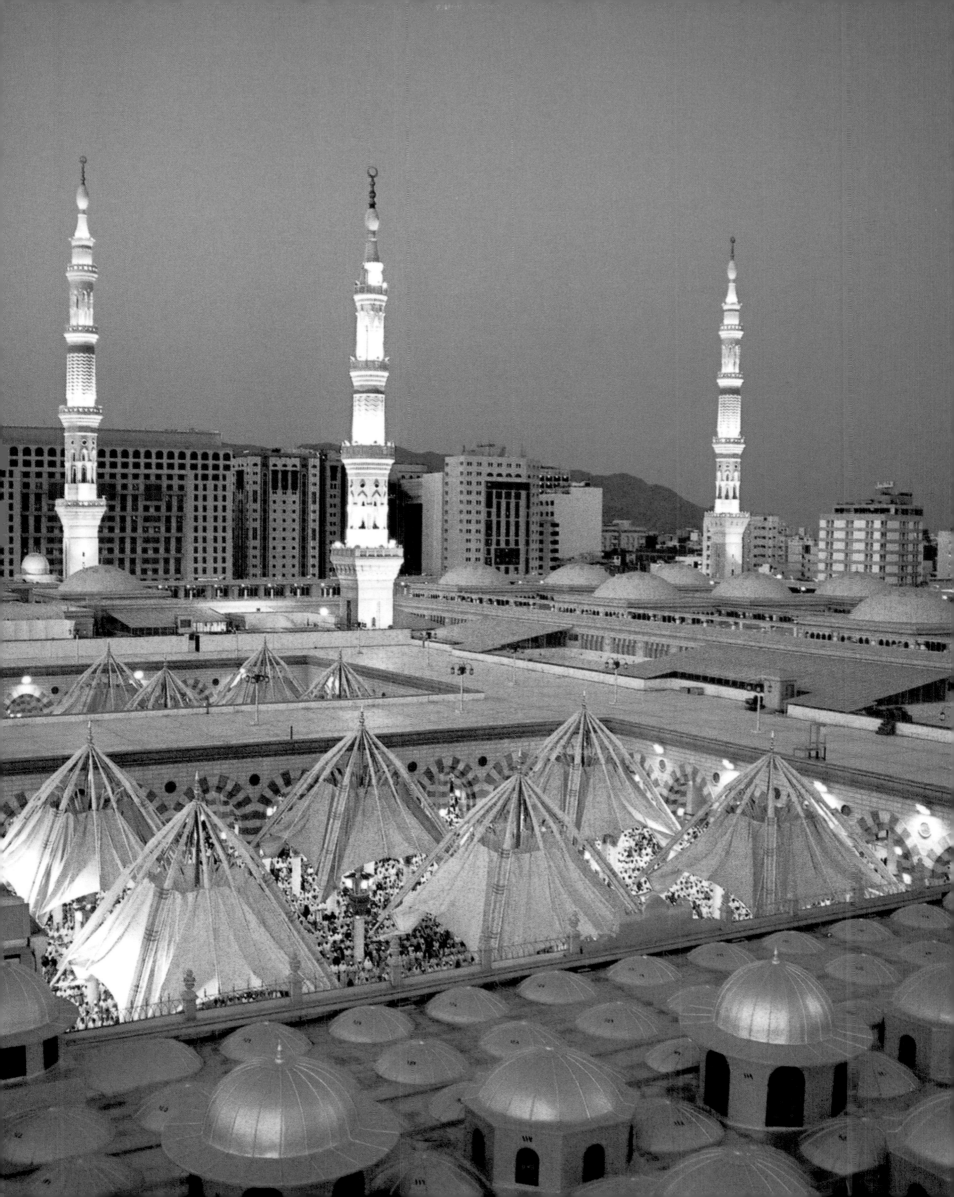

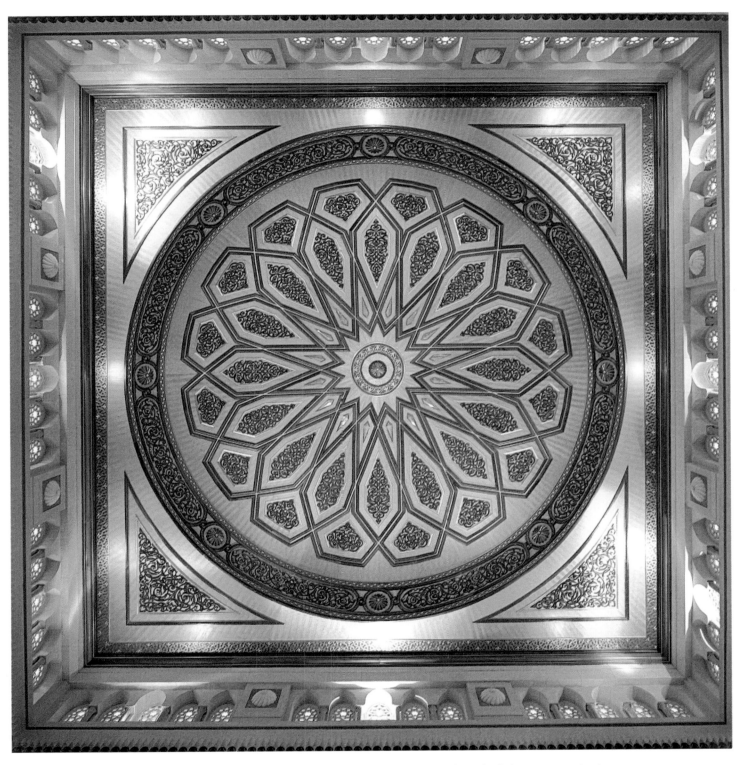

Some of the domes at the Prophet's Mosque are made of cedar and can be slid open at certain times.

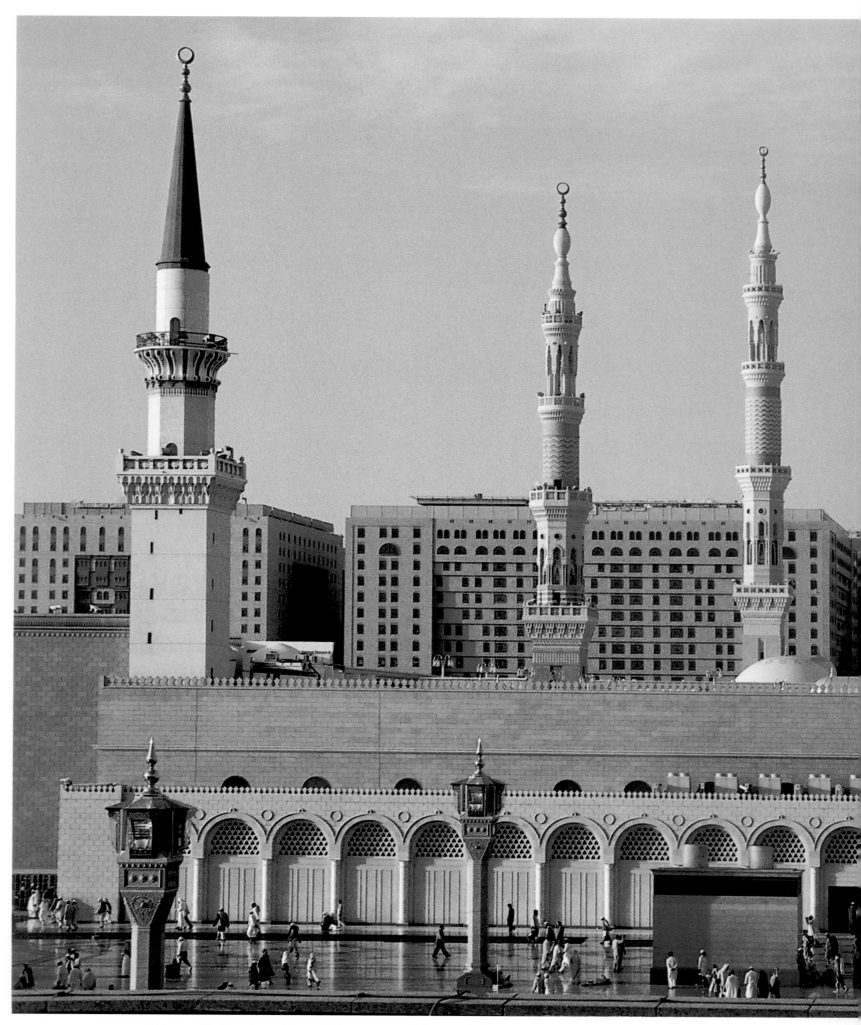

192 *Minarets. Each carries architectural characteristics of the time of the Mamluks, the Ottomans, as well as of recent times.*
They each stand like a muezzin calling from the distant past into the future.

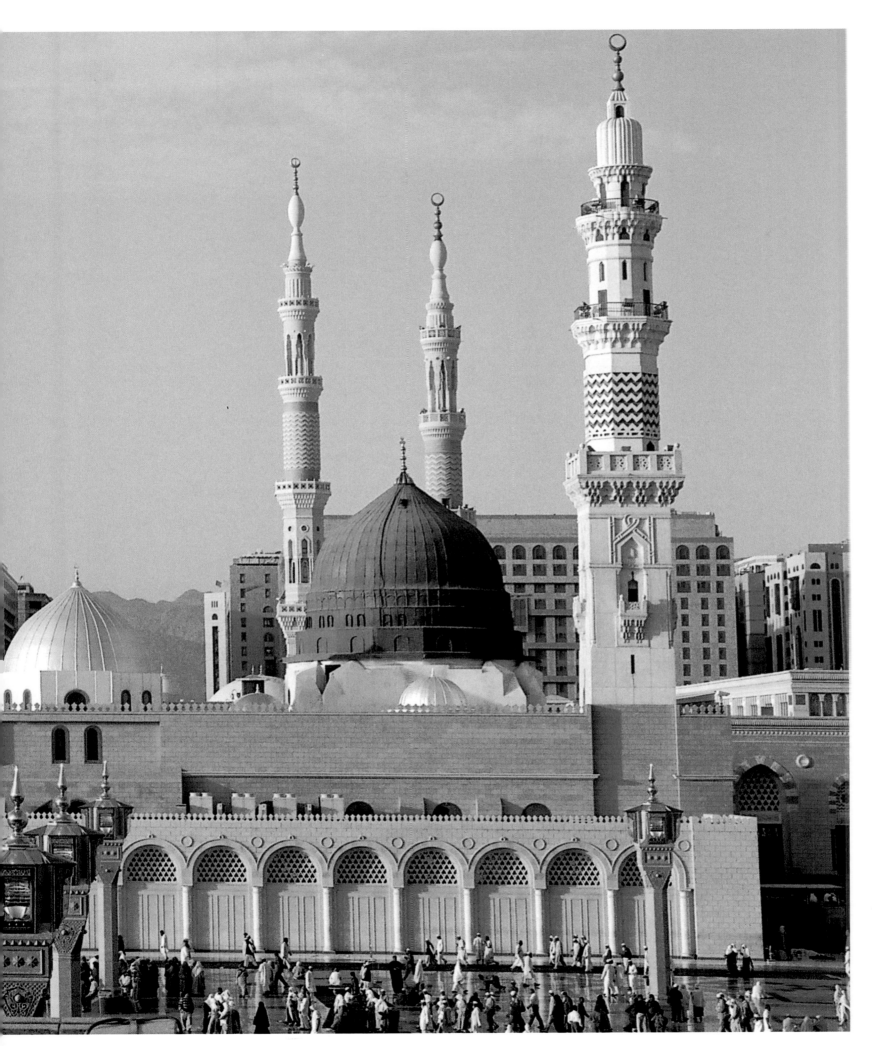

(Overleaf) Festival prayer in Medina. The heavens and the earth are in the same row.

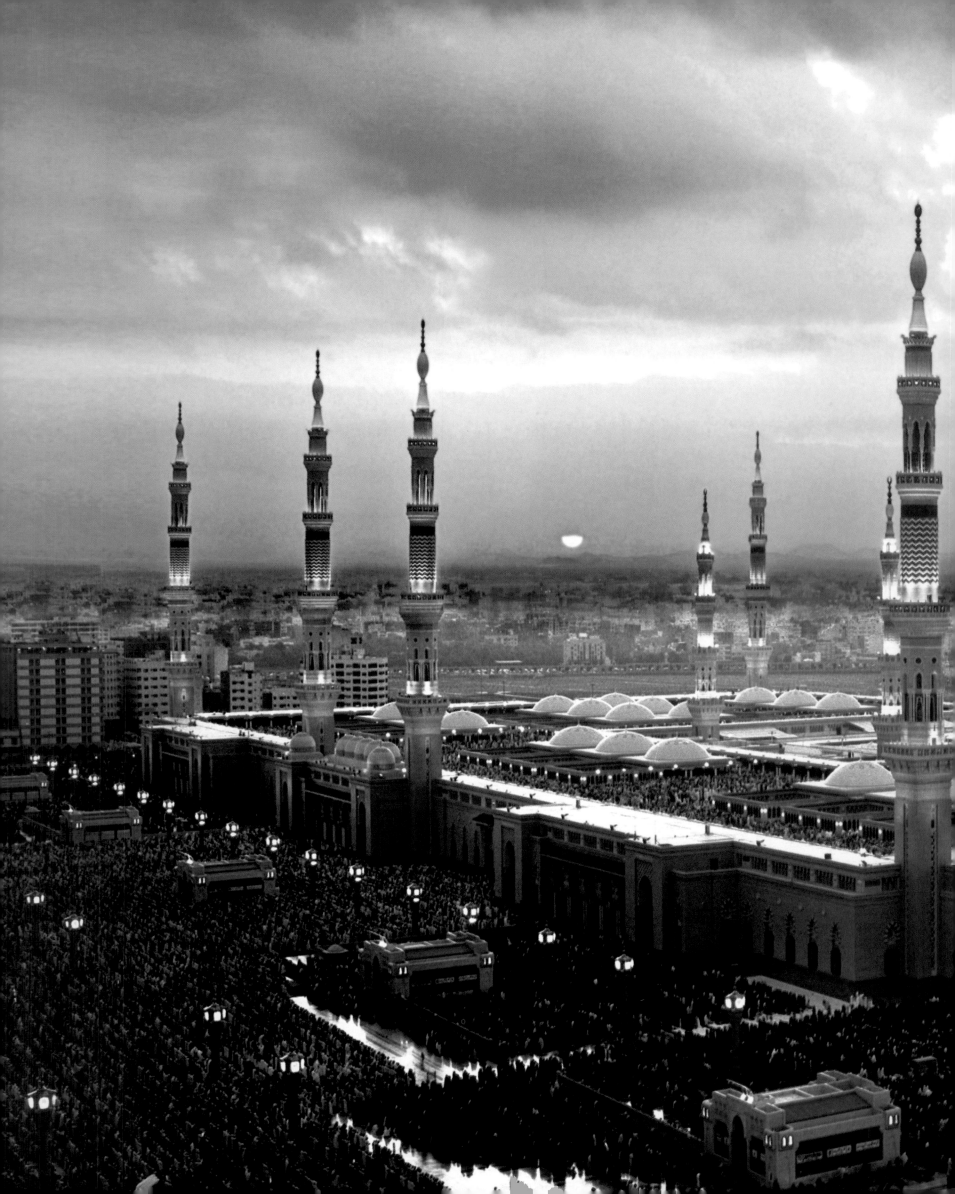

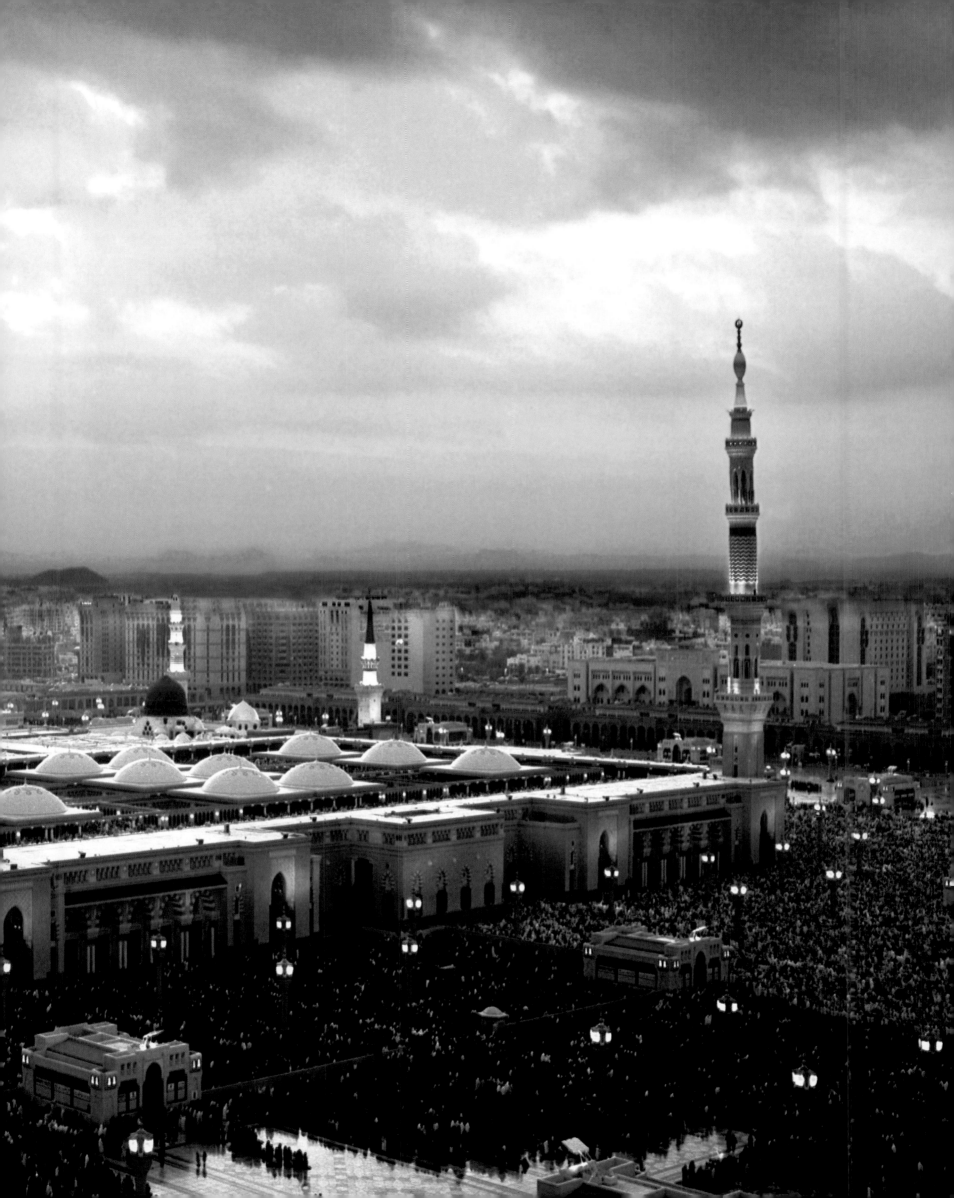

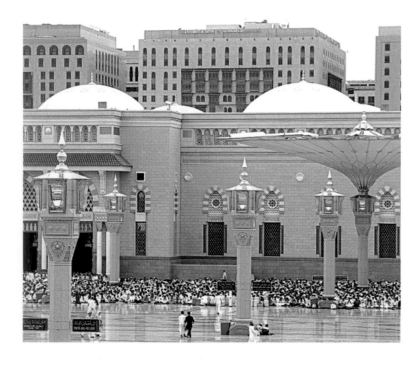

he Tomb and the Green Dome arise like an honorable soul; when lovers join them with all their emotional profundity, the place where they stand feels like a heavenly spot detached from Paradise.

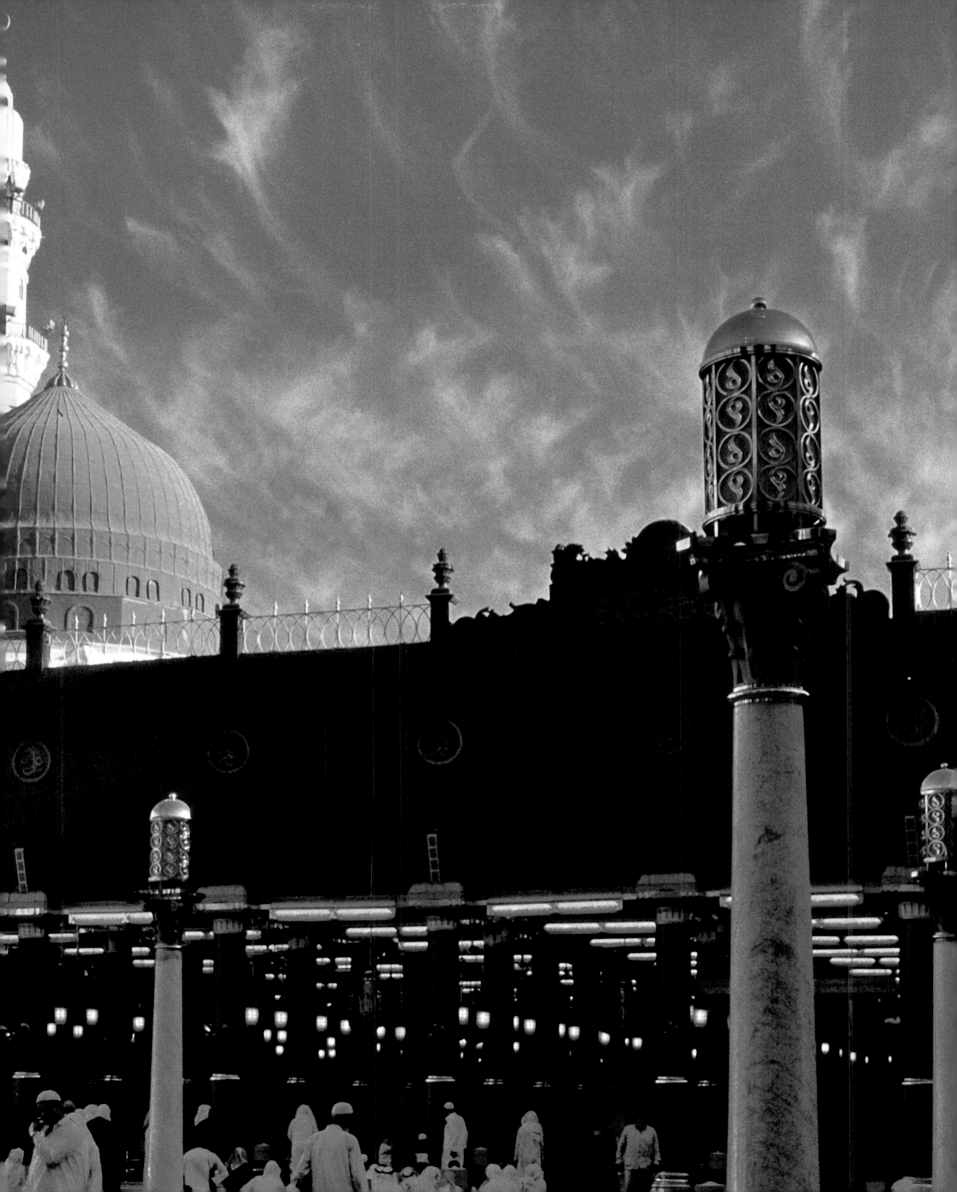

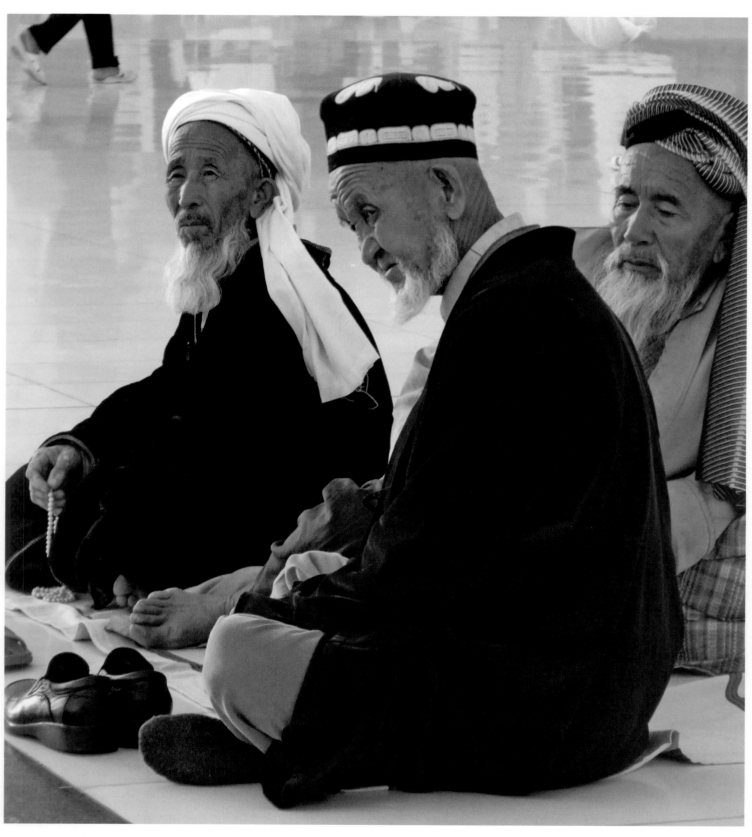

From Samarqand and Bukhara . . . from far away, they have come with the love of Muhammad, peace and blessings be upon him.
Having become neighbors in proximity with the Prophet, auspice is observed in their looks.

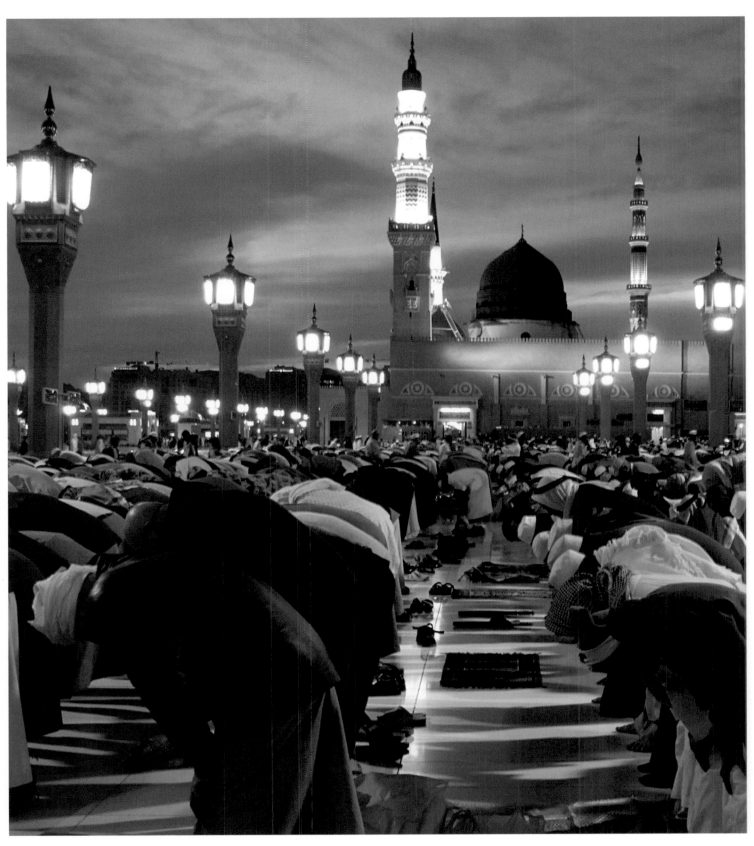

With the dignity, solemnity, and poise that is part of being in the presence of the Prophet, God-loving believers perform prayers, say supplications and blessings, and are inspired by him, filled with love and ardor as if walking through a radiant corridor. Among the rows of such believers, vigilant men move forward toward the Encounter with the feeling that they will meet unprecedented surprises at each step. Then, the Encounter... Having reached there, decent souls commemorate only him, moaning, and find consolation only with his dream and vision, their eyes closed to anything else. And if they are prepared beforehand and they come with depth of awareness and infinity in their hearts, having laid their heads on that threshold in their dreams... it is impossible to describe such a scene and words are insufficient, only making clear their impotence.

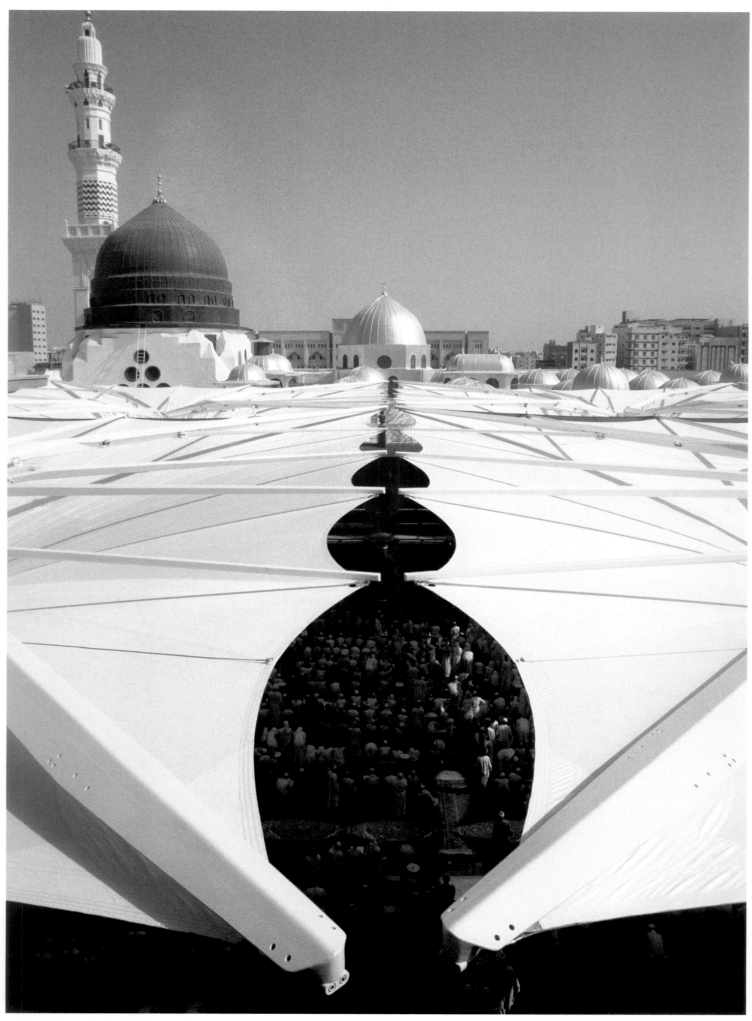

Umbrellas spread over the court of the mosque remind us the Helpers (Ansar) who sheltered the Prophet.

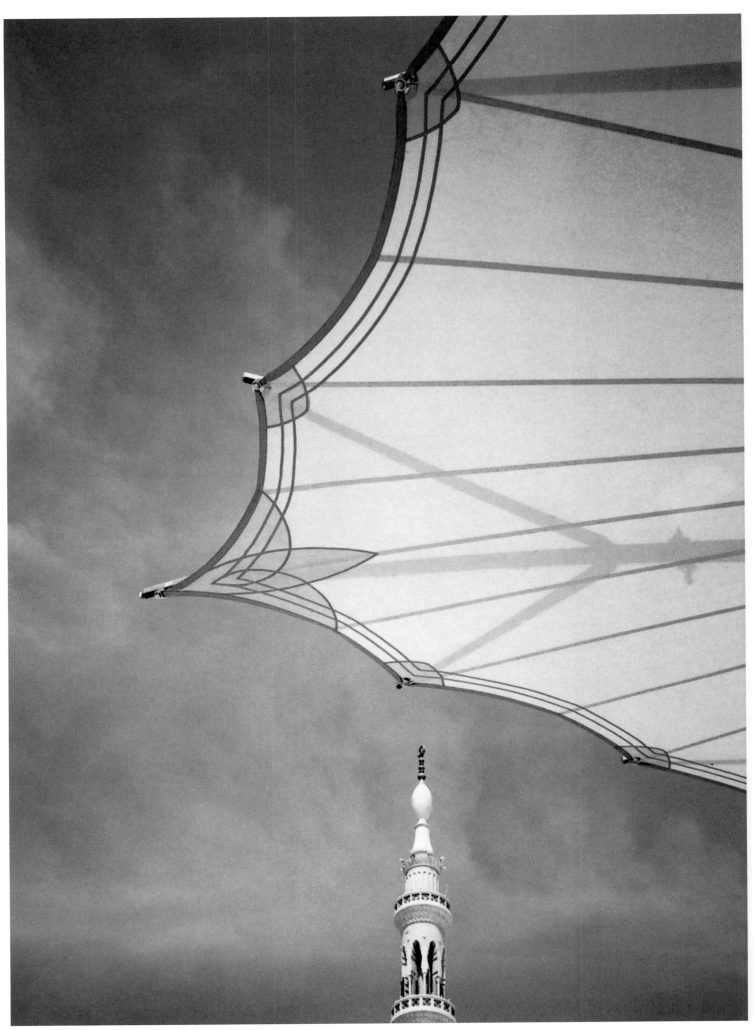

The walls, columns, domes, shades, furnishings, all the objects in this mosque,
live like flowers of every color, blessed with the best of beauties.

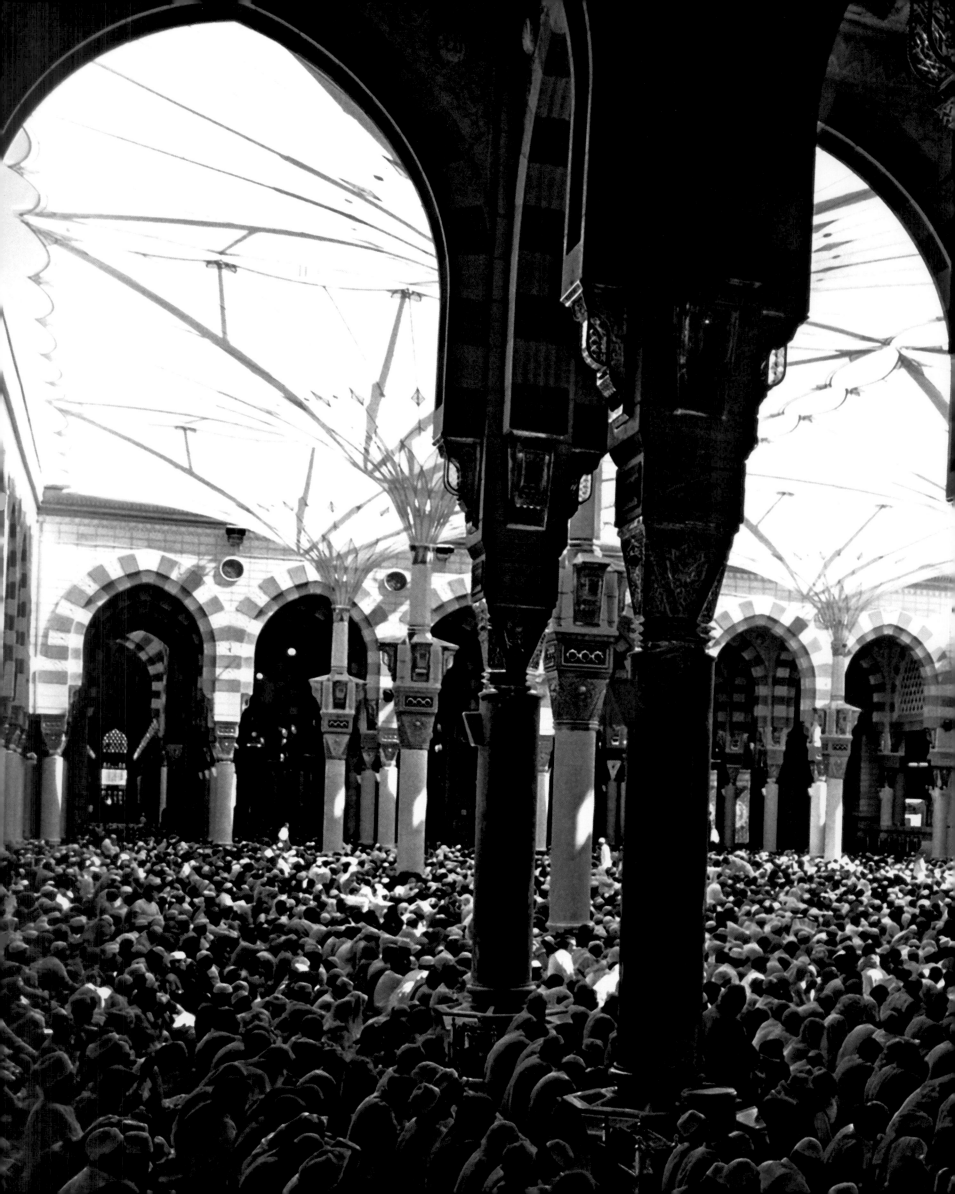

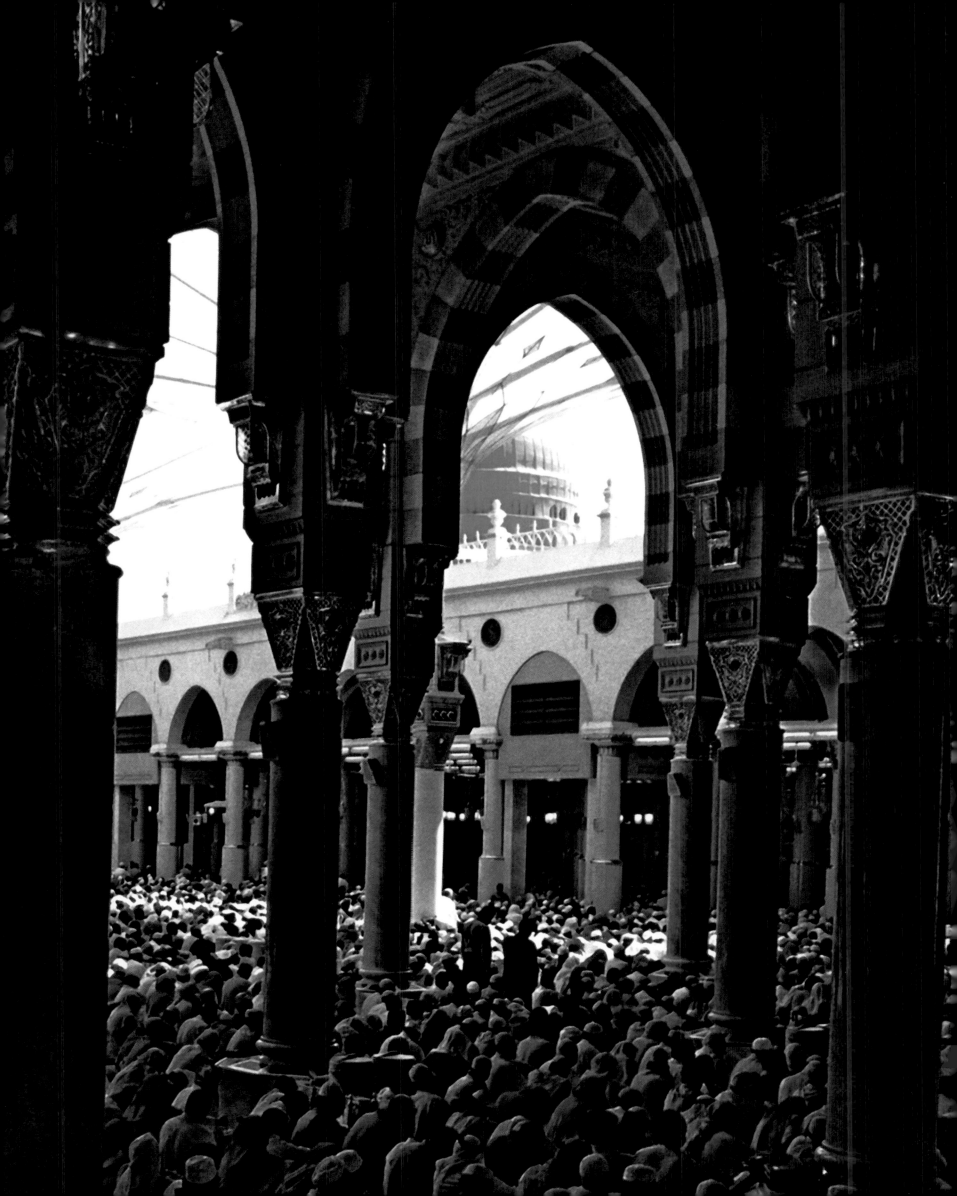

İznik tiles at the Prophet's Mosque

pon reaching the front of the sacred, the curtain located to indicate the direction of the *qibla*, which most resembles a face smiling in sorrow, one finds hundreds of loving souls trembling with the excitement of hope and aspiration. This completely green and magical climate of light gives everybody, according to merit, the feeling of being in front of a gate to another realm. Thus, upon this encounter, every loving soul overflows with enthusiasm and excitement, as if they will soon meet the beloved; and completely new lyrics of love and ardor will be heard from their conscience. And, soon, sounds, words, and images of that golden climate will engulf them completely in a multitude of associations, taking them to a mystical zone that transcends time. In this zone, everybody can perceive the present simultaneously with the past; they are aware of the luminous era of the Beloved and hear the most intimate whispers and lose themselves.

The Blessed Pulpit (minbar) in the Garden of the Prophet. ▶

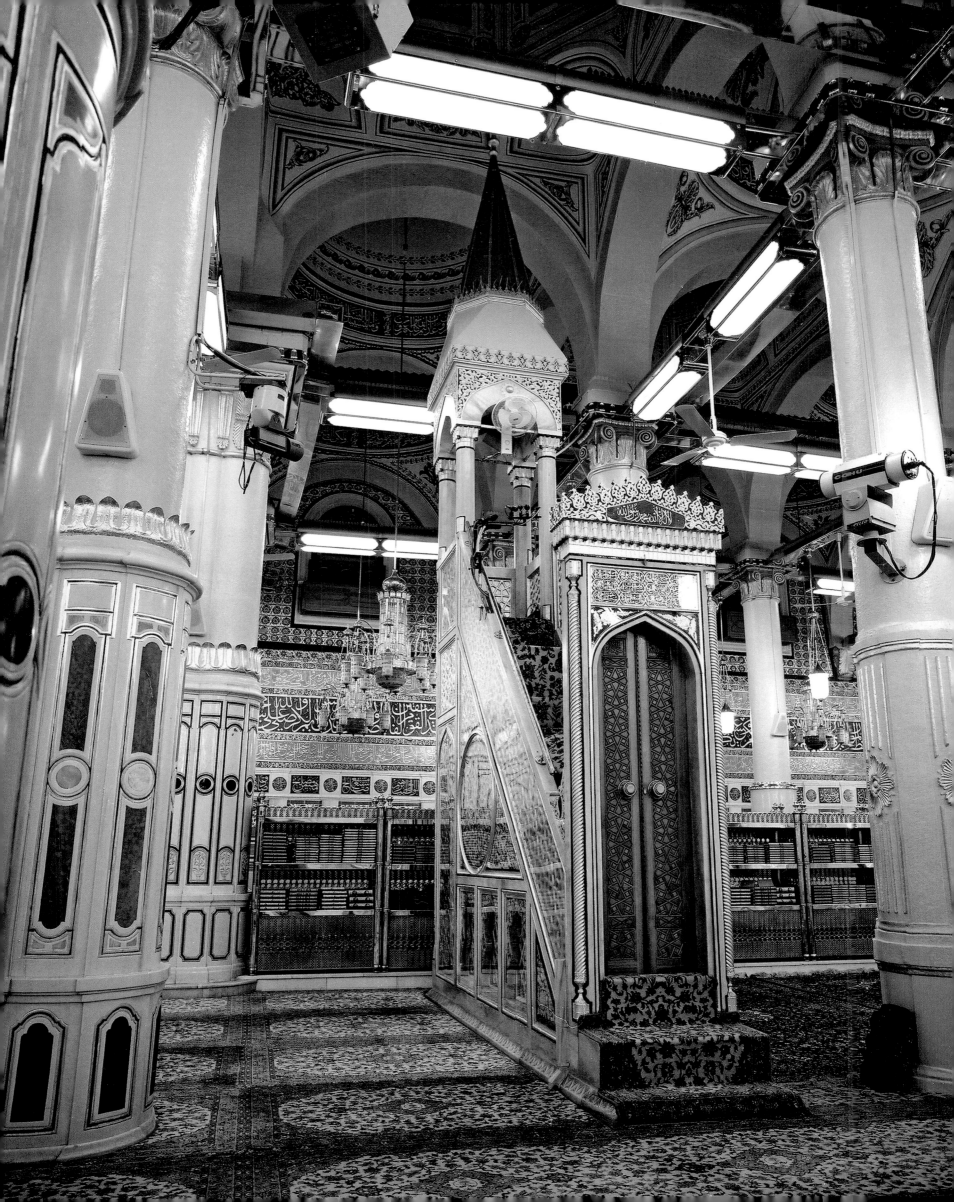

n the face of Rawda, life is always lived as if in a dream. Unless it has been completely alienated from it, no soul wants to leave this magical realm; it is as if it has been captivated, losing itself in this sea of enrapturing love. Here, reasoning is petrified, souls come under the influence of sentiments, and hearts are totally overcome with a desire of reunion. Here, the intimate day-dreams that blossom within a person, like a flower, seem to give one a taste of the delights of the gardens of Paradise and the joys and peace of those living in Paradise. This place is like an extension of the realm beyond the heavens to this world; it has been designed and established by the Divine Power or for eternity in order to penetrate the day-dreams of tender souls; it ignites sentiments, desires, and love, and composes and sings their songs. In this place, those who are capable of releasing themselves into the vivid and affluent climate of belief-based conceptions indulge in endless day-dreams; within the lives they lead, they sense the existence of another "self," which forms the real identity of humankind and which is mostly hidden from us like one who is searching for the clue to a secret or a mystery. Everybody feels as if the finely embroidered curtain of the visible world has been pierced to reveal the essence of mankind as well as the truth of everything, thus making all heavenly, making them conform to the harmony of this other world, and giving them the delights of Paradise.

We always feel ourselves in a zone of worship in Ka'ba, and of love and yearning in Rawda, respectively attempting to respond to the comprehension of the mystery of worship, and embracing it with candor and fidelity. While we fail to distinguish fully the essence of the things we feel here, we feel a realm which is more emotive than the most affective of things, and which is more exhilarating than the most thrilling of things; day-dreaming captivates us, and we become aware of the magic of a unique harmony and a peculiar poetry with indescribable sensations.

Here, life is led among the ebbs and flows of love and ardor with an elation of "the night of union." Each cry or each moan causes the hearts to shudder like the creaking of a door leading to the beloved. Souls long for "reunion"; the face of the lover appears briefly and then disappears in the dreams of those who wait deferentially before His door for a doorway with their eyes closed. Yet there is always desire and hope for ceaseless tenderness.

The qibla (prayer direction) wall in the Prophet's Mosque. ▶

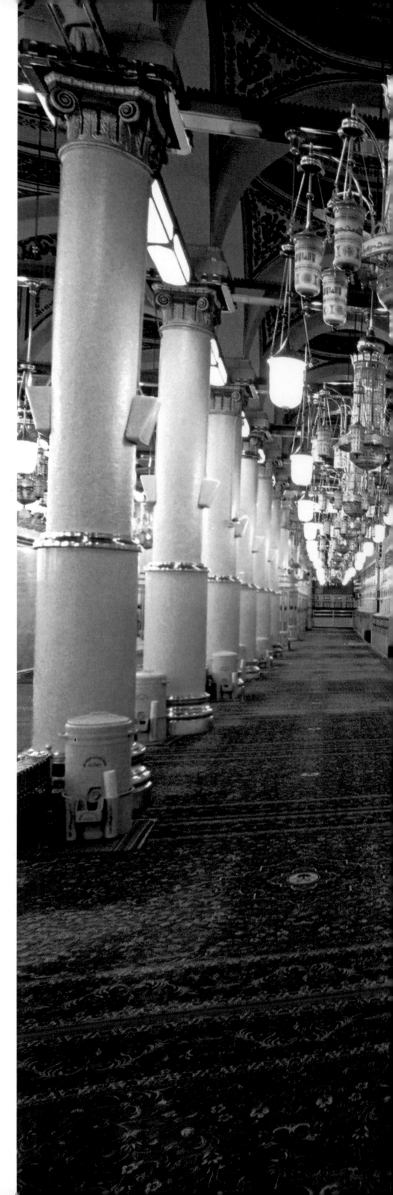

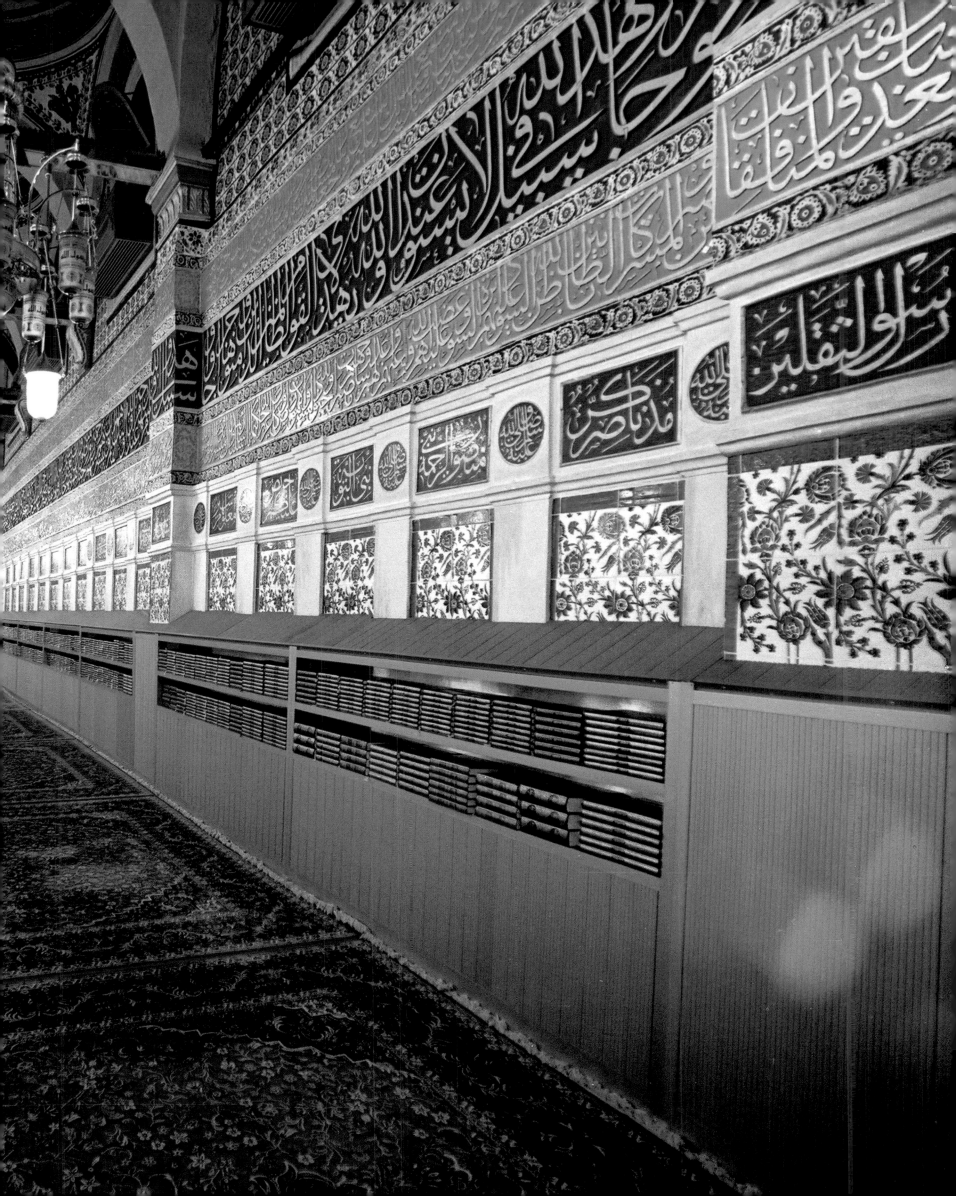

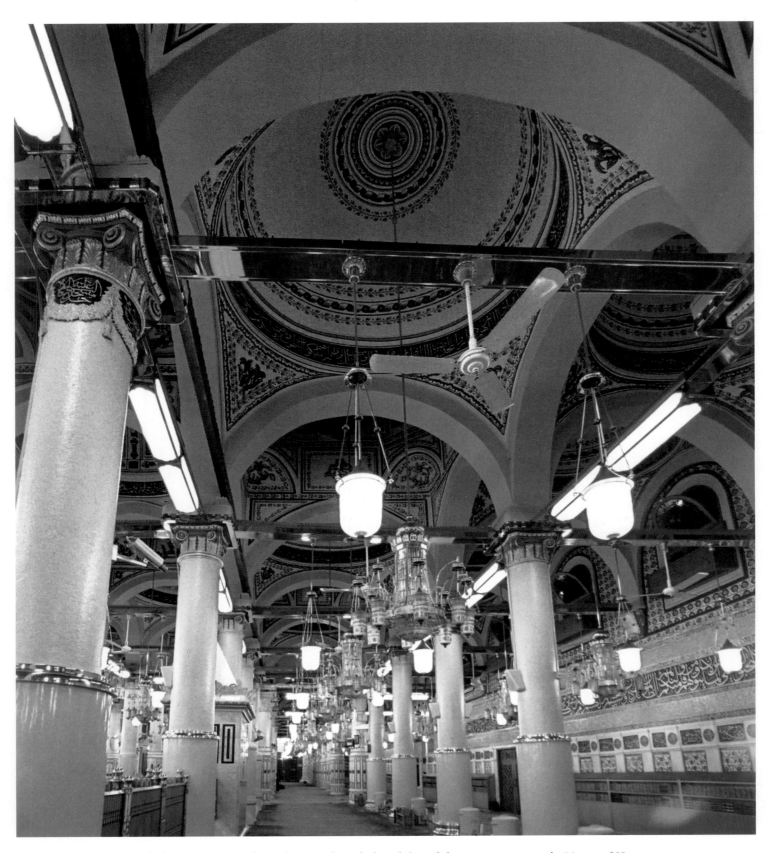

Rawda has many gates. Those who enter through them feel as if they are soon to meet the Master of Hearts.

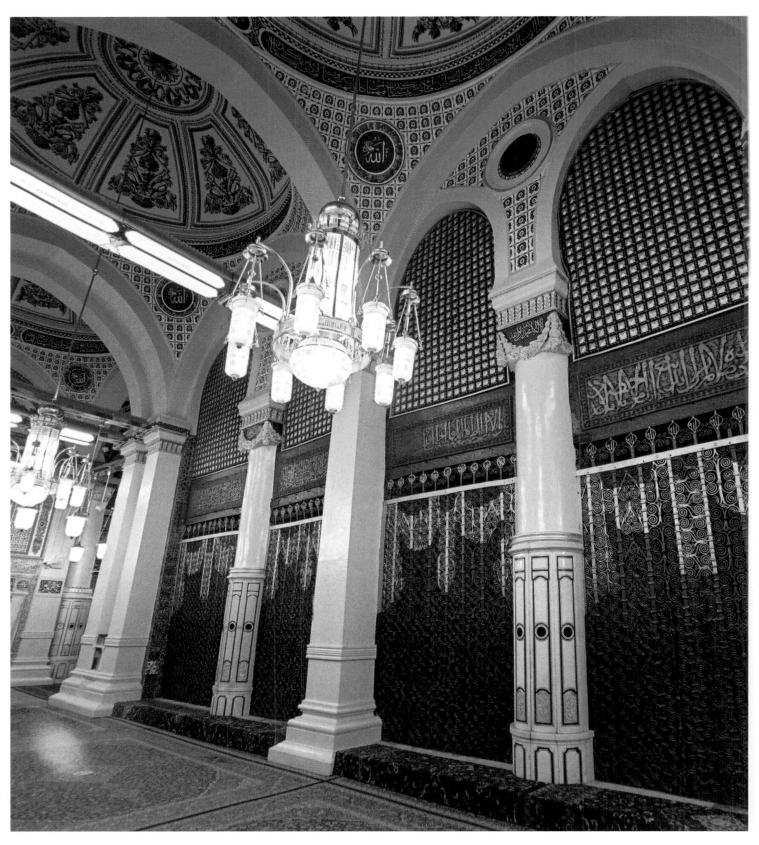

*Having reached his sanctuary, the distinguished soul becomes blind to the rest of the world
and what spill from their lips are praises for him, consoling themselves with his dream and good example.*

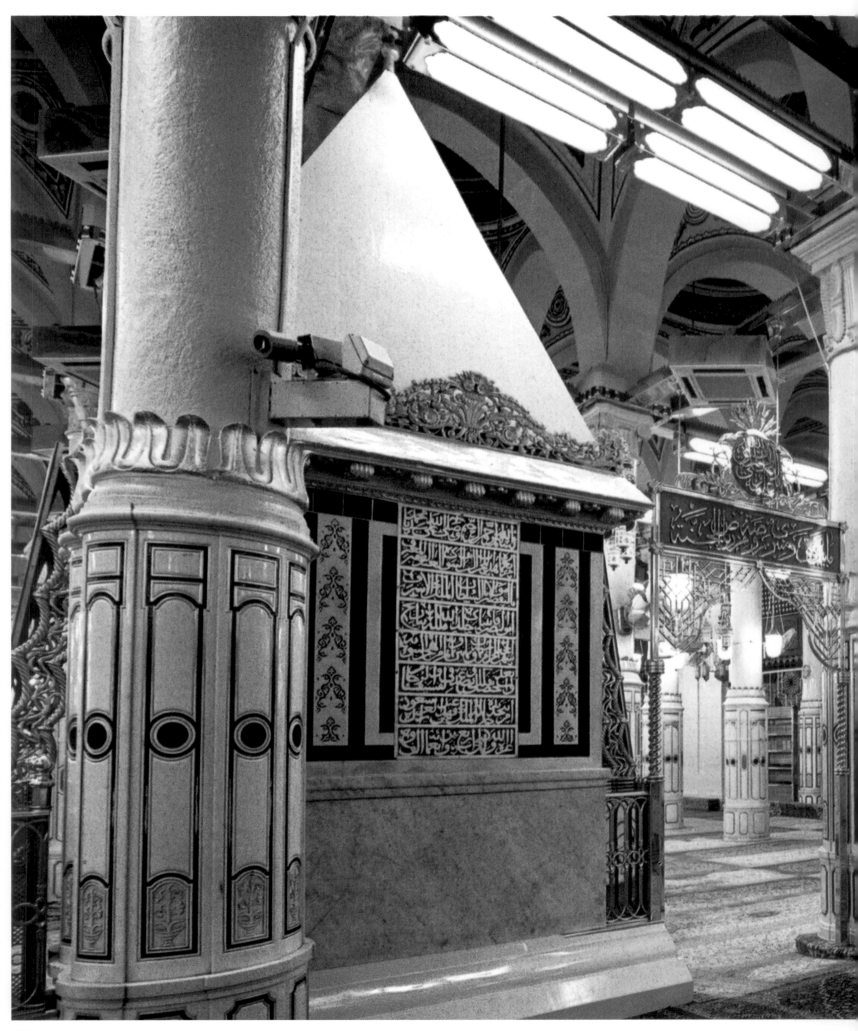

Time spent at the Encounter is luminous, tender, and open to dreams. Every respectful soul reaching there feels as if they live in the Age of Happiness, being able to witness the Messenger's purest face and perceive his elated heart receiving the revelation.

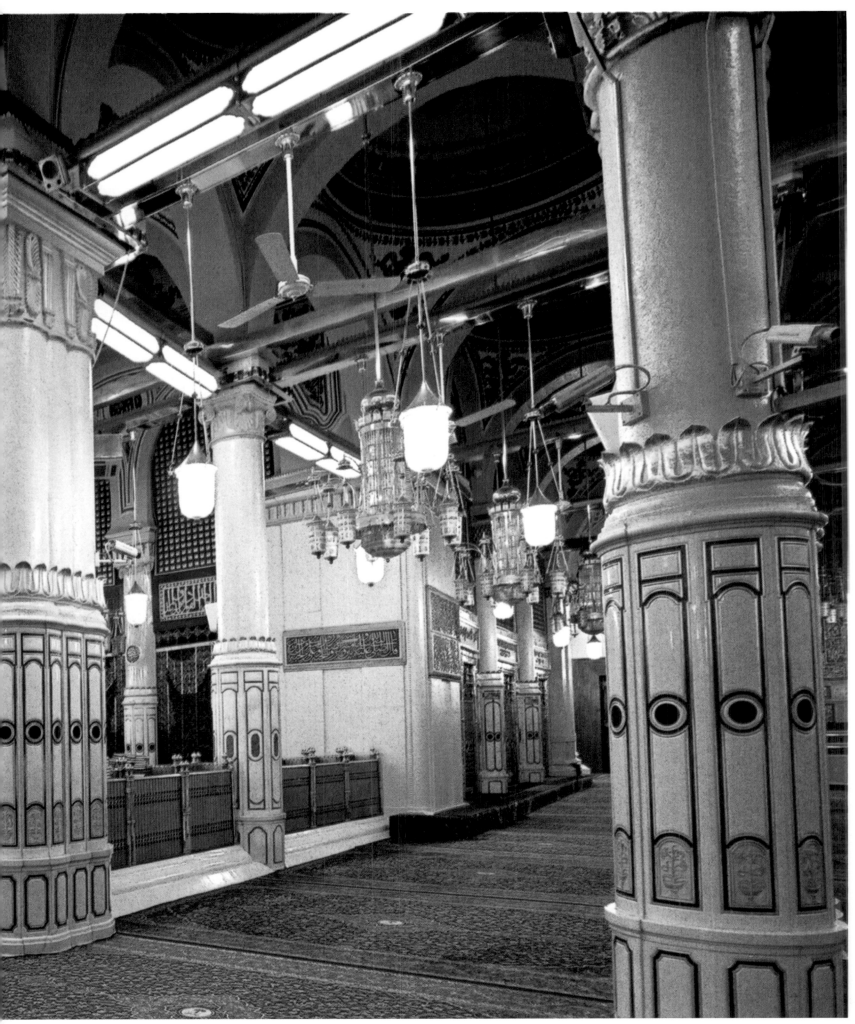

The creak of the opening of the heavenly gates and the sound of Gabriel soaring above can be heard at the Encounter,
while the sonorous sound of the Qur'an is echoed by the eagerness of the pilgrims who feel drenched by the showers of abundance from a blissful era.

212

The top three lines of calligraphy on the wall are verses from the Qur'an.
The beautiful attributes of the Prophet are inscribed below in red boxes.

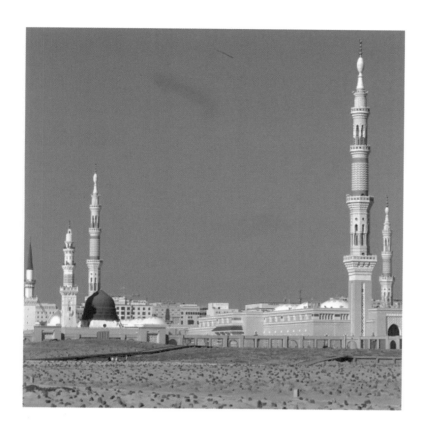

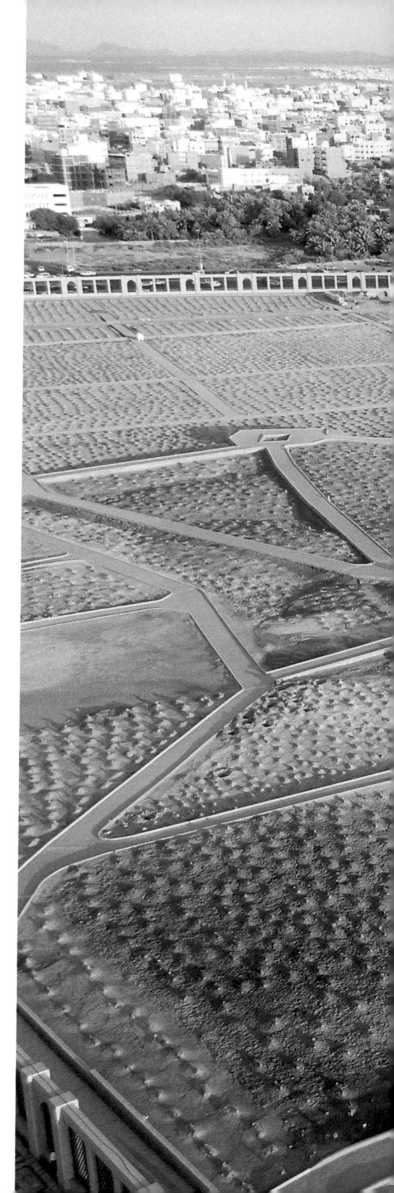

 any Companions of the Prophet, peace be upon him, are buried in this cemetery. Imam Hasan, Imam Zayn al-Abidin, Imam Muhammad al-Baqir, Imam Jafar al-Sadiq, Abbas (the Prophet's uncle), Ruqiyya, Umm Kulthum, and Zainab (the Prophet's daughters), all the Prophet's wives (except Khadija and Maymuna), Aqil ibn Abi Talib, Abdullah al-Jawad bin Jafar al-Tayyar. The first person from among the Prophet's family to be buried in Jannat al-Baqi was Ibrahim, who died when he was nineteen months old. Uthman ibn Madh'un was the first Companion to be buried in this cemetery. The tombs and sacred sites in this cemetery were destroyed in 1806 after control of the city changed hands. The domes were leveled and any structures over the Baqi cemetery were demolished. The tombs were rebuilt by Sultan Abdülhamid II. Following the end of the Ottoman services to the Haramayn, the Jannat al-Baqi cemetery underwent a similar destruction in 1926.

Jannat al-Baqi Cemetery ▶

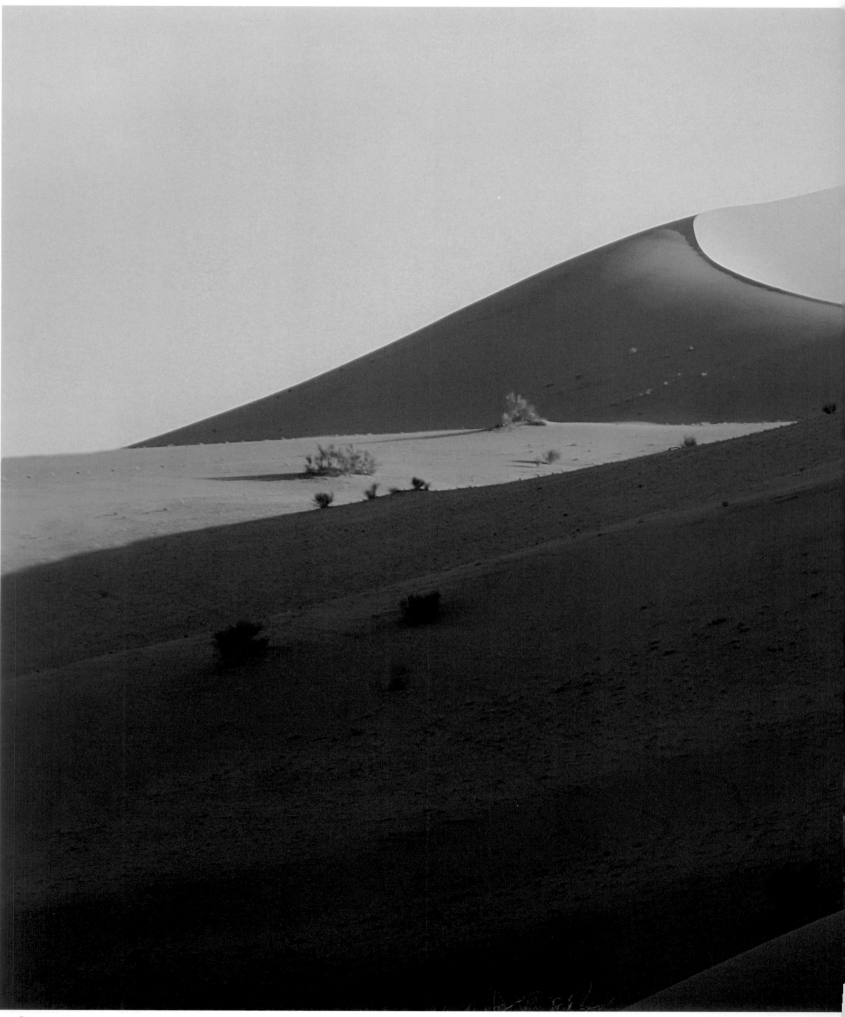

The Archers' hill

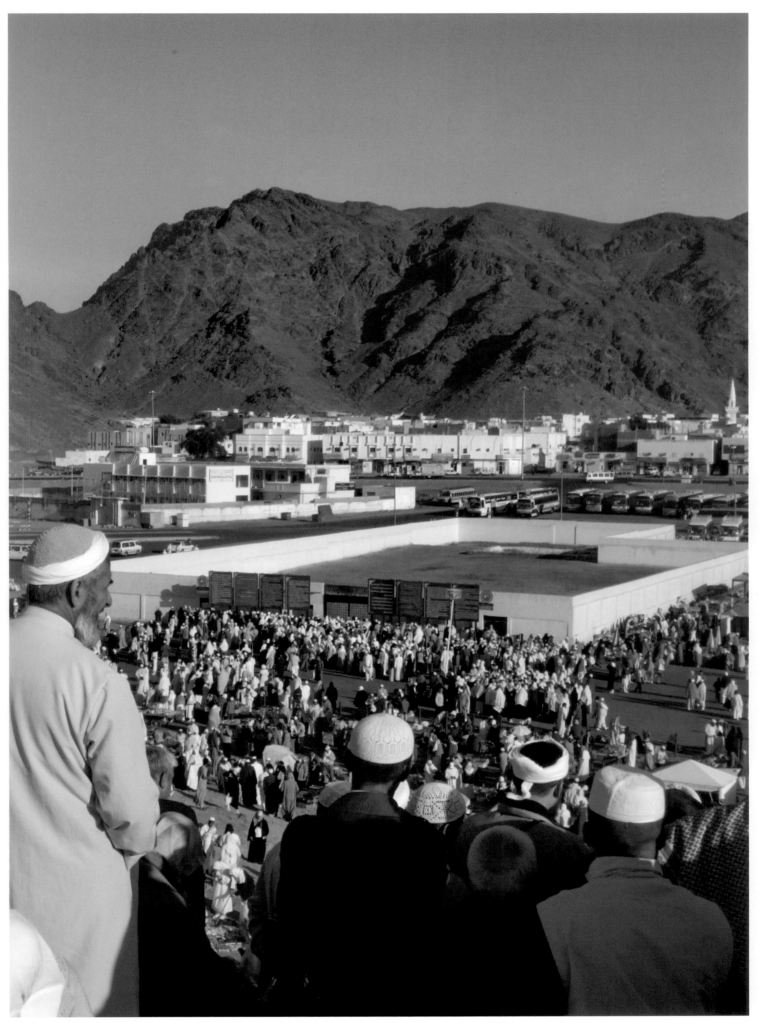

The cemetery of Hamza and martyrs of Uhud.
Hamza was the Prophet's uncle and his milk brother; he was renowned as the Lion of God (Asadullah).

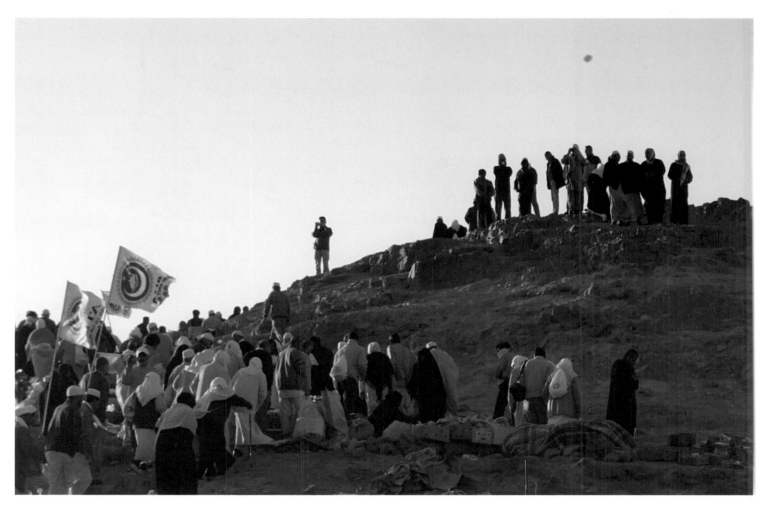

Archers were deployed on this hill during the Battle of Uhud.

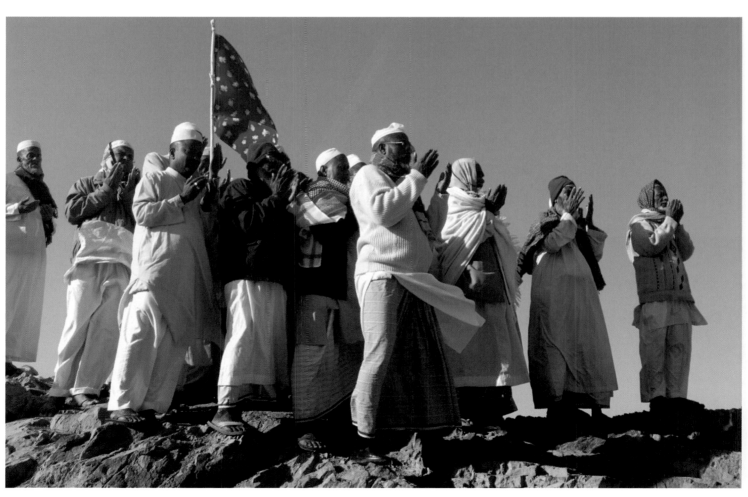

Pilgrims pray at the archers' hill, contemplating the significance of "obeying an order."

During the Battle of Uhud Muslim archers thought they had defeated the pagans, so they left their positions on this hill although the Prophet had ordered them not to. A Pagan cavalry unit came around this hill and attacked the Muslim army from behind.

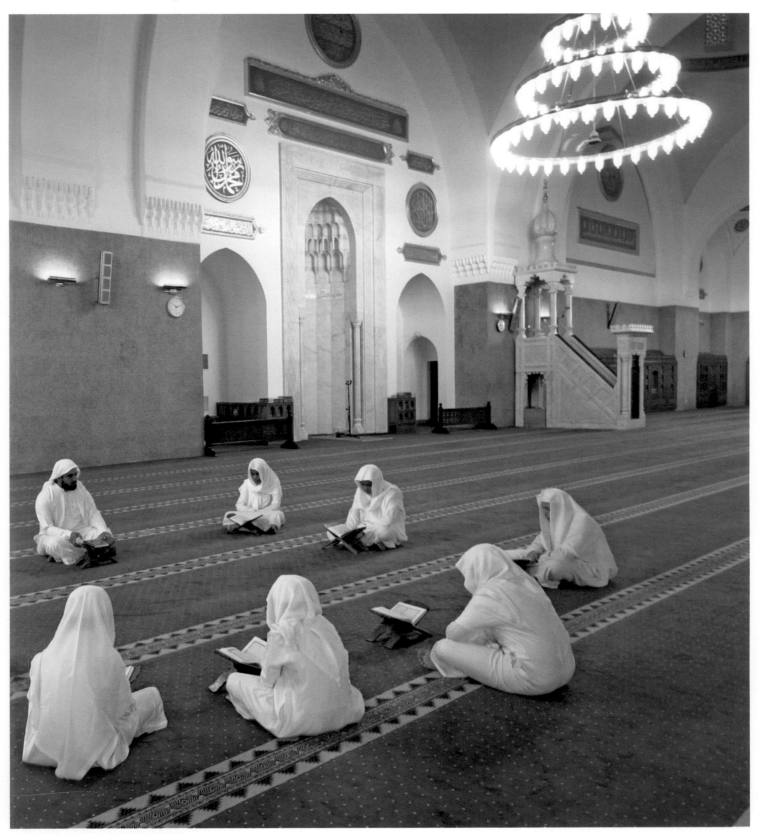

The Quba Mosque. This was the first mosque of Islam. The Prophet stopped at Quba for a short time before he arrived in Medina during the Emigration. The Quba Mosque is described in the Qur'an as follows:

The mosque that was founded on piety and reverence for God from the very first days (in Medina) is worthy that you should stand in it for the Prayer. In it are men who love to be purified. God loves those who strive to purify themselves. (Tawba 9:108)

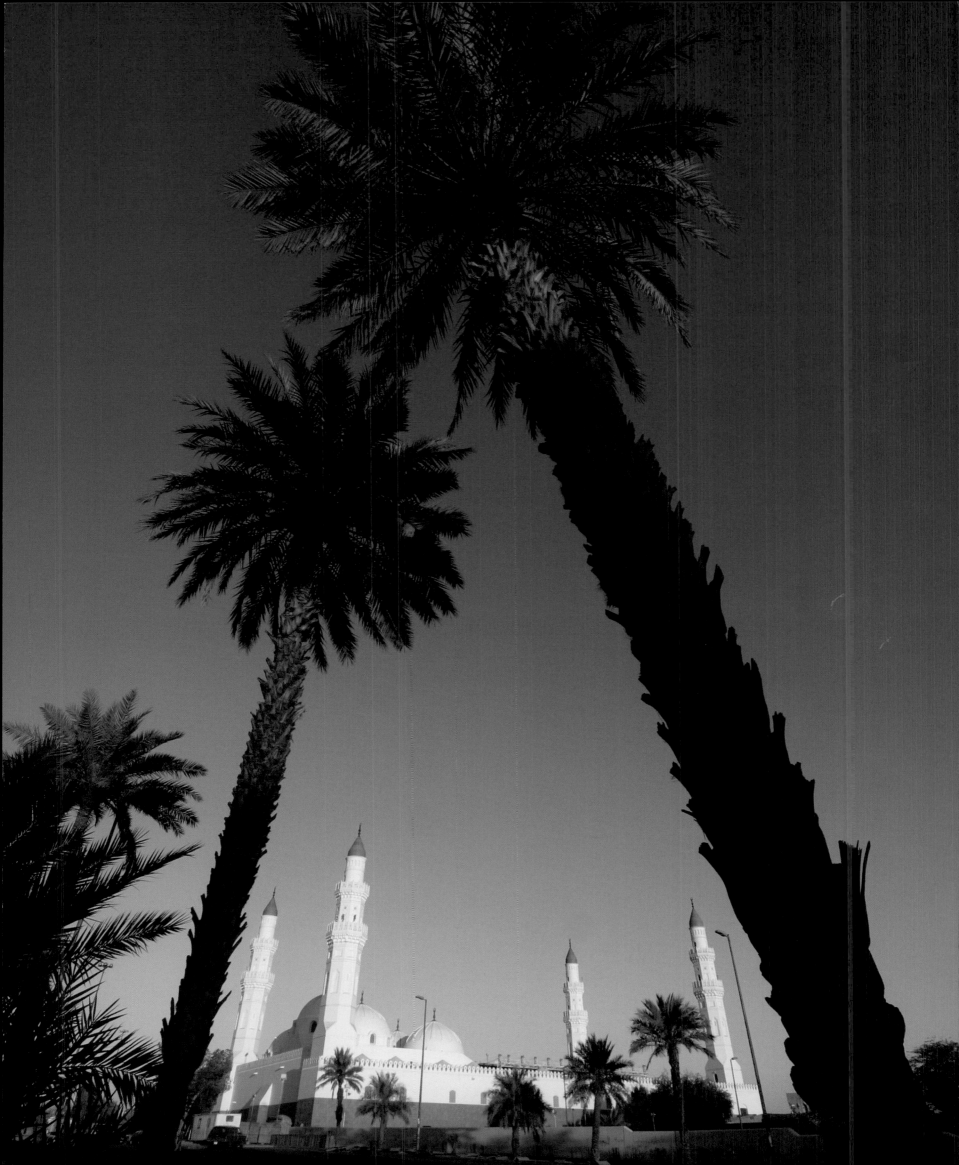

224

Al-Qiblatayn Mosque. The Prophet changed his direction from Jerusalem to the Ka'ba in this mosque after he received the divine order to do so while he was leading the asr (afternoon) prayer.

The congregation followed him and changed their direction as well. This mosque is called Qiblatayn, meaning "two directions."
Turn your face towards the Sacred Mosque. (Baqara 2:144)

Al-Miqat Mosque in Medina. Pilgrims enter the state of ihram in this mosque before they depart for Mecca.

ecca and Medina are two places visitors make immediate plans to come again. The dues required for the visit are to convey the message that was born in these cities to the places of their return. This message is an eternal trust believers are supposed to undertake to carry into the future.

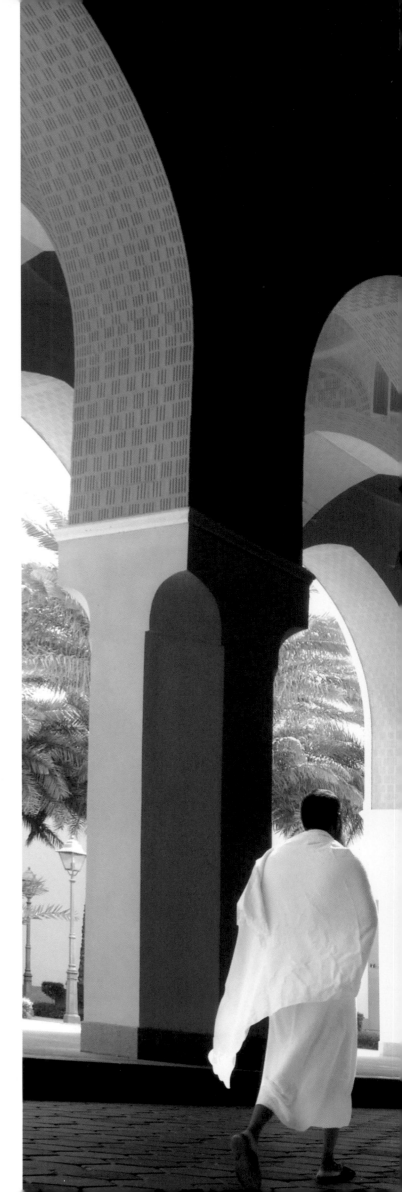

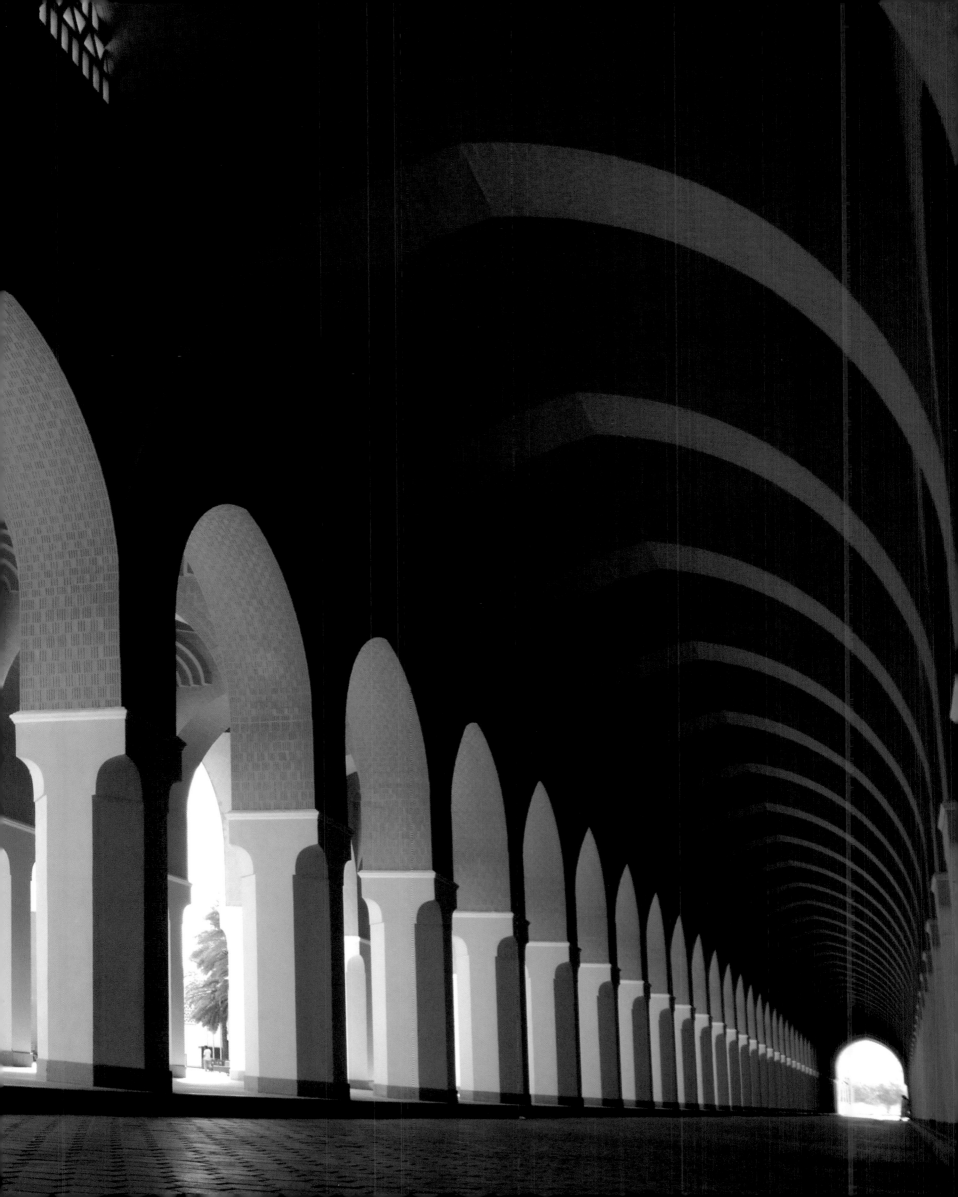

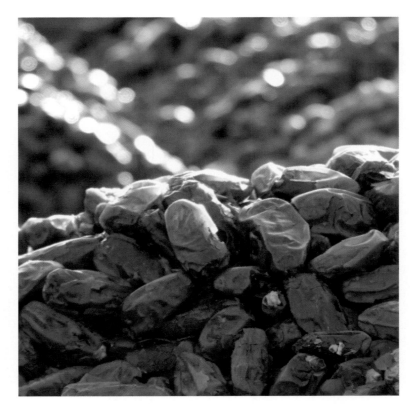

Trees of the blessed city. Eighty kinds of date grow in Medina.

ates were the most essential food item for the Prophet and the Companions. Aisha, the Prophet's wife, narrates, "We spent months in which we never lit a fire (for food); dates and water were our food; except for some meat we were given every now and then."

He it is Who sends down water from the sky, and therewith We bring forth vegetation of every kind, and then from it We bring forth a lively shoot, from which We bring forth close-packed and compounded ears of grain, and from the palm-tree dates thick-clustered hanging (ready to the hand), and gardens of vines, and the olive tree, and the pomegranate: alike and diverse. (An'am 6:99)

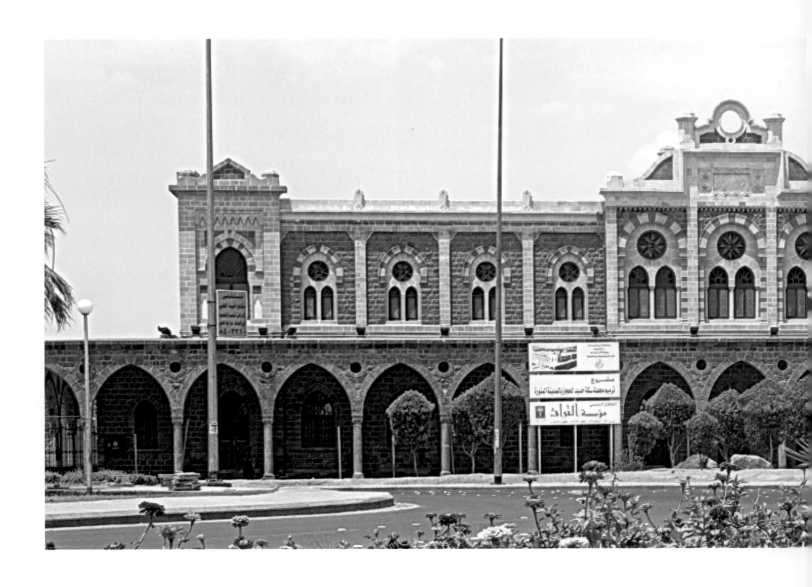

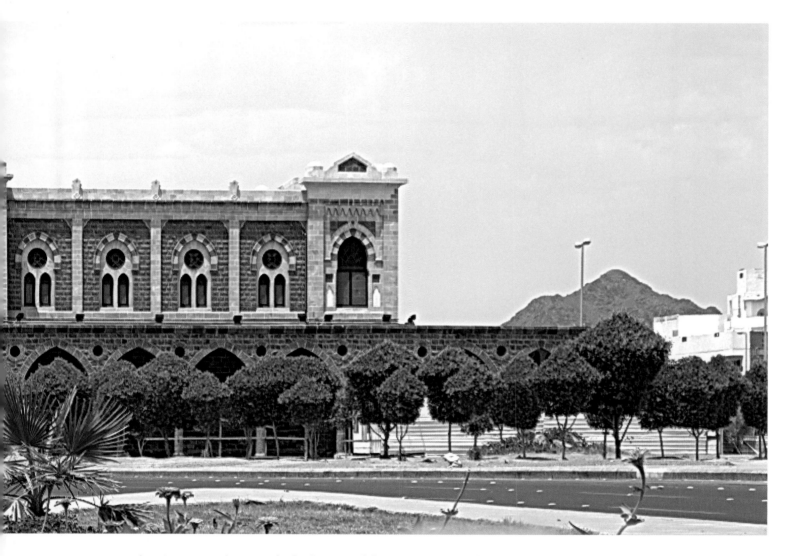

Medina Station. Medina was the final station of the Hijaz Railway which was built in the first decade of the twentieth century. The building of the Hijaz Railway was realized despite many obstructions and armed attacks. Unfortunately, the attackers were successful, and the railway was abandoned not much after it started operating.

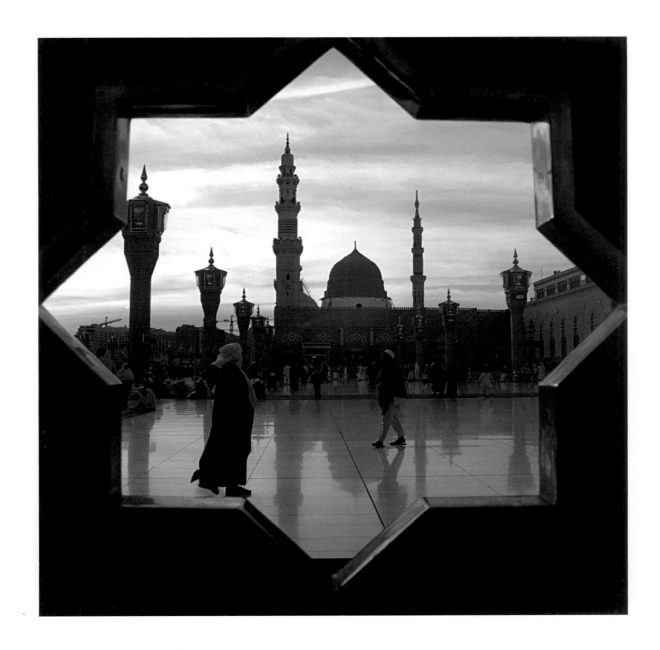

Time to Leave

"For those visiting me after I pass away it will be as if they visited me in life." Following this tradition, pilgrims have visited the Prophet, peace and blessings be upon him. They are now preparing for returning home, their luggage filled with love to share with others.